The Iconography
of the Sarcophagus of
JUNIUS BASSUS

PRINCETON UNIVERSITY PRESS • PRINCETON, NEW JERSEY

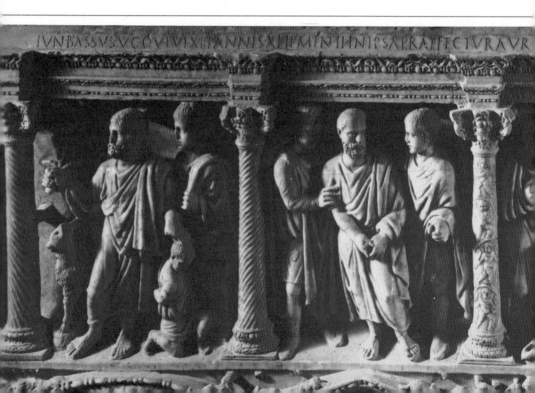

The Iconography
of the Sarcophagus of
JUNIUS BASSUS

◆ NEOFITVS ◆ IIT ◆ AD ◆ DEVM ◆

Elizabeth Struthers Malbon

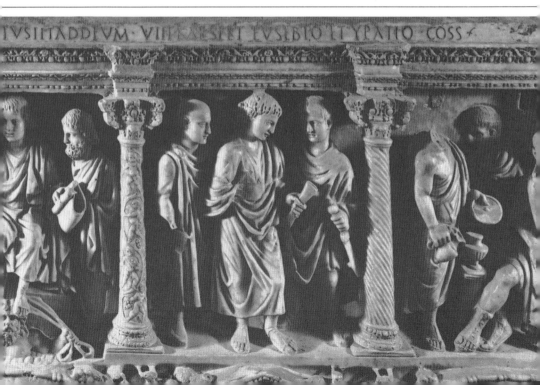

Library
of Congress
Cataloging-
in-
Publication
Data

Malbon, Elizabeth Struthers.
The iconography of the sarcophagus of Junius Bassus / Elizabeth
Struthers Malbon.
p. cm.
Includes bibliographical references.
ISBN 0-691-07355-4 (alk. paper)
1. Bassus, Junius—Tomb. 2. Sarcophagi, Roman—Themes,
motives. 3. Relief (Sculpture), Early Christian—Themes, motives.
I. Title.
NB1810.M26 1990
733'.5'09376—dc20 90-8252 CIP

This book has been composed in Trump Medieval

Princeton University Press books are printed on acid-free paper,
and meet the guidelines for permanence and durability of the
Committee on Production Guidelines for Book Longevity of the
Council on Library Resources

Printed in the United States of America by
Princeton University Press, Princeton, New Jersey

10 9 8 7 6 5 4 3 2 1

For Scott

SINE QVA NON

———————

and

Bradford

NEOFITVS DILECTVS

Contents

viii CONTENTS

Preface

TO VIEW the fourth-century sarcophagus of Roman senator Junius Bassus, the visitor to Rome enters the enormous and enormously impressive sixteenth-century Basilica of St. Peter. Originally placed near the tomb of St. Peter (in the area now serving as the crypt of the basilica), this early Christian sarcophagus is now to be seen in the Museo Historico e Artistico, entered from the left side aisle of the basilica ("turn left at the baldachino"). The museum is more generally known as the Museo Tesoro, the Treasury Museum, because it exhibits many gold and jeweled crosses, candlesticks, and chalices made for use at the altars of St. Peter's. The sarcophagus is displayed as the final treasure (and one of only two sarcophagi) in the Museo Tesoro, where its highly polished white marble facade is stunning against the black-felt-covered walls of the museum. Here the work stands in splendid isolation.

But the Roman visitor can also view and study the scenes of the sarcophagus on a plaster cast displayed in the Museo Pio Cristiano of the Vatican Museums, where it stands in the center of a collection of columnar sarcophagi and at almost the end of the entire collection of Christian sarcophagi. One usually views it after observing the "pagan" sculpture (including sarcophagi) of the lower level of this wing of the museum and the Good Shepherd, strigilated, and frieze sarcophagi of the Museo Pio Cristiano of the upper level. Both views are important. The work is so striking in its design and execution that it does in many ways stand alone. And yet it must also be seen to stand in its mid-fourth-century context; its scenes and their interrelations are best understood against the background of earlier and contemporary conventions of sepulchral art.

I wish to present both these views of the sarcophagus of Junius Bassus as I focus on its iconography. Careful observation of the composition of the work itself will provide the first clues to its iconography. The second clues will be discovered by a consideration of the conventions of earlier and contemporary art and religious literature that stand behind the scenes of the Bassus sar-

cophagus. Contemporary images and texts will be juxtaposed in an effort to catch a glimpse of what the fourth-century viewer saw and understood. My own reading of the iconographical program and my evaluation of the readings of others will follow from these observations on composition and conventions. My concern is to view and understand the work itself, the work as carved, but in its fourth-century context as a tomb for the very newly baptized Christian and rather newly installed city prefect of Rome, Junius Bassus. My approach is to bring both art historical and history of religions methodologies and materials to bear in order to appreciate the interrelated artistic and religious significance of the magnificent sarcophagus of one of whom it could be said, in the words of the inscription: NEOFITVS IIT AD DEVM (newly baptized he went to God).

It is my hope that this book will be of interest to both art historians and religion scholars—as well as to students and scholars of the humanities more generally. Yet perhaps both art historians and religion scholars, to name the two most directly addressed groups, will find this work not quite what they expect in their own fields. Some art historians, for example, may find it strange that the style of this finely carved sarcophagus is nowhere discussed, and that I write of the iconographical *program* of this fourth-century work before arguing with those who contend that such a concept is anachronistic in the mid-fourth century. (In fact, my entire essay is such an argument, as will become clear—but only later.) Some art historians may judge that I linger too long over details of biblical narratives and early Christian exegesis (biblical interpretation) and the roots and varieties of typological thinking—although early Christian art historians will surely appreciate the importance of these elements for understanding iconography. Some religion scholars, on the other hand, may need to become accustomed to evaluating *visual* evidence, to "reading" images as well as words. (Looking carefully at all the photographs before reading may be helpful in this case.) Some religion scholars may judge that undue weight is being given to form over content—although biblical scholars who are accustomed to the more recent literary approaches will certainly be at home with the underlying assumption of the inseparability of form and content.

General readers may wish to forgo the notes, which support

and extend the argument but are not essential to following it. All readers are invited to participate in the uncovering of the iconographical significance of the Junius Bassus sarcophagus—by following the clues given in its composition and its relation to contemporary conventions. My own process of discovery has led to an interpretation striking not in its overall novelty but in certain newly seen aspects as they contribute to a comprehensive view appropriate in the twofold light of the work's compositional cues and contemporary contexts, both visual and verbal. My hope is that the challenge and excitement I have experienced in crossing traditional disciplinary boundaries may be shared and that, thereby, the artistic and religious significance of one extraordinary early Christian sarcophagus may be experienced anew.

Rome
August 1987

Acknowledgments

MY INTEREST in the sarcophagus of Junius Bassus began in 1975. Throughout the years since then I have been fortunate to receive encouragement, support, assistance, and constructive criticism from a number of individuals and institutions, whom I am pleased to name here. I express my gratitude to:

Warren Sanderson for the original encouragement to develop this work from an earlier, more limited study;

Elizabeth Kirby for helpful comments at several stages along the way;

Audrey Wilson, Karen Mellen, and J. D. Stahl for assistance with German translation;

Elizabeth Clark for assistance in tracking down several references to early Christian writers and themes;

The Center for Programs in the Humanities at Virginia Polytechnic Institute and State University for a 1984 summer stipend for research and writing on this topic;

Scott Malbon and also the staff of the Learning Resources Center photo lab at VPI&SU for photographing printed plates;

Anita Malebranche, humanities librarian, and the staff of the Interlibrary Loan Office at VPI&SU, especially Lyn Duncan, for procuring essential materials;

Mrs. Horst R. Moehring for the gift of the personal library of her husband, Professor of Religious Studies at Brown University, to the VPI&SU Library and Religion Department;

Charles A. Kennedy for bibliographic help, including generous loans of books from his personal library;

The National Endowment for the Humanities for a 1987 summer seminar fellowship to study "Art in the Culture of Pagan and Christian Rome in Late Antiquity" in Rome;

The American Academy in Rome for making available library and academic support facilities;

Dr. Leonard E. Boyle, O.P., director of the Vatican Library; Professor Carlo Pietrangeli, director of the Vatican Museums; and Monsignor De Logu, director of the Historical and Artistic Mu-

seum (the Treasury Museum) of St. Peter's, for providing wonderful access to their respective collections;

Fellow participants in the 1987 National Endowment for the Humanities summer seminar in Rome, particularly Mary Heuser,
Debra Israel, Fred Slater, Susan von dom Thall, and David
Wright (seminar director) for helpful comments, questions, and
bibliography, and especially Luther Martin for a critical and encouraging reading of the antepenultimate draft of the manuscript;

Virginia Polytechnic Institute and State University for a study-
research leave for the 1987–1988 academic year;

Glenn Bugh and Andrew Becker for assistance with Latin epigraphs;

Kent Richards for an invitation to present a paper on the topic as
a plenary address to the Society of Biblical Literature International Meeting in Sheffield, England, in August 1988; the University of Sheffield for graciously co-sponsoring the address and
David J. A. Clines for assisting with the arrangements for it;
and the Virginia Tech Foundation and the American Council
of Learned Societies for travel funds;

Tamara Eriksen for consistently competent and courteous assistance with typing;

The Research Division and the Religion Department of VPI&SU
for funds for photographic permissions;

Elizabeth Foster for preparing the line drawing of the sarcophagus
and the three diagrams (1–1, 8–1, 8–2);

Robert Wilken for reading portions of the penultimate draft;

Lawrence Cunningham for reading portions of the penultimate
draft, as well as following the project with lively interest and
helpful comments for years;

Sabine MacCormack for reading two entire drafts and offering
not only many valuable professional suggestions but also warm
personal encouragement;

Cathie Brettschneider, former religion editor of Princeton University Press, for expressing excitement and support throughout the process of moving from manuscript to book;

Alessandra Bocco, assistant production editor, and Frank Mahood, designer, of Princeton University Press, for their quiet
competence;

Jean Hammond and Virginia Hummel for gracious assistance in proofreading;

Debra Law and Ruth Malbon for most welcome help in preparing the indexes.

It should not be thought that each of these individuals agrees entirely with my interpretation of the iconography of the sarcophagus. But all have offered critical assistance, and some have offered the invaluable support of listening and questioning, and I am grateful. All are, of course, absolved from the errors of omission and commission that are bound to occur in a complex interdisciplinary work that has spanned a decade and two continents.

It is to my husband, Scott, and our son, Bradford, that I dedicate this book. The strength and flexibility of their love enabled me to bring this work near to completion in Rome in the summer of 1987, where they were with me in mind and spirit.

Figures

All photographs from Gerke are reprinted by permission of the Deutsches Archäologisches Institut.

Tables and Diagrams

The Iconography
of the Sarcophagus of
JUNIUS BASSUS

1 Introduction

IVN BASSVS V. C.

QVI VIXIT ANNIS XLII MEN. II

IN IPSA PRAEFECTVRA VRBI

NEOFITVS IIT AD DEVM

VIII KAL. SEPT.

EVSEBIO ET YPATIO COSS.

Junius Bassus, *vir clarissimus* [of senatorial rank],[1]

who lived 42 years, 2 months,

in his own prefecture of the city,

newly baptized, went to God,

the 8th day from the Kalends of September,

Eusebius and Hypatius, consuls [August 25, 359].

SO READS the inscription on the upper edge of the sarcophagus of Junius Bassus (see fig. 1). The inscription identifies the deceased by civic class and responsibility and by Christian status and hope, as well as serving to date the sarcophagus to 359.[2] Not much is known about Junius Bassus. He was born in June 317. His father, also named Junius (Iunius) Bassus, served as praetorian prefect in 318–331, became a consul in 331, built a basilica on the Esquiline, and may have been a Christian.[3] Junius Bassus the son— Junius being the *nomen* or *gentile* name (the name of the *gens*), Bassus being the *cognomen* (the name of the family within the *gens*)[4]—was surnamed Theotecnius.[5] He died on August 25, 359, while holding the office of prefect of the city of Rome, a fact noted on the inscription of his sarcophagus and by the fourth-century historian Ammianus Marcellinus.[6] The city prefect was "the highest official residing in Rome, head and leader of the Sen-

ate."[7] According to an inscription set up on July 18, 364, in a room of a large villa near Aqua Viva in Etruria, presumably one of the son's own villas, his career had included the offices of *comes ordinis primi, vicarius urbis Romae,* and *praefectus urbi iudici sacrarum cognitionum.*[8] Although probably committed to the Christian faith earlier in his life, he was apparently baptized on his deathbed, a common enough practice in the fourth century.[9] What was not so common in the mid-fourth century was for a member of a Roman senatorial family to be baptized at all. "The old senatorial families certainly remained predominantly pagan down to the latter part of the fourth century."[10] But, as the inscription of his sarcophagus proclaims, Junius Bassus was *neofitus* as well as *vir clarissimus* and *praefectus urbis.* And there is a clear compatibility between his high social status and the quality of his sarcophagus in design, material, and workmanship.

Even less is known for certain about the workshop (designers, carvers, apprentices) that produced his sarcophagus.[11] But John B. Ward-Perkins's comment about earlier sarcophagi workshops is still applicable here: "Change there was, both in content and in style; but it was change operating within a framework of continuity and of a broadly conservative workshop tradition."[12] Thus it is the sarcophagus itself, more than its patron or its carvers, that commands attention; and the sarcophagus itself is reflective of both continuity and change.[13] In fact, the sarcophagus is often anthologized in histories of early Christian art as an important example of characteristic scenes and stylistic change.[14] It has, however, less often been analyzed in detail in terms of its iconographical program.

Certainly there is much to work with in terms of iconography. The marble sarcophagus (fig. 1), now in the Treasury Museum of St. Peter's, is of the "more expensive"[15] double-register type. One of only two extant double-register columnar sarcophagi (compare fig. 2),[16] it consists of a five-niche entablature-type register over a five-niche arch-and-gable-type register. The ten intercolumniations are filled with scenes of biblical characters: upper register, left to right—the sacrifice of Isaac, the arrest of Peter, Christ enthroned between two disciples, the arrest of Christ, the judgment of Pilate; lower register, left to right—the distress of Job, Adam and Eve in the garden, the triumphal entry of Christ into Jerusalem, Daniel in the lions' den, the arrest of Paul. Old and New

Testament scenes symbolically enacted by lambs, and now quite damaged, are carved on the spandrels of the lower register. These scenes may be identified as the three youths in the fiery furnace, the striking of the rock, the multiplication of the loaves, the baptism of Christ by John, the receiving of the Law, the raising of Lazarus (figs. 17–28).

The ends of the sarcophagus (figs. 29 & 31) are given over to representations of putti, seemingly in the traditional scenes of seasons sarcophagi. But the division of space is confusing when considered in light of this tradition, in which the four seasons are usually personified or represented by four distinct scenes. Here the *two* compartments of the left end are allotted to putti harvesting grapes (usual for autumn); the upper compartment of the right end to putti harvesting grain (usual for summer); and the lower compartment of the right end is given over to six putti with, respectively, olives (usual for winter), a hare and a shepherd's crook, flowers, a lizard and grapes, a bird, and a dish of water for the bird (so unusual that art historians disagree on their interpretation).

On the tabula of the lid "a fragmentary inscription honors, originally in eight distiches, the official functions of Bassus and records the dignified funeral."[17] To the left and right of the central inscription were carved reliefs. Because so little remains of the left side of the lid, the left relief scene cannot be identified (fig. 37). An additional fragment recognized and put in place in 1979 confirms the right relief scene as a *klinē* (Greek: couch) meal, that is, a meal of the dead (fig. 37).[18] The half-remaining mask of Luna, the moon, at the right end of the lid presumably complemented a mask of Sol, the sun, at the left (see fig. 1). The back of the sarcophagus remained undecorated (see diagram 1–1).

The ten intercolumnar scenes, six spandrel scenes, four end scenes, two lid scenes, plus some significant ornamental details, would seem enough to overwhelm the viewer. But the systematic division of space—the careful mapping out of images—tends, rather, to stimulate thought. Despite its multiple scenes, the piece presents a certain visual unity.

The iconographical significance of that multiplicity and unity is the focus of this study. The goal is an understanding of the iconographical program of the work—overall and in detail. As a foundation for such an understanding, we must *look carefully* at

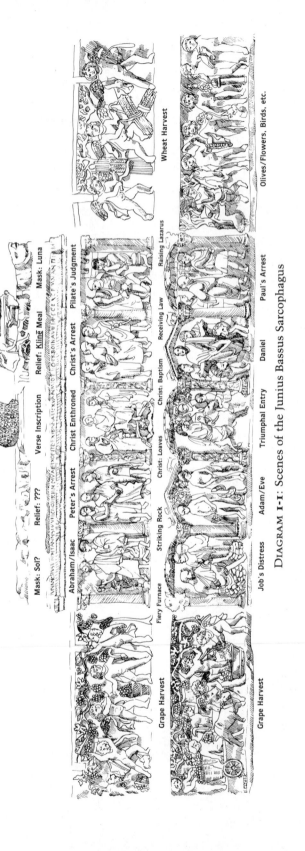

Mask: Sol? Relief: ??? Verse Inscription Relief: Klinē Meal Mask: Luna

Abraham/Isaac Peter's Arrest Christ Enthroned Christ's Arrest Pilate's Judgment

Job's Distress Adam/Eve Triumphal Entry Daniel Paul's Arrest

Fiery Furnace Striking Rock Christ: Loaves Christ: Baptism Receiving Law Raising Lazarus

Wheat Harvest

Olives/Flowers. Birds. etc.

Grape Harvest

Grape Harvest

DIAGRAM I-I: Scenes of the Junius Bassus Sarcophagus

the work itself and *look around* at its contexts. In this introductory chapter we will first look carefully—by noting the compositional cues the work gives the viewer who seeks to understand the iconographical program. Then we will look around—by investigating in summary fashion some contemporary conventions of early Christian funerary art. In the second chapter we will look especially at the interpretations of the iconographical program of the sarcophagus presented by four art historians, questioning whether these interpretations are consistent with what we have observed of the work's compositional cues and contemporary conventions.

COMPOSITIONAL CUES

If we wish to "read" the iconography of the sarcophagus we might well begin by attending to the cues given by its very composition. Some compositional cues are so obvious as hardly to require stating; others are more subtle or even ambiguous. To begin with, the size of the work (almost eight feet long, about six feet high, with the lid, and nearly five feet deep[19]), the quality of the white marble, and the fineness of the carving—especially of the facade—indicate an expensive work crafted with care. It would not be unreasonable to assume that care also went into the overall planning and arrangement of scenes.

Three major sets of scenes are differentiated by placement, content, and style, as well as compositional elements. The ten intercolumniations of the facade are filled with scenes of biblical characters in dignified poses, finely carved in high relief and smoothly polished. The two scenes of the lid—of which only fragments remain—probably presented stylized secular scenes with biographical references; they are somewhat less deeply carved and somewhat less finely polished. The four scenes of the ends depict allegorical or symbolic putti in agricultural settings or occupations and are carved in shallow relief and not smoothly polished. Thus three major areas are marked off in the overall composition: facade, lid, ends. The spandrel scenes of the facade, depicting biblical scenes symbolically enacted by lambs, serve almost as decoration, but their combination of biblical scenes (like the intercolumniations) and symbolic figures (like the ends) provides an interesting link between these groups of images. An in-

terpretation of the iconography must deal with these three major
(and one minor) sets of scenes; it must make sense of them both
separately and together.

The architectural elements of the facade cue the viewer to at-
tend to certain interrelationships between individual scenes of
this dominant set. The two rows of columns clearly demarcate
ten major facade scenes, five on each register; and each of these
scenes occupies approximately the same amount of space. On the
more common double-register *frieze* sarcophagi of the fourth cen-
tury, for example, the Two Brothers sarcophagus (fig. 3), scenes
crowd together, taking up more or less space depending in part
on the number of figures and objects involved; and scenes are not
clearly lined up vertically. Here, however, two central scenes, up-
per and lower, are linked and given special importance by being
framed by vine columns rather than strigilated columns. Since
there is an odd number of scenes on each register, the alternating
arches and gables of the lower register present a symmetrical ar-
rangement: the middle scene, under an arch, is framed by the sec-
ond and fourth scenes, under gables, and then by the first and
fifth scenes, under arches. The entablature and inscription of the
upper register span the upper five scenes as the spandrel scenes
do the lower five. An interpretation of the iconography of the fa-
cade must not contradict these compositional cues that signal a
symmetrical reading and an overall unity.

The positions of the figures in the ten intercolumniations sug-
gest additional relationships. On the upper register the second
and fourth scenes are composed of three draped standing figures,
with the central figure looking to the right. The first and final
scenes of the upper register also contain three figures each—two
standing and one nonstanding, with two figures looking to the
left—as well as carved backgrounds. On the lower register the
second scene features an animal (a snake) between two nude
standing figures, who look down; and the fourth scene features—
or did originally (see chapter 3 below and figs. 14 & 15)—one
nude standing figure, who looks up, between two animals (lions).
In the first and final scenes of the lower register, three draped
figures interact, and the most important figure in each looks to
the right. At the corners of the facade, the first scene of the upper
register and the last scene of the lower register each present three
figures—the most important of whom is standing and looking or

moving outward, that is, away from the center of the piece; the last scene of the upper register and the first scene of the lower register each present two standing figures and one who is seated and looking or turning inward, toward the center of the facade. At the center are depicted two views of the seated Christ. These compositional links suggest that an appropriate interpretation of the iconography must consider not only connections between scenes set out symmetrically on each register but also vertical connections between scenes and between the two registers of scenes (see diagram 8–1).

Important compositional cues are also given in the four scenes of the ends. The upper and lower scenes of the left end are well matched compositionally: all the putti are of the same scale; they are nude—although some are draped with mantles; and they have wings. No wings appear on the first upper putto or the second lower one, however; and no mantles appear on the second or third lower putti, perhaps because upraised arms and the basket were in the carver's way, so to speak.[20] All of the putti of the left end are involved in harvesting grapes. The putti of the right end are not so well matched in terms of either content or composition. While the six putti of the lower scene of the right end are almost in scale with those of the left end (they are somewhat taller in their space), the three putti of the upper scene are noticeably larger in scale than any other putti on the sarcophagus. But the three putti of the upper scene of the right end are all nude, winged, and with mantles—like the putti of the left end—while the six putti of the lower scene of the right end are all wingless, and one is fully clothed. In addition, the three putti of the upper scene are involved in a harvest (grain), similar to the (grape) harvest of the left end. The lower scene is distinctive—and problematic—in this regard: the first putto (clothed) appears to be harvesting olives, but the remaining five (nude, one with a mantle) are holding various objects but do not seem engaged in a single activity. Thus compositional cues indicate that, although each end is divided into two sections, both sections of the left end depict a single harvest scene, the upper section of the right end represents a second harvest scene, and the lower section of the right end may be unevenly divided between an abbreviated third harvest scene and a fourth scene that is initially somewhat

unclear. Again, an interpretation of the iconography must come to terms with these compositional cues.

The symmetry of the lid is clearly signaled, even by the remaining fragments—mask/relief scene/inscription/relief scene/ mask—and serves to reinforce the symmetry of the facade of the box. Only the lower portion of the lid was known when the sarcophagus was discovered in 1597; prior to the discovery and placement of the three fragments of the inscription table in the 1940s and the additional fragment of the right relief in 1979, the lid was frequently ignored by viewers and commentators.[21] It certainly would not have been ignored originally. In relative size the complete lid would have been proportionately higher than the lid of the double-register sarcophagus of Adelphia (fig. 4); the viewer would have taken in three levels of carving, not two. The figure style of the lid reliefs would have fit with that of the facade; its "pagan" or secular scenes would have coordinated with those of the ends. Thus the lid was a more important part of the whole than its fragmented remains may at first suggest. An interpretation of the iconography of the sarcophagus must not ignore the compositional cues given by even the fragments of the lid.

The rules—actually hypotheses—for correlating compositional and iconographical patterns are largely conventional. Because of the symmetry of the human body, some symmetrical arrangements may be widely used by artists and craftspeople and widely perceived by patrons and viewers, but to begin to *interpret* symmetrically arranged scenes one must investigate the conventions contemporary with the work in question.

CONTEMPORARY CONVENTIONS

Late antique pictorial art, particularly when it was religious, was an allusive art: for its interpretation it depended upon a context of allusions shared by maker and viewer; for that reason it is often an elusive art for twentieth-century viewers. This allusive quality is most obvious in relation to works presenting a series of scenes. It has been observed, for example, of both the frescoes of the synagogue at Dura-Europos and early Christian sarcophagi. "The narrative is in both cases of secondary interest," writes Fritz Saxl, "and the interconnection between scenes is such that an uninstructed though attentive observer

could hardly guess the underlying meaning. The worshipper himself [or herself] has to bring an understanding of their unity to the apparently disconnected scenes in Dura and on the Christian tombs."[22]

The late antique/early Christian context was one in which, in the words of Peter Brown,

> many works of art converged with the spoken or sung word to create a single impression. In this situation, no work of art had to say more than it was intended to say in its correct place and time. Just as the shared idiom of the classics could enable a speaker to set the tone of a whole train of thought with the help of one half line of Homer or Virgil, so the hand of God, the arch of a palace, or the position of a figure in relation to the top and bottom registers of a panel would be sufficient to set the scene in its correct context. For the rest, the speaker could assume a tissue of verbal and visual associations that have not survived in their full richness, but that were no less precise for being widespread and un-selfconscious. . . .
>
> Late Antique art is not an erudite or an esoteric art. But it is the art of a city, and an art that assumed onlookers who could supply the associations "triggered off" by a few clear pointers.[23]

Twentieth-century interpreters, guided by the "few clear pointers" a fourth-century work offers, must also be attentive to both verbal and visual traces of the associations those pointers may have "triggered off"—both contemporary texts and artistic representations. It is "[b]y bringing together a knowledge of pictures and a knowledge of texts," writes Sister Charles Murray, that "the interpreter endeavours to fuse the subject matter and the image, and the resulting interpretation becomes, it is hoped, the reconstruction of a lost piece of evidence. This in turn should help to clarify the meaning of an idea in a particular context, since meanings change over a passage of time."[24]

Another way of indicating its primary allusive quality, its assumption of understanding of visual and verbal associations, is to say that "in late antiquity religious art is always allegorical and symbolic."[25] Or, in the terms of Wladimir Weidlé, the *earliest* Christian art is "signative." "It is a code of visible forms intended to serve as signs."[26] "In any signative art it is the choice and combination of themes which is the significant thing, not the way

they are treated."[27] The significance of the choice and combination of scenes—and thus themes—of the sarcophagus of Junius Bassus is the topic of this book. Chapters 3–7 will bring together "a knowledge of pictures and a knowledge of texts" in order to reconstruct lost evidence relevant to interpreting the scenes of the intercolumniations, spandrels, ends, lid, and various compositional and ornamental elements of the Bassus sarcophagus. Chapter 8 will present an integrated interpretation of the work's iconographical program viable in light of contemporary conventions.

A first step toward understanding the conventional associations of the scenes on the Junius Bassus sarcophagus is to observe the contemporary contexts of their occurrence: how often and where are similar scenes portrayed in the early Christian period? Of course, only an unknown, but probably small, portion of early Christian art has survived the exigencies of time; thus we have no complete corpus to serve as a standard. Photographic catalogues have solidified knowledge of the *surviving* corpus.[28] In addition, much of the art preserved from this period is catalogued in the Princeton Index of Christian Art, which—although it has limitations[29]—may serve by default as a rough guide to *which* scenes were being painted or carved *where* and *when*. (*Why* is the even more elusive question, but the one that will prove of most interest.) Since the question here is largely the general one of what was conventional, no attempt is made to date works specifically and to trace probable lines of specific influence. The Bassus sarcophagus facade depicts sixteen events involving biblical characters: ten in the intercolumniations and six in the spandrels. All occurrences of these scenes prior to and through the fourth century that are listed in the Index of Christian Art have been noted. The observations drawn from such an examination must be understood in the light of this broader goal of establishing a context of contemporary conventions.

Conventional ways of depicting particular characters and scenes are presupposed, of course, in identifying the scenes to be counted; but what is under investigation here is not these conventions of *how* to treat scenes but rather the conventions of *which* scenes to treat at all. What results is a tentative "popularity index" that will indicate at which points the Bassus sarcophagus presents popular, and thus perhaps expected, scenes and at

which points it presents rare, and thus perhaps surprising, scenes. This, in turn, may give important clues to the overall significance of the iconography of the piece.

Two aspects of the central scene of the upper register are isolated for comparison: Christ giving the Law (the *traditio legis*) and Christ enthroned over Coelus, the personification of the universe. Two scenes of the upper register, Christ's arrest and Pilate's judgment, must here be considered as one scene, Christ before Pilate, because the two are not catalogued separately in the Index of Christian Art. Two possibilities for the second spandrel scene are considered: Moses striking the rock, in the wilderness for the benefit of the Hebrews, and Peter striking the rock, after his capture and then baptizing the guards with the water. Since all the spandrel figures (except Lazarus) are portrayed as lambs, it is understandably difficult to distinguish Peter from Moses. Two possibilities might also exist for the fifth spandrel scene: Moses receiving the Law or Peter receiving the (New) Law. The Index, however, lists no scenes of Peter receiving the Law separate from the *traditio legis* scene with a central Christ figure.[30]

This exercise in comparison results in four categories of scenes on the Bassus sarcophagus, based on whether the scenes are rare *or* popular in the catacombs *and* on sarcophagi (see table 1-1). Scenes of the first category were the most broadly popular ones common to the Bassus sarcophagus, and those of the fourth category were the least popular during the first four Christian centuries. Scenes of the second category were popular in the catacombs (generally earlier) but not on sarcophagi, whereas scenes of the third category were popular on sarcophagi (generally later) but not in the catacombs.

The first category consists of scenes that are generally popular both in the catacombs and on sarcophagi. Three of the ten intercolumnar scenes meet this qualification: Abraham's sacrifice of Isaac, Adam and Eve in the garden, Daniel in the lions' den[31]; so do three or four of the six spandrel scenes: three youths in the fiery furnace, multiplication of the loaves, raising of Lazarus, and, in a general sense, the striking of the rock. (The Junius Bassus spandrel scenes are unique, however, in portraying the figures as lambs.) Moses striking the rock is very popular in the catacombs but rare on sarcophagi, whereas Peter striking the rock is very rare in the catacombs but very popular on sarcophagi. Fur-

TABLE 1–1

Categories of Junius Bassus Facade Scenes
According to Frequency in the Catacombs and on Sarcophagi

Categories (Catacombs/Sarcophagi)	Intercolumniations	Spandrels
1 (Popular/Popular)	Abraham/Isaac Adam and Eve Daniel	Three Youths (Striking Rock) Loaves Lazarus
2 (Popular/Rare)		(Moses Striking Rock)
3 (Rare/Popular)	Peter's Arrest Christ Giving Law Christ before Pilate Christ's Entry	(Peter Striking Rock) (Moses Receiving Law)
4 (Rare/Rare)	Christ Enthroned over Coelus Job's Distress Paul's Arrest	Christ's Baptism

thermore, Peter is regarded, on several counts, as the second Moses. In chapter 4 we will consider the difficulties in determining whether Moses or Peter is intended in the second spandrel scene of the Bassus sarcophagus. The Adam and Eve scene represents the plight of humankind: sin and death. The other scenes all suggest divine providence, protection, or rescue (i.e., salvation) from that plight. Isaac, Daniel, and the three youths in the fiery furnace are rescued from near death; Lazarus is resuscitated from actual death. The water gushing from the rock struck by Moses means life for the Hebrews in the wilderness (or the water gushing from the rock struck by Peter means new spiritual life— through baptism—for the guards), just as the loaves multiplied by Jesus in a wilderness place mean life for the crowds that follow him.

The second category—scenes that are very popular in the catacombs but rare on sarcophagi—may consist of but a single scene: Moses striking the rock. That is, if the central lamb of the second spandrel scene is taken to represent Moses. This scene alludes to God's gracious providence and rescue and has sacramental connotations, as we shall see. Or the second category may be an empty one.

The third category is made up of scenes rare in the catacombs but generally popular on sarcophagi. It contains four Junius Bassus intercolumnar scenes: Peter's arrest, Christ giving the Law, Christ before Pilate (actually two scenes),[32] and Christ's triumphal entry into Jerusalem. The third category also contains one or two spandrel scenes: Peter striking the rock (if it is Peter, as seems unlikely) and Moses receiving the Law (if it is Moses, as seems likely). Unlike the scenes of rescue in the first two categories, these scenes represent Christ's passion and his authority, the leadership of the apostles and the guidance of the Law.

The fourth and final category comprises scenes rare in the catacombs and also rare on sarcophagi. The four Junius Bassus scenes in this category are thus quite distinctive, including three intercolumnar scenes—Christ enthroned over Coelus, Job's distress, and Paul's arrest[33]—and one spandrel scene—Christ's baptism. The latter scene has, of course, sacramental significance. Christ enthroned over Coelus is an image of Christ's universal reign. Later we will want to consider whether these themes are of special importance on the Bassus sarcophagus. Job's distress points to a divine rescue, Paul's arrest to an apostolic martyrdom. Interestingly enough, it has been the Job and Paul scenes—especially their placement (along with that of Abraham/Isaac)—that have been most difficult for modern interpreters of the sarcophagus to understand. With these scenes, symmetrically set at the ends of the lower register, the Bassus sarcophagus moved beyond the most popular conventions of early Christian art and offered a somewhat new vision to fourth-century viewers.

We may conclude from these observations that the Junius Bassus sarcophagus combines scenes that were very popular, by the contemporary conventions of early Christian funerary art, with other scenes that were quite rare and thus distinctive. In its choice of scenes, therefore, the sarcophagus builds on contemporary conventions, but it also pushes these conventions in some new directions. (The same will be said later of its arrangement of scenes.) The choice (and arrangement) of scenes in catacomb frescoes is an interesting topic in itself but—except for the brief comparisons outlined above—beyond the scope of the present work.[34] In terms of clusters or sequences of scenes on sarcophagi, the Junius Bassus sarcophagus may be seen against the background of two conventional patterns of the early Christian period: (1) frieze

sarcophagi depicting various scenes of salvation from the Old Testament and/or various New Testament scenes, especially Christ's miracles and (2) (usually tree or columnar) passion sarcophagi depicting scenes from Christ's passion and often the martyrdoms of the apostles. Passion sarcophagi date only from about the middle of the fourth century; sarcophagi with Old and/or New Testament scenes of salvation or miracles are known from the early fourth century.

The practice of decorating the front of a sarcophagus with a series of Old and New Testament scenes was initiated early in the fourth century, employing, basically, the biblical motifs already in use in the catacombs.[35] André Grabar includes the Bassus sarcophagus among "the more complete ensembles" of the fourth century in which the image-signs are "grouped systematically" as a general demonstration of salvation history.[36] Concerning passion iconography, Gertrud Schiller notes that the "interpretation of Christ's Death as a victory and a revelation of power which prevailed in the fourth century is expressed most clearly in a series of Passion sarcophagi made between 340 and 400." Here separate scenes from the passion story are subordinated to the underlying idea of the pictorial program: the beginning of Christ's sovereignty.[37] Schiller considers the sarcophagus of Junius Bassus the latest surviving example of this group of sarcophagi on which Old and New Testament scenes, as "visual allusions to Christ's Death and Resurrection," are combined with scenes of the martyrdoms of the apostles and by which early Christians "proclaimed in their cemeteries their faith in Salvation and the attainment of everlasting life."[38] These two general types of sarcophagi—with Old and New Testament scenes of salvation and passion sarcophagi—serve as the visual background against which the choice and arrangement of scenes on the Bassus sarcophagus must be understood.

The first of these two conventional patterns of scenes—scenes of salvation—is well illustrated by several sarcophagi pictured here. The sarcophagus of Santa Maria Antiqua (fig. 11) is an early example, dating from the third quarter of the third century. The scenes of this trough sarcophagus are, from the curved left end to the curved right end: Jonah in the ship (OT; fig. 12); Jonah under the gourd vine (OT); an *orant*, a female personification of piety, prayer, or the soul but also a representation of the deceased; a

seated "philosopher" reading a scroll, a male personification of learning or wisdom and also a representation of the deceased; the Good Shepherd (NT); the baptism of Christ by John (NT); two fishermen with a net—perhaps the miraculous catch of fish by Christ's disciples (NT; fig. 13). As Jonah was saved from the big fish and then from the sun, so the deceased hopes to be saved by the Good Shepherd, into whose baptism and discipleship he or she has entered.

The abbreviated and crowded scenes of the Claudiano sarcophagus (fig. 34) are typical of early Christian frieze sarcophagi. On the box of the sarcophagus we find representations of (from left to right): Peter's miracle of the spring; Peter's arrest; Christ changing water into wine—and blessing a child or healing a petitioner; an *orant*; Christ multiplying the loaves; Christ healing a blind man; Peter's denial predicted by Christ (note the cock) or, more likely, Peter's commissioning by Christ[39]; Christ raising Lazarus—and perhaps healing the hemorrhaging woman—if the crouching woman is not Lazarus's sister. On the lid of this sarcophagus, to the right of the inscription, is a portrait of the deceased framed by putti harvesting grapes and grain. The eucharistic overtones of the scene are to be compared with the baptismal associations of the Santa Maria Antiqua sarcophagus. Scenes alluding to the sacraments (baptism and the eucharist) complement Old and New Testament scenes of salvation because it is through the sacraments that the Christian initiate is incorporated into salvation history.[40]

Three additional frieze sarcophagi with salvation scenes are double-register ones: the sarcophagus of Adelphia (fig. 4), the Two Brothers sarcophagus (fig. 3), and the so-called Dogmatic sarcophagus (fig. 5). The latter sarcophagus receives its name because the scenes seem grouped together in sets on either side of the two central scenes: a portrait of the deceased in a rondel (upper register) and Daniel in the lions' den, set on a low pedestal (lower register). The upper register depicts, on the left, the creation of Adam and Eve by the Trinity and (presumably) the assigning of tasks—symbolized by the sheaf of wheat and the lamb—to Adam and Eve by Christ (the Logos) after the Fall (note the tree and snake). The upper right portrays Christ changing water into wine, Christ multiplying the loaves, and Christ raising Lazarus. On the lower left are shown the presentation of gifts to the Virgin

and Child by the three magi and Christ healing a blind man. On the lower right three scenes of Peter are depicted: Peter's commissioning[41] (or denial), Peter's arrest, Peter's miracle of the spring. The Old Testament scenes suggest both the *need* for salvation (Fall of Adam and Eve) and the *hope* of salvation (Daniel) in order to renew the promise of creation (creation of Adam and Eve). The New Testament scenes suggest that the promise is fulfilled in Christ, who appropriately received the gifts of the magi and graciously gives the gifts of sight (healing the blind) and life (raising Lazarus), and who continues to give the gift of spiritual sight and eternal life in the bread (multiplying the loaves) and the wine (changing water into wine) of the eucharist.

Images of salvation, deliverance, or rescue in early Christian funerary art were parallels to prayer rooted in scriptural imagery.[42] Grabar notes that these images were "thought to function actively," that is, not merely as commemorations of former salvations but as "representations of the divine power that remained forever present."[43] Image-signs of the sacraments, according to Grabar, exemplify a slightly different "psychological intent" from the precedents to salvation on works of sepulchral art. References to the two sacraments signal that the deceased was a Christian, that is, the deceased could "confidently expect the salvation of his soul."[44] "It is no longer only the intervention of God but participation in the sacraments of the Church which assures the salvation of the dead."[45] The depiction of Old and New Testament scenes of salvation and allusions to the sacraments, especially in funerary art, are artistic—and religious—conventions presupposed by the fourth-century designers and viewers of the Junius Bassus sarcophagus.

The second of the two basic conventional patterns of scenes—scenes of Christ's passion and the martyrdoms of the apostles—may be illustrated by several sarcophagi on which five scenes are divided by columns or trees.[46] A columnar sarcophagus from the Cemetery of Domitilla (fig. 8) has a central scene of the *crux invicta* (the Unconquered Cross) or Symbolic Resurrection—two soldiers sleeping beneath a Chi-Rho cross with a wreath and two birds.[47] From the left are Simon of Cyrene being forced by a soldier to carry the cross of Christ and a soldier crowning Christ with thorns. On the right are Christ under arrest and Pilate's judgment. Since Christ's passion and resurrection are the central

salvation event for Christian faith, their portrayal on a sarcoph-
agus of one hopeful of inclusion in this salvation history is appro-
priate.

A badly damaged columnar sarcophagus from the crypt of San
Massimino in Rome (fig. 6) seems also to have displayed a central
scene of the Symbolic Resurrection, but portrayal of the passion
of Christ (to the right: Christ's arrest; Pilate's judgment) is com-
plemented by portrayal of the martyrdom of the two chief apos-
tles (from the left: Paul's arrest; Peter's arrest). This pattern finds
expression again on an unfinished columnar sarcophagus from
San Sebastiano in Rome (fig. 7): Paul's arrest; Peter's arrest;
Christ teaching (rather than the Symbolic Resurrection); Christ's
arrest; Pilate's judgment. A five-niche tree sarcophagus, Lateran
164 (fig. 9) combines Old Testament scenes (which may be un-
derstood as prefigurations of Christ's passion[48]) with scenes of
martyrdom and a Symbolic Resurrection in a pattern that we
must consider in more detail later in relation to the Junius Bassus
sarcophagus. These scenes are, from left to right: the sacrifices of
Cain (sheaf of wheat) and Abel (lamb) to God (who is seated); Pe-
ter's arrest; Symbolic Resurrection; Paul's arrest; Job and his
wife. Job, Peter, and Paul are, of course, also depicted on the Bas-
sus sarcophagus—along with Christ's arrest and Pilate's judg-
ment. Thus the depiction of the passion of Christ (along with
certain Old Testament prefigurations) and the martyrdoms of the
apostles on funerary art is an important artistic—and religious—
convention at the time of the Bassus sarcophagus.

The conventions of representing scenes of salvation (and allu-
sions to the sacraments) in early Christian art lie behind the six
or seven scenes of the Bassus sarcophagus facade that are popular
both in the catacombs and on sarcophagi. The conventions of de-
picting scenes from the passion of Christ and the martyrdoms of
the apostles lie behind the five or six Bassus sarcophagus facade
scenes that are rare in the catacombs and popular on sarcophagi.
The contemporary conventions standing in the background of
the four Bassus sarcophagus facade scenes that are rare both in
the catacombs and on sarcophagi are, of course, more difficult to
interpret, there being fewer occurrences to give clues to their sig-
nificance. These scenes—Christ enthroned over Coelus, Christ's
baptism, and especially Job's distress and Paul's arrest—are thus
a special challenge to anyone who would present an overall in-

terpretation of the iconography of the Bassus sarcophagus. (Conventions involving seasonal scenes and meal-of-the-dead scenes lie behind the Bassus sarcophagus end and lid scenes respectively and will be discussed in the separate chapters on the ends and the lid below.)

It must not be thought that a study of the contemporary conventions behind scenes will produce a simple sign language whereby *the* meaning of each image is established. The overlapping interrelationships of scenes indicate otherwise, and an appreciation of the consistent polyvalence of symbols mandates otherwise. The comments of Sister Charles Murray on this point bear quoting:

> Far from any conception of symbols as an agreed sign-language, the basic premiss from which the mind of the early Church worked was that the meaning of a sign was hidden and only revealed itself to those who knew how to look for the answer. It was this idea that lay behind the whole allegorical interpretation of Scripture which, deriving ultimately from the allegorisation of Homer, reached its peak in the third century with Origen. This conception has its roots in religion rather than in art and it sees symbolisation as of divine origin, mysteriously communicated. It is a method of biblical exegesis, and this must surely be the tradition to which Christian art belongs. On this view, therefore, far from being unambiguous, a symbol could have several meanings [even several *simultaneous* meanings], and conversely several images may illustrate one theme: so that a meal may be the feeding of the five thousand, a funerary feast, or the Eucharist, or the heavenly banquet of the afterlife; and the resurrection may be symbolised by Jonah, Lazarus or a tomb. The very "openness" of some of the symbols of early Christian art may be deliberate. It is essential, therefore, in my view, that Christian iconography must start with a study of institutions, that is, the Church and its tradition, rather than a study of symbols understood as constants and then decoded.[49]

Thus, whereas an investigation of an early Christian iconographical program, such as that of the sarcophagus of Junius Bassus, may set limits to interpretation by showing certain readings to be untenable on the basis of the compositional cues of the work

as a whole or the contemporary conventions of the work in context, it will neither seek to limit nor succeed in limiting interpretation to "the one true meaning." And this is because of the open-endedness of the symbolic images of the work itself, as well as, of course, the limited capacity for understanding of any one viewer. *Interpreting* the meaning and significance of a symbolic or allusive image or pattern of images—if it is to be true to its object—must always be an open-ended process in which visual and verbal evidence is collected, reasons stated, conclusions drawn, and interpretations defended—all in a nondogmatic way, with eyes and ears open to new ways of seeing and hearing images and texts.

2 Interpretations

THE PRESENT focus on compositional cues and contemporary conventions may be understood, in part, as a response to developments in art historical research.[1] The questions that have been asked and the interpretations that have been proposed to date—concerning early Christian art generally and the Junius Bassus sarcophagus specifically—both allow and urge me to ask the questions and offer the interpretations that I do. Thus it may be useful to set the present study—even in a brief, schematic way—in the larger context of art historical research of the early Christian period in general and of the Bassus sarcophagus in particular. This can be most clearly accomplished by noting the relationship to the work of key contributors to the discussion, those whose writings serve as foundations for the present study on the one hand and yet, on the other, serve as reminders of the limitations of certain ways of posing and answering questions.[2]

FOUNDATIONS AND LIMITATIONS

Clearly foundational for the present study is the establishment of a corpus of early Christian sarcophagi for comparative examination. Museums will always be the primary resource, with the Museo Pio Cristiano of the Vatican Museums holding pride of place. But published works are indispensable to art historical research, and Giuseppe Wilpert's *I Sarcofagi Cristiani Antichi*, published between 1929 and 1936 and bound in five folio volumes (three of text and two of plates), serves as an essential museum without walls. (Wilpert's monumental work is in the process of being replaced by the equally significant corpus, *Repertorium der Christlich-Antiken Sarkophage*, prepared by Bovini and Brandenburg and edited by Deichmann, under the auspices of the Deutsches Archäologisches Institut; Volume 1, Rome and Ostia, was published in 1967.) Anyone interested in

the sarcophagus of Junius Bassus must rely on these rich re-
sources for re-creating its contemporary visual context. Yet Wil-
pert was not content with publishing the known corpus; he was
concerned to date monuments, to identify scenes by unraveling
the iconography, and especially to trace the development of the-
ological ideas as suggested by the visual evidence. The whole
"Roman school," of which Wilpert was a part, "presented the ar-
chaeological data of early Christianity in the light of patristic lit-
erature and early church tradition."[3]

The present study also researches early Christian texts as well
as early Christian art; both texts and monuments are utilized in
an attempt to recover the contemporary conventions behind the
Bassus sarcophagus. It should be clear from the outset, however,
how the present approach to evaluating visual and verbal evi-
dence differs from that of the "Roman school" (typified by the
work of Wilpert) to interpreting artifacts and texts. Graydon Sny-
der offers this critique of the methodology of the "Roman
school":

> The "Roman school" has established a rather firm style of inter-
> preting archaeological data. The item or subject first must be re-
> searched in biblical and patristic literature. Then references from
> the *Liber Pontificalis* and pilgrim itineraries are amassed so that
> a literary interpretation or history of the subject can be portrayed.
> Only then will the archaeological data be inserted into the liter-
> ary structure. Assuming the nonliterary data will support the lit-
> erary reconstruction, archaeological materials are used to supple-
> ment the tradition or even prove its validity. In case of conflict
> between the literary and the nonliterary data, the literary tradi-
> tion will be preferred, though resolution of the conflict would be
> highly desirable.[4]

A critical weakness of this method of interpretation is obvious:
"it presupposes a continuity of tradition that may lead to both
chronological and interpretive difficulties. ... Later develop-
ments are read into the earlier stages."[5] Here, in contrast, the ar-
chaeological artifact (the Bassus sarcophagus) provides the frame-
work of the investigation. References to other artworks, earlier
or contemporary with it in the Roman world, and to texts, again
earlier or contemporary, are related to this framework as a way
of enriching our understanding of the cultural, artistic, and reli-

gious (not just theological) context of the sarcophagus. Occasionally sarcophagi or texts dating from after 359 are cited in order to portray the broader context, but later materials in no way provide a framework into which the iconography of the Bassus sarcophagus is fitted.[6]

A second key contributor to the field of early Christian art, and again one whose work both sets foundations and marks limits, is André Grabar. Grabar has been concerned with the historical development of Christian art and especially its iconography, as the titles of two of his most influential books suggest: *Early Christian Art: From the Rise of Christianity to the Death of Theodosius* and *Christian Iconography: A Study of Its Origins.* Because of the work of scholars such as Wilpert and Grabar, the present study need not begin by presenting arguments for the identification of the various individual scenes of the Bassus sarcophagus or their basic iconographical significance. The distinguishing signs of Peter's arrest and Paul's arrest are well established; the Christian theological background of the sacrifice of Isaac and the Roman imperial background of Christ enthroned have been set forth.[7] Yet Grabar's usual focus on single images—Abraham and Isaac, the grape harvest, etc.—has its inherent limitations.

In his enormously helpful *Christian Iconography* Grabar stresses the common or shared images of the "language" of early Christian iconography. In reviewing Grabar's book, Alfred Neumeyer elaborates on this metaphor in a critique: "The role of creative individuality is considered negligible and aesthetic differences between pilgrim bottles with sacred images and the large mosaic cycles remain unconsidered. Here the reviewer asks whether monumental tasks executed by the best craftsmen might not have brought about iconographical innovations prompted by the aesthetic situation. *Yet the vocabulary and grammar, not the poetry of pictorial language, make the character of this book.*"[8] In a related vein, Murray complains of Grabar's "dictionary" understanding of Christian iconography, stressing not Grabar's failure to attend to iconographical innovation but his failure to appreciate iconographical polyvalence or plurisignification.

His theory began with the conviction that the early Christian images were to be seen essentially in the context of the general Hel-

lenised-Western Roman tradition of art, which is undoubtedly true. But then, basing himself on the notion of the interdependence of artistic life in the late Roman world, he went on to discuss the meanings of the Christian images, and so proceeded to establish what appears to be a theory of iconographical constants which can be read as in a dictionary and can provide the key to the puzzles of Christian art. Once a set of constants (for example, Lazarus images = resurrection, vine = eucharist) has been established, one can then demonstrate the function of an image. . . . Since Grabar's book is essential to the study of Christian iconography, it may be his theory which is responsible for the impression that one receives from some recent writings that symbols have a one-to-one relationship between the sign and its meaning.[9]

It is this tendency toward definitive equivalence that marks the limits of Grabar's approach. Just as one cannot clearly equate all occurrences of an early Christian image regardless of their aesthetic contexts (Neumeyer's critique), so one cannot clearly equate a single early Christian image and a simple meaning (Murray's critique).

Furthermore, one cannot so definitively set forth the stages of iconographical development as Grabar would appear to do. This critique is presented forcefully by Robin Cormack, also reviewing *Christian Iconography*: "The book presents ideas in a rather intuitive manner. He attempts to reconstruct the creative process of a period from its accidents of survival. Grabar is successful in piecing together a picture which is at least logical; other interpretations are also possible, and no doubt the whole truth was something less than logical."[10] Grabar's attempt to mark off definitive stages in iconographical development has a particular bearing on interpretation of the Bassus sarcophagus. As Cormack notes: "In treating works incorporating cycles of images, Grabar suggests an interesting historical evolution. He feels that fourth-century parallel cycles of Old and New Testament scenes complement each other in their content, while the fifth-century doors of S. Sabina in Rome use the Old Testament to foretell the New so that art rises to the level of theological commentary."[11] One might well argue, however, that if an iconographical evolution such as Grabar depicts did take place, it probably did not occur in one great step, and that the arrangement of scenes on the Junius Bassus

sarcophagus may be understood as representative of one of the
many smaller steps. It is clear that a theological understanding of
links between events in Judeo-Christian history was well estab-
lished by the fourth-century date of the Bassus sarcophagus. Thus
neither the development of the iconography of early Christian
images nor the iconography of a single image appears to be as
clear-cut and definitive as Grabar would suggest. Our approach
must be more open-ended, and our focus here will be more on
the poetry of one particular pattern of images than on the lan-
guage of imagery in general.

Both Wilpert and Grabar are concerned with the broad sweep
of early Christian art history, and in that regard both are founda-
tional for studies that focus on one work or one closely related
group of works. Such focused studies, in turn, serve to nuance—
and in some cases to correct—the broad overviews. Reference to
three such specific studies may perhaps fill in the background
against which the present study is to be set. Kathleen Shelton's
thorough study of the numerous items of silverwork of the
fourth-century Esquiline treasure is in many ways more com-
plete than the present study—with careful attention to issues of
dating, style, and workshop; its treatment of iconography, how-
ever, is more limited, largely, no doubt, because many of the
items in the treasure display no representational images.[12] Wil-
liam Tronzo's detailed examination of the fourth-century paint-
ings of the Via Latina catacomb, with considerably more repre-
sentational imagery to deal with, does discuss iconography as
thoroughly as dating and style.[13] Even more than Shelton's work,
Tronzo's concentrates on the overlapping Roman and Christian
contexts of the iconography, which we will also have occasion to
note with reference to the Bassus sarcophagus. Suzanne Spain's
work on the iconography of the fifth-century mosaics of Santa
Maria Maggiore, like the present study of the fourth-century
carved images of the Bassus sarcophagus, focuses on illuminating
an iconographical program where others have argued none exists
and finds typological correspondences to be of central importance
to that iconographical program.[14] All three of these studies ex-
hibit a concern for the work as a whole and the work in context
that is the twofold goal of the present study. In the terms em-
ployed here, they are attentive both to compositional cues and
contemporary conventions.

In a final comment on the state of medieval art history, of which late antique/early Christian art history is considered a part, Herbert Kessler notes: "[m]uch of the very best recent scholarly writing has focused on single works or on small groups of related monuments. These monographic studies provide important source material; but the history of medieval art [with its chapter on early Christian art] must still be written."[15] Ideally one might move from a broad survey, like Grabar's, to an in-depth study of a particular monument or monuments, like those of Shelton, Tronzo, and Spain, and back again to a broad overview now enlivened and enriched. In reality such work is beyond the scope of most monographs, including this one, and beyond the competence of many authors, including this one. Rather, we will focus on the iconography of the sarcophagus of Junius Bassus in detail and in context and raise in the final chapter some questions to be asked as part of that larger and ongoing project of rewriting the history of early Christian art—and indeed the early Christian period. Our focal question will be this: how does the fourth-century context illuminate the iconographical program of the sarcophagus of Junius Bassus? Our subsidiary question will be the reverse: how does the iconographical program of the sarcophagus of Junius Bassus illuminate the fourth-century context? For this reason, special attention needs to be given to the work of those scholars who have shared this focus on the iconography of the Bassus sarcophagus.

Four German art historians have concentrated attention on this subject: Anton de Waal and Friedrich Gerke in monographs, Karl Schefold and Johannes Gaertner in articles. The spandrel scenes are of special importance in de Waal's interpretation of the sarcophagus as a testament of faith. Gerke finds the key theme to be Christian death, but he argues on the basis of a rearrangement of two scenes. Schefold argues against Gerke's rearrangement on the basis of specific connections between Old and New Testament scenes; Gaertner argues against these connections and Schefold's symmetrical reading of the two separate registers in favor of an overall chiastic interpretation of the iconographical structure. Although none of these studies is without interest and insight, all exhibit significant weaknesses in their hypotheses and conclusions—especially in light of our desire to be faithful to compositional cues and contemporary conventions. For this rea-

son an overview of these interpretations will also serve as a preview of the problems and possibilities in iconographical interpretation that we will need to address in our own reading of the iconographical program in the following chapters.

A TESTAMENT OF FAITH (DE WAAL)

The body of Anton de Waal's detailed study, *Der Sarkophag des Junius Bassus in den Grotten von St. Peter* (published in Rome in 1900), is comprised of a scene-by-scene examination of the work, first the Old Testament scenes, next the New Testament scenes, then the spandrel pictures. But of greatest interest is de Waal's consideration of the inner connection of the spandrel scenes and the unifying connection of the various scenes of the facade. He first observes that the spandrels show evidence of unified thought (connected with baptism) and then reasons that the same should be true for the larger presentations and the work as a whole. Concerning a work of this scope, why should the artist not have asked the theologians for advice? Even the laity of Junius Bassus's day, de Waal points out, had a deeper comprehension of "holy truths."[16] The sarcophagus of Junius Bassus is a carefully thought-out work of art, and certainly no one will assume that its sculptor chose just any picture that pleased him. We may "happily admit this," states de Waal, "even if it is not possible to prove a unifying thought turning all these flowers into a wreath." But, for de Waal, the unifying thought is "really there."[17]

The two lower corner scenes (Job and Paul, the prophet and apostle of resurrection) and the two corner spandrel scenes (the three youths in the fiery furnace from the Old Testament and Lazarus from the New Testament) are symbols and prefigurations of "our resurrection to eternal life." These scenes should be considered the carrier of the whole pattern of ideas. The two central scenes, the majesty of the Lord and the triumphal entry, are presentations of the glorification of Christ in heaven and are thus closely connected with the idea of resurrection and eternal life. Adam and Eve represent the mortality of all human beings, while Daniel expresses the hope of eternal life. The reason for this hope is stated in the four central spandrel scenes that are connected to Christ and to the participation in his means of salvation in grace

and teaching—in general (miracle of the spring, giving of the Law) and in particular, in baptism and the eucharist (baptism of Christ, multiplication of the loaves). The dead appear in the form of Peter. Before the judgment throne the Christian may hope for merciful judgment because Christ has died for him as a substitute for the sacrifice of Isaac. Such is the meaning of the sarcophagus of Junius Bassus. Every picture is "a piece of Christian knowledge," sometimes from the Old Testament, sometimes from the New, sometimes from tradition and liturgy, but each clearly presented by the artist in the holy iconography of the time.[18]

We have a choice, de Waal concludes, between viewing the sarcophagus of Junius Bassus as a "testament of faith" or as a thoughtless presentation of widely differing pictures. For de Waal, however, the second option is "unthinkable," even though he admits that jokes have been made concerning Roman archaeologists who see whole sermons in sarcophagi. Early Christians did wish, de Waal insists, to express their faith and feeling, which was understood by all, in their sarcophagi, and the sarcophagus of Junius Bassus is surely "such a testament of faith." De Waal is convinced that the meaning he perceives lies in the composition itself and not in his own subjective response. "Let another gaze deeper and find clearer explanations," he invites. The chief problem of anyone accepting such an invitation is the same one with which de Waal himself struggles: the fact that the "picture-speech" that contemporary Christians understood we must learn with difficulty.[19]

While many of de Waal's suggestions are inviting, further research needs to be done concerning the fourth-century theological presuppositions that would have supported the "holy picture-speech" available to the work's sculptors and their contemporaries. For example, contemporary and earlier theologians and artists linked the sacrifice of Isaac by Abraham with its fulfillment in the sacrifice of Christ's death. De Waal alludes to this link in setting forth the overall plan of the work, but his general suggestion calls for fuller elaboration, and his focus on the theme of eschatological judgment, which sounds more medieval than late antique or early Christian, needs adjusting in light of the fourth-century context. De Waal perceives the two central scenes as joined by a common theme—the glorification of Christ—and

the Adam and Eve and Daniel scenes, on the other hand, as paired by opposition—mortality versus eternal life. We must search for the commonality between these links and others in order to understand the unified significance of the work.

CHRISTIAN DEATH (GERKE)

A second attempt to interpret the sarcophagus of Junius Bassus as a unified whole, to set forth its iconographical program, is the briefer but no less interesting monograph of Friedrich Gerke, *Der Sarkophag des Iunius Bassus* (Berlin, 1936). Gerke approaches the Bassus sarcophagus as the most complete artwork of its time,[20] one that takes part in a new treatment of material style and theme, that follows but goes far beyond its Constantinian models.[21] In its arrangement of scenes, it displays a distinct unity and has too lightly been called eclectic.[22] For Gerke, a unified artistic and theological will lies clearly behind the sarcophagus in its entirety. The key to this unity, the main idea of the work, is Christian death.[23] The overall plan of the sarcophagus is regarded as proof of the longing for redemption that occupied serious persons of the time of Junius Bassus.[24]

The overall plan that Gerke outlines, however, is not the plan of the scenes as they appear on the Junius Bassus sarcophagus! According to him, the original plan is somewhat confused because the Abraham/Isaac scene and the Paul scene have been exchanged.[25] Gerke does not speculate concerning the possible reasons for this hypothesized exchange, but he suggests that if the two scenes are reversed, each level may be seen as unified separately and as paralleling iconographical or thematic plans among extant single-register columnar sarcophagi. These parallels serve Gerke as "proof" for the correctness of his rearrangement. He argues that the three-figure grouping of the arrest of Paul and the direction of Paul's gaze demand that the Paul scene be next to the Peter scene. When this transformation is made mentally, the upper register becomes a "normal passion sarcophagus" of the Christ-Peter-Paul type, as seen in five-niche tree or columnar sarcophagi (for an example see fig. 6).[26] As part of the same speculative rearrangement, the Abraham/Isaac scene is placed opposite Job, and the lower register of the Bassus sarcophagus becomes a

"clear Old Testament sarcophagus" in which Old Testament promise stories frame the triumphal entry.[27]

1	2	3	4	5
(Paul)	Peter	Christ	Christ	Pilate

6	7	8	9	10
Job	Adam/Eve	Christ	Daniel	(Abraham)

Gerke observes in this rearranged sarcophagus a new theological construction in which, thematically, the Old Testament promise of salvation reaches its fulfillment in Christ in the experience of Christian death.[28]

A paraphrase of Gerke's summary conclusion clarifies his understanding of this new theological construction. As expressed on the sarcophagus of Junius Bassus, official life and family life (lid) have become insubstantial compared to the Being of humanity in the cosmos, which peaks in maturity between becoming and decay in order to pass into death (seasons and harvest on ends). From suffering, guilt, and death, faith pushes through to a certainty of resurrection (Old Testament sarcophagus—lower register), as symbolized by the triumphal entry of Christ between Adam and Eve and Daniel. The redemptive events of the Bible (lamb allegories in the spandrels) promise salvation and resurrection also for the neophyte buried here (miracle of the spring, baptism of Christ). Christ, Peter, and Paul go to death (passion sarcophagus—upper register) in order to rule in heaven for eternity (Coelus) and to receive all Christians there at the moment of death. For the Christian buried here, Christ has become the grapevine of life (central columns).[29] Thus, Gerke concludes, between the last period of ancient mythology and the first of medieval devotional pictures, between the times of late antique personal memorial art and the first ecclesiastical-sacramental representational art, we find the sarcophagus of Junius Bassus, whose composition is realized in the inscription "he went to God."[30]

Although to the end of his most interesting discussion Gerke fails to appreciate fully the significance of ecclesiastical and sacramental imagery on the Bassus sarcophagus, many of his other specific interpretations remain helpful. Gerke's overall view of the connections among facade, lid, and ends is, in fact, largely

convincing, although it would seem more appropriate to the fourth-century context to speak of the main idea of the work as the Christian assurance of eternal *life* rather than as Christian *death*. But the chief problem with Gerke's interpretation is its unfaithfulness to the sarcophagus as carved; his proposed rear-rangement of two scenes of the facade is unsatisfying.[31] The pos-sible model sarcophagi Gerke points out generally (he does not always give specific examples) suggest interesting comparisons and lead to fruitful inquiries, but he reasons in the wrong direc-tion. What we have before us is the sarcophagus of Junius Bassus with Abraham/Isaac in the upper left intercolumniation and Paul in the lower right. If this differs from certain previous or contem-porary arrangements,[32] we must naturally ask if other patterns were being followed here or if the sculptor of the Bassus sarcoph-agus could have been an innovator at this point, and above all—why?[33]

Old and New Testament Connections (Schefold)

Not long after the publication of Gerke's monograph in 1936, his proposed rearrangement received a challenge—briefly stated but to the point—in an article by Karl Schefold (1939).[34] Schefold cannot accept Gerke's argument that a "thoughtless exchange" of scenes occurred in the carving of the carefully executed and formally constructed sarcophagus of Ju-nius Bassus. Furthermore, Schefold argues, if one were to assume a thoughtless exchange, one would have to assume a repetition of the thoughtlessness on Lateran 174 (fig. 10), a passion sarcoph-agus that is clearly younger than, and dependent upon, the Bassus sarcophagus.[35] In fact, the intertwining of Old and New Testa-ment scenes should not surprise the interpreter of the Bassus sar-cophagus since Von Campenhausen has already explained this very well regarding Lateran 164 (fig. 9), a passion sarcophagus "at least ten years older" than the Bassus sarcophagus: the Old Tes-tament framing scenes are there understood as foreshadowing the passion of Christ.[36] Thus Gerke should not have been dismayed to find Abraham and Isaac along with New Testament scenes on the upper register and Paul (and the triumphal entry) along with Old Testament scenes on the lower register. The arrangement of

scenes on the Junius Bassus sarcophagus must be accepted as intentional and meaningful. The meaning is clearly seen in the connections between Abraham/Isaac and Pilate and between Job and Paul. But the connections, like the scenes themselves, are symbolic or dogmatic, not historical or narrative.

In the scene of Abraham's sacrifice of Isaac we note, Schefold points out, how little the action and suffering of the biblical account are reflected.[37] Abraham is wearing the pallium of the apostles, and "no hint of agony" is seen in his carved face; rather, "he carries out a sacrifice at God's command," the meaning of which we learn from the juxtaposition with the scene of Pilate washing his hands. The Pilate scene is presented as a solemn sacrifice scene—"in which Pilate executes, at divine command, the redeemer of mankind." Thus the Abraham scene is put opposite the Pilate scene as "the Old Testament example" of sacrifice.[38] Peter, between two admiring soldiers, stands opposite Christ as "the first preacher of the Word"; with his hands in a position that reminds one of the famous statue of Demosthenes, he is ready "to announce the truth of the law."[39]

The lower register is equally well thought out. The differences between the Peter and Paul scenes "prove" that they do not belong to the same passion cycle and were separated not accidentally but intentionally. Paul strides down below as "the first martyr"; with his head bowed he is led to the place of execution by the reeds of the Tiber. As "the first" Christian martyr, Paul is put "opposite the first martyr of the old covenant," Job.[40] "It cannot be by chance," Schefold insists, that Job and Paul are placed under eagle-headed conchs; on passion sarcophagi eagles hold martyrs' crowns or wreaths in their beaks. As "a model for the martyrs," Christ rides into Jerusalem under the corresponding middle eagle-headed conch. Between these "passion pictures" are the opposed pictures of Adam and Eve and Daniel—sinful humanity and promised deliverance. These two scenes are the only remains of the topic that had governed the mass of Constantinian sarcophagi: examples of humanity's hoped-for deliverance.[41]

The Junius Bassus sarcophagus is the most important work of the new group that appeared after the Constantinian sarcophagi. These works, Schefold observes, manifest movement away from scenes dealing with the dead and redemption to the portrayal of the fateful omnipotence of God, the Pantocrator.[42] Schefold iden-

tifies this trend in the arrangement of the two registers of the Bassus sarcophagus: the images of suffering and hope of redemption are placed on the lower register, while the upper-register scenes of "the divine mission and the splendor of the Lord" are more emphasized. In this "the programmatic portrayal of the Bassus sarcophagus points directly forward."[43] It may be that Schefold fails to appreciate the vertical connections *between* the two registers of the Bassus sarcophagus and thus underestimates the degree to which it also points back, by incorporating—while reinterpreting—earlier images and themes.

Schefold concludes that Gerke, in describing the unusual arrangement of the facade as a joining of an Old Testament frieze sarcophagus with a passion sarcophagus, has in fact described "the right typological [i.e., model] contexts in which the work belongs."[44] Gerke errs in not seeing that connections between the Old Testament and the New explain the intentional placement of the Abraham/Isaac and the Paul scenes. Schefold's brief interpretive suggestions concerning the ten intercolumnar scenes, which in some ways echo de Waal's,[45] need mainly to be filled in with richer detail, supported more fully by reference to contemporary texts, and coordinated with an interpretation of the other scenes of the sarcophagus (spandrels, ends, lid).

CHIASTIC STRUCTURES (GAERTNER)

In a 1968 article Johannes Gaertner takes as his task explication of the "significance" of the Junius Bassus sarcophagus.[46] He prefaces his own interpretation, as we have done, by a review and critique of the work of the three previous scholars who have "dealt with the systematic arrangements": de Waal, Gerke, and Schefold.[47] In large part his criticisms of de Waal are valid: de Waal stresses the judgment of Christ in a way that seems truer of medieval iconography than of the Junius Bassus sarcophagus; this focus on judgment leads de Waal (wrongly) to identify the Peter figure as a portrait of Junius Bassus—the deceased before the judgment throne; de Waal overemphasizes the importance of the spandrel scenes as the iconographical key to the work. Gaertner's argument against de Waal's assumption of a symmetrical arrangement, however, is not convincing, nor is his assertion that the sacrifice of Isaac is improbable as a prefigura-

tion of the crucifixion in fourth-century art.[48] Concerning Gerke's interpretation, Gaertner focuses exclusively on the issue of the two "rearranged" scenes of the facade. Arguing basically in parallel with Schefold (but with some strongly felt differences as well), Gaertner concludes that the hypothesis that an exchange of scenes took place is less likely than the hypothesis that it did not.[49]

Gaertner's critique of Schefold is problematic. For example, Gaertner correctly observes that "the general smoothness and emptiness of expression of all the figures on the sarcophagus" militate against reading much into the calm expressions of Abraham and Pilate, but he wrongly dismisses Schefold's understanding of the link between these two scenes as purely psychologized.[50] In fact Schefold argues as well on the basis of compositional cues to symmetry and contemporary conventions with regard to Old Testament foreshadowings of the New—both of which Gaertner undervalues. Or again, Gaertner argues, reasonably, that Schefold overemphasizes the martyrial aspects of Christ entering Jerusalem and of Job and Paul—neither Job nor Paul is, of course, a "first martyr"—but he concludes from this, unreasonably, that no link is suggested between the Job and Paul scenes at opposite ends of the lower register.[51]

Gaertner labels his own interpretation "chiastic," that is, based on the form of the Greek letter *chi*, X. This term is somewhat oddly applied, however, since chiastic structures are assumed to be centered and symmetrical, and Gaertner argues for a symmetrical structure *according to formal principles* but for an off-center structure *according to iconographical content or meaning*. He argues vigorously for the fourth-century possibility of chiastic structures in particular and complicated ordering of content in general,[52] as if these were the aspects of his interpretation most in need of defense. But he fails to present adequate argumentation for the weakest element of his hypothesis: that the structure of the content of the Bassus sarcophagus is at odds with the formal structure.

The formal structure results firstly in a "middle axis of Christ, who rides into Jerusalem and reigns in heaven after his resurrection." Secondly, the placement of the corner scenes—Pilate and Job, both seated and turned toward the center, and Abraham and Paul, both turned outward—results in "an obvious chiastic or-

der."[53] Thirdly, the three clothed figures in the second and fourth
niches of the upper register exhibit a "formal correspondence," as
do the naked figures and animals in the second and fourth niches
of the lower register.[54] With this nearly every viewer would con-
cur.

The difficulty arises with Gaertner's sketching out of the
structure of the content or meaning. He appears to be thrown off
by the relationship that "immediately appears" to him between
the Peter scene (scene 2) and the Paul scene (scene 10) and the
diagonal axis between them that he feels can be determined "in
all certainty." Because these two martyr scenes can be said to be
on a diagonal axis—although an axis that does *not* pass through
the center of the sarcophagus—Gaertner searches for other diag-
onal axes. In order to link the necessary scenes, he resorts to very
general or very ingenious similarities. Abraham/Isaac (scene 1)
and Daniel (scene 9) are two salvation paradigms. "Job, the 'suf-
fering righteous one,' the philosopher of the Old Testament, who
conducts a distressing dialogue with his friends and wife, stands
opposite Christ in the position of rhetor and philosopher, who
conducts a dialogue with Pilate. [Gaertner cites three passages of
patristic literature to illustrate that the suffering and redemption
of Job were linked with the death and resurrection of Christ, but
all three are dated *after* the Bassus sarcophagus.] But Pilate, who
more or less commits the second fall of mankind, that makes
possible the sacrifice of Christ, which then, however, redeems
man from sin, stands opposite Adam and Eve, who committed
the first sin and caused the banishment of mankind. Both cases
deal with a fatal decision."[55]

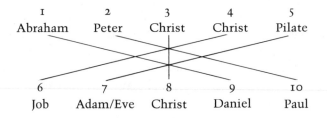

According to Gaertner, drawing diagonal lines to mark these
relationships would result in "a perfect X over the vertical 3–8,"
the two central Christ scenes.[56] (It would seem, rather, that a *per-
fect* X would be *symmetrically* arranged over that center: 1–10,

2–9, 4–7, 5–6.) Furthermore, this X (really two Xs) over a vertical | is understood by Gaertner as the ✗ form of the Chi-Rho, the monogram of Christ.[57] Thus the chiastic arrangement of five paired scenes results in an implicit monogram of Christ.[58]

There is a tension between the symmetry of the Bassus sarcophagus and the asymmetry of Gaertner's chiastic interpretation, but he asserts: "Just this contrast between the formal symmetries, which are in large part bound to tradition, and the meaning correspondences, of which some are first-time and unique, gives the sarcophagus a subtlety without peer."[59] A subtlety without peer, yes, but not on the basis for which Gaertner argues. He concludes that "a chiastic interpretation of the Junius Bassus sarcophagus cannot in any case be rejected because it would be too complicated."[60] This much is true; in fact, the elaborate sarcophagus seems to demand a somewhat complicated interpretation. But an *asymmetrical* chiastic interpretation of its iconography such as Gaertner offers—which violates the work's own compositional cues, largely ignores contemporary artistic conventions, and, in some cases, relies for literary parallels on material from a later period—can certainly be rejected for lack of evidence.[61] Thus many questions about the interrelations of scenes remain unanswered and the overall interpretive key undiscovered.

It is the interrelations of scenes and the structure of the work as a whole that must be understood if the iconography of the Junius Bassus sarcophagus is to be meaningfully interpreted.[62] But the interrelations of scenes are manifold, and they have not yet been convincingly explicated. For this reason the reader of the interpretations of de Waal, Gerke, Schefold, and Gaertner is left with contradictions and questions as well as intriguing suggestions. In various ways and to various degrees, art historians from de Waal onward have described the interrelations of the upper and lower registers, the spandrels, and even—in some cases and in a general way—the interrelations of the facade, lid, and ends. Some of their interpretations are more convincing than others. What remains wanting, however, is a specific discussion of the interrelations of the upper and lower registers with the spandrels, lid, and ends, and a general consideration of the

common element of these interrelations as the guiding principle for the artist's creation and/or the viewer's interpretation.

Such a holistic understanding of the iconographical program is the present goal. To reach it we must (1) follow the compositional cues of the work, which Gerke and Gaertner ignore—Gerke in an extreme way by "rearranging" scenes; (2) move beyond interpretations that clarify individual scenes or pairs or subgroups of scenes, which Grabar, Schiller, and Schefold offer, toward a unified view of the link between the links; and (3) ground our understanding in a method of interpretation viable during the work's fourth-century creation, a standard perhaps most notably transgressed by de Waal, but one rarely of consistent concern to scholars commenting on the sarcophagus. By following the work's compositional cues and investigating the conventions of its time, as they are suggested in earlier and contemporary artistic and literary sources, we may come to understand the iconographic significance of its elements—intercolumniations, spandrels, ends, lid, compositional and ornamental elements (chapters 3–7)—and to integrate these meanings into an overall interpretation of the iconographical program in its fourth-century context (chapter 8).

3 Intercolumniations

THE SARCOPHAGUS of Junius Bassus is perhaps most noted for its style rather than its iconography, although the two are intricately connected. The style of its facade, and especially of the ten intercolumnar scenes, has generally been hailed as an exemplification of the revival, in the second half of the fourth century, of Hellenistic traditions over the local Roman style,[1] as a "perfect example of what the Roman archaeologists now [in 1947] describe as *lo stile bello*,"[2] the Fine Style.[3] This new style has been said to supply "a visual expression for the new order and new balance of the Christian Empire created by Constantine."[4] The crowding of frieze sarcophagi and of the Arch of Constantine are here said to have given way to "a more widely spaced arrangement which enhances the narrative element of the representation considerably."[5] More recently, serious questions have been raised, especially on the basis of careful stylistic analysis, about the reality of any such "Roman Renaissance."[6] In any case the sarcophagus of Junius Bassus may not be claimed as *representative* of the style of the mid-fourth century.[7] Although stylistic analysis is beyond the scope of the present study,[8] it is clear that certain comments about "order" and "balance" are accurate and relevant descriptions of the Bassus sarcophagus. The sculptor imposed a strict order on his reliefs, making use of structural elements such as columns, entablatures, arches, and pediments. The placing of scenes reveals the same concern for orderly arrangement.[9] Christ is in the center of each register, with the scenes on either side set out symmetrically. This order and symmetry are not stylistic only but bear iconographic implications.

The sculptor of the Junius Bassus sarcophagus stood in the tradition of frieze sarcophagi and would have needed a strong reason for employing a columnar form.[10] It is possible that he viewed the "Asiatic" columnar form as especially appropriate for a careful and meaningful arrangement of scenes; this is, at least, a po-

tential impression of the columnar form on the viewer.[11] Gaert-
ner even comments: "The suspicion arises that the form of the
columnar sarcophagus has developed from a striving for symme-
try, parallel to the dogmatic and liturgical systematization of the
church in the post-Constantinian period."[12] Although some use
of symmetry and other special arrangements can serve to draw
connections between scenes on frieze sarcophagi,[13] the lining up
of scenes, both horizontally and vertically, on a *double-register*
columnar sarcophagus greatly enhances opportunities for clear
correspondences and iconographic as well as stylistic links be-
tween scenes.[14]

Art historians, however, are not in total agreement on which
scenes correspond with which and why! Most commentators
have recognized the symmetrical architectural frame of the fa-
cade, but some of those who have sought to comprehend the
overall pattern have been stumped by the distribution of Old and
New Testament scenes within that frame. Four scenes are chris-
tological, four present events from the Old Testament (OT), and
two suggest the martyrdoms of the chief apostles, Peter and Paul.

1	2	3	4	5
OT	Apostle	Christ	Christ	Christ

6	7	8	9	10
OT	OT	Christ	OT	Apostle

But labeling the scenes in this way does not in itself help clarify
the significance of their placement. In fact, it may mislead. Such
a pattern seems so anomalous to Gerke that he simply "rear-
ranges" two scenes (1 and 10) in his discussion of the iconogra-
phy, placing the apostle scenes side by side on the upper register
and all four Old Testament scenes on the lower. Gaertner is also
drawn to make a strong, direct—and equally dominating—con-
nection between the two apostle scenes (2 and 10); he does so,
however, not by "rearranging" scenes but by presenting an off-
center pattern of paired scenes to accommodate their actual
placement. Neither scheme is convincing.

It is true that the ten intercolumnar scenes have commonali-
ties on the basis of whether they are from the Old Testament, the
New Testamant, or the legends of the apostles. (The *martyrdoms*

of Peter and Paul are not recounted in the New Testament.) The
only intercolumnar New Testament scenes depict the passion
and resurrection in power of Christ. Both the apostle scenes are
echoes of Christ's passion and resurrection: as Christ died and
was raised, so Peter and Paul, who died in and for his name, have
received eternal life. The four Old Testament scenes might all be
said to be foreshadowings or prefigurations (or *types*) of Christ,
especially of his passion and resurrection—although to different
degrees, as will be explicated more thoroughly below: as Isaac,
Daniel, and Job were rescued from near death by the miraculous
intervention of God, so Christ, the Second Adam, was resur-
rected from actual death by that same power.

Yet these commonalities alone do not suggest why one Old
Testament scene should be on the upper register and the other
three on the lower, one apostle scene in the second niche of the
upper register and the other in the fifth niche of the lower. What
is suggested is an underlying view of salvation history, the his-
tory of how God acts to save humankind, that focuses on pat-
terns of prefiguration and actualization, event and echo—or, in
the language of the early church, type and antitype. Thus typo-
logical thinking will be one starting point for a new attempt to
understand which scenes correspond with which and why.

A second starting point, in actuality the first, is the work's ob-
vious compositional structure. All commentators are agreed on
one set of paired scenes: the two christological scenes at the cen-
ter. Compositional elements indicate a symmetrical arrangement
of scenes around this double center. Thus the following pairs of
corresponding scenes are suggested:

Triumphal Entry (8)/Christ Enthroned (3)
Abraham's Sacrifice of Isaac (1)/Pilate's Judgment of Christ (5)
Peter's Arrest (2)/Christ's Arrest (4)
Job's Distress (6)/Paul's Arrest (10)
Adam and Eve in the Garden (7)/Daniel in the Lions' Den (9)

As noted in chapter 2 above, typological connections between
certain of these intercolumnar scenes have occasionally been
suggested by commentators.[15] These suggestions can now receive
fuller elaboration. Because interpreters generally have found
clear connections between the Adam and Eve and Daniel scenes

and *any* connections between the Job and Paul scenes elusive, greater attention will be given to their explication.

Concerning the Dogmatic sarcophagus (fig. 5), the Two Brothers sarcophagus (fig. 3), and the Junius Bassus sarcophagus (fig. 1), Kitzinger observes: "Sacred history is being factually re-enacted before the beholder's eyes rather than being merely recalled to his mind for the purpose of conveying an urgent personal message."[16] All the intercolumnar scenes of the Bassus sarcophagus may be considered "historical" in two senses: (1) they depict events in "holy history" (unlike the allegorical or symbolic scenes of putti on the ends); and (2) they depict persons in their "historical" reality as persons (not as symbolic lambs as in the spandrel scenes of "historical" events). Thus it is to a view of history that we turn in order to appreciate their overall arrangement and specific interrelations. We begin with a consideration of typological thinking, with emphasis on understanding the creative and ordering principle behind perceived correspondences between events in "holy history."[17]

TYPOLOGICAL THINKING

Typology,[18] in the Christian theological sense, refers especially to the pointing out of "some person, event, or institution of the Old Law [as] related in some way to the new and definitive self-revelation of God in Christ."[19] But, in fact, typological thinking is rooted in the Hebrew Scriptures or Old Testament (e.g., Isaiah 51:9–16), for, as Jean Daniélou notes, the New Testament writers "did not have to invent typology."[20] It is developed in the New Testament (occurring throughout the Pauline and post-Pauline epistles,[21] the synoptic gospels, and the Gospel of John[22]) and was continued and further developed by the early church fathers,[23] especially in the "schools" of Alexandria (Clement, Origen) and Antioch (Theophilus, Diodore, Theodore of Mopsuestia, John Chrysostom).[24] Strictly speaking, the Alexandrian school[25] tended very early toward allegorical interpretation,[26] with the corollary temptation of undervaluing or dispensing with the literal meaning of the text,[27] against which the Antiochene school reacted with a more stringent typological interpretation.[28] But stringent or allegorical, "[t]ypology itself does not appear to be a scientific method of exegesis, with fixed rules,

but rather a specific form of symbol used to articulate a theology of the relation of Christ to the Old Covenant."[29]

Christian typological exegesis was essentially "a technique for bringing out the correspondence between the two Testaments,"[30] between the type or prefiguring or anticipation and the antitype or fulfillment. For example, the typologist would posit that the incomplete sacrifice of Isaac by Abraham was fulfilled in the complete sacrifice of Jesus by his own death, Isaac being the type and Christ the antitype. Typological relationships could be expanded beyond the two Testaments[31] and were especially applied to the sacraments of the church.[32] Just as the acts of God in Christ were understood as prefigured in the Old Testament, so Christ's acts were understood as "made effective and present" or "post-figured" in the sacramental signs and the liturgy of the church.[33] Thus, to continue the example, Jesus's sacrifice of himself on the cross, prefigured in the sacrifice of Isaac by Abraham, may be said to be fulfilled continually in the sacrament of communion, the sacrifice of the Mass.[34] The sacrifice of Christ both completes the sacrifice of Isaac by Abraham and, in some sense, is completed in the sacrament of communion. Cyril of Jerusalem makes this second type of connection clear in relation to the sacrament of baptism in his second *Mystagogical Lecture*, that is, lecture on the mystery of baptism, delivered sometime after 350: "[W]e know full well that Baptism not only washes away our sins and procures for us the gift of the Holy Spirit, but is also the antitype of the Passion of Christ."[35]

This typological linkage of the Old Testament with the New and the New Testament with the church illustrates the typologist's view of history. "The typologist took history seriously; it was the scene of the progressive unfolding of God's consistent redemptive purpose."[36] In fact, the basic assumption underlying typology proper is that the history of God's people and of God's dealings with them is "a single continuous process in which a uniform pattern may be discerned."[37] Or, phrased from the other side, "the typology of anticipation and fulfillment is the basic category of a Christian understanding of history."[38] Typological thinking manifests a dynamic view of the fulfillment of God's purpose within history.

Works of the fourth century illustrate well this typological view of history. By an examination of both contemporary doctri-

nal writings and secular and religious poetry, Camille Jungman demonstrates that "the expression of typological ideas in the arts is clearly in the air in the first part of the fourth century."[39] As Grabar notes, Origen, Tertullian, Gregory of Nyssa, Ambrose, and Augustine all drew typological correspondences between the Old and the New Testaments and thus "involuntarily invited the image-makers to do the same."[40] Grabar details the way in which a number of sculptors took up this invitation in making visual typological comparisons between the narratives of the Old and New Testaments and between the biblical narratives and the sacraments of the church, in representing dogmas by juxtaposing images.

Grabar, however, fails to see that the sculptor of the Junius Bassus sarcophagus breathed that air and accepted that invitation. He writes: "Though the front of the sarcophagus is planned on new, more vigorous lines, the choice of images and the haphazardness of their arrangement remind us of earlier sarcophagi."[41] Upon a close examination, we are reminded by the familiar scenes of the Bassus sarcophagus not only of earlier sarcophagi but also of later, more complex iconographical programs here anticipated in the arrangement of scenes on the basis of a view of history stressing anticipation and fulfillment, event and echo.[42] This is not to say, of course, that the connections underlying the scenes of the intercolumniations are to be interpreted in terms of the developed—even rigidified—typological programs of medieval Christian art. Anachronism is rarely helpful, and it is certainly not needed in order to challenge the judgment of "haphazardness" in relation to the Junius Bassus sarcophagus.

UPPER REGISTER SCENES

1	2	3	4	5
Abraham/ Isaac	Peter's Arrest	Christ Enthroned	Christ's Arrest	Pilate's Judgment

Abraham/Isaac and Pilate

The first paired scenes to consider are the first and last scenes of the upper register. As Saxl has observed, the first scene, the sacrifice of Issac by Abraham, "does not mean here what it meant

previously, a promise of salvation; it is to be understood as the Jewish prototype of the death of Christ, the father's willingness to sacrifice his son."[43] Isaac is the type of Christ perhaps most frequently expressed in the writings of the early church fathers. Daniélou cites typological interpretations of the story in Tertullian, Pseudo-Barnabus, Irenaeus, Melito, Augustine, Cyprian, Hilary, Zeno of Verona, Ambrose, Athanasius, Gregory of Nyssa, John Chrysostom, Theodoret, Clement of Alexandria, and Origen![44] It is no wonder that Augustine (354–430) writes that the "deed [is] so famous, that it recurs to the mind of itself without any study or reflection, and is in fact repeated by so many tongues, and portrayed in so many places, that no one can pretend to shut his eyes or his ears to it."[45]

Several examples, one from the New Testament and three from early church writers, will illustrate this rich tradition of typological exegesis.

Hebrews 11:17–19:
By faith Abraham, when he was tested, offered up Isaac, and he who had received the promises was ready to offer up his only son, of whom it was said, "Through Isaac shall your descendants be named." He considered that God was able to raise men even from the dead; hence, figuratively speaking, he did receive him back.[46]

Irenaeus (ca. 125–ca. 202):
For Abraham, according to his faith, followed the commandment of the Word of God, and with a ready mind delivered up, as a sacrifice to God, his only-begotten and beloved son, in order that God also might be pleased to offer up for all his seed His own beloved and only-begotten Son, as a sacrifice for our redemption.[47]

Tertullian (ca. 155–ca. 230):
This "wood," again, Isaac the son of Abraham personally carried for his own sacrifice, when God had enjoined that he should be made a victim to Himself. But, because these had been mysteries [sacramenta] which were being kept for perfect fulfilment in the times of Christ, Isaac, on the one hand, with his "wood," was reserved, the ram being offered which was caught by the horns in the bramble; Christ, on the other hand, in His times,

carried his "wood" on His own shoulders, adhering to the horns of the cross, with a thorny crown encircling His head.[48]

John Chrysostom (ca. 345–407):

A lamb was offered for Isaac, and a spiritual lamb was offered for the world. The reality had to be depicted beforehand in type. Consider, I beg you, to what extent everything had been told in advance. In both instances we have an only son; in both instances one who is greatly loved. The first was offered as a victim by his father, and so was the latter offered by the Father (Rom. 8:32). The type carries us a long way, but how much further does the reality go.[49]

As noted in chapter 1 above, the sacrifice of Isaac was an established scene in the catacombs and very popular on early Christian sarcophagi. Art historians who have studied these materials recognize that the "binding of Isaac directly suggest[s] the thought of Christ's sacrificial death and resurrection."[50] Among Old Testament motifs presented as prefigurations of Christ's passion on passion sarcophagi, the most important was the sacrifice of Isaac.[51] On the Junius Bassus sarcophagus this scene, the type of Christ's death and resurrection, is placed opposite the scene of Pilate's judgment, which serves as an allusion to the antitype, Christ's actual death and resurrection. "Pilate Washing his Hands is a typical theme of western Roman art. . . . a type [i.e., model] for it evolved during the fourth century among the sculptures on sarcophagi, and it alone often served to represent the whole story of the Passion."[52] In the mid-fourth century Jesus's death is not portrayed directly.[53] We have several examples of single-register five-niche columnar sarcophagi with Christ or the Labarum (Symbolic Resurrection) in the center, an additional scene or scenes of Christ (especially his arrest), scenes of apostles (especially Peter and Paul under arrest), and Pilate's judgment (always in the niche farthest right).[54] (For examples, see figs. 6, 7, 8.) These "passion sarcophagi" make it clear that Pilate's judgment is to be understood as a reference to Christ's passion. As noted in chapter 2 above, a number of scholars— including de Waal, Schefold, and Schiller—have called attention to the significant pairing of the sacrifice of Isaac and the judgment of Pilate on the Bassus sarcophagus. In the words of Panofsky, the link between these

two outer scenes is the antithetical correspondence between "Isaac's 'deliverance from the hands of his father, Abraham,' as it says in the prayers *in extremis*" and "Christ's deliverance into the hands of the Jews."[55]

A seven-niche sarcophagus of about the same time as the Bassus sarcophagus, and perhaps influenced by it (fig. 10), provides a visual parallel to the pairing of Abraham/Isaac and Pilate. In addition, the Two Brothers sarcophagus (fig. 3), usually dated to the period just before the Bassus sarcophagus, has the two scenes side by side in a prominent position, filling the space to the right of the portrait shell on the upper register. In each of these three cases, including the Bassus sarcophagus, the Old Testament type is to the left, the allusion to the New Testament antitype to the right, with the correspondence being more obvious on the two columnar sarcophagi. Thus a typological link so commonly given verbal expression in the early Christian period is given visual expression here in the symmetrically set terminal scenes of the upper register: the type, the (incomplete) sacrifice of Isaac by Abraham, is fulfilled in the antitype, the sacrifice of Jesus by his death, as alluded to in Pilate's judgment.

Peter and Christ

The second and fourth scenes of the upper register, the arrest of Peter and the arrest of Christ, are also symmetrically placed, framing the central scene. The connection between these two scenes is additionally stressed by the parallel arrangement and treatment of the three figures in each. Christ's arrest and suffering can be viewed as the event that is echoed or post-figured in the arrests and suffering of the members of the early church, here the arrest of Peter. The arrest of Paul, presented in the right terminal niche of the lower register, may also be viewed as the post-figuring of Christ's arrest. The scene of Paul's arrest, however, lacks the strict parallelisms in arrangement and treatment that link the arrest scenes of Peter and Christ. The representation of Paul is not centered in its niche, and both Paul and the guard show more movement than the upper-register figures. Not only does an eagle-headed conch rise above the Paul scene but reeds are suggested in the background.[56] The upper-register scenes of the arrests of Peter and Christ lack such details.[57]

According to Schiller, the seizure of Peter or Paul "always sig-
nifies the Death of Christ and the victory he won by his Death:
the death of a martyr as a triumph over death was proof of his
fellowship with Christ."[58] The sense of triumph over suffering is
clear on the Junius Bassus sarcophagus. The scene of Christ's be-
ing led before Pilate is, according to Saxl, "the only scene that
indicates Christ's suffering, and His bowed head is the only sign
of His impending martyrdom. On the left, as a counterpart, St.
Peter accepts his fate like a philosopher."[59] Thus Peter mirrors or
post-figures Christ's resolution and assurance in the face of
death.[60]

The typological connections between Christ and Christian
martyrs are especially interesting. All Christians are understood
to participate in the death and resurrection of Christ through
baptism. As Paul writes in Romans:

> Do you not know that all of us who have been baptized into
> Christ Jesus were baptized into his death? We were buried there-
> fore with him by baptism into death, so that as Christ was raised
> from the dead by the glory of the Father, we too might walk in
> newness of life. For if we have been united with him in a death
> like his, we shall certainly be united with him in a resurrection
> like his.
>
> Romans 6:3–5[61]

Martyrs, by their obedience unto death, reenacted Christ's own
obedience unto death and thus were even more dramatically
united with Christ in a death like his. Martyrdom, in fact, was
regarded as a "second baptism" by the early church.[62] As Tertul-
lian explains:

> We *have* indeed, likewise, a *second* font, (itself withal *one* [with
> the former,]) of *blood*, to wit; concerning which the Lord said, "I
> have to be baptized with a baptism" [Luke 12:50], when He had
> been baptized already. . . . These two baptisms He sent out from
> the wound in His pierced side [John 19:34], in order that they
> who believed in His blood might be bathed with the water; they
> who had been bathed in the water might likewise drink the blood
> [see John 6:53, etc.]. This is the baptism which both stands in
> lieu of the fontal bathing when that has not been received, and
> restores it when lost.[63]

Thus martyrdom, the second baptism of a special few, post-figures the sacrament of baptism, which itself post-figures the death and resurrection of Christ—as entered into by all who are baptized.

Christian typological thinking is, not surprisingly, christocentric.[64] Appropriate events of the Old Testament, such as the sacrifice of Isaac, are said to prefigure Christ; they are types, Christ is the antitype. Appropriate events of the New Testament or beyond, such as the sacraments and martyrdoms, are said to post-figure Christ; they are echoes of history's central event. If historical chronology were determinative for typology, Christ's crucifixion might be said to be the type of Peter's martyrdom, the antitype. But because in Christ "the fulness of God was pleased to dwell" (Colossians 1:19), later events are said to reflect, not to fulfill, the reality of Christ.

The outermost pair of the upper register is comprised of an Old Testament scene (the type) to the left and a New Testament scene (the allusion to the antitype) to the right—perhaps the "standard" typological arrangement. But the pair formed by the second and fourth scenes is comprised of two scenes of New Testament characters, and the chronologically later scene, Peter's arrest, is to the left. This placement is most obviously necessitated by the fact that Christ's arrest and Pilate's judgment form a two-scene depiction of Christ before Pilate, and Pilate's standard position on sarcophagi is the niche farthest right.[65] But this placement also serves to give precedence—not simple chronological precedence but ontological precedence—to Christ. Christ has greater being, greater value as the final fulfillment, the ultimate antitype. Thus the scenes of Christ are given the positions of greater honor: central, upper, right. Christ is portrayed in the center of both registers; no scene but one of Christ is placed above Christ, and no scene but an allusion to Christ is placed to the right of Christ. Christ's death and resurrection are prefigured in the sacrifice of Isaac and post-figured in the martyrdom of Peter. Christ is the center point of typological thinking.

Christ Enthroned

Even interpreters who have found the Junius Bassus sarcophagus haphazard in its choice of scenes, even interpreters who have disagreed on all other correspondences, have been struck by the sig-

nificant placement of the scene of Christ enthroned over the cosmos[66] and between two disciples above the scene of the triumphal entry of Christ into Jerusalem. Both scenes are christological and may be understood as presupposing the Peace of the church by their visual application of the analogy: Christ is to heaven (or all heaven and earth—the cosmos) as the emperor is to the empire. As Grabar points out, two motifs current in Roman imperial art are drawn upon here.[67] The first is "the king enthroned with the cosmos at his feet (symbolizing worldwide sovereignty),"[68] as employed in the presentation of the emperor Diocletian on the Arch of Galerius in Salonika.[69] The upper central scene of the Junius Bassus sarcophagus repeats this motif clearly (fig. 44), as do several other early Christian sarcophagi.[70] (See fig. 10.) The Bassus enthronement in heaven scene is "one of the most interesting examples, and perhaps the earliest."[71] The second Roman imperial motif is "an *adventus*, the monarch's State entry into his city,"[72] here transformed into Christ's triumphal entry into the holy city of the earth, Jerusalem. Sabine MacCormack argues that the *adventus* offers "the expression and establishment of a relationship between ruler and ruled."[73] The Junius Bassus sarcophagus suggests a transformation of this experience to the religious plane: a relationship is expressed and established between the deceased Junius Bassus and the eternal Jesus Christ.

The upper central scene (Christ enthroned) may also be viewed as a scene of the *traditio legis*, the handing on of the Law by Christ to Peter and Paul.[74] A central *traditio legis* scene on a passion sarcophagus, Schiller asserts, "makes the point, in hieratic manner, that Christ as Emperor through his victory over death gives the New Law in eternal sovereignty."[75] As noted in chapter 1 above, Schiller considers the sarcophagus of Junius Bassus the latest surviving example of a series of passion sarcophagi made between 340 and 400 on which Old and New Testament scenes, as "visual allusions to Christ's Death and Resurrection," are combined with scenes of the martyrdoms of the apostles and by which early Christians "proclaimed in their cemeteries their faith in Salvation and the attainment of everlasting life."[76] The central motifs of these passion sarcophagi are the *crux invicta* (the unconquered cross), *Christus victor* (Christ victorious), and the *traditio legis* (the exalted Christ delivering the gospel as the

New Law). (See, for example, figs. 6, 7, 8, and 9.) The uncon-
quered cross remains the frequent central motif on passion sar-
cophagi until the period of Theodosius (379–395). But from about
350 on, the Christ enthroned in heaven, or from about 370 on,
the *traditio legis* with Christ standing on the Mountain of Para-
dise, may instead fill the central position.

As Margaret Frazer observes, the *traditio legis* "was created in
Rome in the fourth century, probably for the apse of St. Peter's.
It emphasized the primacy of Peter and the importance of Paul as
the princes of the apostles and as Roman martyrs. [Peter and Paul
are, of course, given importance on the Bassus sarcophagus.] The
scene, however, is primarily eschatological; Christ is the resur-
rected Lord of the Second Coming."[77] This eschatological mean-
ing is emphasized on the Bassus sarcophagus by portraying the
Christ who hands on the Law as enthroned over Coelus. Like the
enthronement, the *traditio legis* has an imperial model: "the al-
locution of the emperor in public or at a palace consistory, when
he receives or dispenses gifts"—such as that depicted on the Arch
of Constantine in Rome, dedicated in 314 (i.e., before the Bassus
sarcophagus).[78] The Missorium of Theodosius I, dated to 388 (i.e.,
after the Bassus sarcophagus), depicts the emperor "seated in a
tribunal as he delivers a codicil to an official, with his two sons
and two soldiers on either side of him."[79] The Junius Bassus up-
per central scene combines the *traditio legis* with an enthrone-
ment over Coelus, and it may be the latter that is dominant—the
handing on of the Law being *one* function of the eternally reign-
ing Christ.

Imperial ceremonial may also stand behind the juxtaposition
of an *adventus* and an enthronement in heaven on the Bassus
sarcophagus. MacCormack notes that

> in an imperial context, a particular historical *adventus* could be
> related to and could become a universal imperial presence, could
> be made to reach beyond the facts of history. In similar fashion,
> in Christianity Christ's historical entry into Jerusalem was de-
> scribed by the same technical term *apantēsis* as was his second
> coming. In visual art, these two arrivals, the historical and the es-
> chatological, are conjoined on the sarcophagus of Junius Bassus.
> . . . The juxtaposition of these two scenes, one above the other,
> and the central place they both occupy in the iconographical

scheme of the sarcophagus as a whole indicate that the content of each was clearly understood to be related to the other, and both scenes are rendered in iconographies familiar from imperial art.[80]

MacCormack's careful work on art and ceremony in late antiquity paints the background against which these paired scenes are highlighted. As she observes:

> [T]he motif of the emperor enthroned on the earth or the universe . . . disappeared from imperial art at the very same time that it emerged in Christian art. This was because, once this image of majesty had been applied to Christ, it was impossible to apply it again to the emperor. . . . Dominion over the cosmos, and specific, historical dominion over the empire both were imperial themes, had both been applicable to the pagan emperor and had both found various expressions in imperial art and iconography. On the sarcophagus of Junius Bassus, two imperial iconographies were applied to Christ in such a way as to show Christ in his divinity, his majesty, in heaven, and in his humanity on earth.[81]

Furthermore, the debate about the human and/or divine nature of the emperor was overtaken in the course of the fourth century by the debate about the human and divine nature of Christ, "the first stage of which was officially defined by the Council of Nicaea, and which was of universal application. The two scenes on the sarcophagus which concern us here may be understood, therefore, as a carefully deliberated theological statement."[82]

In addition, scenes such as the enthronement have been classified by René Grousset as "idéales," "groupés dans une action imaginaire" rather than following the scriptural narrative.[83] The one "ideal" scene of the sarcophagus of Junius Bassus is, significantly, given the place of first importance: the upper-register, center intercolumniation.[84] This idealized enthronement of Christ triumphing over the cosmos rests upon the triumphal entry, that is, Christ triumphing over the earthly Jerusalem. And Christ's earthly and temporal kingship is fulfilled by Christ's universal and eternal kingship.[85] In an analogical sense the former might be said to be the type of the latter. The central scene of the upper register, Christ enthroned, would then be thought of as the antitype of the scene below it, the triumphal entry, and

the upper-register Christ as the "idealized" antitype of the lower-register, New Testament type.

Thus the upper register of the Junius Bassus sarcophagus, with its symmetrical arrangement of paired scenes has three emphases: (1) *sacrifice*, pointed to by the outermost, framing pair of scenes, the sacrifice of Isaac by Abraham and Pilate's judgment as an allusion to Christ's sacrifice; (2) openness to self-sacrifice or *obedience* to one's task as the Christ or to one's faith as a Christian, suggested by the second and fourth scenes, the arrest of Peter and the arrest of Christ; (3) the *victorious Christ*, depicted in the central scene, Christ enthroned. An earlier, incomplete sacrifice prefigures a final one. A later faithful death postfigures an earlier, definitive one. An eternal triumph extends an earthly one.[86]

LOWER REGISTER SCENES

6	7	8	9	10
Job's Distress	Adam/Eve	Triumphal Entry	Daniel	Paul's Arrest

Triumphal Entry

Like the upper register—and the typological view of history itself—the lower register is centered on Christ. The scene of Christ's triumphal entry into Jerusalem serves not only as a signal of his passion in that city but also—and more emphatically, as we have just seen—as an earthly prefiguration of his eternal triumph in heaven, depicted in the scene above. As Schiller notes:

> The earliest representatives of the Entry into Jerusalem date from the fourth century and are influenced not only by the liturgy for Palm Sunday but also by the symbolic meaning of the city of Jerusalem. Jerusalem is not only the political and ideal capital of Jewry—whose great festivals were celebrated there in the Temple of Solomon—or the scene of Christ's Passion; it is also the eternal city, the heavenly Jerusalem of Christendom. In the earliest representations in the Hellenistic world the emphasis is on this

symbolic meaning: Christ's entry into the city of heaven represents his triumph over death.[87]

Georg Daltrop even argues that the type of tree depicted in the entry scene indicates Christ's triumph rather than his passion as the focus: "In place of the olive tree in the background there stands here the oak tree; the Romans associated a particular significance with oak leaves and the oak wreath, for the oak wreath was conferred *ob cives servatos*. Therefore there is here less of an allusion to the coming passion than to the youthfully triumphant Christ, riding ahead into the heavenly Jerusalem."[88] Thus here at the center of the work and of its ideas we see the triumphal entry and Christ enthroned; we view Christ, as Gerke explicates, as the ruling middle point from which nature and human life retreat as death retreats from the divine eternity.[89] The strong center of the sarcophagus facade, in which Christ rides as king into Jerusalem in order to reign as eternal king in heaven, has the character of announcement and proclamation.[90]

Job and Paul

The relationships among the four remaining scenes of the lower register are less obvious; Schiller groups these four scenes generally as references to "man's Salvation through Christ's Death and Resurrection."[91] For a more specific understanding of their interrelations, an interpreter must return to the broader context of the images: the biblical materials from which they come.[92] Representations of Job and Paul are placed symmetrically in the terminal niches of the lower register, each under an eagle-headed conch. Perhaps because individual scenes of both Job and Paul are rare not only in the catacombs but also on third- and fourth-century sarcophagi, interpreters have had difficulty explicating their placement and significance here.[93] Compositional arrangements imply a correspondence between them, but it is biblical and early church materials that make this correspondence explicit.

Job was first "persecuted" by God and then addressed, restored, and blessed by God. Paul first persecuted the people of God, the "Christians"; then, after being addressed by God on the road to Damascus, he was himself persecuted as a spokesman for God in Christ and thus brought to full participation in Christ's death and resurrection. Therefore Job and Paul are related to each other

through suffering and "salvation" and are thus related to Christ's death and resurrection. Job's restoration prefigures Christ's resurrection,[94] and Paul's martyrdom post-figures Christ's death and resurrection. This relationship is clearly suggested by two or three early Christian sarcophagi on which representations of Paul (niche 4) and Job (niche 5) appear side by side to the right of a scene of the Symbolic Resurrection (see fig. 9).[95] To the left are Peter (niche 2) and Cain and Abel offering their sacrifices to God (niche 1), so that we have a symbol of Christ's sacrificial death and resurrection framed more immediately by two post-figurations of it and more distantly by two prefigurations. But a typological relation to Christ's death and resurrection does not distinguish Job and Paul from most of the persons represented in the other scenes of the Junius Bassus sarcophagus.[96]

There are, however, aspects of experience that Job and Paul share in contradistinction from the others. Both had a bodily affliction regarded as a "trial."[97] As part of a process agreed upon by the Lord and Satan in order to test Job's faithfulness to the Lord, Satan "afflicted Job with loathsome sores from the sole of his foot to the crown of his head" (Job 2:7). Paul reported in his second letter to the Corinthians: "And to keep me from being too elated by the abundance of revelations, a thorn was given me in the flesh, a messenger of Satan, to harass me, to keep me from being too elated" (2 Corinthians 12:7). Both Job and Paul came through their respective afflictions, their trials, with a renewed sense of their own weakness or smallness before God's greatness and strength. In response to the Lord's voice from the whirlwind, Job answered:

> "Behold, I am of small account;
> what shall I answer thee?
> I lay my hand on my mouth.
> I have spoken once, and I will not answer;
> twice, but I will proceed no further."
>
> Job 40:4–5

> ". . . I have uttered what I did not
> understand,
> things too wonderful for me, which
> I did not know. . . .

> therefore I despise myself, and repent
> in dust and ashes."
>
> Job 42:3b, 6

Similarly, Paul proclaimed:

> Three times I besought the Lord about this [thorn in the flesh],
> that it should leave me; but he said to me, "My grace is sufficient
> for you, for my power is made perfect in weakness." I will all the
> more gladly boast of my weaknesses, that the power of Christ
> may rest upon me. For the sake of Christ, then, I am content
> with weaknesses, insults, hardships, persecutions, and calami-
> ties; for when I am weak, then I am strong.
>
> 2 Corinthians 12:8–10[98]

And Paul was strong and Job was restored. The result of each trial
was a renewal of life by the power of God.

In fact, a vivid, personal encounter with the power of God is
another aspect of experience shared by Job and Paul. Job encoun-
tered God's power as God answered him out of the whirlwind
(Job 38:1–41:34); Paul encountered God's power in the risen
Christ on the road to Damascus (Acts 9:3–9). Job, in his experi-
ence of God, in a sense prefigures Paul in his experience of God
incarnate, Jesus Christ. For each, this divine encounter led to a
dramatic change in behavior: Job the persistent questioner be-
came silent (Job 40:3–5), repented "in dust and ashes" (42:6), and
interceded with God for the sake of his "friends" (42:7–10); Paul
the persecutor of "Christians," initially blinded (Acts 9:8–9), be-
came Paul the most important missionary of the first Christian
generation. Thus Job, witness to God's personal interaction with
humankind, seems to foreshadow Paul, witness to the action of
God, in the person of Christ, for humankind.

But the similarity between Job and Paul that was apparently
most significant for the early Christian church was their exem-
plification of patience.[99] The *patience* of Job, although problem-
atical, was and remains proverbial (see James 5:7–11). Tertullian
found no need to call Job by name when first referring to him in
De Patientia:

> Happy, too, was that man who displayed every manner of pa-
> tience against every vicious attack of the Devil! [Cf. Job 1:15–19]

... Far from being turned away by so many misfortunes from the reverence which he owed to God, he set for us an example and proof of how we must practise patience in the spirit as well as in the flesh, in soul as well as in body, that we may not succumb under the loss of worldly goods, the death of our dear ones, or any bodily afflictions.[100]

Paul, of course, gives his own testimony of his patience: "I am content with weaknesses, insults, hardships, persecutions, and calamities" (2 Corinthians 12:10). And further testimony to the patience of Paul (and to a lesser extent Peter) is given by Clement in his Letter to the Corinthians (written in Rome, probably toward the close of the first century or the beginning of the second):

But, to leave the ancient examples, let us come to the heroes nearest ourselves; let us consider the noble examples of our own generation. Through jealousy and envy the greatest and holiest pillars [of the Church] were persecuted, and they endured to the death. Let us put before our eyes the good apostles: Peter, because of unrighteous jealousy, underwent not one or two, but many sufferings, and having thus borne testimony [martureō] went to his well-deserved place of glory. Because of jealousy and dissension Paul pointed out the way to the reward of endurance: Seven times he was put in chains; he was banished, stoned; he became a herald in the East and in the West and received the noble renown of his faith. He taught righteousness to the whole world, and after reaching the confines of the West, and having given testimony before rulers, passed from the world and was taken up to the Holy Place, having become the outstanding model of endurance [or patience].[101]

That this similarity between Job and Paul, in which Job might be said to prefigure Paul, did not go unnoticed by the early church fathers is evidenced in, for example, one of the festal letters (dated to 341) of Athanasius, Bishop of Alexandria. In discussing the reason for "numerous afflictions and bitter persecutions," heresies, scourges, and ill treatment, Athanasius weaves together references to Job and Paul:

For such things as these serve for exercise and trial, so that, having approved ourselves zealous and chosen servants of Christ, we may be fellow-heirs with the saints. For thus Job: *The whole*

world is a trial to men upon the earth (Job 7, 1). . . . And further, for this cause He trieth each one of us, either that to those who know it not, our virtue may be discovered by means of the trials laid upon us: as was said respecting Job; *Thinkest thou that I was revealed to thee for any other cause, than that thou shouldest be seen righteous?* (Job 40, 3, 4. LXX version). Or, that, when men come to a sense of their deeds, they may know the temper of them, and may therefore either repent of their wickedness, or re-main steadfast in the faith. Now the blessed Paul, when troubled by afflictions, and persecutions, and hunger and thirst, *in every thing was a conqueror, through Jesus Christ, Who loved us* (Ro-mans 8, 37). Through suffering he was weak indeed in body; yet, believing and hoping, he was strong in spirit, and his strength was made perfect in weakness [2 Corinthians 12:9].

But the other saints also, who had a like confidence in God, ac-cepted a probation such as this with gladness; as Job said, *Blessed be the name of the Lord* (Job 1, 21).[102]

It is not insignificant that this letter of Athanasius was dated Easter Day, that is, the festival day of Christ's resurrection; for while Job (by his trials and restoration) prefigured Christ's death and resurrection, Paul (by his martyrdom) participated in that death and resurrection. Thus Job and Paul are both related typo-logically to Christ. Yet Job's "trial" of faith called forth an incom-plete sacrifice (the sacrifice of his health, wealth, and family), while Paul's "trial" of faith moved beyond "a thorn in the flesh" to martyrdom—a complete sacrifice (the sacrifice of his life). Thus the martyrdom of Paul is related to the distress of Job as the full sacrifice of Christ is related to the incomplete sacrifice of Isaac. (The scenes of Abraham's sacrifice of Isaac and Pilate's judgment of Christ as an allusion to Christ's sacrifice appear above the scenes of Job and Paul respectively.) Thus, as Saxl ob-serves, "Job on this sarcophagus is to be understood, not as one of the faithful saved but as a protomartyr, as one of the precursors and the Old Testament counterpart of St. Paul propagating the teachings of the Lord by preaching and suffering."[103]

If one were to apply the terms of typological interpretation an-alogically, one could suggest that Job is the type of Paul, Paul the antitype of Job. It is not likely, however, that early Christians

would have used the terms in this way, since typology is chris-
tocentric: Christ or at least the Body of Christ (the church or the
sacraments) is the universal antitype. What does seem likely is
that the basic *principle* behind typological correspondence, so
clearly illustrated in the upper register, has influenced the lower
register as well. This basic principle is stated clearly by John
Chrysostom:

> You see now the relationship of the type with the anti-type, and
> of the superiority of the latter over the former. The type need not
> have nothing in common to the anti-type, then there would be
> nothing typical. Nor on the other [hand] has one to be identical
> with the other, or it would be the reality itself. There must be
> that proportion, so that it neither possesses all that the reality
> has, nor is entirely lacking.[104]

Thus, although it would not be appropriate to label Job a type of
Paul, the typological view of history has influenced their place-
ment and significance on the Junius Bassus sarcophagus. The re-
lationship between the Job and Paul scenes of the lower register
is analogous to that between the scenes of type and antitype por-
trayed and alluded to just above them on the upper register.

Adam/Eve and Daniel

Does a typological analogy inform the iconography of the final
pair of scenes as well? Representations of Adam and Eve and
Daniel are placed symmetrically in the second and fourth niches
of the lower register, each under a gable. Certainly Adam and Eve
in the garden and Daniel in the lions' den cannot be related as
type and antitype in the strict sense because both represent Old
Testament characters and events, and Christian typology always
locates the antitype in an event with Christ. As with Job and
Paul, an examination of biblical and early church materials is
needed to clarify the basis of the correspondence suggested by
their symmetrical placement.

 As was also the case with Job and Paul, these materials suggest
that both Adam and Daniel point first to Christ. Daniel, perhaps
more dramatically than Job and less so than Isaac, is rescued from
near death by the power of God and thus prefigures the passion
and resurrection of Christ. In the third-century commentary on

the book of Daniel by Hippolytus, Bishop of Rome, Daniel is called "a prophet and witness of Christ."[105] Concerning Daniel 10:16, Hippolytus offers this comment:

> For one unseen touched me [i.e., Daniel], and straightway my weakness was removed, and I was restored to my former strength. For whenever all the strength of our life and its glory pass from us, then we are strengthened by Christ, who stretches forth His hand and raises the living from among the dead, and as it were from Hades itself, to the resurrection of life.[106]

Adam is also identified as the type of Christ by early church writers, who, in this case, have Paul's clear lead to follow.[107]

> Yet death reigned from Adam to Moses, even over those whose sins were not like the transgression of Adam, who was a type of the one who was to come. . . . Then as one man's trespass led to condemnation for all men, so one man's act of righteousness leads to acquittal and life for all men. For as by one man's disobedience many were made sinners, so by one man's obedience many will be made righteous.
>
> Romans 5:14, 18–19

> For as by a man came death, by a man has come also the resurrection of the dead. For as in Adam all die, so also in Christ shall all be made alive.
>
> 1 Corinthians 15:21–22

This Pauline tradition, further developed by Tertullian and especially Irenaeus, was carried on in the fourth century by Ambrose (340?–397):

> Adam is born of the virgin earth, Christ is born of a Virgin. The former was made in the image of God, the latter *is* the image of God. The first was set over irrational animals, the second over all living beings. By a woman came foolishness, and by a Virgin true Wisdom. A tree brought death, life comes from the Cross. While one is deprived of his spiritual endowments and is clothed with leaves, the other, deprived of earthly goods, does not regret being clothed with a body. Adam is in the desert, Christ is likewise in the desert.[108]

Christ has not only to fulfill the promise of Adam's creation but to reverse the pattern of his disobedience. Similarly Eve is understood to be a type of the Virgin Mary, who both fulfills Eve's role and reverses her response, and also a type of the church, which is both the bride and the body of Christ ("bone of my bones and flesh of my flesh," as Adam says of Eve), and to whom Adam-Christ cleaves so that "they become one flesh" (see Genesis 2:23–24; cf. Ephesians 5:31–32; see also John 19:34).[109]

The issue of obedience is central to the typological linkage of Adam with Christ and Eve with Mary. As Irenaeus writes:

> And because, being all implicated in the first formation of Adam, we were bound to death through *disobedience*, the bonds of death had necessarily to be loosed through the *obedience* of Him who was made man for us; . . .
>
> And just as it was through a virgin [Eve] who *disobeyed* that man was stricken and fell and died, so too it was through the Virgin [Mary], who *obeyed* the word of God, that man resuscitated by life received life.[110]

A typological link to Christ is, as we have already observed, that which is shared by the events depicted in the intercolumniations of the Junius Bassus sarcophagus. We are looking now for what may distinguish Adam/Eve and Daniel as a pair, what may link them directly and in a significant way. Thus it is important to note that the contrast between disobedience and obedience is also clearly manifest with Adam and Eve in the garden and Daniel in the lions' den.

The linking of Adam and Eve and Daniel in early Christian art is not unique to the sarcophagus of Junius Bassus. Of approximately thirty-four Adam and Eve figures on early Christian sarcophagi (or fragments that reveal the order of scenes) illustrated in Wilpert's *I Sarcofagi Cristiani Antichi*, nine figures, that is, over one-fourth, appear to be related (by symmetrical or adjacent placement) to a Daniel figure.[111] Such paired or opposed scenes may imply a perceived correspondence between the two events of the Old Testament story; but it is, again, biblical and early church writings that make such a correspondence explicit.

According to the second creation story in Genesis, Adam and Eve disobeyed the commandment of God by succumbing to

temptation and eating a forbidden fruit, thus forfeiting their home in the paradisiacal garden (Genesis 3:1–24).[112] In contrast, Daniel obeyed the commandment of God by keeping the Hebrew law of prayer three times daily, even against the interdict of King Darius, thus being "found blameless" before God and saved by God from the lions (Daniel 6:1–28). Adam and Eve, whose mutual relationship and relationship to God were broken by disobedience, look away from each other and down, away from God. The original Daniel, a naked *orant* figure known from a seventeenth-century engraving (fig. 15) and an eighteenth-century drawing (fig. 14), must have looked up toward God in prayerful obedience.[113] Thus originally the stylistic balance of two naked figures flanking one animal (Adam and Eve flanking the tree with a coiled snake) opposite one naked figure between two animals (Daniel between two lions) reinforced the thematic pairing—an arrangement analogous to that of the two arrest scenes directly above these two scenes, where the stylistic balance of the three standing figures reinforces the typological pairing. "Adam and Eve—again [as on other sarcophagi] with the symbols of their punishment, corn sheaf and lamb—turn away in shame from the tree round which the snake coils. The corresponding picture of Daniel in the lion's den is meant to be understood as a promise of their ultimate salvation."[114] Concerning Adam, Paul writes: "[O]ne man's trespass led to condemnation for all men" (Romans 5:18). Daniel (along with Noah and Job) serves as a model of righteousness in contrast to transgression for the Hebrew prophet Ezekiel (14:12–20), and Daniel is cited as an *exemplum* in the moral exegesis of Tertullian and Cyprian.[115] Adam and Eve, through disobedience and punishment, are a negative prefiguration of the obedience and salvation of Daniel, the positive fulfillment.[116] Not surprisingly the prefiguration is presented to the left, the reversal and fulfillment to the right.

The biblical narrative gives as a sign of Adam and Eve's disobedience the eating of a food forbidden by God, and as a sign of Daniel's obedience the refusal to eat the rich food offered by King Nebuchadnezzar (Daniel 1:8–16). Whereas Adam and Eve were punished by God for eating from "the tree of the knowledge of good and evil," which was "to be desired to make one wise" (Genesis 3:6), Daniel was given by God "learning and skill in all letters and wisdom" and "understanding in all visions and

dreams" (Daniel 1:17) for refusing to eat the food of the foreign king. Again Daniel reverses—and thus sets straight—the pattern initiated by Adam and Eve.

Food continues to be an important symbolic element in the extended stories of disobedient Adam and Eve and obedient Daniel. Beside and slightly behind Adam and Eve are the symbols of their soon-to-be hard-earned meals outside the garden: the sheaf of wheat and the lamb. "In the sweat of your face," God tells the fallen Adam, "you shall eat bread" (Genesis 3:19).[117] In the Genesis account the expulsion from the garden is followed immediately by the sacrifice of Cain and Abel, the first parents' sons. "Cain brought to the Lord an offering of the fruit of the ground, and Abel brought of the firstlings of his flock" (Genesis 4:3–4). On early Christian sarcophagi their offerings are depicted just as the sheaf of wheat and the lamb seen here beside their parents (see fig. 9). The lamb sacrifice is found to be acceptable to the Lord (and to early Christian typologists!); the wheat is not. Cain kills his brother as disobedience continues and wheat (for bread) remains problematic.

In the apocryphal book of *Bel and the Dragon*, Daniel, while in the lions' den, receives a meal of stew and bread miraculously delivered by the prophet Habakkuk. When Habakkuk arrives, being carried by his hair by an angel, he calls out: "Daniel! Daniel! Take the dinner which God has sent you." And Daniel answers, "Thou hast remembered me, O God, and hast not forsaken those who love thee" (verses 37–38). When this episode is depicted on early Christian sarcophagi in the background of the Daniel in the lions' den scene, the food is usually shown as round, crossmarked loaves with clear eucharistic allusions (see fig. 3).[118]

Thus, it is intriguing to note that on the Bassus sarcophagus the Adam and Eve and Daniel scenes each share one of the lower columns decorated with putti gathering grapes—another clear eucharistic allusion. Perhaps the alimentary associations of Adam and Eve and Daniel may be extended to their physical and spiritual descendants,[119] who most certainly need and, in the eucharistic sacrifice of the church, may obediently receive the food of salvation in the fruit of the "true vine." Indeed, in discussing the spandrel scene of the multiplication of the loaves (just above Eve's head) as a symbol of the eucharist, de Waal suggests a link

backwards to the fall of humankind in Adam and Eve's disobedient eating: "food that brings death and food that brings life."[120]

A sacramental extension may also have been signaled to the fourth-century Christian viewer in the nakedness of Adam and Eve and Daniel. Adam and Eve and (the original) Daniel are the only nude figures on the sarcophagus facade. Jonathan Z. Smith has argued that nudity in early Christian art is to be seen as manifesting a "positive symbolic value" rather than as "either a decorative use of mythological conventions or an imitation of classical Greek painting."[121] There is, Smith notes, "a remarkable fixedness" to those figures who are represented as nudes: in the Old Testament—Adam and Eve, Jonah, Daniel, the resurrected in the vision of Ezekiel—all types of the resurrection; in the New Testament—apart from baptismal scenes, one representation of the raising of Lazarus and one of the miracle at Cana (in Syrian tradition, a type of baptism).[122] "On the basis of this iconographical evidence," Smith concludes, "nudity is clearly a symbol of new life as promised in the resurrection (cf. John 20:5–6 and Luke 24:12 in some MSS) and, when appearing in connection with baptism, must be interpreted as signifying sacramental rebirth."[123]

Early Christians were baptized in the nude, and the biblical proof-text by which this was explained was Genesis 2:25: Adam and Eve "were both naked, and were not ashamed." A "fully developed baptismal typology based on this verse"[124] is found in the *Mystagogical Catechesis* II of Cyril of Jerusalem (ca. 350):

> Immediately, then, upon entering, you removed your tunics. This was a figure of the "stripping off of the old man with his deeds" [Colossians 3:9]. . . . Marvelous! You were naked in the sight of all and were not ashamed! Truly you bore the image of the first-formed Adam, who was naked in the garden and "was not ashamed."[125]

The same "fully developed baptismal typology" is found in the baptismal homilies of Theodore of Mopsuestia (ca. 350–428):

> You draw, therefore, nigh unto the holy baptism, and before everything [all] you take off your garments. As when Adam was formerly naked and was in nothing ashamed of himself, but after having broken the commandment and become mortal, he found

himself in need of an outer covering, so also you, who are ready
to draw nigh unto the gift of the holy baptism so that through it
you may be born afresh and become symbolically immortal,
rightly remove your covering [clothing], which is a sign of mor-
tality and a reproving mark of that (Divine) decree by which you
were brought low to the necessity of a covering.[126]

According to Theodore, there are two types of nakedness: the na-
kedness of shame (represented by Adam and Eve after the Fall and
the postulant before baptism) and nakedness without shame
(Adam and Eve before the Fall and the newly baptized).[127] Adam
and Eve moved from no shame (that is, no sin) to shame (that is,
sin) and so from nudity to clothing, while the Christian neophyte
moved in the opposite direction in his or her baptism—from
clothing to nudity because from sin to no sin.[128]

The Adam and Eve figures on the Junius Bassus sarcophagus
must be understood to depict directly the nakedness of shame—
after the Fall. In the moment captured in their scene they repre-
sent the universal need for baptism, but retrospectively they rep-
resent as well the promise inherent in their creation and the pos-
sibility of a new creation initiated in baptism. As Weidlé
observes of the Adam and Eve scene in early Christian cata-
combs: "It may have a double reference, and at once signify Par-
adise Lost and Paradise Regained."[129] Daniélou points out that
"[i]t was a theme of elementary catechetical instruction that Bap-
tism is an entry into Paradise," the paradise of the church.[130]
Gregory of Nyssa (331?–394?), for example, uses the paradisiacal
typology of baptism: "You are outside Paradise, Catechumen, as
sharing in the exile of Adam our first parent. But now that the
gate has been opened once more, enter in again."[131] And, in a ser-
mon on the baptism of Christ delivered to the newly baptized,
Gregory continues: "Thou [Lord] didst banish us from Paradise,
and didst recall us; thou didst strip off the fig-tree leaves, an un-
seemly covering [,] and put upon us a costly garment; . . . nor
shall the flaming sword encircle Paradise around, and make the
entrance inaccessible to those that draw near; but all is turned to
joy for us that were the heirs of sin."[132] Thus Adam and Eve on
the sarcophagus of the newly baptized Junius Bassus point to
both baptism's necessity and its promise.[133]

The Daniel figure appears to have shared with Adam and Eve

not only a standard nude presentation but also a connection with baptism. Daniélou argues that "the deliverance of Susanna and Daniel are just as much types of Baptism as that of Noah. Early Christianity saw in Baptism a miracle of deliverance, and recognized its symbol in the principal types of deliverance in the liturgy of the synagogue."[134] The "sacramental meaning" of the Daniel image is "confirmed by Hippolytus' grouping together Daniel in the lions' den and the crossing of the Red Sea as figures of baptism."[135] In addition, Daniel shares some of the connotations of the second baptism of martyrdom. Because Daniel was thrown into the lions' den on account of his steadfast witness to his (Jewish) faith and because he was delivered from the lions by God, Daniel served the early Christian church as an image of martyrdom and resurrection.[136] Cyprian (200?–258) sees Daniel as a model of the martyr (the word means "witness") despite his rescue: "For there was not less dignity of martyrdom . . . [in the case of] Daniel, because he who had been cast to the lions for booty, not consumed, remained in his praises, lived protected by the Lord for glory. Among the confessors of Christ, martyrdoms deferred do not lessen the merit of confession, but show the greatness of the divine protection."[137] In the words of Hippolytus, Daniel was "a prophet and witness of Christ,"[138] the "Christ, who stretches forth His hand and raises the living from among the dead, and as it were from Hades itself, to the resurrection of life."[139]

Resurrection is understood as the fulfillment of the promise of baptism. As Paul writes in Romans: "Do you not know that all of us who have been baptized into Christ Jesus were baptized into his death? . . . For if we have been united with him in a death like his, we shall certainly be united with him in a resurrection like his" (Romans 6:3, 5). As noted above, martyrs were even more dramatically united with Christ in a death like his, and martyrdom was regarded as a "second baptism" by Tertullian and others. Baptism conferred forgiveness of prior sins, but sins committed after baptism endangered one's soul.[140] A martyr, of course, had no opportunity to fall into sin again and thus lose the benefits of his or her "second baptism." And this security was shared by a Christian baptized just before natural death—such as Junius Bassus, who, as the inscription of his sarcophagus proclaims, was

NEOFITVS at the time of his death and who thus assuredly IIT AD DEVM.

Daniel is not alone as a martyr or proto-martyr on the Junius Bassus sarcophagus. Death and resurrection typology underlies Isaac and Job, both of whom point to Christ. Peter and Paul were the archetypical martyrs in Rome, following the example of Christ. But Daniel's nudity, his *orant* posture,[141] and his position opposite Adam and Eve may mark him especially as an image of the security of the "second baptism" of martyrdom and perhaps even as an allusion to the similar security of one whose "first baptism" just preceded his death.

Not only are the Adam and Eve and Daniel scenes linked together compositionally and iconographically but they are somewhat distinct from the other intercolumnar scenes. They come from a different repertoire: not columnar passion sarcophagi (like the scenes of Christ, Peter, Paul, Isaac, and Job) but frieze sarcophagi with Old and New Testament scenes of salvation (along with the triumphal entry and the spandrel scenes). In addition to this closer tie with the spandrel scenes, the paired scenes of Adam and Eve and Daniel, with their strong baptismal associations, seem to have a more personal connection to the deceased, the newly baptized Junius Bassus. Yet Saxl overstates the case: "Only these two sections, with Adam and Eve, and Daniel in the lion's den, have an immediate bearing on the fate of the man buried in this splendid tomb; they are now incorporated into the cycle of martyrdom and the triumph of Christ and His Church."[142] For the triumph of Christ and his church also has an immediate bearing on the fate of Junius Bassus: it is the vehicle of his assured "going to God."

The arrangement of scenes of the lower register parallels that of the upper register. The outermost pair is comprised of an Old Testament scene, Job's distress, to the left and a corresponding New Testament scene, Paul's arrest, to the right. (The pair of scenes above Job and Paul is comprised of an Old Testament type to the left and an allusion to the New Testament antitype to the right.) The pair formed by the second and fourth scenes of the lower register is comprised of two scenes from the same testament, here the Old Testament. It is not surprising in a basically typological arrangement that an Old Testament pair is

placed *below* a New Testament pair, as it were, supporting it. Since no narrative requirement prevents it, the (negative) anticipation, Adam and Eve, is to the left, the (positive) fulfillment, Daniel, to the right. The central scene, the triumphal entry, serves as the prefiguration of the scene above it, Christ enthroned, thus joining the two registers at their centers. Like the upper register, the lower register presents three emphases: (1) patience or endurance in the *sacrifice* of well-being or of life itself, suggested in the outermost pairing of Job and Paul; (2) *obedience* in reference to the promise of salvation, imaged negatively in Adam and Eve and positively in Daniel; (3) the *victorious Christ* portrayed in the triumphal entry at the center. An earlier, limited sacrifice prefigures a later and total one. A later faithful response and rescue overturn an earlier event of disobedience and disruption. An earthly triumph prefigures an eternal one.[143]

INTEGRATED INTERCOLUMNAR SCENES

1	2	3	4	5
Abraham/ Isaac	Peter's Arrest	Christ Enthroned	Christ's Arrest	Pilate's Judgment

6	7	8	9	10
Job's Distress	Adam/Eve	Triumphal Entry	Daniel	Paul's Arrest

The two registers of the Junius Bassus sarcophagus are joined most obviously but not exclusively at their centers. As Christ is in the center of typological thinking, so he is depicted at the center of each register. As the typological view of history assumes not mere sequence or simple repetition but promise and fulfillment, so the eternal triumph of Christ is depicted above his earthly triumph in Jerusalem. Symmetrically paired scenes illustrate these same convictions. In three of four cases the left scene of the pair prefigures, in some sense, the right scene; in the fourth pair the left scene post-figures the right one, which is christological. Perhaps only one pair of scenes could be classified as typological in the strict sense of the term: the sacrifice of Isaac by Abraham as the type of the sacrifice of Christ alluded to in Pilate's judgment. Isaac appears to be, however, the type of Christ

most frequently and most elaborately explicated by early church writers, and the paired type and antitype are given prominent positions on this sarcophagus.[144] Thus they give a clear signal to the viewer to keep a typological understanding of history in mind when considering the remaining scenes.

Below the clear type and antitype are Job and Paul. The parallels between these outside pairs are obvious: the almost sacrificed lives of Isaac and Job prefigure the actually sacrificed lives of Christ and Paul. The inside symmetrical pairs of the two registers have analogous relations but unique features as well. Rather than the one Old Testament scene and the one New Testament scene of the outside pairs, the lower inside pair has two Old Testament scenes and the upper one has none. Daniel (on the right) fulfills the promise of Adam and Eve by contrast more than completion, and Christ's arrest—and thus crucifixion—(on the right) is recapitulated not revealed in Peter's arrest—and thus martyrdom. But the sense of the rhythm of holy history as one of promise and fulfillment before its central event, and event and echo afterwards, is clear throughout. It is in this larger sense that the intercolumnar scenes of the facade may be said to be typological in their arrangement.

If the connections between paired scenes were thematic only and not in some sense typological, scenes could presumably be reversed within their pairs with no great loss in meaning. But to put Paul in Job's place here would damage a network of significant relations. Typology stresses both similarities and differences between corresponding events. The similarities establish the pair, but the differences determine which one of the pair is first (left or lower) and which second (right or upper). The differences are more than a matter of chronology, although that is of assured importance. The Job story comes after the story of Abraham and Isaac, but the former cannot be the second member of a pair with the latter. That is, on the Bassus sarcophagus we cannot have Abraham/Isaac on the left and Job on the right because Job repeats but does not extend the Abraham/Isaac sacrifice. Typology is not simply chronological; it is profoundly theological. As Daniélou asserts: "Typology reveals analogies which are a unifying thread of all, bestowing as it were the signature of God on his work, and guaranteeing the authenticity of Scripture."[145] A typological view is not just orderly, but hopeful *and* confident.

Although such an iconographical program may be as much finer in its elaboration as the carving style of the Bassus sarcophagus is finer than that of most fourth-century sarcophagi, it is clearly within the bounds of fourth-century possibilities. This iconographical program depends in large part on the greater systematization of scenes made possible by the work's double-register columnar form. Kitzinger finds even the double-register *frieze* arrangement "without precedent in the vast output of funerary reliefs in pagan Rome." "This device," he observes, "which made it possible to pack the front of the tomb with even more content, seems to have been invented specifically for Christian purposes."[146] The double-register *columnar* form, which is distinctive but not quite unique—there being one other such sarcophagus extant (fig. 2)[147]—permits greater systematization of that packed content. It would appear that with the Junius Bassus sarcophagus a step in iconographical development was taken together with the more stylistic step of, as it were, subdividing both registers of a frieze sarcophagus by columns, or arranging one columnar sarcophagus on top of another.

More likely "models" for the Junius Bassus facade are found among columnar (or tree) passion sarcophagi. For example—and somewhat hypothetically, with no reference to the essential questions of style and workshop—a single-register tree sarcophagus from St. Paul's Outside the Walls in Rome (fig. 9)[148] has a central christological scene with reference to the death and resurrection (the Labarum) flanked inside by two apostolic post-figurations (Peter and Paul) and outside by two Old Testament prefigurations (the sacrifices of Cain and Abel and Job's distress).[149] An unfinished single-register columnar sarcophagus from the Cemetery of San Sebastiano in Rome (fig. 7) has four scenes identical in placement to scenes on the Bassus upper register: Peter's arrest, Christ (standing rather than enthroned), Christ's arrest, and Pilate's judgment.[150]

The Junius Bassus facade is related iconographically to both of these passion sarcophagi, but it is fuller and richer than either, and in accommodation of this fullness some changes in traditional patterns are manifest. Perhaps Gerke is partially right in thinking that the Paul scene was "moved" from the upper register (cf. figs. 6 & 7),[151] but he is wrong in labeling such a "move" a mistake and especially in ignoring the present reality of the

work.[152] In fact, it is because Paul does not appear to the left of Peter, where he might, that space is available, so to speak, for the Isaac scene in that position, which thus sets up a pattern of "typological" pairs. Since it is clear that Paul must also be related to Christ, as Peter is above, Paul's presence on the lower register also ties it to the upper, just as the appearance of Abraham/Isaac on the upper register also ties it to the Old Testament scenes on the lower. Connections overlap—as the remaining chapters will make even clearer.

It is as if the designer of the Junius Bassus facade wanted, in a double-register sarcophagus, to portray both Old Testament prefigurations and apostolic post-figurations of the death and resurrection of Christ—as the tree sarcophagus shown in fig. 9 does in an abbreviated way on one register—*and* to integrate the two registers more completely than just providing christological scenes at the double center, *and* to include scenes from the repertoire of frieze sarcophagi. Perhaps the taste and situation of the patron (whether the deceased before his death or his family after) suggested a passion sarcophagus, but his purse and prestige suggested a double-register one. In this hypothetical scenario the designer of the facade was able to meet both desires with integrity, making references as well to the deceased's status as NEOFITVS. Perhaps we may be absolved from this temporary commission of the intentional fallacy in light of the previous sins of omission by art historians who have not attended carefully to the work itself. For it is really from the work itself that we conclude that, in selection and arrangement, the intercolumnar scenes of the Junius Bassus sarcophagus are not asymmetrical and not "mistaken" and not "haphazard."

4 Spandrels

PERHAPS because the intercolumnar scenes are so im-
posing in their presentation and intriguing in their in-
terrelations, whereas the spandrel scenes are small,
badly damaged, and quite curious in their depiction of
persons as lambs, the spandrel scenes of the Junius Bassus sar-
cophagus have not received a great deal of attention from art his-
torians. They are discussed, however, in the two monographs on
the sarcophagus. Both Anton de Waal and Friedrich Gerke view
the spandrel scenes as arranged in symmetrical pairs on the basis
of iconographic content: a and f, b and e, c and d—that is, ((())).
One might even say that de Waal gives the spandrel scenes too
much attention, or, rather, too much importance, for he sees
them as the iconographical key to the entire composition.[1] But
de Waal is on the right track; the questions he raises are the ones
that need answers: how are the spandrel scenes related to each
other? and how are the spandrel scenes related to the work as a
whole, especially to the intercolumnar scenes of the facade?

a	b	c	d	e	f
Fiery Furnace	Striking Rock	Christ: Loaves	Christ: Baptism	Receiving Law	Raising Lazarus

From left to right the spandrel scenes may be identified as: (a)
three youths in the fiery furnace, (b) striking the rock, (c) Christ
multiplying the loaves, (d) baptism of Christ, (e) receiving the
Law, (f) Christ raising Lazarus. Only Lazarus, represented in the
usual way as a mummy, is not depicted as a lamb (see figs. 17–
28).[2] Because of the considerable damage, there has been some
confusion about the identity of the first scene. It is drawn by de
Waal as the three youths in the fiery furnace, but Grousset, fol-
lowing the engravings of Bottari, identifies the first spandrel
scene as the passage through the Red Sea.[3] What Bottari and
Grousset see as waves, de Waal sees as flames, as do most other
commentators. Although the carved scene is damaged and worn,

the identification is secured by the traditional triple arch of the fiery furnace that is still visible.

A problem with identifying the main character in the second and fifth spandrel scenes results from the stylistic fact that lambs do not give the usual clues to personal identity (bearded or not, clothing style, headgear) and from the iconographic fact, to be discussed below, that Moses is regarded as the precursor of Peter and Peter as the second Moses. Stories both of Moses and of Peter striking the rock are known; both Moses and Peter are known as receivers of the Law.

The Bassus sarcophagus spandrel scenes are distinctive on several counts. Any spandrel scenes whatever are at least notable, for only columnar sarcophagi with arches, gables, or an alternation of the two have the appropriate spaces for spandrel scenes. Since the extant early Christian columnar sarcophagi are single-register with but two exceptions, spandrel scenes rarely appear between two registers as well as between two scenes. Spandrels are usually filled with relatively simple symbolic objects in repeating or alternating patterns; most frequent are birds, baskets of fruit, and wreaths. The only other known double-register columnar sarcophagus, from the Old Church of St. Trophime in Arles (fig. 2), has a bird in the first and last of its spandrels and a wreath in each of the others (there are seven niches and thus eight spandrels). Thus the distinctiveness—and in some cases uniqueness—of the Bassus sarcophagus spandrel scenes is clear: (1) the spandrel scenes are surrounded by intercolumnar scenes— above and below, right and left (except, of course, at the ends of the facade); and (2) although the lambs have a decorative effect, they portray specific characters engaged in actions to depict biblical events.[4]

THE SIGNIFICANCE OF LAMBS

The portrayal of persons as lambs per se is distinctive, wherever it occurs, especially if the lambs are engaged in activity. The substitution of lambs for persons is based, as Panofsky notes, on biblical references to Christ as the Lamb and to the faithful, especially the twelve disciples, as lambs.[5] It would seem that Christ performing the miracle of Cana (turning water into wine) was depicted as a lamb with a nimbus amid six or seven

vessels on the mosaic on the wall west of the tower of Santa Cos-
tanza, contemporary with the Bassus sarcophagus but now
known only by an anonymous drawing and a description and
sketch by Ugonio.[6] Later sarcophagi, especially in Ravenna, por-
tray Christ and the apostles as lambs, but they are shown stand-
ing or perhaps processing in some timeless and placeless situa-
tion that evokes Christ's eternal majesty. On the apse mosaic of
Sant' Apollinare in Classe in Ravenna three lambs represent the
three disciples who witness Christ's transfiguration (represented
by the cross), but it is their number and position in relation to
the central cross rather than any gestures or props that identify
them and thus the scene. On the Bassus sarcophagus (as, presum-
ably, on the Santa Costanza mosaic) the lamb scenes are identi-
fiable because the lambs repeat the gestures and are accompanied
by the objects made familiar in numerous parallel scenes on
frieze sarcophagi.

Grabar finds the lamb scenes of the Bassus spandrels parallel
to later uses of lambs on apses, in allegorical "replication" of
more realistic images of Christ and the apostles on those very
apses. "This duplication was probably intended to remind the
spectator of the Christian significance of the motifs represented;
to provide against the possibility of his taking these allegorical
images merely at their face value." According to Grabar, "This
practice, seen to be superfluous, was soon abandoned."[7] But the
lamb scenes are not superfluous here because they depict biblical
events not otherwise portrayed on the sarcophagus. Rather, it is
as if the carver or designer had so much to say that every avail-
able space was given significant iconographic content. On a fa-
cade already quite full with ten scenes of biblical characters, the
spandrels present six more—an example, it would seem, of what
Ernst Kitzinger calls "the innate Christian urge to pack the im-
age with content."[8]

Perhaps lambs rather than people are employed in the spandrel
scenes for technical or decorative reasons: in the relatively small
spandrels where one was accustomed to seeing a bird or a wreath,
complicated groupings of people would be difficult to carve and
distracting to view. But even so the lambs as lambs would bring
special connotations to the scenes. According to Snyder, the
lamb, which after the Peace of the church appears primarily as a
symbol of the crucified Christ (the "lamb of God"), before the

time of Constantine was a symbolic reference to "a kinship community both present and past (sepulchral art), where such community did not exist in a blood sense." Since bucolic scenes (often including lambs) "reflect the presence of a philanthropic
community, then the lambs, probably rather imprecisely, reflect
the presence of the religious actor in that community."[9] More
simply, Marucchi refers to the sheep as "the emblem of the believer" among early Christian "ideographic symbols."[10] Both the
"lamb of God" imagery (see, e.g., John 1:29 and Revelation 5:6,
12, and passim) and the lamb of the cared-for-flock imagery (see,
e.g., Psalm 23, Luke 15:3–7, and John 21:15–17) have strong biblical foundations.[11] According to Weidlé, in a fresco in the catacomb of Cagliari "a lamb coming up from the water stood for the
baptized, and therefore saved, soul." The scene was apparently
part of a Jonah scene, which would have had both salvific and
sacramental import.[12] Schiller refers to the twelve lambs that
many early Christian images depict walking towards the mountain of paradise as "in a wide sense not only the apostles but also
the baptized," and she calls the lamb that the baptized Christ is
touching on the sarcophagus of Santa Maria Antiqua (fig. 11) "an
allusion to the community of the baptized, which means in this
case those who have been saved by the Shepherd and by baptism."[13] Baptism is the ritual of incorporation into the Christian
community.

Since on the sarcophagus of Junius Bassus lambs portray not
only Christ (and not only Christ and the apostles as was the rule
later) but all the characters in the biblical events depicted, it
would appear to be this communal sense that is presupposed.
Those saved from the fiery furnace, given drink and bread under
miraculous circumstances, baptized, provided with the Law, and
raised from the dead are gathered into one flock, one well-cared-
for flock. The Bassus sarcophagus is, of course, from the post-
Constantinian era, and, as we observed in chapter 3 above, its
two central christological scenes presuppose the Peace of the
church by their adoption and adaptation of imperial motifs. Yet,
as we have also observed, the sarcophagus relies as well on earlier
pictorial and iconographic traditions developed in the catacombs
and on earlier sarcophagi. Thus it is not so surprising to find here
the earlier connotation of lambs as community members.

The spandrel scenes are important linking scenes on the Junius

Bassus sarcophagus. Like the ten intercolumnar scenes of the fa-
cade, they depict significant events in the lives of biblical char-
acters. Like the scenes of putti on the ends, the lambs of the
spandrels have a significant symbolic and decorative aspect. As
we investigate their iconographical significance more closely, ad-
ditional links will become obvious.

THREE YOUTHS IN THE FIERY FURNACE AND
RAISING OF LAZARUS

Both de Waal and Gerke correctly note that the span-
drel scenes are presented in symmetrical pairs on the basis of
iconographical content—an outer pair (1 and 6), a second pair (2
and 5), and a central pair (3 and 4). According to de Waal, the two
corner pictures—the three youths in the fiery furnace from the
Old Testament and the raising of Lazarus from the New Testa-
ment—belong together and give believers presentations of a def-
inite eschatological character. Two christological scenes—the
multiplication of the loaves and the baptism of Christ—stand in
the center and participate in the main idea of the divine judge.
The four middle pictures—the two of Christ plus two of Moses
(striking the rock, receiving the Law)—together represent
grounds for the hope for which the events in the corner pictures
are the spoken promise. De Waal reads these four central scenes
as follows: in the baptism of Christ, the Christian receives all the
graces, as shown forth in the water from the rock of Christ; above
all, the Christian receives grace in the eucharist, which—to-
gether with the reading of the divine Law—is the foundation of
his blissful resurrection. Thus the unifying thought, clearly
stated in the spandrels, is that "the dead man, because he is a
Christian, has in Christ and in Christ's mercy and gospel, the
foundations for his hope of eternal bliss."[14]

As Gerke phrases it, in the spandrel scenes of the Bassus sar-
cophagus we hear the "dignified chords of human hope."[15] The
first spandrel scene, the three youths in the fiery furnace (an old
symbol of salvation), "matches" the sixth spandrel scene, the
raising of Lazarus. The second and fifth spandrel scenes are like-
wise matched; they are, according to Gerke's interpretation, Pe-
ter's miracle of the spring (second) and the reception of the Law
by Moses (fifth). The third and fourth spandrel scenes—the mul-

tiplication of the loaves and the baptism of Christ by John—form the final matched pair. While Gerke finds the portrayal of the persons in these scenes as lambs highly decorative, he realizes that the spandrel scenes serve more than a decorative function, for "through the lamb allegories sounds the *cantus firmus*—death and resurrection—of the hymn of Christ's miracles."[16] The lamb allegories plus the triumphal entry lead to the main theme, expressed in the upper register: the death of Christ. De Waal's emphasis on eternal bliss—or eternal life—seems more appropriate to the work's fourth-century context than Gerke's focus on Christian death, although neither scholar presents a thoroughly convincing interpretation of the iconography of the spandrel scenes.

The outer pair of spandrel scenes clearly involves relationships of a kind dominant with the paired intercolumnar scenes. Both the first scene on the left, the three youths in the fiery furnace (Daniel 3; figs. 17 & 18), and the last scene on the right, the raising of Lazarus (John 11:1–44; figs. 23 & 24), are scenes of salvation and thus types of Christ's resurrection. Schiller observes that a scene of the raising of Lazarus is "a prefiguration of the Resurrection of Christ and the resurrection of the dead at the Last Judgment" and that scenes such as the three youths in the fiery furnace are "visual allusions to Christ's Death and Resurrection."[17] De Waal recognizes the scene of the three youths in the fiery furnace (a symbol of escape from danger and loss of life) as not only a comforting example for martyrs but also for every believer a witness of hope for eternal life.[18] According to E. Baldwin Smith, "The Raising of Lazarus, from its immediate relation with the Christian hope of spiritual salvation in the life hereafter, was from the earliest days of Christian art the most popular and frequently represented of Christ's miracles. . . . Typifying the resurrection of the body, it stood in the Christian mind as the guarantee of immortality."[19]

But, in addition to being types of Christ's resurrection, the first scene may be understood as a foreshadowing (analogous to a type) of the last scene: salvation from the flames that threaten life prefigures salvation from the tomb that marks the end of life. And, like the paired intercolumnar scenes directly above and below these paired spandrel scenes (Abraham's sacrifice of Isaac/Pilate's judgment of Christ; Job's distress/Paul's arrest), the scenes of the

three youths and Lazarus mark the movement—from left to right—from a threatened death to an actual death. The Old Testament prefiguration is to the left, the New Testament fulfillment to the right.

The pattern of Old Testament event and New Testament event, anticipation and actualization, near death and actual death recurs in all three pairs of first and final scenes: upper register, spandrels, lower register. Although only the upper-register pair may be labeled type and antitype in the strict sense (since only there is the fulfillment christological), the three pairs work together to provide a strong framework based on a view of history that is not just sequential but progressive, that looks for later events to complete earlier ones.

STRIKING THE ROCK AND
RECEIVING THE LAW

In terms of typology and typological analogies the relationship of the second (figs. 19 & 20) and the fifth (figs. 25 & 26) spandrel scenes is especially interesting because parallel stories of Moses, the precursor of Peter, and Peter, the second Moses,[20] seem to have confused the identity of the two scenes. Do these scenes depict the New Testament Peter working the miracle of the spring to the left and the Old Testament Moses receiving the tablets of the Law to the right? According to an apparent apocryphal legend, Peter works the miracle of the spring at his capture or in prison and baptizes the guard (or guards) with water from the spring.[21] It may be, however, that the visual image of Peter striking the rock antedates the legend in verbal form. Charles Pietri regards the scene as an "image created by the ateliers of sculptors [in Rome] at the beginning of the Christian empire in order to celebrate Peter, the new Moses, who makes water to spring forth from the rock, quenching the thirst of the soldiers of Christ."[22] As evidence in favor of reading the second and fifth spandrel scenes as suggesting Peter and Moses, we may note that (1) scenes of *Peter* striking the rock, while very rare in the catacombs, are very popular on early Christian sarcophagi; and (2) scenes of Moses receiving the Law represent the receiver, Moses, as the central figure, which seems to be the case in the fifth spandrel. Yet if the second and fifth spandrel scenes portray Peter to

the left and Moses to the right, this is the only pairing on the Bassus sarcophagus with a scene of a New Testament character to the left and an Old Testament scene to the right.

Or is it Moses, transmitter of the Old Law, striking the rock at Massah (Exodus 17:1–7), to the left, and Peter, the "rock" (Matthew 16:18), receiving the New Law, to the right? Massah, according to the text of Exodus, means "proof" and was so named "because of the faultfinding of the children of Israel, and because they put the Lord to the proof by saying, 'Is the Lord among us or not?' " (Exodus 17:7). In fact, the entire thrust of the reporting of the miraculous spring is on Israel's denial of the Lord by the failure of trust. Moses himself did not deny the Lord, but "cried to the Lord, 'What shall I do with this people?' " (Exodus 17:4). Peter, the second Moses, was the disciple most well known for denying the Lord (Mark 14:66–72, Matthew 26:69–75, Luke 22:54–62, John 18:25–27). But both the people led by Moses and Peter himself became again obedient to their respective covenants, the Old suggested on the left, the New on the right. The appearance of the Old Testament figure to the left and the New Testament figure to the right is evidence in favor of this identification. Nevertheless, as evidence against identifying the scenes as Moses (left) and Peter (right), we may note that (1) scenes of *Moses* striking the rock, while very popular in the catacombs,[23] are rare on early Christian sarcophagi; and (2) scenes of Peter receiving the New Law represent the Law-giver, Christ, as the central figure, which does not seem to be the case in the fifth spandrel.

Perhaps both the second and the fifth spandrel scenes are depictions of Peter. As such they might repeat the pattern of the upper register, Peter obedient unto death (Apostle) and Christ obedient unto death (NT): the obedience of both Peter and his captor manifest in the captor's baptism by Peter (Ap) and obedience to the New Law transmitted by Peter (Ap). Or perhaps both scenes are of Moses. As such they might repeat the pattern of the lower register, disobedient Adam and Eve (OT) versus obedient Daniel (OT): the disobedience of the Hebrews at Massah (OT) versus obedience to the Law given through Moses (OT). If so, two representations of Moses would enclose two representations of Christ (third and fourth spandrel scenes), an arrangement that has not only typological justification but also a form of precedence in the fact that two paired Old Testament scenes on the

lower register (Adam and Eve/Daniel) support two paired scenes of New Testament characters on the upper register (Peter/Christ).

Based on the similarity of the positions and gestures of the lambs in the fifth spandrel scene to the usual depiction of Moses receiving the Law (see, e.g., fig. 3), it seems likely that Moses is depicted receiving the Law here.[24] But, even though *Moses* striking the rock is rare on sarcophagi, it may be that he is depicted striking the rock in the second spandrel scene on the Bassus sarcophagus.[25] If so, the "faultfinding" of the Hebrews at Massah is associated with the disobedience of Adam and Eve, and obedience to the Mosaic Law is associated with the obedience of Daniel. This identification of the second pair of spandrel scenes (Moses/Moses) would fit well with the overall schema in which all three outside pairs (upper register, spandrels, lower register) present an Old Testament scene to the left and a New Testament scene to the right; all three second pairs present characters from the same Testament (Old or New); and the two central pairs present christological scenes.

	outside pairs (OT/NT)	second pairs (same T)	central pairs (Christ)
upper register:	Isaac/Pilate	Peter/Christ (NT)	Enthroned
spandrels:	3 Youths/Lazarus	Moses/Moses (OT)	Loaves/Baptism
lower register:	Job/Paul	Adam & Eve/Daniel (OT)	Entry

Nevertheless, because the second and fifth spandrels each "touch" four scenes of the facade, the arguments based on their placement are manifold. Because all the characters of the spandrel scenes (except Lazarus) are depicted as lambs, figural details cannot help distinguish Moses and Peter. And because stories of precursor and fulfiller interpenetrate in the traditions of the church, it may simply be impossible to determine without a doubt whether Peter, the second Moses, or Moses, the prefigured Peter, is depicted. Perhaps this iconographic ambiguity may be understood as typological richness.[26] In relation to either figure, Moses or Peter, the covenant is crucial. The covenant—initiated by election and confirmed by Law—sealed and defined the relationship between God and the people of God. In the words of Daniélou, "the continuity of the covenant" is "the Divine steadfastness which is seen as the essential basis of typology."[27] Thus it may be that Moses and Peter are to be viewed chiefly as the

leaders of the covenanted community—old and new, almost as types of the church.[28]

The scene of the striking of the rock enjoys an additional typological richness as a sacramental type. If the scene depicts Peter working the miracle of the spring, baptism is alluded to directly, not as a type. But if the scene suggests Moses in the desert, then it probably reflects the more common interpretation among early church writers, based primarily on John 19:34, that the gushing waters are a type of baptism.[29] In the fourth century, Gregory of Elvira sets this out plainly:

> When the Israelites were thirsty in the desert, Moses struck the rock with his wooden staff and water gushed forth; and this foretold the sacrament of Baptism. The Apostle [Paul] teaches that the rock is a type of Christ, when he says: They drank of the rock which followed them and that rock was Christ [1 Corinthians 10:4]. This water which gushed forth from the rock was a type of the water which was to issue from the side of Christ [John 19:34] in the sacrament of Baptism to be a saving refreshment to those who were thirsty.[30]

But God's provision of a saving drink is also interpreted as a type of the eucharist, following 1 Corinthians 10:1–4 more closely. As Ambrose writes in *De Sacramentis* (ca. 390):

> First of all, the figure which preceded in the time of Moses, what does it mean? For, when the people of the Jews were thirsty and murmured, because he could not find water, God ordered Moses to touch the rock with a twig. He touched the rock, and the rock poured forth a great deal of water, just as the Apostle says: "And they drank of the rock that followed, and the rock was Christ" [1 Corinthians 10:4]. It was not an immovable rock that followed the people. And do you drink, that Christ may follow you. See the mystery: "Moses," that is, the Prophet, "with a twig," that is, with the word of God—The priest with the word of God touches the rock, and water flows, and the people of God drink. Then the priest touches the chalice, water abounds in the chalice, the people of God spring up into eternal life and drink, who acquired the grace of God.[31]

Sacramental typology, which can be of first importance in relation to the striking of the rock scene, may be somewhat in the

background with the second spandrel scene on the Bassus sar-
cophagus, but sacramental typology moves unambiguously into
the foreground with the third and fourth spandrel scenes, the
central pair.

MULTIPLICATION OF THE LOAVES AND
BAPTISM OF CHRIST

The third and fourth, or central, spandrel scenes pre-
sent quite clearly the types of the two sacraments of the early
Christian church: the type of the sacrament of the eucharist in
Jesus's multiplication of the loaves to the left (figs. 21 & 22) and
a type of the sacrament of baptism in Jesus's baptism by John to
the right (figs. 27 & 28).[32] Christ's baptism (the type) prefigures
Christian baptism (the antitype), and Christ's miraculous feeding
(the type) prefigures the eucharistic meal (the antitype). At an-
other level the elements of the eucharist, the bread and wine of
communion, are themselves antitypes or figures of the body and
blood of the Lord; this is expressed in the language of Hippolytus,
Tertullian, and Ambrose.[33] Thus the sacrifice of Christ (the type)
is brought to completion, that is, made available for the salvation
of humankind, in the celebration of the eucharist (the antitype).

One could also say that the Christian's participation in the sac-
raments, both baptism and the eucharist, are a foretaste, a prefig-
uring of his or her own resurrection to eternal life. De Waal refers
to the multiplication of the loaves as a symbol of the eucharist,
the "foundation of our eventual resurrection," and he notes that
"early believers saw in the baptism of the Lord a prefiguration of
their own baptism, through which they became children of the
church and thereby participants in all the promises and hopes
that in death are the comfort of the dying as well as those who
live on."[34]

When these observations are combined with the fact that Old
and New Testament stories concerned with water or bread or
wine are frequently understood to be types of the sacraments, an
interlocking pattern of types and antitypes is established: the
multiplication of the loaves is a type of the eucharist, which is
both the antitype of Christ's body and blood—dead and resur-
rected—and the type of the Christian's own experience of death

and resurrection. A chain of events in the history of salvation is forged.

Even within the New Testament the multiplication of the loaves is understood to prefigure the Last Supper of Jesus and his disciples, the model for eucharistic observance. At the miraculous feedings of the 5,000 (Mark 6:41, Matthew 14:19, Luke 9:16; cf. John 6:11, 23) and the 4,000 (Mark 8:6, Matthew 15:36), Jesus is said to take bread, bless it, break it, and give it. These same verb phrases recur at the narration of the Last Supper (Mark 14:22, Matthew 26:26, Luke 22:19) and were probably employed by the early church in its eucharistic celebration.[35] In early Christian art the gospel story of the multiplication of the loaves and fishes was "from the very first . . . considered the principal symbol of the Eucharist."[36] By the end of the third century the symbolism had been "abbreviated and the multiplication of the loaves alone had come to stand for the Eucharist,"[37] and as such it became one of the most popular presentations of early Christian art.[38] The scene was simplified to Christ touching with his wand the baskets of bread, generally seven in the catacomb paintings but on sarcophagi "usually reduced to six, three, or even one."[39] Three baskets appear in the third spandrel scene of the Junius Bassus sarcophagus, and a lamb awkwardly holds a wand with a forefoot.

In contrast to the numerous scenes of the multiplication of the loaves in the catacombs and on sarcophagi, the scene of Jesus's baptism by John was "uncommon during the first few centuries of Christianity."[40] Rather, baptism was frequently "represented in its symbolic significance" by scenes from the Old Testament[41]: scenes of deliverance, not only but especially deliverance through water—particularly Moses striking the rock or the miracle of the spring at Massah, the passage through the Red Sea, and Noah and the flood.[42] It may be that a more familiar Old Testament type of the sacrament of baptism was rejected for the fourth spandrel scene of the Bassus sarcophagus in order that only christological scenes appear at the center of the work. The third-century sarcophagus of Santa Maria Antiqua (fig. 11) depicts the baptism of Jesus by John in the way that became standard in the West: John, full-sized, places his hand on Jesus, who—nude and standing less than knee-deep in water—is child-size; a

dove descends over Jesus.[43] According to Saxl, this "sarcophagus represents Baptism as the rite of initiation, granting resurrection and salvation to the faithful."[44] Le Blant explains the small stature of the Christ figure in such scenes on the basis of the Christian concept of baptism as a birth into spiritual life, whence the name "infans" given to the baptized.[45] Similarly, Snyder wonders whether the nudity and smallness of the figure of Jesus and the laying on of hands result from utilizing the New Testament baptism of Jesus "to convey the baptism of the local church member."[46] On the fourth spandrel of the Bassus sarcophagus a lamb puts one forefoot on a smaller lamb; the stream of water (to the left) and the head of the dove above the smaller lamb are still visible.

As Daniélou observes, "[T]he biblical types of the Sacraments were an integral part of early Christian mentality" and part of "the rudimentary teaching of the Church."[47] And Grabar regards iconographic signs representing the two major sacraments of the church, baptism and communion, as one of two kinds of earliest Christian images.[48] Thus at the center of the spandrel scenes of the Junius Bassus sarcophagus we are at the center of early church teaching and artistic representation: the multiplication of the loaves and Jesus's baptism are types of the sacraments, participation in which prefigures the Christian's appropriation of Christ's death and resurrection. All this has more than an abstract theoretical value in relation to the Bassus sarcophagus, of course. For, as the inscription states so prominently, at the time of his death Junius Bassus was NEOFITVS (newly initiated into the Christian faith) and thus confident of going to God (IIT AD DEVM).

De Waal credits Grisar with first explaining the importance of the initiatory rite of baptism for the interpretation of the Bassus sarcophagus spandrel scenes. Grisar perceived that the spandrels represent in figures what the inscription says—that Junius Bassus had been led, before his death, to the church and to the enjoyment of her salvation. Since baptism and the eucharist portray the double act of initiation, the scenes representing them—the baptism of Christ and the multiplication of the loaves—stand in the center. The account of the three youths in the fiery furnace, heard as part of the readings for Easter Saturday and seen in the first spandrel, gave the neophyte courage to demonstrate in

works the faith he was now receiving. The miracle of the spring and the giving of the Law show to those of the church the double strength of salvation in the means of grace. The raising of Lazarus, Grisar concluded, ends the "homily" on the entry into the church through the proof to believers of a true, blissful resurrection.[49] But de Waal is not convinced by the details of Grisar's argument linking particular events in that rite with individual spandrel scenes. In particular de Waal finds the order of the two central scenes odd, since the loaves are to the left and the baptism to the right, whereas baptism precedes the eucharist for the catechumen undergoing initiation.[50] De Waal abandons Grisar's sequential interpretation of the spandrels (1–6) for a reading of them in symmetrical pairs (1 and 6, 2 and 5, 3 and 4). Yet on a sarcophagus that takes considerable care in the left and right placement of scenes in symmetrical pairs, one might well ask about possible significance here.

We must first consider the relationship of baptism and eucharist in early Christian faith and practice. In an intriguing little monograph entitled *The Baptism of Art*, Weidlé paints the picture clearly by first contrasting the experience of contemporary Christians and early Christians:

> *Fiunt, non nascuntur Christiani*; it is not possible to understand early Christianity without paying heed to these words of Tertullian: "Christians are made and not born." But how are they made? Through baptism, treated as initiation. There is no other way. So it was in those first ages; so it is still, in theory at any rate. In practice, however—and that for a long time now—it has come to look very different.
>
> . . . The believer, now, lives by the eucharist, and gives little thought to his baptism. If not on the plane of existence, on that of awareness, we were none of us made, but born, Christians. The early Church for the most part was made up of those who were newly converted, and therefore could not but feel otherwise. Baptism for them was the most important event in the life of a Christian, and to his mind would appear as a single and singular initiatory mystery, experienced once for all and unrepeatable, beyond comparison with anything in the world. But included within this one mystery, on the same footing with the baptismal

act, there were two other moments, each more intense than the
last; the chrismation, and holy communion.

 This uniqueness and unity of the one mystery are most impor-
tant.[51]

Weidlé marshals an impressive list of witnesses to the unity of
baptism and eucharist as a Christian initiatory rite: among pa-
gans, Lucian and Pliny; among Christians, Hipploytus (*Apostolic
Tradition*), the *Didache*, Justin (*Apology*), the legendary *Acts of
Xantippa, Polyxena, and Rebecca*, Tertullian, Didymus of Alex-
andria, Cyprian, and the Epistle of Dionysius of Alexandria to
Pope Xystus II.[52] From the *Apology* of Justin (ca. 100–ca. 165)
especially, Weidlé concludes "that the Christian mind of his day
was aware, not as we are, of two sacraments, baptism and then
the eucharist (with, no doubt, others as well), but of one. The
foundation was laid in the baptismal eucharist; thereupon fol-
lowed, Sunday by Sunday, its reproduction in part, bound up
with the memory of it."[53]

With regard to the Junius Bassus sarcophagus then, it may be
that the central spandrel scenes should be taken *together* as types
of the rite of Christian initiation—baptism and eucharist. The
eucharist, just as baptism, is a reminder of Christ's death and res-
urrection and a foretaste of eternal life. Paul writes to the Corin-
thians: "For as often as you eat this bread and drink the cup, you
proclaim the Lord's death until he comes" (1 Corinthians
11:26).[54] Or it may be that the baptismal scene is to the right,
and thus second in the pair, not because of chronology (which
does not fit) but because of value: baptism incorporates but sur-
passes the eucharist—not too unlike the sacrifice of Christ incor-
porates but surpasses the sacrifice of Isaac, and the martyrdom of
Paul incorporates but surpasses the distress of Job, and the raising
of Lazarus incorporates but surpasses the rescue of the three
youths from the fiery furnace.

 Weidlé's discussion also makes plain why images of initiation
through baptism and eucharist might appear at the center of an
early Christian work of art—as reflections of the centrality and
ultimacy of the full baptismal rite.[55] Augustine, for example,
"testifies that in his Africa the Punic Christians called baptism
simply Salvation, and the eucharist, which first gives life in the
baptismal mystery and even after remains 'the food of immortal-

ity,' they called, in like fashion, Life."[56] In the center of the Junius Bassus sarcophagus we have two intercolumnar scenes of the triumphant Christ—triumphant on earth and in heaven, triumphant over death and in eternal life—and two spandrel scenes that typify the sacraments by which Christians participate in Christ's saving death and resurrection and thus enjoy eternal life. The sacraments, represented here by their types in the life of Christ, are the link between Christ, of whose body and blood they are antitypes, and the buried Christian, of whose own death and resurrection they are types, foretastes of his eternal life, promises of his going to God.

It would appear, furthermore, that baptismal imagery informs more than just the central pair of spandrel scenes. While Grisar's connection of each spandrel scene in sequence with an element of the traditional baptismal rite of catechumens at Easter may not hold up,[57] his conviction that the key to the organization of the spandrel scenes is baptism seems true in some sense, even if its truth is not the whole truth. But a broader context than Grisar presents is needed—and readily available: in the imagery of early Christian art generally and in early Christian typological exegesis of the Exodus specifically.

As M. L. Therel notes, the literary source of the first Christian iconography must be recognized particularly in the Scripture readings that, during Lent, prepared catechumens to receive baptism. "Rather than a funeral iconography, therefore, it is necessary to recognize in these images the reflection of the early Christian initiation rite. ... The same images decorate the places where the Christian enters into the church and those where he awaits the resurrection."[58] Baptism is an important part of the background of early Christian art generally. Baptism was understood as an act of God's gracious deliverance, providing a renewal of life for the baptized, just as earlier acts of grace had done for the three youths in the fiery furnace and for Lazarus.

The archetypical story of deliverance for early Christians was the Exodus of the people of Israel from Egypt into the promised land. It is, then, not so surprising that "the core of Patristic interpretation of the Exodus" consists in "types of the Sacraments."[59] With ample models in the Old and New Testaments (e.g., Isaiah 43:16–21 and 1 Corinthians 10:1–13), early church writers developed an intricate typology of the sacraments as a

new Exodus.[60] Two examples must here serve to indicate the pattern. Theodoret (ca. 393–ca. 458), in his *XXVIIth Question on Exodus*, presents the following interpretation of 1 Corinthians 10:2–4:

> The things of former time were types of the later: the Law of Moses was the shadow while grace is the body. When the Egyptians pursued the Hebrews, these latter by passing through the Red Sea escaped the savage cruelty of the pursuers. The sea is the type of the baptismal font, the cloud of the Holy Spirit, and Moses of Christ our Saviour; the staff is a type of the Cross; Pharaoh of the devil and the Egyptians of the fallen angels; manna of the divine food and the water from the rock of the Saviour's Blood. Just as they enjoyed a wonderful refreshment coming from a miraculous source, after they had passed through the Red Sea, so we, after the saving waters of Baptism, share in the divine mysteries.[61]

Hilary (ca. 315–ca. 367?) offers an alternate view of Moses as a type. "By Moses we understand the Law," he writes in explaining the account of Moses's rescue from the waters of the Nile by Pharaoh's daughter. Just as she receives Moses upon going into water, so "[t]he Church also receives the Law when she comes to the waters of Baptism."[62]

As these passages make obvious, the stories of Moses striking the rock and receiving the Law are, in the early church, as embedded in a baptismal/sacramental context as the stories of Christ's baptism and multiplication of the loaves. What the whole Exodus event was for Israel, baptism—together with the eucharist—is for the new Israel, the church. Thus the four central spandrel scenes are more closely connected than might first be thought. Even if Peter is intended in the second or fifth spandrel scene instead of Moses—or, as would be more likely, in addition to Moses—the Exodus imagery is not displaced, since Peter strikes a new rock and receives a new Law in his role as the second Moses.

a	b	c	d	e	f
Fiery Furnace	Striking Rock	Christ: Loaves	Christ: Baptism	Receiving Law	Raising Lazarus

We have come, then, to answer the two questions with which we began: how are the spandrel scenes related to each

other? and how are they related to the work as a whole, especially to the intercolumnar scenes of the facade? Each pair of linked spandrel scenes is symmetrically arranged, and the themes of the paired spandrel scenes echo the themes of the paired intercolumnar scenes of the two registers. The outside, framing pair (Old Testament foreshadowing and New Testament fulfillment) points to salvation/resurrection in the face of the threatened (three youths) or actual (Lazarus) *sacrifice* of life. Paired spandrel scenes two and five (striking the rock and receiving the Law) point to God's ongoing covenant with the people of God—led by Moses (and Peter)—and the need for *obedience* to that covenant. The central scenes (two New Testament types) symbolize the sacraments of the church, eucharist and baptism, through which the Christian shares in the *victory of Christ.* An earlier rescue from danger prefigures a later resuscitation from death. A later occasion demanding obedience surpasses an earlier instance of disobedience, as a new and sacramental Exodus supplants an old geographical one. Events in the life of Christ prefigure sacramental events that give life to the Christian.

 While the intercolumnar scenes appear to be drawn from two repertoires—frieze sarcophagi with Old and New Testament scenes of salvation or miracles and columnar passion sarcophagi—the spandrel scenes come only from the first of these, and the spandrel scenes seem especially related to those intercolumnar scenes from the frieze repertoire: Adam and Eve, Daniel, Abraham and Isaac.[63] As noted in chapter 3 above, the Adam and Eve and Daniel scenes both have baptismal associations, partly but not exclusively in relation to nudity as an image of new life. The four spandrel scenes with strong baptismal associations are the central four—those directly resting on the Adam and Eve and Daniel scenes. The other pair of spandrel scenes (three youths, Lazarus) sets up an outer frame of images of near death and actual death much like the Abraham and Isaac scene and its opposite directly above them.

 While the Bassus sarcophagus is unique in many ways, it is not unrelated to other fourth-century sarcophagi in dealing with these images of the sacraments and salvation. A number of these scenes appear on the so-called Dogmatic sarcophagus, a double-register frieze sarcophagus dating from the second quarter of the fourth century (fig. 5).[64] Of its eleven scenes of biblical charac-

ters, six have parallels on the Junius Bassus sarcophagus. On the upper register, to the right of the portrait shell, are represented Christ's miracle of Cana (changing water to wine), the multiplication of the loaves, and the raising of Lazarus. The wine and bread scenes signify the sacrament of the eucharist, the Lazarus scene the result of participation in that sacrament: resurrection. Opposite these three scenes, to the left of the portrait shell, are two scenes of Adam and Eve: their creation and their fall, images of the promise and the necessity of new creation through Christian initiation. Below the portrait shell, and set distinctly on a raised platform, is a scene of Daniel in the lions' den; Daniel's obedience and deliverance—and his nudity—suggest baptism; the bread being offered to him points to the eucharist. To the right of Daniel, Peter striking the rock and Peter's arrest are included with the prediction of Peter's denial (or the commissioning of Peter[65]) to form a narrative of the leader of the new covenant community.

Of the six scenes of the Dogmatic sarcophagus in common with scenes on the Junius Bassus sarcophagus, three appear in its spandrels and three in its intercolumniations. For all their differences in composition and style, the spandrel and intercolumnar scenes overlap in iconography. Although the spandrel scenes manifest a unified iconographic significance among themselves, they are also very much a part of the larger iconographic significance of the facade—and indeed of the whole work. The experience of moving from death to life by means of participation in the sacraments of Christ's death and resurrection is signaled not only on the facade of the Junius Bassus sarcophagus but on its ends.

5 Ends

THE FACT that the spandrel scenes depict biblical events as enacted symbolically by lambs suggests a movement from "historical" to symbolic representation. This movement culminates in the scenes of putti[1] on the end panels of the sarcophagus (figs. 29 & 31). The ends of the Junius Bassus sarcophagus have attracted little commentary from art historians. George M. A. Hanfmann, however, in examining season sarcophagi, takes brief notice of the end scenes of the Bassus sarcophagus in that context.[2] The Bassus sarcophagus is not, of course, a season sarcophagus proper, but one of three that Hanfmann points out as having very elaborate scenes symbolizing the four seasons on their ends.[3] (The other two are the Ariadne sarcophagus from Auletta and the Three Good Shepherds sarcophagus, Lateran 181 [figs. 33, 30, & 32]). These three sarcophagi, as well as pictures in the Catacomb of Praetextatus (Januarius Crypt) and in the Catacomb of Marcus and Marcellinus, appear to reflect a seasonal cycle that must have become known in Rome in the early fourth century, in which each season was represented by a "panoramic landscape" with several putti engaged in appropriate seasonal occupations.[4] In these "panoramic" or "occupational" scenes the attempt was made "to convey a broader idea of the Seasons by depicting seasonal activities in various stages," with many putti replacing the individual personification of each season.[5] Such panoramic views of the seasons are confined to a very few monuments in Rome—monuments, Hanfmann concludes, "done by the best and perhaps most classically minded among the early Christian artists."[6] Just such a description is generally applied to the sculptor of the Junius Bassus sarcophagus.

The evidence that the season motif was indeed acceptable to Christians is given in certain architectural sarcophagi in which scenes of the seasons appear along with biblical or otherwise explicitly Christian scenes.[7] These sarcophagi include, besides that

of Junius Bassus, (1) Lateran 181 with seasonal scenes on the ends (figs. 30 & 32), (2) a sarcophagus from Tipasa (fig. 35) that represents "the Lord (?) enthroned in the center" and, according to Hanfmann, the baptism of the centurian Cornelius at the right end, (3) Lateran 110 in which the Good Shepherd appears in the central niche, (4) Lateran 184 in which the seasons are represented under the medallion of the double-register sarcophagus.[8] The "elaborate versions of idyllic seasonal labors performed by putti" painted in the Catacombs of Praetextatus and Marcus and Marcellinus corroborate the acceptability of seasonal scenes in Christian contexts.[9]

SEASONS AND RESURRECTION

What, then, was the significance of these seasonal scenes as they appeared in Christian contexts? "The interpretation most favored by modern scholars is," as Hanfmann notes, "that Seasons symbolize resurrection." He reasonably argues that this possibility is stronger "when the central place is held by a figure motif representing the theme of salvation."[10] As examples of such figure motifs, Hanfmann lists the Good Shepherd, the Orans (or *orant*—female personification of prayer), and the Lamb; he might also have included such biblical scenes as the sacrifice of Isaac, Daniel in the lions' den, the afflictions of Job, or the whole pattern of scenes of the facade of the Bassus sarcophagus.

The interpretation of seasonal scenes in Christian contexts as symbols of the resurrection is supported by early Christian writings. Hanfmann points out that, although Christian writers "often violently attacked the seasonal arguments for immortality in pagan cults, [they] nevertheless suggested that the seasonal changes and the cycle of nature prove the doctrine of resurrection."[11] Hanfmann offers several clear examples of this generalization. First, in the *Octavius*, the second-century apologetic dialogue of Minucius Felix, the Christian Octavius dismisses the Pythagorean theory of transmigration as a half-truth but also says:

"Notice, also, how all nature hints at a future resurrection for our consolation. The sun sets and rises again; the stars sink below the horizon and return; the flowers die and come to life again;

the shrubs spend themselves and then put forth buds; seeds must decompose in order to sprout forth new life. Thus, the body in the grave is like the tree in the winter, which conceals its live sap under an apparent dryness. Why do you urge that in the depths of winter it should revive and return to life? We must also wait for the spring of the body."[12]

Tertullian also states that God made the universe a prototype of human resurrection:

> The light of day, after it has passed away each twilight, again shines brightly; darkness in turn gives way to light and then follows it; the stars wane and come to brightness again; fruit withers away but returns; seeds spring up with greater fruitfulness only when they have rotted and are destroyed; all things are preserved by dying. All things, from their destruction, are restored.[13]

Elsewhere Tertullian writes that God is powerful and "[t]he whole . . . of this revolving order of things bears witness to the resurrection of the dead."[14]

Such arguments as these of Minucius Felix and Tertullian assume, as do the arguments of Stoic philosophers and Neo-Pythagoreans, that the perpetual return of the seasons indicates a cyclic continuity of life.[15] Yet, as Hanfmann indicates, "the analogy ill fits the Christian doctrine of resurrection," for Christian resurrection was understood not as "a cyclic repetition" but as "a unique awakening to new life."[16] Some early Christian writers, including Tertullian, felt the difficulty in applying the analogy of the seasons to the resurrection[17]; others succumbed to the analogy's implicit dangers and applied it heretically.[18] Because of the dangers of the ill-fitting analogy between the recurring seasons and the unique Christian resurrection, use of such imagery was eventually circumscribed, and what Hanfmann labels the "canonic interpretation" was given by Augustine (354–430). Augustine consistently insisted on the opposition of the "eternity" of God and the "time" of the world: "eternity was before time nor closes in time." He confessed that "the Resurrection of Christians will be once (*semel*)." Thus the cyclic return of the seasons was reduced to a reminder that from repeated coming and going, birth and revival, Christians must believe in the unique resurrection.[19]

Thus it is not surprising that, as Hanfmann notes, most of the pictorial references to the seasons, including those of the sarcophagus of Junius Bassus, occurred before the time of Augustine[20]: the most elaborate painted seasonal scenes appeared within one or two generations after the triumph of Christianity; the sculptured use of putti among seasonal plants was most frequent between 312 and 360.[21] In other words, it was the *early* church fathers who accepted the seasons as a symbol of resurrection, the simile having originated, Hanfmann reasons, "when Christianity was on the defensive, at a time when a familiar Stoic argument would have appealed to philosophically inclined Romans."[22] With the triumph of the church, seasonal symbolism was not only limited but also occasionally denied.

But pointing symbolically to the resurrection may not be the only significance of seasonal scenes, even in Christian contexts. Hanfmann cautions interpreters not to overlook other possible meanings of sepulchral representations of the seasons. Among these alternatives are the following: (1) when the seasons appear with the Good Shepherd as the image of the Lord, or especially with Christ enthroned or teaching, Christ's power over time may have been signified; (2) the seasons might have been viewed as symbols of this earthly life, which the dead have relinquished for eternal bliss; (3) the seasons may have symbolically suggested paradise, "where the best things of all Seasons were to be found at all times"; (4) in carrying over from paganism themes of generally human character, the seasons might have adorned Christian tombs to symbolize the years spent by the deceased with his relatives. Whatever the possible meanings of seasonal scenes in Christian contexts, "the Seasons as personified forces were never endowed with a Christian meaning which was sufficiently convincing to insure their survival in Christian funerary symbolism."[23] Perhaps it is for this reason, one might add, that it is sometimes difficult for twentieth-century viewers to appreciate the Christian significance of the putti among vines and wheat and olives and flowers appearing on the ends of the Bassus sarcophagus and thus enclosing the biblical scenes of its facade.

Yet all the above-mentioned interpretations of seasonal scenes in Christian contexts, including the interpretation of the seasons as a symbol of resurrection, are, according to Hanfmann, "clas-

sical notions about the Seasons which were adapted to Christian ideology."[24] A new Christian symbolism of the seasons, however, did gradually begin to take shape, based on the exegetical premise that each scriptural passage contains "hidden truth" referring to Christian belief or dogma. Beginning in the third century and increasing immensely after the Peace of the church, Christian commentators were active in bringing out this hidden truth through their interpretations of individual passages of Scripture. Hanfmann observes that "[m]any of these Christian interpretations refer to individual or contrasting Seasons and tend to weaken the emphasis on the cyclic character of seasonal changes."[25] For example, for Origen (third century), winter is the season of death, in contrast to spring, the season of resurrection.[26] Hanfmann, who is not of course chiefly interested in the Bassus sarcophagus, makes no direct application of this type of Christian interpretation to it, but we will want to keep it in mind.

GRAPES, GRAIN, AND EUCHARIST

In assigning the putti of the four end scenes of the Three Good Shepherds sarcophagus, Lateran 181 (figs. 30 & 32), to their respective seasons, Hanfmann observes several "iconographic mistakes [that] prove that the artist is adapting a composition, perhaps from a different medium."[27] In turning his attention to the end scenes of the Bassus sarcophagus, however, Hanfmann confesses that "the iconographic confusion is even greater."[28] Instead of one compartment for each season, both compartments of the left end are allotted to representations of autumn (putti harvesting grapes); the upper compartment of the right end is allotted to representations of summer (putti harvesting grain); and the lower compartment of the right end includes representations of, in Hanfmann's evaluation, "at least three" seasons: winter (putto with olives), autumn (putto with lizard and grapes), and spring (four putti with, respectively, a hare and a shepherd's crook, flowers, a bird, a dish of water for the bird). Thus Hanfmann proposes that we see one representation of winter, followed by two of spring, interrupted by one of autumn, followed by two more of spring. If his assignations are accurate, the result is surely the "iconographic confusion" he proclaims![29]

I	III
Grape Harvest	Wheat Harvest
II	IV
Grape Harvest	Olives/Flowers, Bird, etc.

Such iconographic confusion may be due in part to the sculptor's confused use of a model and/or his use of a confused model. "It is quite possible," Hanfmann states, "that he did not work from the original composition, but from sarcophagus Lateran 181 or one like it."[30] Hanfmann has previously stated that Lateran 181, the Three Good Shepherds sarcophagus, is itself an adaptation of another composition. In addition, he asserts that the Roman sculptors of the fourth century, including the sculptors of the Three Shepherds and the Bassus sarcophagi, drew upon illustrations of the months in calendars.[31] In further explanation of the iconographic confusion of the end scenes of the Bassus sarcophagus, Hanfmann suggests that the "artist apparently took the vintage scenes to be a subject distinct from the representations of the Seasons and attempted to accommodate all four Seasons" on the right end.[32]

It seems reasonable to suggest that the putti involved in various activities on the end panels of the Junius Bassus sarcophagus participate in a somewhat confused way in two systems of symbols or allegories. The grape- and grain-gathering putti of the ends of the sarcophagus not only represent the seasons of autumn and summer respectively but also point symbolically to Christ as the "true vine" (John 15:1) and the "bread of life" (John 6:35)—to the elements of the eucharist and the *agape* feast of paradise (see Mark 14:25).[33] The symbol of the vine is given emphasis not only by filling two end compartments but also by decorating the four central columns of the facade.[34] There is, de Waal posits, an "intended reference to Christ of whose vine we are the branches and only in union with whom we have life and bring forth fruit for eternal life."[35] If the sculptor was using the Three Good Shepherds sarcophagus (Lateran 181) itself as a model and not merely a common model of its ends,[36] it is not surprising that the vintage was emphasized since the vintage forms a significant part of the facade of the Three Shepherds sarcophagus (fig. 33). The focus of the grain-gathering scene of the Bassus sarcophagus is more

clearly on grain than that of the Three Shepherds sarcophagus, since the olive-picking putto has been eliminated. Such a change leaves the Bassus grain scene more open to a sacramental symbolism beyond the seasonal symbolism of eternal renewal or resurrection. Thus a second symbolic meaning, a specifically Christian sacramental one, overlays the significance of the seasonal cycle.

Such a sacramental interpretation is bolstered by the presence of grapes and grain, or the vintage and the grain harvest, on a number of early Christian sarcophagi. An especially telling example is a single-register frieze sarcophagus in the Terme Museum on whose lid, to the right of the epigraph, are carved a putto harvesting grain and another harvesting grapes, who, together with two putti holding a canopy, form a frame for the portrait of the deceased (fig. 34).[37] The sculpted stone seems to proclaim: "This man tasted the 'bread of life' and the fruit of the 'true vine'; now he enjoys eternal life." A further example is a two-register frieze sarcophagus of biblical scenes that has at its upper center a double portrait within a shell (an early Christian symbol of baptism) and below it, at the center of the lower register, a scene (set apart by strigilated columns) of wingless putti treading on grapes in a vat (fig. 36).[38] Above the shell, on the lid, two winged putti bear the inscription. It would seem that the putti below as well as those above the carved portraits help identify the dead: the deceased, having been baptized into the body of Christ, was (or were) partakers of the wine of the eucharist, the blood of the new covenant, and thus inheritors of everlasting life.[39]

Concerning Christian vine symbolism in general, Goodenough comments: "Clement of Alexandria said that Christ is the true vine because he gave his blood for us in love; the great cluster of grapes is 'the Logos bruised for us.' It does not seem strained to find this behind the Christian vintage scenes on tombs and sarcophagi."[40] Goodenough is especially concerned to show the existing symbolic value inhering in vine imagery when it is taken up by Christian art.[41] In particular Goodenough notes that when baskets appear in vintage scenes (as they do on the left end of the Bassus sarcophagus), "it is not a stretch of imagination to suppose that the early Christians who saw them took their implication to be that the Erotes in the vine were plucking no ordinary fruit but the eucharistic gift of the True Vine which divine love

had made available." Christian baskets, Goodenough observes, seem to stem from Jewish prototypes and indicate the sanctification of what is enclosed.⁴² Relevant to the grain harvest, Goodenough argues that the Jewish conservation of First Fruits "was originally one of the important inspirations of the Christian eucharistic bread. The tradition all goes back, presumably, to the strange story about an incident in the life of Elisha," in which Elisha is able to multiply "bread of the first fruits, twenty loaves of barley, and fresh ears of grain" to feed a hundred men—with "some left" (2 Kings 4:42–44), the story being "the clear prototype of the feeding of the multitude in the Gospels,"⁴³ which in turn is a foreshadowing of the eucharist. Thus from Jewish and pagan roots grows the vine and grain imagery that appears on the ends of the Junius Bassus sarcophagus; it bears fruit here as a symbolic reference to the eucharistic sacrament of bread and wine.

Cyprian was "the first of all the early Christian writers" to elaborate on a typology of the eucharist. Following John's Gospel and 1 Corinthians, he identifies a prefiguration of the eucharist in the manna in the wilderness.⁴⁴ In arguing against Christian "heretics" who forbade the use of wine for the eucharist and substituted water, Cyprian develops a typological connection between the wine of Noah (Genesis 9:20–21) and the eucharistic wine (with a reference also to Psalm 22:5, LXX):

But thus the Chalice of the Lord inebriates as Noe [Noah] drinking wine in Genesis was also inebriated. But because the inebriation of the Chalice and of the Blood of the Lord is not such as the inebriation coming from worldly wine, when the Holy Spirit says in the Psalms: "Your chalice which inebriates," he adds, "how excellent it is!" [Psalm 22:5, LXX: *kai to potērion sou methuskon hōs kratiston*] because, actually, the Chalice of the Lord so inebriates that it makes sober, that it raises minds to spiritual wisdom, that from this taste of the world each one comes to the knowledge of God and, as the mind is relaxed by that common wine and the soul is relaxed and all sadness is cast away, so, when the Blood of the Lord and the lifegiving cup have been drunk, the memory of the old man is cast aside and there is induced forgetfulness of former worldly conversation and the sor-

rowful and sad heart which was formerly pressed down with distressing sins is now relaxed by the joy of the divine mercy.[45]

The joy is the point, as Daniélou observes: "[T]he symbolism of wine in Jewish ritual is precisely to express the joy experienced at a feast, and this symbolism persisted into the use of the wine of the Eucharist."[46] Such joy is captured in the faces of the putti in the vintage scenes of the left end of the Bassus sarcophagus.

WINTER AND SPRING, DEATH AND LIFE

Less agreement is found among art historians in regard to the six putti of the lower compartment of the right end of the Junius Bassus sarcophagus. However, the keys to understanding these six putti are (1) a comparison with their probable models in the putti of the right end of the Three Good Shepherds sarcophagus and (2) an understanding of the uniquely Christian interpretation of seasons as symbols of death and life rather than as signs of cyclical time.

In examining the end scenes of the Three Good Shepherds sarcophagus (figs. 30 & 32) we observe greater order and symmetry than in the comparable scenes of the Bassus sarcophagus (figs. 29 & 31): each of the four scenes contains four winged putti; each of the four scenes seems quite clearly to represent one of the four seasons: vintage—fall; olive harvest—winter; grain harvest—summer; hare, lizard, flowers and bird, pipes—spring. The four putti of the spring scene are, admittedly, somewhat curious. Hanfmann labels the putto with a lizard in one hand and a bunch of grapes in the other an "iconographical mistake" since this putto "really belongs to Autumn."[47] But even if it were a "mistake," an uncertain argument, it was nevertheless assigned by the sculptor of the Three Shepherds sarcophagus to the spring scene. And this is how it was apparently viewed and copied by the Junius Bassus end sculptor.[48] Both the putto with the lizard and grapes and the putto with the hare and shepherd's crook appear to be modeled after those in the Three Shepherds scene of spring and thus to represent spring on the Bassus sarcophagus. The other two spring putti of the Three Shepherds sarcophagus appear to have been adapted more freely by the Junius Bassus end sculptor. No putto with shepherd's pipes is included, and instead of

one putto with a bird and flowers, three putti appear: one with flowers, one with a bird, one with a dish of water for the bird. But these alternate putti are clearly related to those of the model spring scene and do represent spring. Thus the last five putti of the right lower compartment—the wingless, nude putti—represent spring.

The remaining putto of the right lower compartment, the only fully clothed putto on the sarcophagus, is generally recognized as a representation of winter since he carries a basket of olives and an olive branch. On the surface it almost appears that the seemingly misplaced olive-picking putto in the fourth position in the grain-harvesting scene of the Three Good Shepherds upper compartment has been moved to the first position in the Junius Bassus lower compartment. We have already noted that such a move clarifies the grain-harvesting scene and leaves it more open to interpretation as a symbol of the "bread of life." Such a move also places one clothed winter putto and five nude spring putti in clear opposition in the lower compartment. This clear opposition of winter and spring parallels in the plastic arts the exegetical understanding of certain early church writers.

Hanfmann observes that many Christian interpretations, based on a style of allegorical exegesis of scriptural passages, "refer to individual or contrasting Seasons and tend to weaken the emphasis on the cyclic character of seasonal changes."[49] As an example he cites the reference of Origen (185?–254?) to winter as the season of death, in contrast to spring, the season of resurrection.[50] An additional example is provided in the *Commentary on the Song of Songs* of Gregory of Nyssa (331?–394?):

> Now it seems to me that the effects of winter and everything like them have a figurative meaning. . . .
> . . . Human nature initially flourished while it was in Paradise and was nourished by the water of the fountains there. Instead of leaves, man had the blossom of immortality adorning his human nature, but when the *winter* of disobedience dried up the root, the flower was shaken off and fell to the ground. Man was stripped of the beauty of immortality, the grass of the virtues withered, the love of God grew cold through the multiplication of iniquity. . . .
> But later there came one who brought *spring* to our souls. . . .

once again our nature began to bud and be adorned with its own flowers. The virtues are the flowers in our life, now blossoming and bearing fruit in their own season.[51]

Gregory's winter/spring imagery emphasizes the present availability of the resurrection experience to the baptized Christian, Origen's its joyful finality.

Thus the six putti of the lower compartment of the right end suggest the Christian experience of winter and spring, dry disobedience and flourishing serenity, death and life. The only fully clothed putto of the end panels appears to be the only one lacking a positive connotation in the Christian symbol system. The nude harvest putti suggest the sacrament of communion. The nude spring putti point to resurrection. But the clothed winter putto points only to death.[52]

A similar opposition between nude putti with mantles and a fully clothed putto is seen in a fragmented, five-niche columnar sarcophagus from Tipasa (fig. 35).[53] The second and fourth niches, without gables, contain two putti each, and their representation of the seasons in the correct order of the year seems clear: first putto (nude), holding flowers—spring; second putto (nude), holding a sheaf of wheat and a sickle—summer; third putto (nude), holding a bunch of grapes, with a lizard below—fall; fourth putto (clothed), holding a staff and a goose (?)—winter. Here the clothed winter putto opposes not just spring but all the other seasons. This might also be true of the Bassus sarcophagus. The lower compartment of its right end does indeed depict putti whose seasonal representations are not easy to decipher. The nude putti there have been labeled spring, summer, and fall in varying arrangements; the clothed putto is always labeled winter.[54] Even amid the confusion, the opposition of winter to the rest of the year, of death to life, is clear.[55]

I	III
Grape Harvest	Wheat Harvest
II	IV
Grape Harvest	Olives/Flowers, Bird, etc.

Thus all four seasons are indeed represented on the ends of the Bassus sarcophagus, but with two significant changes:

(1) two seasons, fall and summer, represented by nude *winged* putti, have been emphasized because their characteristic products, grapes and grain, were also viewed as symbols of the sacrament of the eucharist; and (2) two seasons, winter and spring, represented by nude (spring) and clothed (winter) *wingless* putti, have been placed in clearer opposition because they were also viewed as symbols of death and life, that is, death and resurrection.[56] Again we observe the tendency of the Junius Bassus sarcophagus toward iconographical richness—or perhaps even iconographical overload. On the facade, six spandrel scenes add to the already quite full program of biblical scenes of the ten intercolumniations. On the ends, what could have been a series of either harvest scenes or seasonal scenes becomes both—and both elicit specifically Christian overlays of meaning.[57]

The Three Good Shepherds sarcophagus, whose seasonal scenes very likely either served as a model for the Junius Bassus end sculptor or shared a common model with him, is one of those early Christian sarcophagi that would have been viewed as implicitly Christian by those able to understand its symbols (the Good Shepherd, the vintage, the seasons) through their own faith and as not explicitly Christian but in line with pagan, classical models by those outside the Christian faith.[58] Thus its portrayal of the four seasons may well have signified allegorically the circle of the seasons as an image of eternal renewal or resurrection. Such an interpretation must be counted among, in Hanfmann's words, "classical notions about the Seasons which were adapted to Christian ideology."[59] The Junius Bassus sarcophagus, in contrast, is a fourth-century work with the explicitly Christian scenes of its facade arranged in a complex program issuing from a distinctly Christian understanding of salvation history. Thus it is perhaps not so surprising, after all, that its end scenes, although apparently originally modeled on a seasonal cycle, show changes that reflect explicitly Christian interpretations: the eucharist, suggested in the harvests of grapes and grain; resurrection from the dead, suggested in spring's following and opposing winter. And, of course, the spring of resurrection was made available to a Christian such as Junius Bassus through the sacramental drinking and eating of the grape and the grain. Again the end scenes of the sarcophagus seem to render in plastic form the words of a patristic theologian, in this case, Ignatius, late first/

early second-century Bishop of Antioch: the elements of com-
munion are "the medicine of immortality and the antidote
against death, enabling us to live for ever in Jesus Christ."[60]

Although carved by a different hand than the facade, not so
clearly divided spatially, and allegorical or symbolic rather than
"historical" in iconographic content, the end scenes of the Junius
Bassus sarcophagus are nevertheless quite closely related to the
overall theme of the work.[61] In early Christian thinking "the Sac-
raments prolong in the Church the 'Wonders,' the *thaumata* of
the Old Testament"[62] and post-figure the "miracles" of Christ.
We may "read" the facade of the sarcophagus: God's action for
salvation in "historical" events, often typologically interrelated,
is appropriated in the sacraments of Christ's church. And we may
"read" the ends of the sarcophagus: God's offer of resurrection
(new life after death) is appropriated through the sacrament of
Christ's body and blood (the bread and wine of the eucharist). Of
course Junius Bassus, NEOFITVS, has accepted that sacramental of-
fer and has thereby been incorporated into that divine action: IIT
AD DEVM.

6 Lid

MORE OF the lid of the Junius Bassus sarcophagus is missing than is present—and even what is extant is in one large and four smaller fragments (figs. 1, 37, 40).

The box of the sarcophagus has experienced some damage in its long life—notably the loss of the Daniel figure and substantial damage to the spandrel scenes, but also the loss of the heads of Pilate's servant and of Job and the leg of the donkey—but the lid barely survived into the modern era at all. And until the four smaller fragments were discovered in 1942 and 1979, the extant lower portion of the lid was sometimes discredited as not belonging originally to the box[1] and was occasionally wildly misinterpreted. Thus one who seeks to understand the iconography of the lid itself and of the lid in relationship to the entire sarcophagus must first establish, to the extent possible, what representations appeared on the lid. Although that is certainly a more reasonable goal today than it was previously, the fragmentary nature of the lid makes any discussion of its iconography incomplete and speculative.

DISCOVERY OF LID FRAGMENTS

The lid is a typical L-shaped one; from the right end of a sarcophagus an unbroken lid appears as an uppercase L, with the elongated horizontal leg of the L covering the box and the vertical leg of the L being carved on the front. It is this vertical part of the L that has been almost entirely broken off of the Bassus sarcophagus lid. Although the sources do not give grounds for certainty, it would appear that the lid was broken off at the time of the modern "discovery" of the sarcophagus in 1597.[2] As Georg Daltrop explains:

> Fragments of an inscription tablet of pentelic marble, which belong to and fit the lid of the Junius Bassus sarcophagus, were found by the excavators of the necropolis under St. Peter's in the

year 1942 in the wall filling of the south wall of the Capella Clem-
entina, which was erected under [Pope] Clement VIII shortly be-
fore 1600 and which was broken through to form an entrance to
the necropolis. . . . This find gives rise to the suspicion that the
vertically erect relief wall of the sarcophagus lid may have first
come to light in the course of the lowering of the floor of the Ca-
pella Clementina in 1597 and that, due to the lack of knowledge
that this relief might be the lid decoration of a sarcophagus, it
was hacked off [and its fragments used for fill for the south wall].[3]

It would seem that at least one more fragment of the Junius Bas-
sus lid was also unearthed in 1942; but, not being recognized as
such, it was displayed as an unattached fragment at the exit of
the Vatican Grottoes until, in 1979, Daltrop, having realized that
it was part of the right relief scene, had it relocated to the Bassus
sarcophagus lid.[4]

Thus when reviewing scholars' interpretations of the Bassus
sarcophagus lid, it is critical to take note of what form of the lid
each knew. Until the middle of the twentieth century, scholars
knew only the lower portion. In addition, according to Giuseppe
Bovini, after 1773 a major portion of that known lid fragment
was covered with a fine stucco that gave it the aspect of white
marble.[5] When publishing his monograph on the Junius Bassus
sarcophagus in 1900, Anton de Waal commented that one side of
the double picture of the lid "is missing," so the other side is
incomprehensible.[6] But some years later[7] de Waal returned to the
sarcophagus and painstakingly removed the stucco. He revealed
the scenes, or rather fragments of scenes, but their significance
remained an enigna to him.[8] While in his monograph of 1900 de
Waal assumed that the lid had been put on after the discovery of
the sarcophagus, in an article published in 1907 he argued that
the lid and box probably belonged together originally, although
the lid representations, which had been taken over from secular
life, did not belong to the original program.[9]

In 1919 Giuseppe Wilpert examined the lid (that is, the lower
portion) with Table II of de Waal's 1907 article in hand. Wilpert
identified the figure seated on a folding chair as Dionysus playing
with his panther.[10] He decided not to publish the fragmentary
scenes since he was unable to integrate them, but he reported
observing, in addition to the so-called Dionysus, fragments of the

heads of the sun and moon at the corners, a female attendant at a banquet (verified by the feet of a table) next to the moon, and a bundle of manuscript volumes and another folding chair and person. Wilpert's only attempt to explain the significance of these fragmentary scenes was the statement that the seated Dionysus playing with his panther serves to qualify the guests at the banquet as his devotees.[11]

In 1936 Friedrich Gerke stated that the scenes of the lid could be reconstructed from the existing fragments, and he described them as an official scene (with people in togas) on the left and a family scene (including a seated figure, a table, and a dog) on the right.[12] Bovini reported that Josi, while working in the Vatican Grottoes in 1944 (cf. Daltrop's date of 1942), found three fragments of the lid that contain an almost entire epigram in which Junius Bassus is praised as one of the magnificent prefects of the city. These fragments belong certainly to this lid because the lines of fracture conjoin perfectly with it. Bovini (in 1949) accepted Josi's discovery as confirmation of de Waal's hypothesis that the lid was not reutilized but made particularly for that sarcophagus and also of Gerke's interpretation of the mutilated scenes as episodes of family life and official life of the prefect of Rome rather than pagan representations, as Wilpert maintained.[13]

In 1973 a prophetic breakthrough in interpreting the right scene of the lid was made by Nikolaus Himmelmann.[14] Although he pictured and commented on the fragment of a meal scene then displayed in the Vatican Grottoes,[15] Himmelmann did not realize that it fit the Bassus sarcophagus; and yet he recognized the right scene as in some sense a representation of a meal of the dead solely on the basis of the lower fragment. This was no small accomplishment since, as Himmelmann observed, "a survey of the secular representations on Christian or pseudo-Christian sarcophagi offers no immediate typological points of connection with the preserved remnants."[16] Some problems with Himmelmann's detailed explanation and interpretation of the right relief are resolved in light of Daltrop's discovery of the fit of the additional fragment, which, as he recognized, conclusively establishes the right scene as a depiction of a meal of the dead.[17] The scene, while unique on a fourth-century Christian sarcophagus, was popular in earlier Roman funereal art. As I. A. Richmond has

observed: "On countless tombstones of soldiers and civilians from all over the Roman world the funeral banquet becomes [in the second century] a favourite theme. It honours the dead, reminds the living of their recurrent obligations of piety to departed kin, but, above all, typifies the pleasures which the blessed dead were conceived to enjoy."[18]

RIGHT RELIEF: MEAL OF THE DEAD

Even without considering the major fragment of the right relief, Himmelmann realized that the relatively small figure sitting on the folding stool and the accompanying animal could not satisfactorily form the main group of the composition since then "the exact center of the relief would be filled only with half-high representations (dog, table) while human figures would be missing." But without the additional fragment, he could not help but ask "whether one could still assume the old heroic type of the *klinē* [Greek: couch] meal in this time [mid-fourth century] and in this [Christian] connection."[19] The tradition of the meal of the dead on grave monuments is to be found in several parts of the empire since early Roman imperial times,[20] but it is "even more striking how small the role of the meal of the dead is on sarcophagi of the city of Rome."[21] Apart from two conditional examples from Ostia, "the meal of the dead theme is missing entirely in the early group of Roman sarcophagi." The child's sarcophagus in the British Museum, with its meal-of-the-dead scene played allegorically by Amors and Psyches (fig. 39), is perhaps the earliest example, and it belongs to the third century. "All other previously known representations of the *klinē* meal of the Roman sarcophagi seem to belong to the time after the middle of the third century"[22] (see figs. 41 & 42). The diversity of the main figures suggests that specific deceased persons are portrayed in these carved meals of the dead.[23]

The right relief of the Bassus sarcophagus lid has typological connections (i.e., it shares certain formal elements and common models) with this mid- to late third-century group[24]; here we may add to Himmelmann's list on the basis of the now recognized additional fragment. The typological connections include both figures and objects: the main figure or figures lying on the *klinē* (figs. 39, 40, 41, 42), the standing server or servers at the

side or sides (figs. 39, 40, 41, 42),[25] the female stringed instrument player in the chair to the left (figs. 39, 40, 41, 42), the child or children playing with the dog in front of the *klinē* (figs. 40, 42),[26] the three-legged table with the fish plate in front of the *klinē* (figs. 39, 40, 41, 42),[27] the double basket-bottle with carrying handle to the right of the three-legged table (figs. 40, 41; 39 has a single basket-bottle), and, of course, the *klinē* itself. "These elements are always mixed anew so that no representation can be regarded as a simple copy of another."[28] "In the light of these connections we can also confidently assume for it [the right relief of the Bassus sarcophagus] the representation of the *klinē* meal."[29]

But Himmelmann continued immediately: "There remain, however, some difficulties that cannot all be removed in similarly satisfactory fashion."[30] Some of the difficulties in identifying the figures of the scene and establishing their typological connections—explaining the "missing" seated female lute player, for example—have been resolved with the fitting of the additional fragment; other difficulties—what figure or figures are behind the seated female musician, for example—may have to await another fortuitous discovery. Himmelmann's greater concern, however, seemed to be that the meal-of-the-dead scene on the Bassus sarcophagus lid be understood not as a simple memorial picture[31] but as an image with allegorical or symbolic significance. He arrived at this conclusion from three paths: (1) consideration of the typological origin of the meal of the dead on sarcophagi in the city of Rome, (2) examination of the relationship of the *klinē* meal to the *sigma* meal, and (3) observations about the placement of the *klinē*-meal scene within iconographical programs of the later sarcophagi.

First, he discovered the origin of the type not in Hellenistic reliefs, which differ in a number of ways from the later Roman ones and derive from continental Greek models, but in earlier meal-of-the-dead representations from the Greek-Persian border area. Although he found the actual process of transmission difficult to trace, the most significant changes in the scene were clear to him: a decided "bourgeoisification" (*Verbürgerlichung*) and allegorizing traits.[32] Second, he found the *sigma* meal (with several diners reclining on a semicircular bolster) more bucolic and idyllic than the *klinē* meal, which was more personal but became

equally symbolic, perhaps as a "personal apotheosis."[33] Third, he observed that the *klinē* meal was linked or paired with other scenes rich with allegorical meaning—the hunt, the wagon journey, the vintage—especially on lids, indicating its equivalent allegorical value, even if its meaning cannot be confidently specified in detail.[34] "The question of its thought content cannot be satisfied with archaeological means alone and is perhaps not conclusively to be answered at all in the case of the meal of the dead, for which explicit written testimonials are sparse and inconsistent."[35] This aspect of Himmelmann's argument is easily convincing, especially if one doubts that memorial pictures are ever "simple" rather than also symbolic. In addition, we might surmise that the meal of the dead depicted on the right relief of the lid was the more important of the two relief scenes, since the pattern of accentuating the right is manifest on the facade of the box and probably on the ends as well.

Himmelmann's conclusions in 1973 prepared the way for understanding the soon-to-be-placed additional fragment of the right relief of the lid. He argued that "De Waal's reservations that the lid, because of its profane representations, could not fit with a biblically decorated box were not convincing even in his own time."[36] "According to the evidence of the Junius Bassus sarcophagus, it [the *klinē* meal type], notwithstanding its more than a thousand-year-old pre-Christian past, could still be used, at least in individual cases, alongside biblical themes."[37] But "the *klinē* meal type, which the honors-bearing Bassus, who stemmed from a proud aristocratic family, still perhaps connected with a kind of 'private apotheosis,' is apparently not represented any more after this individual incidence."[38] Daltrop's placing of the previously unidentified fragment on the Bassus sarcophagus lid in 1979 confirmed Himmelmann's interpretation, and Daltrop's conclusion echoes his: "Although the differences [between the classical Greek reliefs and] the late form of the Bassus sarcophagus are also considerable, the allusion to a taking part in the meal of the blessed still remains present. This-worldly/earthly and transcendent/other-worldly motifs and ideas intermingle in the picture."[39]

Neither Himmelmann nor Daltrop delved into the social and religious background and significance of actual memorial meals, which are surely of importance to the understanding of depicted

meals of the dead. Perhaps the subject was too vast for them to enter into, as it is for us here.[40] And yet it must at least be pointed out here that the Roman (if not nearly universal) idea of the communion of the living with the dead through the eating and drinking of a memorial meal moves easily with and/or into the Christian idea of the communion of the saints, living and dead, and the anticipation of a shared eternal life through the eating and drinking of sacramental bread and wine. To share a meal is to be incorporated into a family.[41] The right relief of the Junius Bassus sarcophagus lid must be seen in a richly allusive but difficult to specify relationship with the eucharistic connotations of the spandrels and ends as discussed in the two preceding chapters and also of certain ornamental elements of the facade to be discussed in the following chapter.

Left Relief: Missing Scene

When we turn our attention from the right to the left relief of the Bassus sarcophagus lid, we move from related materials too vast to survey to gaps too vast to fill. The left side of the lid is considerably more damaged; less remains of the bottom of the lid, and no additional fragments have been located. Remaining are two-and-a-half pairs of feet (presumably belonging to three male figures or to one female figure and two males), the hem of one long garment (presumably belonging to a female figure), and the bottom half of a bundle of rolls (scrolls). These are arranged as follows, from left to right: male or female foot wearing a sandal; female garment hem; broken-off roll bundle; two sets of frontally placed male feet, ankles, and shins with indications of togas. The center of the relief may be marked by the roll bundle (which seems to be the center of the remaining carvings), or it may be marked by the clearly female figure (which is more nearly the center of the available space). Himmelmann's assumption that the relief on the left is "apparently a somewhat shorter one"[42] seems unwarranted. Only the trace of carved remains is shorter, not the available space. Himmelmann was correct, of course, in noting that "the relationship of these figures with each other is difficult to determine."[43] In fact, all suggestions of the specific representations and their iconography are speculative.

Gerke speculated conservatively. He simply suggested that an

"official scene" (indicated by the togas, the official garments of men of the senatorial class) was presented in contrast with and parallel to the "family scene" on the right. Now that we have a fuller conception of the right scene it is clear that "family scene" is not quite the correct label. A meal-of-the-dead scene is a family scene only in a rather public and even official way. Nor can we be sure that the left relief, with a female figure perhaps at the center, is free of familial aspects. Gerke was correct, however, to understand the lid scenes as involving stylized biographical references.

Himmelmann, who, unlike Gerke, knew the fragments of the inscription table and figured out more of the right relief from its bottom portion, suggested that the left side is "probably not a unified action picture, or an official scene as Gerke wished, but rather a sequence of symbolically significant figural types."[44] Lacking final confirmation of the unity of the right relief, Himmelmann reasoned on the basis of other sarcophagus reliefs (especially lids) that do, in fact, present such a sequence of symbolic figures—for example, a shepherd with sheep overlapping a *sigma* meal or an *orant* (a female figure with arms lifted in prayer) paired with a philosopher (a male figure reading a scroll).[45] Along these lines he proposed that the two male figures on the right would probably depict two officials, as suggested by their togas and by parallels on other sarcophagi.[46] The figure on the left (to the left of the clearly female figure), perhaps dressed in a pallium since he wears sandals and no evidence of a toga is present, might be a philosopher type.[47] "Probably the polarity of palliatus and togatus that has been transmitted for so long already on sarcophagi has played a role here."[48] The female figure might be an *orant* or a woman in a pallium reading a scroll; both depictions would indicate her spiritual or intellectual nature.[49] "The combination of *orant* or palliata with magistrates (togati) and/or philosopher (palliatus) has an ancient tradition, the origins of which have not yet been worked out. They lie probably in the region of biographical sarcophagi, the scenes of which . . . have a strongly symbolic content."[50] Thus the female figure might be an allegorical figure or a depiction of the wife of Junius Bassus; either would serve as an appropriate corollary to the meal-of-the-dead scene on the right. Although no wife of Junius Bassus is mentioned in the in-

scriptions, the excavators of the tomb (in 1942) believed they could recognize the remains of two corpses in the sarcophagus.[51]

The one unified scene that Himmelmann considered, albeit briefly, as a possible type of the left relief was the *dextrarum junctio*, the Roman marriage gesture of joining right hands.[52] "Since a central figure seems to be missing," Himmelmann argued, "one could think of a *dextrarum junctio* in the middle,"[53] with the clasped hands occupying the central space. He concluded, however, that this possibility is "probably excluded by the fact that behind the woman the remains of a parapetasma [a knotted curtain, indicating that the figure is of the dead; for an example, see fig. 34] are apparently recognizable."[54] The presence of a parapetasma, however, would not eliminate the possibility of the *dextrarum junctio*; Lawrence illustrates and discusses four season sarcophagi that have the *dextrarum junctio* at the center, of which two show a parapetasma behind the scene and a third (known only from a drawing and a fragment) may also have had a parapetasma.[55] But it may be that there is no parapetasma on the Bassus sarcophagus lid; the carved remains are unclear at best.[56] It may also be that a central figure is not missing; the clearly female figure on the left relief may be central.

Daltrop's reading of the left relief of the lid differs in two ways from Himmelmann's: (1) he identifies the farthest-left extant figure (the sandaled foot) as female, not male; and (2) he considers the *dextrarum junctio* reasonable as a type for the entire left scene. Concerning the sandaled foot, he identifies it as belonging to "a figure in a long garment taking a wide step, hurrying from left to right" and adds: "Supplementing N. Himmelmann . . . I believe that I can recognize the hem of the long garment not only between the feet but also over the left foot. The garment is hardly a pallium, but rather surely a long hanging garment that is worn by the striding, presumably female figure."[57] It would appear that Daltrop, following Himmelmann, proposes that the figure is taking a wide step on the basis of the amount of space between the extant right foot and the necessary end of the relief.[58] The basis on which Bovini and Brandenburg argue that this figure is *seated* toward the right is not clear.[59] It would seem at least as reasonable to suggest that there were two figures, not one, to the left of the clearly female figure, or perhaps one figure and an additional object or objects.

Concerning the left relief as a whole, Daltrop points out that it "lets one think of a *dextrarum junctio;* such a scene with the roll bundle is also documented on a sarcophagus that is now lost" and known only from a seventeenth-century drawing (fig. 38). "Moreover," he adds, "the representation of a *dextrarum junctio* would stand in equal value opposite a scene of a meal of the dead with a man and a wife." After a reminder that traces of the burial of two persons were found in the tomb by the excavators of the necropolis of St. Peter's in 1942, he continues: "The woman seems to be included in the representations on both the lid reliefs. The scenes are taken from the earthly-pagan realm. They include, however, a clear suggestion of a happy reunion in the hereafter. In view of the *dextrarum junctio* the memorial of Antonius Pius should be called into memory: on the relief of the column base the emperor's wife, who had died twenty years before, is celebrated in her reunion with him in the apotheosis."[60]

There are problems, of course, with interpreting the left relief scene as a simple *dextrarum junctio*: Who are the "extra" figures and what are they doing or representing? Is the roll bundle really in the center, as might be expected? The presence of a bundle of scrolls does not necessarily indicate a *dextrarum junctio;* on a Christian sarcophagus from Arles (dated to around 330) a roll bundle stands just to the left of a centrally placed *orant.*[61] Although it may seem natural to assume that the female figure in some way depicts Junius Bassus's wife (who may also share the *klinē* with him on the right; cf. fig. 39), we cannot prove this supposition, and we certainly cannot go beyond it to declare in what role or scene she is represented.

Surely there is a lesson to be learned from the changing identifications of the figures and objects of the right relief: Wilpert's Dionysus playing with his panther has become a child playing with a dog; Bovini and Brandenburg's tree around which a snake winds itself[62] has become a double basket-bottle with a carrying handle. Neither Himmelmann's nor Daltrop's suggested figural types are as exotic as panthers and snakes, and neither are put forth dogmatically. It does seem reasonable to suggest (against Himmelmann) that the left relief of the lid, like the right relief—and, in fact, all other scenes on the Junius Bassus sarcophagus—presents a unified scene; at the very least it would probably have been no less unified than the arrangement of the six figures in

the lower compartment of the right end (one putto representing winter opposed to five putti probably representing spring). But it is clearly not possible from the surviving left side of the lid to describe that unity.

VERSE INSCRIPTION

We find ourselves in somewhat better circumstances with the inscription table in the center of the sarcophagus lid. The three inscribed fragments found and identified in the 1940s present most of the inscription table (see figs. 1, 37, and below). Based on the evidence of the marble below the inscription as well as on the fragments themselves, we can surmise that the inscription was set off from the reliefs by undecorated or plainly decorated space. The original epigraph was composed of eight distichs, or two-line units.[63] Only one line of the inscription, the first half of the first distich, is missing entirely. Only bits and pieces of words remain of lines 1b–3b, although it is possible to complete line 3b. Line 1b manifests the first two letters of Ba[ssi] before it is broken off. Lines 3a and 3b both contain most of the word *praefectoram* or *praefecturam*. Thus the first three distichs probably referred to various specific offices Junius Bassus had held or responsibilities he had carried out, especially as city prefect. The last five distichs are fairly well preserved on the three conjoined fragments, and what gaps appear may be reasonably filled in. These verses depict, in rather flowery phrases, the widespread mourning at his funeral.[64]

1a
1b . . .h]aec Ba[ssi . . .]
2a [. . .]nerim[. . .]
2b [. . .]o regi co[. . .]
3a [hic pra]efectorum [. . .]erem[. . .]
3b [per] praefectur[am flu]mina promi[t opum.]
4a [hic mo]derans plebem patriae sedemque se[natu,]
4b [ur]bis perpetuas occidit ad lacrimas.
5a [nec l]icuit famulis domini gestare feretrum,
5b [c]ertantis populi sed fuit illud onus.
6a [fle]vit turba omnis, matres puerique senesque,
6b [fle]vit et abiectis tunc pius ordo togis.

7a [flere vide]bantur tunc et fastigia Romae,
7b [ipsaque tun]c gemitus edere tecta viae.
8a [cedite sublim]as spirantum cedite honores,
8b [celsus est culmen] mors quod huic tribuit.⁶⁵

4a He, governing the people of his native land and the senate
 house,
4b Died to the perpetual tears of the city.
5a Nor was it permitted to the servants of the lord to carry the
 bier,
5b But that was the burden of the striving people.
6a All the crowd wept—mothers and boys and old men,
6b And then the pious order [of senators] in their saddened togas
 wept.
7a Then even the roofs of Rome seemed to weep,
7b And then the houses themselves along the way (seemed) to
 give forth sighs.
8a Grant the highest (honors) of those who live, grant honors;
8b Lofty is the height that death has assigned to him.

Lines 1a through 3b apparently indicate why Junius Bassus was
worthy to be mourned at death: he served well as a Roman offi-
cial. Line 4a sums this up; *moderans* has the denotation of gov-
erning and the connotation of governing well—with moderation
or restraint in the exercise of power and authority. For this very
reason he was beloved, and restraint was *not* shown in mourning
his death: the perpetual tears of the city were shed (4b), and the
people themselves took over the task (and honor) of carrying his
bier, a task usually carried out by the servants of the deceased
(5a–5b). Lines 6a–7b depict the weeping that spread without re-
straint throughout the city at his funeral—touching not only his
own household servants but also the entire crowd (mothers, boys,
old men, senators), involving, in fact, not only the inhabitants of
Rome but their very habitations (roofs, houses). Because several
words have to be supplied at the beginning of the final two lines,
the wording of distich 8 is somewhat uncertain, yet the point is
clear: Junius Bassus, worthy of honors, has received the highest
honors from the living people of Rome, including honorable rites
for the dead (*honores* may mean either honors given to a living
person or rites performed for the dead; probably a double mean-
ing is intended here), but death has honored him more by assign-

ing him to a lofty height. The phrases appear to be conventional, but the orderly progression of ideas and the building up of images seem wholly in keeping with the sarcophagus of Junius Bassus.

MASKS OF SOL (?) AND LUNA

The transition from life to death mourned in the central inscription is marked with a visual metaphor by the masks at the ends of the lid. Commentators generally seem to be in agreement with de Waal that the half-preserved mask on the right ("distinguished by the crescent moon," according to Daltrop) is of Luna, the moon, and that, accordingly, the missing mask on the left would have been of Sol, the sun.[66] The course of a life, like the course of a day, has a beginning and an end: sunrise and moonrise, birth and death. Other sarcophagi suggest the same idea by an upright torch on the left and an inverted torch on the right. The light darkens. The lid ends of other sarcophagi are carved with two human or human-like masks; the sarcophagus of Porto Torres (fig. 41) shows such masks. Sometimes the two human masks are recognizable as comic and tragic or young and old. Youth becomes old age; the fullness of life becomes tragic death.

In general, masks on sarcophagi may allude backwards to the life of the deceased or they may allude forward to a hoped-for afterlife. Nock credits Hanfmann with the remark that "it is natural to interpret many funerary representations as looking backwards to the dead man's life (or the kind of life which could with dignified propriety be ascribed to him), rather than as looking forward to whatever destiny might be his in the Hereafter." Nock continues: "Even the masks, which are no doubt often decorative and sometimes Dionysiac, could hint at the idea of the dead man as having played his part on the stage of life. To us 'all the world's a stage' is a mere metaphor; to the dying Augustus it was not."[67]

On the other hand, Goodenough argues that masks on sarcophagi suggest the "putting on" of divinity, becoming united—in death and afterlife—with the god depicted by the mask.[68] The masks that appear on pagan, Jewish, and Christian sarcophagi derive from Greek masks, "and in Greek tradition masks . . . had overwhelmingly a Dionysiac association"[69]; their "basic meaning was eschatological: that the dead person had gone to join the

heavenly *thiasos*."[70] But, according to Goodenough, "it begins to look strongly as though the masks had become part of the lingua franca of late Roman mysticism, to be used as meaningfully with Isis as with Dionysus. It is precisely such symbols, detached from any specific original association and explanation, which the Jews and Christians were at liberty to adopt because they could give them their own explanations while the basic symbolic value of the motifs was still felt."[71] Thus the masks of the sun and the moon on the sarcophagus of Junius Bassus may refer metaphorically to either his life—from birth to death—or his death—and transformed life among the spheres of heaven.

Or the representations of Sol and Luna may have an even more specific, more Christian reference. Schiller points out that on the "earliest surviving example of a Passion sarcophagus" (ca. 340, here fig. 8) "Sol and Luna appear in the form of small busts in the corners above the wide curve of the eagle's wings." (The Bassus sarcophagus also has this eagle-headed conch, three times on the lower register.) In Roman art Sol and Luna were "the triumphal symbols of the victory and glory of the empire," as seen, for example, on opposite sides of the Arch of Constantine. "On the [fig. 8] sarcophagus," however, "combined with the *crux invicta*, they refer to the cosmic sovereignty of Christ and his eternal reign."[72]

Compositionally the masks of Sol and Luna facing outward at the ends of the lid reinforce the clear symmetry of the lid—mask/relief/inscription table/relief/mask—which in turn reinforces the symmetry of the facade of the box, marked most obviously by the alternating arches and gables of the lower register but signaled again and again both compositionally and iconographically. In relative size the complete lid would have been proportionately higher than the lid of the double-register sarcophagus of Adelphia (fig. 4), and in overall visual impact more striking and considerably less "busy." It would have commanded attention. Its figure style would have fit with that of the facade; its "pagan" or secular scenes would have coordinated with those of the ends. Prior to the placement of the three fragments of the inscription table and the large fragment of the right lid relief, viewers were occasionally lulled into ignoring the lid; the lower lid fragment seemed little more than a fringe above the two striking registers of biblical scenes. (The agricultural putti scenes of the ends have often been similarly ignored and rarely reproduced in photo-

graphs.) Thus the placing of the four lid fragments offers, as Dal-
trop notes, "an important visual aid for the entire presentation.
For the monument consists not only of the images of the two
registers of the sarcophagus box, but also of a third relief zone of
the sarcophagus lid lying above it, with an inscription table in
the middle"[73] and masks of Sol and Luna at the ends.

A	B	C	D	E
Mask:	Relief:	Verse	Relief:	Mask:
Sol?	???	Inscription	*Klinē* Meal	Luna

In the visual movement from the central inscription
and the left and right relief scenes, with their combined refer-
ences to the honorable Junius Bassus, to the masks of the sun and
the moon at the corners we move symbolically from *bios* to cos-
mos. The life of Junius Bassus, as significant as it was, is set
within a larger frame.[74] The pattern is seen below the lid as well,
with the harvest and season putti of the left and right ends serv-
ing as a cosmic (or natural world) frame for the biblical scenes of
the facade. But the framing context is not necessarily the most
important. There is a hierarchy of spheres of importance here—
first biblical, then biographical, then natural/cosmic—that cor-
relates with the importance of the zones of the sarcophagus—
first facade, then lid, then ends. The personal history of the de-
ceased (lid) is to be seen in the broader context of the biblical
history of salvation (facade), which also gives new meaning to the
natural order of the cosmos (Sol, Luna, ends). Daltrop is also
aware of this process of inclusion: "In this redemptive process
[suggested by the facade scenes] the pagan world is included and
transformed: the vintage, the grain harvest, and the seasons on
the ends point symbolically to the afterlife, while the lid pictures
of the meal of the dead and the *dextrarum junctio* allude to an-
cient Roman custom that retains its value for Christian faith in
the hereafter."[75]

The Junius Bassus sarcophagus is distinctive in a number of
ways, but among them is *not* the merging of "pagan," or perhaps
more properly, secular imagery and specifically Christian im-
agery. This was almost typical of the mid-fourth century—an ob-
servation to which we shall return in the concluding chapter.
One cannot help but wonder if the shifts of later centuries that
caused this blending to be reevaluated made the lid of the Bassus

sarcophagus not only increasingly difficult to understand but also increasingly vulnerable to damage or destruction.[76] As Daltrop has so correctly observed: "The newly re-fitted lid fragment, therefore, not only visually completes the appearance of the Junius Bassus sarcophagus, but it leads us deeper into an understanding of the world of A.D. 359, the time after the Edict of Toleration of Constantine the Great and before the Edict of Theodosius, between the recognition and the exclusive acceptance of the Christian religion."[77] Before concluding this study with a brief view of that fourth-century world and an integrative review of the iconography of the sarcophagus, we will examine several compositional and ornamental elements of the piece that in themselves reflect that complex world and initiate that work of integration.

7 Compositional and Ornamental Elements

EVEN ELEMENTS of the composition and ornamental structure of the Junius Bassus sarcophagus seem to confirm significant correspondences between and among scenes and to lead the viewer beyond a separate understanding of the upper and lower registers, spandrels, ends, and lid to a unified vision of the whole. Most importantly, the double-register columnar form allows clear linkages to be made between scenes that are symmetrically placed within one register and/or between scenes that are lined up vertically, thus unifying the work and undergirding iconographic connections.

VINE COLUMNS

The central scenes of the sarcophagus facade, upper and lower, are strongly set apart from the others and linked together vertically. A minor visual link is presented in the curve of the arch, as repeated in the curve of the drapery over the head of the personification of the cosmos. But the major link is provided by the two central pairs of columns that are distinguished from the other columns by their representations of putti gathering grapes (figs. 43 & 44). Gerke, noting that these columns serve to bring out the most important scenes,[1] "the heart of the composition,"[2] observes that such columns generally flank a center scene of the Unconquered Cross or Christ enthroned (see fig. 6).[3] The Junius Bassus sarcophagus, of course, presents a Christ enthroned; and the connotations of triumph and resurrection are also borne by the triumphal entry, which, through its portrayal of the historical Christ as earthly king, presents a foreshadowing of Christ enthroned as heavenly king in a way the Unconquered Cross would not. The vine columns not only center our focus and tie together the two registers, but their putti also refer us to the grape-gathering putti of the left end of the sarcophagus and thus

link facade and ends. And, of course, the vines themselves have rich connotative significance in early Christian literature and art.

Gerke observes that (1) (grape) vine columns are often used on Christian sarcophagi, whereas columns of pagan sarcophagi generally feature ivy[4]; and (2) such columns with vine tendrils appear on passion sarcophagi from 340 to 370, sarcophagi to which the Junius Bassus sarcophagus is close in style.[5] The reasons for the Christian preference for grape vines over ivy are made plain in the comments of early Christian writers as they elaborate on John 15:5, "I am the vine, you are the branches," or Isaiah 5:1–7, the song of the vineyard. Hippolytus (d. ca. 236) writes: "The spiritual vine was the Saviour. The shoots and vine-branches are his saints, those who believe in him. The bunches of grapes are his martyrs; the trees which are joined with the vine show forth the Passion."[6] In a mystagogical catechesis for neophytes, a homily on Isaiah 5:1–7, which was read during the paschal vigil, Zeno of Verona (ca. 370) writes: "[The new vineyard is the church. The Lord] trained it to bear an abundant harvest. And so today among your number, new shoots are trained along their trellises; bubbling like a sweet stream of fermenting must, they have filled the Lord's wine-vault to the great joy of all."[7] In another mystagogical catechesis, that of Asterius the Sophist (d. after 341), we find an even closer tie between the vine and neophytes: "The divine and timeless vine has sprung from the grave, bearing as fruits the newly baptized, like bunches of grapes on the altar."[8] Such vine imagery is related to the symbol of the church as a "planting" and the figure of the baptized person as a "tree." The direct connection to baptism is manifest in the literal meaning of *neofitus*, "newly planted."[9]

COMPOSITIONAL ELEMENTS

The double rows of columns, with the vine columns at the center, give a vertical orientation to the sarcophagus. Likewise the upper entablature and inscription and the lower arches, gables, and spandrels give a horizontal orientation to the work. The level entablature of the upper register unites the five scenes over which it extends; the inscription seems a continuation of the entablature. Although all the poses of the characters depicted

on the facade are dignified, the upper-register scenes seem espe-
cially compatible in their almost "heavenly" stateliness and sta-
bility. The perfect bisymmetry of the central scene is echoed to
the right and to the left in the two arrest scenes. The first and
final scenes each contain one standing figure with both arms in
action, one background figure looking to the side, one nonstand-
ing figure (Isaac kneeling; Pilate sitting), a short pillar, and a sug-
gestion of scenery (ram and shrub; building or city gate). The
spandrel scenes are a part of the unifying system of alternating
arches and gables of the lower register. The lower-register scenes
are more earthy or earthly in their details: piles of rocks or dung,
trees, a snake, wheat, a lamb, an ass, lions, reeds, and naked hu-
man bodies appear, as compared with only the obligatory ram and
a background shrub and building above. Even the vine columns
of the lower register follow this pattern; they are richer and more
varied in detail, including on the right a dancing fawn and on the
left a fawn or satyr with a sheep on his shoulders.[10] On the lower
register, the two gables single out two scenes for comparison; the
three arches relate three others; and both gables and arches signal
that symmetry is a key to interrelating the scenes. Under the ga-
bles naked figures and animals are portrayed and paired. Under
the first and final arches groupings of three adult figures interact.

One might ask whether the compositional and figural symme-
try of the Bassus sarcophagus is weakened by the Job/Paul pair-
ing. Gerke's argument that the three-figure grouping of Paul's ar-
rest and the direction of Paul's gaze demand that the Paul scene
be next to the Peter scene is at least understandable. Exchanging
the Abraham/Isaac and the Paul scenes, as Gerke suggests, would
result in all the main figures of the corner scenes facing inward
or looking inward. One could also argue that the seated Job, fac-
ing inward, would more closely parallel the seated Pilate, facing
inward.[11] But from the perspective of the Bassus sarcophagus as
it was carved, and not the possible antecedents of its hypotheti-
cal rearrangement, a visual, figural symmetry is indeed at work
in the four scenes in question—not a horizontal but a diagonal
symmetry. Although the arrangement of these four scenes ap-
pears to be based primarily on the thematic or even typological
relations of the biblical characters and events they portray, it is
not necessarily accidental that the Job and Pilate scenes, which
are rough mirror images of each other, form the poles of a diago-

nal axis. Abraham and Paul are less strictly parallel in a compositional sense, but in contrast to Job and Pilate they are standing and looking outward. The diagonal lines of symmetry have their imaginary crossing in the center of the sarcophagus, from which the scenes radiate symmetrically. From the corner scenes attention is refocused on the center.

Thus, in addition to suggesting paired relations between scenes of the upper and lower registers by their symmetrical arrangement, the Junius Bassus facade seems to refer the viewer from Abraham to Pilate, from Pilate to Job, from Job to Paul, from Paul to Peter, from Peter to Christ, from Christ to Abraham, in a never-ending pattern of visual and iconographical cross-references. The viewer's gaze is drawn purposefully from one scene to another and another. Similarly, the gazes of the carved central characters appear not to be random. Paired Abraham and Pilate look left; paired Peter and the arrested Christ look right, as do the related figures of Job and the riding Christ and Paul. Disobedient Adam and Eve look down, obedient Daniel (orant) looks up, and the enthroned Christ looks forward and outward. To follow the gazes of these characters is perhaps to glimpse the inner vision of their sculptor.[12]

The enthroned Christ figure looking outward at the viewer draws him or her into the center of the work. Two additional details attract attention in that center: above the enthroned Christ the inscription, and above the triumphant Christ the eagle-headed conch.

INSCRIPTION

The inscription "rests on" the entablature, as the spandrel scenes "rest on" the arches and gables, suggesting a possible parallel between the inscription and the spandrel scenes. The central pair of spandrel scenes (multiplication of the loaves, baptism of Christ) are types of the sacraments, and it is interesting to note that the words inscribed over the central scene of the upper register are NEOFITVS IIT AD DEVM (see fig. 44)—that is, this new Christian having experienced the sacraments of God's action in Christ went to eternal life in God.[13] Had the complete inscription been accurately centered in the available space, the NEOFITVS phrase would have appeared to the right of center, as it

does in the drawing by P. L. Dionysius shown in fig. 14, in contrast to the engraving by A. Bosio shown in fig. 15, which is truer to the original in its spacing of the inscription (see fig. 1). Of course the exact placement of words could be accidental: the inscriber could have simply assumed the inscription would fill the entire space, begun work near the left, arrived at NEOFITVS in the center, and had a bit of space to spare at the right when he finished.[14] Yet this seems to me unlikely, as it does to Daltrop: "These words [NEOFITVS IIT AD DEVM] cannot have been carved directly above the middle scene by accident. They cast a light on the way in which Junius Bassus [or his family] must have wanted the represented images to be understood."[15] Thus the central spandrel scenes, types of the sacraments, find their antitype signified in the centrally inscribed words. Participation in the sacraments prefigures eternal life: NEOFITVS IIT AD DEVM.

EAGLE-HEADED CONCHS

A second significant detail in the center of the work is the eagle-headed conch, which fills all three arches of the lower register (see fig. 45). Lawrence, in observing the sarcophagus from a stylistic point of view, finds the eagle-headed addition to its conch "[m]ost curious of all." As she describes, "The conventional petal conch appears below but instead of a hinge at the top we find an eagle head with a full naturalistic treatment of eyes and feathers."[16] Lawrence points out a short series of sarcophagi with an arching eagle or an eagle-headed conch in this position, each of which, except that of Junius Bassus, is "above the Symbolic Resurrection, where its presence is motivated by the labarum" (for example, Lateran 171, fig. 8). Therefore, Lawrence asserts, this "notable inconsistency" shows that the sculptor of the Junius Bassus sarcophagus "completely misunderstood" the theme; in fact, his "model" probably contained the Symbolic Resurrection, which he did not like or understand, and for which he thus substituted the triumphal entry.[17]

A careful iconographic reading of the sarcophagus makes it obvious that the placement of the triumphal entry was no casual substitution. Though it may perhaps be argued that a Symbolic Resurrection scene would have served as well as the triumphal entry as a counterpart to or even a type of Christ enthroned, such

a symbolic scene would have been somewhat awkwardly out of place among the otherwise strictly "historical" intercolumnar scenes.[18] From other details it appears that the sculptor of the Junius Bassus sarcophagus intended the central focus to be the upper center scene, not the lower one. Had the Symbolic Resurrection appeared in the lower center intercolumniation, it surely would have drawn attention away from the scene of Christ enthroned. The eternal kingdom of Christ was of central importance to the sculptor, and its depiction in the Christ enthroned is appropriately supported by the triumphal entry of Christ into Jerusalem as earthly king. Thus, if the sculptor made a substitution of a scene under an eagle-headed conch, it was a careful substitution based on the overall plan of his work.

In view of the careful design and execution of the work, we may feel quite secure in regarding as an overstatement Lawrence's assertion that the eagle-headed conch without the Symbolic Resurrection and repeated three times is "now deprived of all significance."[19] Gerke's judgment is less harsh: although the Unconquered Cross (or Symbolic Resurrection) is missing on the Bassus sarcophagus and the eagle's head that is usual over this scene appears "generalized and less clear," still the eagle's head reminds "the initiated from afar of this motif."[20] It seems entirely possible that this iconographic allusion to the resurrection was significantly retained by the sculptor, who placed it appropriately above the *triumphal* entry and thus below and supporting the *resurrected* Christ enthroned and also above Job and Paul in order to link these anticipations (or, in the case of Paul, an echo) of the resurrection. As mentioned above, Wilpert pictured three sepulchral examples of adjacent Job and Paul scenes that are linked to the resurrection by their placement to the right of a Symbolic Resurrection scene (see fig. 9).[21] The eagle-headed conch filling the arches of the Junius Bassus sarcophagus links the extreme scenes to the center, and the lower center scene is linked to the upper center scene, as we have observed, to complete the unifying movement.

In addition to its placement, the eagle-headed conch is significant in itself. The joining of an eagle's head to a shell is not, of course, a natural connection but a symbolic one. The conch, associated with the water of its natural environment, was a pagan symbol of the birth of Aphrodite from the shell of the sea and

became a symbol of Christian baptism, the ritual experience of death and rebirth.[22] The eagle was the symbol of the "power to take men to immortal life with God"[23] or the symbol of Jupiter in the art of the Roman triumph[24] or the imperial symbol of victory[25] and, as illustrated in the series of sarcophagi pointed out by Lawrence, was apparently associated with the triumph of Christ the king in the resurrection. Thus, when the eagle and the conch are joined, the resulting combination may be "read" typologically: Christ's death and resurrection are reactualized in the sacrament of baptism, which is the type (and present foretaste) of the Christian's own death and resurrection.

Since the earliest Christian tradition, baptism was indeed understood as a participation in Christ's death and resurrection. We refer once more to Paul's letter to the Romans:

> Do you not know that all of us who have been baptized into Christ Jesus were baptized into his death? We were buried therefore with him by baptism into death, so that as Christ was raised from the dead by the glory of the Father, we too might walk in newness of life. For if we have been united with him in a death like his, we shall certainly be united with him in a resurrection like his.
>
> Romans 6:3–5[26]

The understanding of the sacraments as the beginning of salvation/resurrection through participation in God's action in Christ is, of course, central to the overall meaning of the sarcophagus of Junius Bassus.

8 Integration

WE BEGAN this study by focusing on the compositional cues of the sarcophagus of Junius Bassus and the contemporary conventions behind it, that is, by looking carefully at the work itself and looking around at other works of its time (chapter 1). We listened to what several art historians have had to say about the iconographical program of the sarcophagus (chapter 2). We have argued that an overall interpretation of its iconographical significance that contradicts either the cues of its composition or the constraints of its context (as suggested by both images and texts) cannot be finally convincing. By examining each group of scenes (intercolumniations, spandrels, ends, lid, as well as some significant compositional and ornamental elements) in the light of these two sets of factors we have sought to present a convincing—if never final—reading of the iconographical program (chapters 3–7). As we integrate these observations into a concluding statement, we again draw attention to the work itself and the work in context. In addition, we will move from our focal question to our subsidiary question, as given in chapter 2 above: from asking "How does the fourth-century context illuminate the iconographical program of the sarcophagus of Junius Bassus?" to asking "How does the iconographical program of the sarcophagus of Junius Bassus illuminate the fourth-century context?"

ICONOGRAPHICAL PROGRAM

The discussion of the iconographical program of the Junius Bassus sarcophagus presented in this book aims beyond Gerke's intriguing interpretation by remaining faithful to the arrangement of scenes as sculpted, and beyond Gaertner's ingenious one by following the work's compositional cues. It aims beyond de Waal's systematic approach by anchoring the understanding of the work in contemporary, early Christian modes of

interpretation, especially typological thinking. It seeks to expand and deepen the brief suggestions of typological connections given by Schefold by proposing a unified iconographical program that is typological in a broad sense—in the sense of resting on a conviction of the connectedness of events in "holy history."

In an integration of the overall significance of the Bassus sarcophagus, a statement of the full iconographical program of the work, we must consider simultaneously relationships of anticipation and fulfillment (usually expressed in scenes arranged symmetrically on the same register) and thematic parallels (frequently expressed in scenes in line vertically).[1] In other words, we must review not only how Job relates to Paul but also how Job relates to Abraham and Isaac, not only how Daniel relates to Adam and Eve but also how Daniel relates to the arrested Christ. In addition, we must summarize how the spandrels relate to the intercolumniations and how the lid and the ends relate to the facade. The number of interrelationships dictates discussion by means of a simplified schema—in which Arabic numerals represent the scenes of the intercolumniations, lower-case letters the spandrel scenes, upper-case letters the lid scenes or elements, and Roman numerals the end scenes. Diagram 8–1 represents compositional links between scenes, and diagram 8–2 suggests iconographic connections.

Compositional elements give the first cues that the scenes of the sarcophagus were carefully arranged and are to be carefully read. The compositional links are not all of the same kind or strength. Scenes 6, 8, and 10 appear under eagle-headed conchs, scenes 7 and 9 under gables. Scenes 3 and 8 appear between vine columns. Scenes 2 and 4 are composed of three draped standing figures, with the central figure looking to the right. Scenes 1 and 5 also contain three draped figures—two standing and one nonstanding, with two figures looking to the left—as well as carved backgrounds. Scene 7 features an animal between two nude standing figures, who look down; scene 9 features—or did originally—one nude standing figure, who looks up, between two animals. In scenes 6 and 10 three draped figures interact, and the most important figure in each looks to the right. At the corners, scenes 5 and 6 present two standing figures and one who is seated and looking inward; and scenes 1 and 10 present three figures— the most important of whom is standing and looking outward.

At the center, scenes 3 and 8 depict two views of the seated Christ. On the lid, now fragmented, the central inscription (C) was framed by two relief scenes (B & D), in turn framed by two masks (A & E). In composition, the upper and lower scenes of the left end (I & II) are more parallel than those of the right end (III & IV), although all the end scenes are much closer in style and composition to each other than to the scenes of the facade or the lid.

Typological thinking is the key to the pattern of the iconographic connections among scenes of the Junius Bassus sarcophagus (see diagram 8–2). Only in the case of scenes 1 and 5 may we speak in the strict sense of a paired type (Abraham's sacrifice of Isaac) and antitype, and even here the antitype (God's sacrifice of Christ) is presented by allusion (in the scene of Pilate's judgment of Christ). Yet the typological categories of promise and fulfillment, anticipation and completion, are certainly in the near background of the paired intercolumnar scenes: 1 and 5, 2 and 4, 3 and 8, 6 and 10, 7 and 9. Interrelations between linked pairs suggest a unified reading of each register. Upper register: Christ, obedient to God in his sacrificial death (scenes 4 & 5), fulfills victoriously (scene 3) the incomplete sacrifice of Isaac by Abraham (scene 1) and is post-figured by the martyrdom of Peter (scene 2). Lower register: Christ's obedience to death and sovereignty over death (scene 8) are foreshadowed by Daniel's obedience and rescue (scene 9), which reverse Adam and Eve's disobedience and death (scene 7), and Christ's victorious death is post-figured by Paul's martyrdom (scene 10), which goes beyond Job's patient suffering and restoration (scene 6).

Yet the two registers together also present a unified meaning, one that is supported by thematic connections between scenes lined up vertically. Scenes 3 and 8 obviously present the victorious Christ—central for the sarcophagus and for typological thinking, as for Christian faith generally. Scenes 2 and 4 suggest death—but triumphant death—through martyrdom (or crucifixion) in obedience to faith. Scenes 7 and 9, below 2 and 4, also concern obedience, death, and rescue from death: the disobedience and death of Adam and Eve are reversed by the obedience and rescue of Daniel (or the promise of Adam and Eve's creation is fulfilled in Daniel's rescue). It is commonly recognized that the sacrifice of Isaac by Abraham (scene 1) finds its completion in the

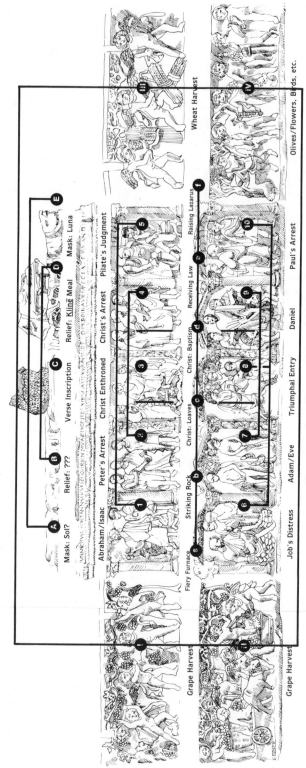

Mask: Sol? Relief: ??? Verse Inscription Relief: Kline Meal Mask: Luna

Abraham/Isaac Peter's Arrest Christ Enthroned Christ's Arrest Pilate's Judgment

Fiery Furnace Job's Distress Adam/Eve Triumphal Entry Daniel Paul's Arrest

Striking Rock Christ: Loaves Christ: Baptism Receiving Law Raising Lazarus

Grape Harvest Grape Harvest Wheat Harvest Olives/Flowers, Birds, etc.

DIAGRAM 8-1: Compositional Links

Mask: Sol? Relief: ??? Verse Inscription Relief: Klinē Meal Mask: Luna

Abraham/Isaac Peter's Arrest Christ Enthroned Christ's Arrest Pilate's Judgment

Christ: Loaves Christ: Baptism Receiving Law Raising Lazarus

Fiery Furnace Striking Rock Paul's Arrest

Job's Distress Adam/Eve Triumphal Entry Daniel

Wheat Harvest Olives/Flowers, birds, etc.

Grape Harvest Grape Harvest

DIAGRAM 8-2: Iconographic Connections

sacrifice of Christ, alluded to in Pilate's judgment (scene 5). But art historians have generally ignored the analogous link between Job and Paul (scenes 6 and 10, below 1 and 5) by which the incomplete sacrifice of Job (his family dies, but he lives and is restored) is related to the complete sacrifice of Paul (martyrdom), as the incomplete sacrifice of Isaac by Abraham (the ram is killed, but Isaac is spared) is related to the complete sacrifice of Christ (crucifixion).

When the relationships of the four corners of the sarcophagus facade are understood, it is also understood that one is to view Paul's martyrdom (although depicted on the lower register) as equivalent to Peter's martyrdom (depicted on the upper register) in its parallel to Christ's crucifixion. The typological links are complex: the sacrifice of Isaac by Abraham prefigures Christ's crucifixion, which is post-figured in the martyrdoms of Peter and Paul. Thus the placement and interrelation of scenes are complex: Christ's crucifixion is suggested in two adjacent scenes (4–5); Abraham/Isaac (1) is symmetrically opposite the one (5); Peter (2) is symmetrically opposite the other (4); and Paul (10) is directly below the one Abraham/Isaac is opposite (5). Peter's arrest is given a positive connotation by its placement on the upper register, adjacent to Christ enthroned and symmetrical with Christ's arrest. And Paul's arrest is given a positive connotation by its placement not only on the right of its pair (Job/Paul)—the right side being always the more positive side on the Junius Bassus sarcophagus facade—but also in the niche farthest right on the lower register, paralleling the allusion to Christ's death in the judgment of Pilate in the niche farthest right of the upper register.

Typological thinking is also behind the paired spandrel scenes, but in a somewhat different way. The outermost spandrel scenes, a and f (three youths in the fiery furnace and the raising of Lazarus), are most clearly types of the resurrection, yet the story of Lazarus goes beyond the story of the three youths: the three youths are rescued from approaching death; Lazarus is raised from actual death. Thus scenes a and f, the first and final spandrel scenes, are related like scenes 1 and 5, and 6 and 10, the first and final scenes of the two registers. Spandrel scenes b and e are, in a broad sense perhaps, types of the church, as represented by its typological leader before Christ (Moses) and, possibly, its apos-

tolic leader after Christ (Peter, the antitype of Moses). The two central spandrel scenes are types of the sacraments of the church: eucharist (c, multiplication of the loaves) and baptism (d, baptism of Christ).

Three of the four end scenes also suggest the sacrament of the eucharist, not typologically but symbolically. The left end scenes (I & II) and the upper right end scene (III) allude to the elements of the eucharist: wine and bread. The lower right scene (IV) is symbolic of the resurrection (a season of new life after death—hence its connection to 5/10/f) anticipated by those who partake of the sacraments. Thus the spandrel and end scenes suggest typological or symbolic correspondences to realities beyond the biblical scenes of the intercolumniations: the sacraments, the church, resurrection.

These realities also receive emphasis in the middle of the sarcophagus facade, where the iconography points to the presence of the victorious Christ in the sacraments of the church. While pictorial reference to the victorious Christ is doubled (scenes 3 and 8), pictorial references to the sacraments are made repeatedly in the area circumscribing the center or framing each of the two central christological scenes (c = multiplication of loaves, d = baptism of Christ, grape-gathering putti on central columns, NEO-FITVS, eagle-headed conch). Since the ends of the sarcophagus repeat this sacramental motif, in moving away from the center we return to the central motif. As Grabar states, references to the sacraments of baptism and the eucharist in Christian funerary art signal that the deceased was a Christian and thus could "confidently expect the salvation of his soul."[2] G. W. Olsen has argued that the method of typology itself was specifically connected with the liturgy of baptism:

> Paul's interpretation of baptism in I Cor. 10:1-4 [in which passing through the Red Sea is given as a type of baptism] is probably merely a Christian adaptation of what Paul had studied of Jewish proselyte baptism. The close connection between typology and the liturgy from the beginning of the Christian dispensation illustrates the claim that the traditional spiritual sense of Scripture is in origins often a dogmatic sense which attempts, above all through the liturgy of baptism, to state the relationship between the Old and New Dispensations. The catechesis of the Church

was, going back even into Judaism, a catechesis articulated espe-
cially through the typology associated with baptism.[3]

Such an argument is surely of significance in relation to the sar-
cophagus of the newly baptized Junius Bassus, where typological
thinking in the broad sense underlies so many interrelations of
scenes.

Although the lid of the sarcophagus is badly damaged, enough
remains to indicate that it focused directly on the life and death
of Junius Bassus. The inscription praises his public service in life
and depicts the public mourning of his death. The right relief
must have presented his image in the meal-of-the-dead scene;
perhaps his wife was portrayed there as well and/or in the left
relief. The masks of Sol and Luna at the corners transpose this
life, this *bios*, and this death onto the cosmos: in life Junius Bas-
sus shone as brightly as the sun; in death that light is reflected
(as the sun's light is reflected by the moon) in the praises of the
people who preserve his memory.

The inscription above the entablature of the upper register
links the references to personal history on the lid with the scenes
of "holy history" on the facade: Junius Bassus, city prefect, is
Junius Bassus, Christian neophyte. Peter Brown argues that
"Christian baptism was a ceremony of simplification: it was not
so much a ceremony of rejection and renunciation as of cutting
down anomalous and conflicting strands in the life and person-
ality of the baptized."[4] For Junius Bassus, who was likely bap-
tized on his deathbed, the simplification seems to have entailed
a focus on and an assurance of incorporation into the history of
salvation. Gerke suggests that Junius Bassus realized that, in the
face of death, the Bible was more important than family life.[5] It
is a "beautiful thought," Gerke muses, to suppose that the whole
composition leads back directly to Junius Bassus's wish.[6]

While it may be a "beautiful thought," it cannot be demon-
strated. What can be demonstrated is that the total sculptural
program intends to include Junius Bassus, NEOFITVS, in the his-
tory of God's saving acts toward humankind, culminating in
Christ's victorious death and eternal reign and in the sacraments
of the church whereby Christians participate in Christ's death
and resurrection.[7] God's promises of redemption and their fulfill-
ment in Christ's death and resurrection are the theme of the

paired scenes of the intercolumniations of the facade. The Christian's participation in this reality through incorporation into the redeemed community by baptism and the eucharist is the theme of the spandrels, the ends, the inscription, and various ornamental details. The typologist views history as "the progressive unfolding of God's consistent redemptive purpose."[8] It is in this broad sense that the Junius Bassus sarcophagus may be considered typological: as the Old Testament promises of redemption (scenes 7, 1, 9, 6) are fulfilled in the New (scenes 8, 4, 5), so the New Testament story is continued in the church—its sacraments (c, d, i, ii, iii), its martyrs (2, 10), and even its neophytes (facade inscription, lid), for Christ's reign is universal and eternal (3, iv).

Whereas typological links—whether strict or analogous—are mostly between scenes arranged symmetrically on the same register (3–8 is the exception), thematic parallels operate on both the horizontal and the vertical axes of the work. The resulting iconographical program is to be read concentrically: from 3–8/c–d (center), to 2–4/7–9/b–e (inner zones), to 1–5/6–10/a–f (outer zones), to A–B–C–D–E (lid), to i–ii–iii–iv (ends). Thus we may read the facade from the center outward: this Christian's participation in the sacraments (c–d—also i, ii, iii) of the victorious Christ (3–8) incorporates him (A–B–C–D–E) into the community (b–e) of those for whom obedient death (2–4/7–9) is overcome in an experience of resurrection (1–5/6–10, a–f—also iv). Perhaps the eagle-headed conch sums up this meaning; it is a succinct symbolic image of resurrection through baptism, salvation through sacrament.[9]

Although we must beware of seeing "everywhere the influence of the 'ecclesiastical doctor' who composed scenes redolent with meaning for Christian doctrine," an offense Marion Lawrence (rightly) accuses Wilpert of committing,[10] the strong interrelationships and the overall unity—in structural, compositional, and ornamental elements and in iconography—of the sarcophagus of Junius Bassus simply cannot be ignored. They are, rather, to be understood in their fourth-century context. If perhaps we err in seeing the work as *too* carefully organized along typological lines, our vision may at least serve as a corrective to viewing the sarcophagus as a "haphazard" arrangement of images[11] or a mistaken rearrangement of scenes.[12] Our discussion of the significance of the interrelated images is not meant to replace them

(schematic diagrams are a poor substitute for carved marble) or to reduce them to a "proven" program, but to enable us to view them—again and again—with ever new understandings. Good-enough's comment on "proof" in historical interpretation is well taken: "*Proof* of motives, causes, and meanings in history always lies beyond the historian."[13] Yet awareness of the theological dimensions of early Christian art, and especially its iconography, does clarify understanding of its more strictly artistic dimensions, just as greater attention to artistic evidence strengthens understanding of early church history and theology.[14]

The typological view of events within Judeo-Christian history—a biblically rooted view expressed in early Christian theology and art—is most helpful in understanding the way in which Old and New Testament scenes and pictorial references to the sacraments of the church are interrelated on the Junius Bassus sarcophagus. As Jean Daniélou affirms: "[T]ypology is found to be at the point where N[ew] T[estament] exegesis and patristics meet in the life of the ancient Christian community,"[15] that is, in hearing and telling the biblical narratives, in praying prayers and participating in the sacraments, in burying the dead. The best safeguard against the hypothesized "ecclesiastical doctor" is the realization that Christian sepulchral art was not meant to argue dogmas but to affirm beliefs and to attest hopes. The iconography of the sarcophagus of Junius Bassus presents an at once confident and hopeful view of salvation history, from Adam and Eve to Junius Bassus. It is a confession of faith and an ardent prayer poured out together and frozen eternally in stone.

FOURTH-CENTURY CONTEXT

The sarcophagus of Junius Bassus seems in some ways antiquarian and in other ways avant-garde within its fourth-century context. The lid depicts a *klinē* meal of the dead otherwise unknown on Christian sarcophagi but popular on Roman grave monuments of the second century. The ends present seasonal scenes of a "panoramic" type that became known in Rome in the early fourth century. The facade (intercolumniations and spandrels) includes among its sixteen scenes some well known from the catacombs and sarcophagi—especially frieze sarcophagi—of the third and fourth centuries (Abraham and Isaac, Adam and

Eve, Daniel in the lions' den, the three youths in the fiery furnace, striking the rock, multiplying the loaves, raising Lazarus), some scenes popular on sarcophagi—especially tree or columnar sarcophagi of the second half of the fourth century (Peter's arrest, Christ giving the Law, Christ before Pilate, Christ's triumphal entry), and other scenes rare in both those repertoires (Christ enthroned over Coelus, Job's distress, Paul's arrest, Christ's baptism). Since the Bassus sarcophagus looks both backward and forward in its choice and arrangement of scenes, we must also look back, at least briefly, to the second and third centuries, as well as to the fourth century, in order to understand its historical context.

In the Roman West the late second and the third centuries of the Christian era manifested, in the words of Peter Brown, a "new mood" in religious sensibilities.[16] An important aspect of this "new mood" was the experience of the power of "conversion." Many religious traditions, including Christianity, stressed the disjunction between one's "real," spiritual self and one's conventional, social self. "The 'reborn' pupil of Thrice-Great Hermes, the 'spiritual' man of the Gnostics, the baptized Christian, each felt that a glass wall stood between his new life and his past: his new behaviour owed everything to God and nothing to society."[17] Conversion involved a turn away from a mundane, even threatening, reality to a more vivid and sustaining reality.

> By conversion, by accepting a revelation, they [the converted] cut themselves off from their own past and from the beliefs of the mass of their fellows. They manned the barricades in an invisible battle with the demons. As a result, the individual came to feel more strongly than ever previously that he needed to survive in another, better existence. The third century saw an increase in the influence of religious groups who claimed that their members, who had to defend with such ferocity a new-won sense of uniqueness in this world, would enjoy victory and rest in the next.[18]

It is this "new mood" that is displayed visually in the paintings of the catacombs and the carved scenes of third-century Christian sarcophagi: Daniel rescued from the lions' den, Isaac rescued from the hand of his father, Abraham, Jonah rescued from the sea monster and later from the sun's rays, and others. Daniel, Isaac,

and Jonah are saved from the threats of existence and participate in a truer reality—a new or renewed relationship with God. A clear example of this link between conversion and salvation is seen in the sarcophagus of Santa Maria Antiqua (figs. 11, 12, 13), dated to the third quarter of the third century. Central figures of a woman (orant) and a man (as a philosopher reading), representatives of the deceased, are flanked on the left by scenes from the story of Jonah and on the right by a Good Shepherd, the baptism of Christ by John, and two fishermen, presumably Christ's disciples. As we noted in chapter 1 above, this sarcophagus may be read: as Jonah was saved from the big fish and then from the sun, so the deceased hopes to be saved by the Good Shepherd, into whose baptism and discipleship he or she has entered. Saxl observes that this "sarcophagus represents Baptism as the rite of initiation, granting resurrection and salvation to the faithful"; and thus it is to be viewed in light of the custom "in pagan times to represent on the tombs legends which could be allegorically explained as a promise of salvation."[19] Sacrament and salvation are inextricably connected in the Christian expression of the "new mood." As Weidlé puts it, "[W]e can find the key to understand the early Church in general, and early Christian art in particular, only if we will refuse to divorce salvation and the sacrament, even in thought."[20] This is the third-century heritage of the sarcophagus of Junius Bassus.

Roman society in the fourth century is, again in a helpful phrase of Peter Brown, "a world restored."[21] "The newly formed governing class that had emerged throughout the empire by 350 thought of itself as living in a world restored to order: *Reparatio Saeculi*[,] 'The Age of Restoration,' was their favourite motto on coins and inscriptions."[22] The legend *Felicium temporum reparatio* (restoration of happy times) appeared on coins issued between 346 and 350 by the Christian emperors Constans and Constantius II.[23] Although the fourth century was a time of enormous religious and cultural changes, it was also a time of revival. Late antique society differed significantly from that of the classical Roman period, but it was "a rich and surprisingly resilient society" in its own right.[24]

Central to the momentous religious and cultural changes of late antiquity was the growth and development of the Christian church. It is not so much the conversion of Constantine but the

conversion of Christianity that demands attention. "For the con-
version of a Roman emperor to Christianity, of Constantine in
312, might not have happened—or, if it had, it would have taken
on a totally different meaning—if it had not been preceded, for
two generations, by the conversion of Christianity to the culture
and ideals of the Roman world."[25] The early fourth-century
Christian apologists, for example, were not simply defenders of
the faith but took an offensive position by claiming that what-
ever truths the classical world had to offer were confirmed and
superseded by the revealed truth of Christianity.[26] It is against
this background that we must view certain scenes on Christian
sarcophagi of the third and fourth centuries: for example, the fig-
ures of the philosopher reading and his muse (now *orant*), the
shepherd, and Neptune on the sarcophagus of Santa Maria Anti-
qua (figs. 11 & 12), and the scenes of the harvests, the seasons,
the meal of the dead, and possibly the Roman marriage gesture
on the Junius Bassus sarcophagus. Artists working for Christian
patrons were fully as able as Christian apologists to assimilate
pagan elements into an emerging Christian synthesis.

Junius Bassus, city prefect of Rome in 359, was part of the
newly formed governing class that viewed its age as "a world re-
stored." Junius Bassus, *neofitus*, was also part of the growing
Christian world that viewed itself as the completion of all that
was best in classical culture. This double sense of assurance per-
meates the pagan and Christian scenes of his thoughtfully con-
ceived, carefully structured, and finely carved sarcophagus. Saxl
refers to a new sense of "heroic dignity" displayed in the passion
sarcophagi that culminate with the Bassus sarcophagus. He even
compares columnar passion sarcophagi to "a type of heroic sar-
cophagus [that] had developed in the second half of the second
century, showing in the openings of a colonnade the labors of
Hercules, the most distinctive hero of the Greeks"; Saxl asserts
that the "time had come for the Christian heroes [Christ and
apostles] and their deeds to be shown in the same manner."[27]
Such "heroic dignity" seems born of a deeper sense of assurance
that the history of the individual through life *and death*, like the
history of the world in an age of restoration and the history of the
church in an age of triumph, is under God's sure and revealed
control.

If the conversion of the individual was a crucial aspect of the

"new mood" of the late second and third centuries—and thus part of the heritage of the Bassus sarcophagus—it was the conversion of a culture that was crucial to the growing Christian confidence and assertiveness in the fourth-century "Age of Restoration"—and dominantly expressed on the Bassus sarcophagus. But it was not only the Roman culture that was converted to Christianity; Christianity was converted to Roman culture as well. The Christianization of Rome and the Romanization of Christianity were parts of a twofold process.[28] The baptism of Junius Bassus, not only a senator but the city prefect himself, is evidence of the former, the Christianization of Rome. Since "[t]he old senatorial families certainly remained predominantly pagan down to the latter part of the fourth century,"[29] Junius Bassus's personal conversion was likely not a mere response to the cultural conversion. After his deathbed baptism, Bassus's high social standing in life found a parallel in his honored position in death: his sarcophagus was placed in immediate connection with the wall of the crypt of St. Peter.[30] The sarcophagus of the newly baptized Junius Bassus presents clear iconographic evidence of the Romanization of Christianity: the two central scenes, Christ enthroned and the triumphal entry, depend upon Roman imperial models; the appearance of Peter and Paul flanking the enthroned Christ and there receiving the Law, as well as their separate appearances in scenes of arrest that point to martyrdom, emphasize the importance of Peter and Paul as the chief apostles—on their way to becoming the patron saints *of Rome*.[31] Political power structures and images are being taken over by religious power structures and images, as Christianity is transformed from a persecuted faith to a tolerated tradition to (eventually) the established religion of the Roman empire.

Two aspects of the Bassus sarcophagus seem especially characteristic of its mid-fourth-century context, with its bold "Romanness" and confident Christianity: (1) its integration of so-called "pagan" and Christian imagery and (2) its more systematic iconographical program. We will look at these two aspects in turn, observing as well, although briefly, their wider application in fourth-century art and, more briefly still, religious writing.

First, the iconographical program of the Bassus sarcophagus illuminates the fourth-century context by reminding us that the neat divisions between "pagan" and Christian are ours, not those

of Junius Bassus and his contemporaries. For this reason we set the term "pagan" in quotation marks, signifying "so-called pagan." (Oftentimes the term "secular" or "conventional" would be more appropriate.) What seems most impressive about the scenes with "pagan" models on the Bassus sarcophagus is how much a part of a unified iconographical program they have become. Christian appropriation of "pagan" models was a well-established tradition by the mid-fourth century.[32] Concerning early Christian funerary art in particular, Henry Chadwick observes, "Human beings are in nothing so conservative as in funeral customs, and in the decoration of tombs and sarcophagi many of the conventions of the pagan workshop were simply continued."[33] For example, the porphyry sarcophagus of Constantina (or Constantia), the daughter of Constantine, who died in 354 and was buried in the mausoleum of Santa Costanza, depicts putti harvesting grapes, a motif familiar on Dionysiac sarcophagi as a suggestion of the joys of immortality.[34] But "pagan" and Christian conventions—in images and in words—occurred together on nonfunerary and nonsculptural artifacts as well.

Sometimes "pagan" and Christian elements were simply juxtaposed. The vault mosaics of Santa Costanza present geometric patterns, dolphins, Cupids and Psyches, grape harvests with putti, figures and heads, and images associated with paradise—all motifs known from "pagan" examples, while the cupola mosaics (destroyed in 1620 but known from drawings and a description) originally presented biblical scenes, "the scenes in the lower register being from the Old Testament, those above from the New."[35] The Projecta casket, a silver box for carrying toilet articles that is part of the Esquiline Treasure, dated to the mid-fourth century, juxtaposes a scene of the Toilette of Venus and a Christian inscription: "Secundus and Projecta, live in Christ" (SECVNDE ET PROIECTA VIVATIS IN CHRISTO).[36] The Calendar of 354, an almanac in codex form, now known only from fifteenth- and sixteenth-century copies of a Carolingian copy, contains lists of emperors, consuls, city prefects, and bishops of Rome, an Easter table from 312 to 410, the ecclesiastical calendar of the Roman church, and "the official city calendar in which the old Roman holidays are recorded without the addition of any Christian festivals,"[37] as well as drawings of imperial personnel, personifications of cities, planets, and months, and the signs of the zodiac.[38]

Chadwick comments: "The contents of this almanac, with its quiet juxtaposition of the old and the new without fusion, are symbolic of the gradual *transition* from pagan to Christian taking place in high Roman society during the second half of the fourth century."[39] Stephen Zwirn notes, with a somewhat different accent: "Its invocations, illustrations, historical and festal notices—secular, Christian, and imperial—attest to the *blending* of these elements at a high social and intellectual level (cf. [catalogue] no. 386 [the sarcophagus of Junius Bassus])."[40]

Sometimes pagan figures were Christianized. On the sarcophagus of Santa Maria Antiqua (fig. 11) the philosopher and muse frequently found on Roman sarcophagi[41] have become the Christian man and woman or the Christian reader of revealed texts and the personification of prayer or the soul (the *orant*).[42] On various early Christian monuments the mythological figures of Orpheus, Sol, and Ulysses were—to varying degrees—"associated with Christ Himself."[43] As Janet Huskinson has observed: "Most examples of these 'christianised' figures come from religious sites, many from funerary settings, and many from the area of Rome and Ostia."[44] The "great majority" of such representations "date from before the Peace of the Church or the mid-fourth century at the latest . . . and thus belong to a period in which Christians borrowed many motifs from contemporary pagan art to symbolise their beliefs about salvation."[45]

Sometimes conventional "pagan" scenes were transformed into conventional Christian ones with similar themes. The sleep of Endymion became the rest of Jonah under the gourd vine; the divine birth of Dionysus influenced the portrayal of the nativity of Christ; the horse-drawn chariot of Helios or Persephone reappeared as the chariot of Elijah or Christ.[46] As Lawrence observes: "Just as the ancient buildings were frequently turned into churches by the early Christians or used as quarries for their fine materials and rich carvings, so the antique monuments were treated as quarries for ideas, patterns for Christian stories, lending not only beauty to the new art but authority and the prestige of ancient wisdom as well. Theme after theme reappears transplanted from a pagan context to a Christian one but given new meaning and acclimated to new surroundings."[47]

Similar juxtaposition and transformation of "pagan" and Christian elements can be seen in early Christian literature. The

Octavius of Minucius Felix, "the only apology for Christianity written in Latin at Rome during the time of the persecutions"[48] (at the end of the second century), is a fictitious dialogue between the author, a lawyer, and two friends, the Christian Octavius and the pagan Caecilius. But this defense of Christianity against "paganism" employs "pagan" arguments—concerning the observed order of the universe, human reason, ethical behavior—and includes materials borrowed from Cicero, Seneca, and Plato, but no citations from Scripture. Of course, this may be just good strategy when attempting to convince and convert educated "pagans." It reminds one of the (later) Three Good Shepherds sarcophagus, where the context and the commentary, not the images per se, make the presentation Christian.

The main work of Lactantius (of Nicodemia in Bithynia) was the *Divine Institutes* (304–313), "in spite of all its shortcomings the first attempt at a Latin summa of Christian thought."[49] Although it does make minimal use of the Bible, it "abounds in quotations from classical authors, especially Cicero and Vergil" and also utilizes the Sibylline oracles and the writings of the *Corpus Hermeticum*.[50] Lactantius is also thought to have written a poem, *The Phoenix*, which retells the myth of the phoenix reborn from its ashes as an implicit symbol of the crucified and resurrected Christ, thus transforming this myth,[51] as the scene of Helios driving his chariot is transformed into a christological scene in the (earlier) ceiling mosaic of the tomb of the Julii in the Vatican necropolis.

With Tertullian, in contrast, we find basically a confrontation between "pagan" images and themes and Christian ones. Tertullian is, except for Augustine, "the most important and original ecclesiastical author in Latin."[52] All of his writings are polemical. The struggle between Christianity and "paganism" is the struggle between "truth" and "falsehood." His most important work, the *Apology*, written in 197, argues vehemently against any validity to "pagan" gods or worship and against any legitimacy to "pagan" complaints against Christians. For Tertullian, Christianity is not merely a new philosophy; it is divine revelation. As "truth" made known by God, Christianity cannot be destroyed by its persecutors. But in a smaller work written in the same year, *The Soul's Testimony*, Tertullian is somewhat less polemical—arguing that Nature is the teacher of the soul because

Nature is an image of God. Yet even here Tertullian, in contrast to the Greek apologists, emphasizes the uselessness of recourse to "pagan" philosophy.

Finally, with Augustine we see a clearly hierarchical, selective appropriation of "pagan" philosophy by Christian theology. A passage from Augustine's *On Christian Doctrine*, begun about 396,[53] makes this plain by an analogy with the Hebrew people's "spoiling the Egyptians" (Exodus 3:21–22):

> If those who are called philosophers, especially the Platonists, have said things which are indeed true and are well accommodated to our faith, they should not be feared; rather, what they have said should be taken from them as from unjust possessors and converted to our use. Just as the Egyptians had not only idols and grave burdens which the people of Israel detested and avoided, so also they had vases and ornaments of gold and silver and clothing which the Israelites took with them secretly when they fled, as if to put them to a better use. They did not do this on their own authority but at God's commandment, while the Egyptians unwittingly supplied them with things which they themselves did not use well. In the same way all the teachings of the pagans contain not only simulated and superstitious imaginings and grave burdens of unnecessary labor, which each one of us leaving the society of pagans under the leadership of Christ ought to abominate and avoid, but also liberal disciplines more suited to the uses of truth, and some most useful precepts concerning morals. Even some truths concerning the worship of one God are discovered among them. These are, as it were, their gold and silver, which they did not institute themselves but dug up from certain mines of divine Providence, which is everywhere infused, and perversely and injuriously abused in the worship of demons. When the Christian separates himself in spirit from their miserable society, he should take this treasure with him for the just use of teaching the gospel. . . .
>
> . . . That which was done in Exodus was undoubtedly a figure that it might typify these things. I say this without prejudice to any other equal or better understanding.[54]

Tertullian's antagonistic rejection of "pagan" philosophy was two hundred years earlier than Augustine's selective acceptance, but the appropriation of "pagan" philosophy by Minucius Felix

was contemporary with Tertullian and the comparable use by Lactantius post-dated Tertullian.

Factors in addition to date are clearly involved in how a Christian work interrelates "pagan" and Christian elements and themes. The social location of the writer or artist and his or her purpose and audience are crucial variables. Augustine and Boethius provide an additional example. Augustine's *Confessions*, written at the end of the fourth century, is filled with biblical quotations and allusions, although it also comments favorably on platonic philosophy. Boethius's *Consolation of Philosophy*, written in 524, expresses Roman world-weariness in a Christian-classic synthesis but without mention of Jewish history, Christ, or Paul, or any reference to Scripture. The arguments are founded on the idea of God as the highest good, natural theology, and reason. While both Augustine and Boethius were Christians, Augustine was a bishop and influential leader of the church and Boethius was a Roman senator and consul. Thus, although there may be general chronological patterns to the interrelation of "pagan" and Christian ideas in art and in religious texts in the late antique world, other factors (social and psychological, concerning author and audience) are equally important.

How is this fluidity between "pagan" and Christian images and "pagan" and Christian meanings possible in the late antique/ early Christian period? A variety of related answers has been offered. In the general terms of Shelton, it is because "many allegorical themes, while perhaps pagan in origin, were clearly of general application by the late empire."[55] In the more specific theoretical terms of Goodenough, it is because there existed a lingua franca of symbols in the Greco-Roman period, a shared language in which "live symbols" migrated from one religious tradition to another—adding new explanations or interpretations while their "values" or connotational or associative meanings remained constant.[56] In a thought-provoking phrase from Murray, the reason for this fluidity is that early Christian art is creative but not original: it is not "underived or independent of what has been produced before," but, "though proceeding from an established base, yet calls into existence something completely new because a fresh conception has entered into the old form, making the result not simply a copy or an imitation but a new production of human intelligence and power."[57]

It is perhaps ironic, as Goodenough notes, that "Christians borrowed pagan symbols most extensively and effectively, it would seem, during the fourth century, the very time when it was most busily engaged in liquidating paganism."[58] The nonironic aspect of this borrowing was that Christians presumably felt free to adopt and adapt what no longer seemed altogether alien or annihilating. The conversion of the culture to Christianity gave Christian artists and patrons the confidence to baptize "pagan" images and themes, although at the same time the conversion of Christianity involved in the adoption and adaptation of "pagan" images and themes prepared for the culture's conversion to Christianity.

The sarcophagus of Junius Bassus marks an important and intriguing transitional stage in the process of moving from late antique "pagan" imagery to early medieval Christian imagery. On the one hand, the Three Good Shepherds sarcophagus (figs. 33, 30, 32; last third of the fourth century [?][59]) exemplifies the type of neutral imagery that could be interpreted as either "pagan" or Christian: the shepherd as the Roman god of gardens or the representation of *humanitas* or *philanthropia*,[60] the vintage as symbolic of the joys of immortality, the seasons as natural images of cyclical renewal; or the shepherd as Christ the Good Shepherd, the vintage as an allusion to the vine of the Lord (and possibly the eucharist), the changing seasons as pointers to the resurrection of the dead. On the other hand, neither the Dogmatic sarcophagus (fig. 5; second quarter of the fourth century) nor the Two Brothers sarcophagus (fig. 3; second third of the fourth century) includes "pagan" imagery; all the scenes portray biblical events or later Christian traditions. But the Bassus sarcophagus occupies a *theoretical* place between the Three Good Shepherds sarcophagus and the other two, even though that may not be its *chronological* place. (Junius Bassus's commitment to *Roman* culture presumably played a role here.) The Bassus sarcophagus includes not only christological scenes with imperial (i.e., "pagan") models but also essentially "pagan" scenes (the seasons, the *klinē* meal). The christological content of the Christ enthroned and the triumphal entry quite overwhelms the model, and these two scenes are given the center focus on the facade. The Christian allusions of the seasons scenes of the ends, and especially the *klinē* meal of the lid, are more subdued, and these scenes are

subordinated to the clearly Christian ones that dominate the façade.

Thus on the Bassus sarcophagus specifically Christian scenes are given the place of first importance—the façade (intercolumniations and spandrels), and scenes that would be thought of as entirely "pagan" in another context are given a Christian or christianized significance by their placement on the lid and ends in subordination to the façade. (Similarly, the contemporary mosaics of Santa Costanza presented scenes with "pagan" models in the vaults over the ambulatory and Old and New Testament scenes on the central cupola.) This is a step beyond the juxtaposition of images and the christianization of individual figures or scenes. Several *systems* of thought and imagery are set in analogous yet hierarchical relation: "pagan" harvests of grapes and grain allude to the Christian "medicine of immortality," the bread and wine of the eucharist; "pagan" personifications of the seasons of winter and spring suggest the Christian hope of new life after death; perhaps the "pagan" meal of the remembered dead even elicits thoughts of the Christian meal of the eternally alive.[61]

But what channels this flow of "pagan" and Christian images and meanings so that the Bassus sarcophagus becomes a stream of significant scenes and allusions rather than a downpour of details or a whirlpool of confusion? At the ideological level, the images and meanings are channeled by a view of life that emphasizes the *extra*-ordinary symbolic dimensions of ordinary reality and a view of history that stresses the interconnections of past, present, and future events. (We will return to these ideas in a moment.) At the compositional level, the various "pagan" and Christian images and meanings of the Bassus sarcophagus are channeled by the careful arrangement of scenes in the overall presentation. This brings us to the second way in which the iconographical program of the sarcophagus of Junius Bassus illuminates the fourth-century context: it informs us that a quite complex Christian iconographical program can indeed be presented by about 360.

The contrast between the sarcophagus of Santa Maria Antiqua (figs. 11, 12, 13) and—three quarters of a century later—the sarcophagus of Junius Bassus illustrates the extent of the change. Both contain pagan figures or scenes; both contain scenes from

the Old Testament, the Bible of the Jews and the earliest Christians; and both contain scenes from the New Testament. Both presuppose the centrality of the sacraments for salvation and of salvation for life itself. But the sarcophagus of Santa Maria Antiqua has been described as "the paradigm of the syncretism associated with the reign of Gallienus"; and the "lack of fusion of the different figures and episodes, compositionally or even in scale," has been said, perhaps somewhat hyperbolically, to convey "a sense of the bizarre often found at the start of a new tradition in art or iconography."[62] The Bassus sarcophagus, in contrast, has been described as not only "illustrating several different possibilities of structural organization" but also arranging—"with an almost scholastic passion for system—much of the iconographical subject matter that was at the disposal of Early Christian funerary sculpture by the middle of the fourth century."[63] We need not repeat here our earlier comments on *how* the Bassus sarcophagus arranges all this iconographical subject matter by architectural frames, symmetry, subordination, parallels, etc. Perhaps the extreme rarity of the double-register columnar form may serve as a reminder that new possibilities of structural arrangement were at work here.

Of course, other fourth-century monuments, including Christian sarcophagi, are known to have relatively complex iconographical programs. The Dogmatic sarcophagus (fig. 5), for example, groups two Adam and Eve scenes at the upper left and three christological scenes at the upper right, separated by the portrait rondel; and two christological scenes at the lower left and three Peter scenes at the lower right, separated by Daniel in the lions' den. But the iconographical program of the Bassus sarcophagus (like its carving style) is exceptional for a fourth-century Christian work. In the following century, patterns of organizational structure—both compositional and ideological—employed here are further developed. The mosaics of Santa Maria Maggiore[64] and the carved wooden panels of the doors of Santa Sabina[65] are excellent examples of the continuing development.

While some have glimpsed the complexity of the iconographical program of the Bassus sarcophagus only to deny it because of its mid-fourth-century date (e.g., Grabar), others have glimpsed it only to explain it in non-fourth-century terms (e.g., de Waal,

Gaertner). We have sought, in contrast, to do justice to both the iconographical program and the fourth-century context, so that the two may prove mutually illuminating. We must conclude that any understanding of the development of early Christian art and iconography that assumes a smooth and logical progression in the two areas focused on here—the integration of "pagan" and Christian imagery and the increasing complexity of iconographical programs—is sadly oversimplified. Although in many cases a logical progression can be seen behind the chronological development, there are significant exceptions, and other factors need to be considered. In the case of the sarcophagus of Junius Bassus, the social and political status of the deceased must have influenced the work considerably. The traditional scenes and verse inscription of the lid portray a man proud to be a Roman; the biblical scenes and the Christian inscription of the facade suggest a man secure in his Christian faith; the end scenes, with their "pagan" models and their Christian allusions, point to a man not of two competing worlds—"pagan" and Christian—but of one world, a Christianized Roman world, in which all things have their time and place—including Junius Bassus.

This sense of things in their rightful time and place returns us to the ideological foundation that makes of the twenty-two scenes of the Bassus sarcophagus a significant unity. As mentioned above, the various "pagan" and Christian images and meanings are ordered by a view of life that emphasizes the *extra*ordinary symbolic dimensions of ordinary reality (e.g., seasons, grapes, grain) and a view of history that stresses the interconnections of past, present, and future. In fact, typological thinking embraces just this view of life and of history. The basic assumption underlying typology proper is that the history of God's people and of God's dealings with them is "a single continuous process in which a uniform pattern may be discerned."[66] Typology perceives patterns; it integrates potentially divergent traditions. And, as we have noted, "the expression of typological ideas in the arts is clearly in the air in the first part of the fourth century."[67] Christian typology, which is rooted in the Jewish use of typology, was apparently developed especially to show the connections between Jewish history and Christian history, and thus the antiquity of the Christian faith. It may be that in the fourth century—

the century of the Peace of the church, the century when (Judeo-) Christian history and world history (that is, the history of the Roman world) seemed to be moving in the same direction—typological thinking was given an added impetus.[68] Typology is one way of affirming that history not only makes sense but progresses. When Christian ecclesial and sacramental typology is added to a typology of biblical events, a place is made in "holy history" for the individual sacramentally incorporated into the people of God. Through symbolic uses of the everyday substances of water, wine, and bread, an individual's own life history is made a part of the broader sweep of history as a revelation of God.[69]

Allusions to two other works—one artistic and prior to the Bassus sarcophagus, the other literary and after it—may shed light on these conclusions: the Arch of Constantine, completed in 315–316, and the *Confessions* of Augustine, written in 397–398. The Arch of Constantine, near the Colosseum in Rome, commemorates Constantine's victory over Maxentius at the Battle of Milvian Bridge in 312. Tradition maintains that Constantine was assured of victory in a God-given vision of the Chi-Rho, or monogram of Christ, accompanied by the words "by this sign conquer." In 313 Constantine promulgated the Edict of Toleration, which provided "that no man should be denied leave of attaching himself to the rites of the Christians, or to whatever other religion his mind directed him, that thus the supreme Divinity, to whose worship we freely devote ourselves, might continue to vouchsafe His favour and beneficence to us."[70] The inscription on the arch employs similar language to refer to God—language that leaves room for a Christian or a non-Christian understanding: ". . . to Constantine . . . because through the inspiration of Deity (QVOD INSTINCTV DIVINITATIS) . . . he avenged the state. . . ." The two long sides and two short ends of the arch provide space for a full and systematic presentation of images. The work incorporates not only earlier images but earlier sculpture itself, with pieces from the reigns of Trajan, Hadrian, and Marcus Aurelius "borrowed," sometimes recut, and fitted into the overall iconographical program. There are clearly symbolic or allegorical dimensions to certain elements of the imagery, including the personifications of the four seasons in the spandrels. A connection is established between the personal and the universal in his-

tory and the world—a movement from *bios* to cosmos: Constantine's victory is a victory for Rome; the sun and the moon, the seasons and the river—all are supportive of the establishment of Constantine's reign as sole emperor. A "typological" view of anticipation and fulfillment in history may also be present: the re-use of sculptures of previous "good" emperors to refer to Constantine suggests that he continues and completes what they began; it has even been argued that biblical typology is alluded to as well, with the struggle at the river and victory at Milvian Bridge recalling the Exodus struggle at the Red Sea and victory over the Egyptians, and the siege of Verona recalling the fall of Jericho under Joshua.[71]

The *Confessions* of Augustine, written as both a confession of sin and a confession of faith, presents Augustine's reflections on his earlier life from his later position as Bishop of Hippo in North Africa. (Although born in North Africa and baptized in Milan, Augustine had taught rhetoric in the city of Rome and certainly thought of himself as a citizen of the *Roman* empire.) A quite systematic presentation of philosophical and theological ideas overlays the chronological retelling of his story in the *Confessions*. The work incorporates "pagan" (secular) rhetorical devices and allusions to "pagan" texts and ideas; for example, "Platonism" is presented as an anticipation of the Christian revelation given more fully in John's Gospel. Symbolic or allegorical interpretation of biblical stories is practiced, following the lead of Ambrose. A connection is established between the personal and the universal in history and the world—a movement from *bios* to cosmos, or from cosmos to *bios*: Augustine is convinced that God directs not only the created world and history in general but his particular life as well. A typological view of anticipation and fulfillment in history is also present, based on the widely shared Christian conviction that events of the Old Testament are fulfilled in events of the New Testament; this view is further elaborated in Augustine's later work, *The City of God*. The centrality of the conversion experience and confidence in a new Christian order are clear.

These three works—the arch, the sarcophagus, and the book—give us glimpses of the early, mid, and late fourth century. They reflect the continuing development of the twofold process of the

Christianization of Rome and the Romanization of Christianity. With Constantine, Christian culture has a chance to grow and develop within Roman culture. With Augustine, Roman culture is surpassed by Christian culture, as the "city of God" supersedes the "city of man." With Junius Bassus, between these two both chronologically and theoretically, Roman tradtion, while affirmed, is subordinated to Christian tradition.

There are, of course, many differences in these three works—in material and in message, in specific context and content. Augustine, for example, although he continued to employ classical Latin rhetorical techniques, confessed as a sin his childhood love of secular Latin literature, whereas those responsible for the Bassus sarcophagus, especially its lid, proudly professed their love of older Roman traditions. In addition, the typological thinking that may be implicit on the Arch of Constantine is considerably clearer on the sarcophagus of Junius Bassus, and full and explicit in the *Confessions* of Augustine. Yet all three works—the arch, the sarcophagus, the book—manifest a fourth-century confident view of the meaningfulness of the connections in history in general and of the incorporation of the converted individual (admittedly, a particularly significant individual)—Constantine, Junius Bassus, Augustine—into that meaningful pattern of history.[72]

Two images presented by Jean Daniélou capture this sense of connection and incorporation that is implicit in typological thinking. First, "[t]ypology reveals analogies which are a unifying thread of all."[73] Second, "the typological chain links up the legal, the prophetic, the Gospel, the Church, the eschatological, in the one theme of the Redemption."[74] As we have seen, the iconography of the sarcophagus of Junius Bassus itself "reveals analogies which are a unifying thread of all"; it suggests a "typological chain" that links Adam and Eve, and Abraham and Issac, and Daniel and Job and Christ and Peter and Paul and Junius Bassus. A third image of typology presented by Daniélou suggests the assurance, the confidence underlying such a view of history's interrelatedness: early church writers on typological themes "see in history the fulfillment of the divine plan, baffling from our human point of view, yet offering a coherence and inner harmony which allows man's faith to rest therein as upon an immovable

rock."[75] The iconographical program of the sarcophagus of Junius Bassus presents a similar coherence and inner harmony that manifest a fourth-century Christian's faith resting on a rocklike conviction of God's continuing activity in history. Thus Junius Bassus, newly baptized, like Daniel and Job and Peter and Paul and countless Christian initiates before him, with confident assurance went to God: NEOFITVS IIT AD DEVM.

Notes

CHAPTER 1: Introduction

1. See Arthur E. Gordon, *Illustrated Introduction to Latin Epigraphy* (Berkeley/Los Angeles/London: University of California Press, 1983), 173; Orazio Marucchi, *Christian Epigraphy: An Elementary Treatise with a Collection of Ancient Christian Inscriptions Mainly of Roman Origin*, trans. J. Armine Willis (Cambridge: Cambridge University Press, 1912), 17–18; and A.H.M. Jones, *The Later Roman Empire, 284–602: A Social, Economic, and Administrative Survey*, 2 vols. (Norman: University of Oklahoma Press, 1964), 1:8 and 48.

2. See, e.g., André Grabar, *Early Christian Art: From the Rise of Christianity to the Death of Theodosius*, trans. Stuart Gilbert and James Emmons (New York: Odyssey Press, 1968), 246. On the debate about this date—that is, on whether it records an original burial or a reuse of a sarcophagus carved much earlier—see Alexander Coburn Soper, "The Latin Style on Christian Sarcophagi of the Fourth Century," *Art Bulletin* 19 (1937): 161, and Marion Lawrence, "Columnar Sarcophagi in the Latin West: Ateliers, Chronology, Style," *Art Bulletin* 14 (1932): 128, n. 55.

3. A.H.M. Jones, J. R. Martindale, and J. Morris, *The Prosopography of the Later Roman Empire, Vol. I, A.D. 260–395* (Cambridge: Cambridge University Press, 1971), 154–55. See also A. Balil, "Iunius Bassus Problema Prosopografico," *Sobretiro de Zephyrus* 11 (1960), Seminario de Arqueologia de Salamanca, Varia 249; and L. Michael White, "The Social Setting of the Junius Bassus Sarcophagus: Analysis and Implications," paper presented to the American Academy of Religion, Dallas, December 1980. On Junius Bassus the elder, especially concerning the basilica he dedicated and whether or not he was a Christian, see Ragna Enking, *S. Andrea Cata Barbara e S. Antonio Abbate Sull' Esquilino*, Le Chiese de Roma Illustrate, 83 (Rome: Marietti, 1964), esp. 5–10, 32–34. "[A]ccording to Prudentius, *contra Symm.* 1. 559," Junius Bassus the son (d. 359) "was the first of his family to become a Christian" (*Ammianus Marcellinus*, 3 vols., trans. John C. Rolfe, Loeb Classical Library [Cambridge: Harvard University Press, 1935, 1963], 1: 368, n. 1). The text of Prudentius reads: "non Paulinorum, non Bassorum dubitavit/prompta fides dare se Christo stirpemque superbam/gentis patriciae venturo attollere saeclo" ("The quick faith of a Paulinus and a Bassus did not hesitate to surrender to Christ and to lift up the proud stock of a patrician

clan to meet the age that was to come"). ("Contra Orationem Symmachi," 1, 558–60, in *Prudentius*, 2 vols., trans. H. J. Thomson, Loeb Classical Library [Cambridge: Harvard University Press, 1949], 1: 393). White even speculates that "the basis for Prudentius' comment is the place of honor given to his sarcophagus in the crypt of St. Peter's" ("Social Setting," 19). For a diagram of this prominent location, see Philippus Laurentius Dionysius, *Sacrarum Vaticanae Basilicae Cryptarum Monumenta*, rev. ed. [Rome: Superiorum Facultate, 1828], diagram after p. xxxi); for a description of the original position of the sarcophagus and a discussion of the significance of this position, see Anton de Waal, "Zur Chronologie des Bassus-Sarkophags in den Grotten von Sankt Peter," *Römische Quartalschrift* 21 (1907): 117–19. For the general historical and political background of the time of Junius Bassus, see Jones, *Later Roman Empire*, 1: 77–137. For the general social and religious background of his time, see Peter Brown, *The World of Late Antiquity: From Marcus Aurelius to Muhammad* (London: Thames and Hudson, 1971), esp. 22–47, 70–95.

4. On the Roman system of naming, see Marucchi, *Christian Epigraphy*, 1–9; or, for a brief overview, see Graydon F. Snyder, *Ante Pacem: Archaeological Evidence of Church Life Before Constantine* (Macon, Ga.: Mercer Univeristy Press, 1985), 129.

5. Jones, *Prosopography*, 1: 155. Marucchi describes surnames as "familiar sobriquets, but in no sense legal or recognised; none the less, in the third and fourth centuries they had become so common that some people of mark were known to the vulgar by their surname only" (*Christian Epigraphy*, 8).

6. *Ammianus*, XVII, 11, 5 (Loeb, 1: 366–69): "Dum haec ita aguntur, Romae Artemius curans vicariam praefecturam, pro Basso quoque agebat, qui recens promotus urbi praefectus, fatali decesserat sorte, cuius administratio seditiones perpessa est turbulentas, nec memorabile quicquam habuit quod narrari sit dignum" ("While these things were thus happening, at Rome Artemius, who held the office of vice-prefect, also succeeded Bassus, who a short time after he had been promoted to be prefect of the city had died a natural death. His administration suffered from mutinous disturbances, but had no remarkable incident which is worth relating"). This is the only direct reference to Junius Bassus by Ammianus. It is not entirely clear from the grammar of the sentence *whose* administration "suffered from mutinous disturbances." White takes the phrase to refer to Junius Bassus and adds that one should keep in mind Ammianus's "prejudices": he was "a pagan with little use for Christian senators" ("Social Setting," 14). White even asks: "Is it possi-

ble that the 'mutinous disturbances' are a pagan's perception of Bassus' dealings with the Christian populace? It was a period of considerable upheaval by Christians—both among themselves (in terms of the Arian controversy) and with the old 'paganism' of Rome (as evidenced by Constantius' removal of the Altar of Victory)" (15). But one could well argue that, since the one-sentence paragraph of Ammianus is basically about Artemius (Junius Bassus's death being mentioned parenthetically to explain how Artemius came into office mid-term), it was Artemius's administration that was described as suffering from "mutinous disturbances."

7. Georg Daltrop, "Anpassung eines Relieffragmentes an den Deckel des Iunius Bassus Sarkophages," *Rendiconti della Pontificia Accademia Romana di Archeologia* 51–52 (1978–1980): 163–64.

8. Jones, *Prosopography*, 1: 155. Junius Bassus the son was not a "former consul," as is erroneously stated in Grabar, *Early Christian Art*, 246. Another phrase of Grabar (or his translator) is misleading: "Junius Bassus was a high Christian dignitary of the empire" (246). Better, he was a high dignitary of the empire who was Christian.

9. Concerning Constantine's deathbed baptism, Jones writes: "It has been thought strange that one who for many years regarded himself as the Servant of God and as 'appointed by God to be bishop of those without' the Church, should have remained to his dying day a catechumen. But Constantine was merely following the practice of many serious Christians, who fearing that they could not avoid mortal sin in the course of an active secular life postponed baptism until they could sin no more" (*Later Roman Empire*, 1: 110). On the early Christian sense of the absoluteness and finality of baptism that lay behind such postponements, see Wladimir Weidlé, *The Baptism of Art: Notes on the Religion of the Catacomb Paintings* (Westminster [London]: Dacre Press, n.d.), 26–31. Marucchi observes that "a record of baptism in a sepulchral inscription is almost exclusively confined to the case of the death of the baptized person (whether child or adult), shortly after receiving that Sacrament" (*Christian Epigraphy*, 104).

10. A.H.M. Jones, "The Social Background of the Struggle between Paganism and Christianity," in *The Conflict between Paganism and Christianity in the Fourth Century*, ed. Arnaldo Momigliano (Oxford: Clarendon Press, 1963), 21.

11. See n. 8 to chap. 3 below for reference to a dissertation in process that will likely discuss the workshop of the Junius Bassus sarcophagus.

12. John B. Ward-Perkins, "Workshops and Clients: The Dionysiac Sarcophagi in Baltimore," *Rendiconti della Pontificia Accademia Romana di Archeologia* 48 (1975–1976): 237. Although it is concerned

with a group of earlier and Dionysiac sarcophagi, Ward-Perkins's discussion of workshops and clients presents several generalizations that are helpful here: "Once again we see how closely the religious and artistic manifestations of the time were bound up with the more mundane considerations of day-to-day workshop output" (219). "[W]orkshop practice was an important factor in the development of a stable symbolic language, just as it was to be later in the development of a stable language of Christian visual symbolism" (236). "The symbolism as such was not new; but it was in these (or similar) pieces that it entered the repertory of sarcophagus carving; and it shows us that the best workshops did include sculptors capable of such creative translation, just as in the fourth century they included sculptors capable of creating a repertory of specifically Christian themes" (237). In another presentation Ward-Perkins emphasizes the other half of the equation—not the craftsman but the client: "Meaning was emphatically in the eye of the beholder. As for the craftsman, it was quite immaterial whether he was a pagan or a Christian. . . . Meaning, I repeat, was in the eye of the beholder; and if we ourselves were to keep this distinction more clearly before us, the distinction between[,] on the one hand[,] the rather simple, generalized, visual language of the craftsman, an[d,] on the other[,] the almost infinite subtleties of visual interpretation that were available to the client, I think we would often save ourselves a great deal of unnecessary controversy" ("The Role of the Craftsmanship [sic] in the Formation of Early Christian Art," *Studi di Antichità Cristiana* 32 [1978] = *Atti del IX Congresso Internazionale de Archeologia Cristiana* [Roma, 21–27 Settembre 1975]: 646).

13. Sister Charles Murray notes more generally: "Christian art shares in, and emphasises, one of the general paradoxes of the Christian historical patterns: that of continuity and discontinuity. It is the part of the Christian craftsman to provide artistic continuity; in other words, formal symbolism can go on, but iconographic or specific content can change" (*Rebirth and Afterlife: A Study of the Transmutation of Some Pagan Imagery in Early Christian Funerary Art* [Oxford: B.A.R., 1981], 7).

14. E.g., John Beckwith, *Early Christian and Byzantine Art* (Baltimore: Penguin Books, 1970), 19; Pierre du Bourguet, *Early Christian Art*, trans. Thomas Burton (New York: Reynal & Co./William Morrow & Co., 1971), 166–67, 178–80; Beat Brenk, *Spätantike und Frühes Christentum* (Frankfurt am Main/Berlin/Vienna: Propyläen Verlag, 1977), 59, 138, fig. 76; Grabar, *Early Christian Art*, 246, 248–49; H. W. Janson, *History of Art* (Englewood Cliffs, N.J.: Prentice-Hall, 1962; New

York: Harry N. Abrams, 1962), 166–67; Charles Rufus Morey, *Early Christian Art* (Princeton, N.J.: Princeton University Press, 1942), 134–35, 271, fig. 141; W. F. Volbach, *Early Christian Art* (London: Thames and Hudson, 1961), 22–23, pls. 41–43; Kurt Weitzmann, ed., *Age of Spirituality: Late Antique and Early Christian Art, Third to Seventh Century* (Catalogue) (New York: Metropolitan Museum of Art/Princeton University Press, 1979), 427–29, no. 386. Lawrence ("Columnar Sarcophagi") and Soper ("Latin Style") have examined in detail the work's stylistic characteristics.

15. George M. A. Hanfmann, *The Season Sarcophagus in Dumbarton Oaks*, 2 vols. (Cambridge, Mass.: Harvard University Press, 1951), 2: 27.

16. The other is the one from the Old Church of St. Trophime in Arles (fig. 2); see Lawrence, "Columnar Sarcophagi," 171; Friedrich Gerke, *Der Sarkophag des Iunius Bassus* (Berlin: Verlag Gebr. Mann, 1936), 6; M. Edmond Le Blant, *Étude sur les sarcophages chrétiens antiques de la ville d'Arles* (Paris: Imprimerie Nationale, 1878), pl. 25; Giuseppe Wilpert, *I Sarcofagi Cristiani Antichi*, 3 vols. (Rome: Pontificio Istituto di Archeologia Cristiana, 1929–1936), 1: 215.

17. Erich Dinkler, "The Christian Realm: Abbreviated Representations," in Weitzmann, ed., *Age of Spirituality* (Catalogue), 428.

18. Daltrop, "Anpassung," 157–62.

19. "Sarcophagus: 141 × 243 × 144 cm. (4 ft. 7½ in. × 7 ft. 11¾ in. × 4 ft. 8¾ in.); lid: 40 × 240 × 137 cm. (1 ft. 3¾ in. × 7 ft. 10½ in. × 4 ft. 5¹⁵⁄₁₆ in.)" (Dinkler, "Abbreviated Representations," 427).

20. Erwin R. Goodenough concludes that cupids gathering or pressing grapes "can have wings or not, with apparently no change in meaning whatever." "That is, I can see no significant basis for contrasting the types. Each type meant the same, and a man making a design used whichever suited his taste." Goodenough cites one example in which two cupids press the grapes, one winged and one not (*Jewish Symbols in the Greco-Roman Period*, 13 vols. [New York: Pantheon Books and Princeton University Press (Vol. 13), 1953–1968], 8: 4 and 4, n. 6).

21. The details of the discovery of the sarcophagus and its lid fragments are discussed in chap. 6 below.

22. Fritz Saxl, "Pagan and Jewish Elements in Early Christian Sculpture," in *Lectures*, by Saxl, 2 vols. (London: Warburg Institute, 1957), 1: 52–53. Cf. Eduard Stommel on the active participation of the observer in understanding Constantinian sarcophagi (*Beiträge zur Ikonographie der konstantinischen Sarkophagplastik* [Bonn: Peter Hanstein Verlag, 1954], 64–68).

23. Peter R. L. Brown, "Art and Society in Late Antiquity," in Kurt Weitzmann, ed., *Age of Spirituality: A Symposium* (New York: Metropolitan Museum of Art/Princeton University Press, 1980), 22. Of course, all art—not just early Christian art—is contextually embedded and presupposes some shared experiences, ideas, feelings, and skills between maker and viewer/hearer/participant. As anthropologist Clifford Geertz has observed, artistic expressions "materialize a way of experiencing." "The capacity, variable among peoples as it is among individuals, to perceive meaning in pictures (or poems, melodies, buildings, pots, dramas, statues) is, like all other fully human capacities, a product of collective experience which far transcends it, as is the far rarer capacity to put it there in the first place. It is out of participation in the general system of symbolic forms we call culture that participation in the particular we call art, which is in fact but a sector of it, is possible" ("Art as a Cultural System," *Modern Language Notes* 91 [1976]: 1478, 1488). When the culture in which a particular artistic expression participates is no longer surviving—no longer open to our actual participation—attention must be given to its surviving traces that enable a degree of imaginative participation.

24. Sister Charles Murray, "Early Christian Art and Archaeology," *Religion* 12 (1982): 171; cf. Murray, *Rebirth and Afterlife*, 8–9. On the legitimacy—and, in fact, necessity—of utilizing early Christian texts in seeking to understand early Christian art, cf. Stommel, *Ikonographie*, esp. 59–61, 67–68. See also the work of Henry Maguire, who states: "By studying the parallels between art and literature it is possible to reveal the common patterns of thinking that may have inspired both artists (or their patrons) and writers" (*Earth and Ocean: The Terrestrial World in Early Byzantine Art* [University Park and London: Pennsylvania State University Press for the College Art Association of America, 1987], 1).

25. Sister Charles Murray, "Art and the Early Church," *Journal of Theological Studies*, N.S. 28 (1977): 330; this article was later incorporated into *Rebirth and Afterlife*; for the quotation see p. 27. The generalization applies not only to Christian *art* in late antiquity: "There was already a strong understanding in the pagan world that the use of symbols is the only artistic process which can express with some sort of fitness an interior religious activity; and it was in fact this form of art which predominated in the age when Christianity first began to make representations. The whole tendency of the age, in keeping with its general outlook, was towards allegory and symbol" (*Rebirth and Afterlife*, 7; cf. Murray, "Early Christian Art," 168).

26. Weidlé, *Baptism of Art*, 32. Cf. Ernst Kitzinger, *Byzantine Art in the Making: Main Lines of Stylistic Development in Mediterranean Art*,

3rd–7th Century (Cambridge: Harvard University Press, 1977), 20: the earliest Christian images are "ciphers conveying an idea."

27. Weidlé, *Baptism of Art*, 13. In his study of Constantinian sarcophagi Stommel argues that the placement of an image among other images in its immediate environment (whether the decorative scheme of a cubiculum or the tectonic laws of sarcophagus friezes) helps determine its significance among manifold possibilities of meaning (*Ikonographie*, 66–67). Herbert L. Kessler notes that on early Christian sarcophagi "isolated episodes from various texts are juxtaposed for symbolic reasons" ("Scenes from the Acts of the Apostles on Some Early Christian Ivories," *Gesta* 18 [1979]: 115).

28. For early Christian sarcophagi see Wilpert, *Sarcofagi*, and Giuseppe Bovini and Hugo Brandenburg, *Repertorium der Christlich-Antiken Sarkophage, I: Rom und Ostia*, ed. Friedrich Wilhelm Deichmann (Wiesbaden: Franz Steiner Verlag, 1967).

29. While extremely useful in a general way, the Princeton Index of Christian Art is in some ways limited by its broad scope. Because its categories of scenes were devised to account for Christian art from the first through the twentieth centuries, they are not always appropriate to the earliest Christian centuries. (Note the problem below with the scene of Christ's arrest.) In addition, determinations of dating, provenance, and iconography are constantly revised by scholarship on the basis of new information, new criteria, and new interpretations. Thus the judgments made for the Index are sometimes superseded. It is, of course, also the broad scope of the Index that makes it useful in the present case of surveying briefly several centuries of early Christian art in all media (catacomb frescoes, sarcophagi, ivories, gold glass, etc.).

30. Because "precise" totals might give this exercise a "scientific" appearance that would be inappropriate, the following scale is employed:

unknown	—— no citations in the Index
unknown?	—— one or more questionable citations
very rare	—— 1–9 citations
rare	—— 10–19 citations
established	—— 20–45 citations
popular	—— 50–60 citations
very popular	—— 80–140 citations

The totals are based on my examination of the copy of the Princeton Index of Christian Art in the Vatican Library in Rome during the summer of 1987. These approximate numbers and descriptive labels, of course, and thus the conclusions drawn from them, apply to extant or otherwise known works of art—not to all of early Christian art but to

whatever, through the accidents of preservation, we can know of it (see table 1–2).

TABLE **1-2**
Occurrence of Junius Bassus Facade Scenes
in the Fourth Century or Before

		Catacombs	Sarcophagi	Other
1	Abraham/Isaac	established	very popular	established, esp. gold glass
2	Peter's Arrest	unknown	very popular	very rare
3a	Christ Giving Law	very rare	established	very rare
3b	Christ over Coelus	unknown	rare	unknown
4/5	Christ before Pilate	unknown	established	unknown?
6	Job's Distress	rare	very rare	very rare
7	The Fall	established	very popular	established, esp. gold glass
8	Christ's Entry	unknown?	established	very rare
9	Daniel/Lions	popular	popular	established, esp. gold glass
10	Paul's Arrest	unknown	rare	unknown
a	Three Youths	established	popular	established, esp. gold glass
b	Peter/Rock	very rare	very popular	very rare
b'	Moses/Rock	very popular	rare	established
c	Loaves	established	very popular	very rare
d	Christ's Baptism	very rare	rare	very rare
e	Receiving Law	very rare	established	very rare
f	Lazarus	popular	very popular	established

31. Morey classifies these three intercolumnar scenes as "traditional Latin subjects" (*Early Christian Art*, 135). Gerke notes that these three scenes are from the Constantinian frieze canon (*Iunius Bassus*, 16–17).

32. According to Daltrop ("Anpassung," 166) on the Junius Bassus sarcophagus, "For the first time in early Christian art, Christ appears before Pilate in the picture next to the judgment scene."

33. According to Gerke (*Iunius Bassus*, 24) and Daltrop ("Anpassung," 165), the Junius Bassus sarcophagus presents the first representation of Paul in art. Kessler, however, comments that "[i]solated scenes from the lives of Peter *and Paul* appeared on sarcophagi even before the conversion of Constantine" ("Acts of the Apostles," 109, italics mine). The fact

that both the scenes of Peter's *arrest* and Paul's *arrest* were unknown in the catacombs, and the latter was rare on sarcophagi, must be seen in light of the slightly later development of the cult of the saints; see Peter Brown, *The Cult of the Saints: Its Rise and Function in Latin Christianity* (Chicago: University of Chicago Press, 1981).

34. For an introduction to the study of the catacombs and their decoration, see J. Stevenson, *The Catacombs: Rediscovered Monuments of Early Christianity* (London: Thames and Hudson, 1978).

35. Grabar, *Early Christian Art*, 240.

36. André Grabar, *Christian Iconography: A Study of its Origins*, trans. Terry Grabar (Princeton, N.J.: Princeton University Press, 1968), 12–13.

37. Gertrud Schiller, *Iconography of Christian Art*, 2 vols., trans. Janet Seligman (Greenwich, Conn.: New York Graphic Society, Vol. 1: 1971; Vol. 2: 1972), 2: 3; see 3–7. Schiller adds: "It is impossible to say whether there were also separate images, biblical and historical in character, of Christ's sufferings as early as the Constantinian period" (2: 3).

38. Ibid., 2: 4.

39. On this type of scene as the commissioning of Peter (John 21:15–17) see Stommel, *Ikonographie*, 88–109. Stommel argues that (1) Peter's gesture of embarrassment refers to the gospel report of his sadness at the three questions of Jesus, and (2) the cock indicates that this sadness was called forth by Peter's recalling of his three denials before the cock's crow. The scroll in Christ's left hand and the gesture of the right would also seem to suggest the commissioning rather than the prediction of the denial. On the more traditional view of this type of scene as the denial of Peter see Charles Pietri, *Roma Christiana: Recherches sur l'Église de Rome, son organisation, sa politique, son idéologie de Miltiade à Sixte III (311–440)*, 2 vols. (Palais Farnèse: École Française de Rome, 1976), 1: 286–95, who gives various citations to early Christian writers.

40. Grabar recognizes two kinds of the earliest Christian funerary "image-signs": (1) references to divine intervention for the salvation or preservation of certain believers (representations of this type are numerically dominant) and (2) iconographic signs representing the two major sacraments of the Christian church, baptism and communion (*Christian Iconography*, 10).

41. See n. 39 above.

42. In addition to the fact that the various events of deliverance are retold from scriptural sources, the first-century, post-Pauline Letter to the Hebrews groups a number of these images together. Hebrews 11 lists the actions "in faith" of Noah, Abraham, Isaac, Moses, the people crossing the Red Sea, Daniel (by implication), and others.

Grabar (among others) points out the parallels between early Christian

images of salvation on sepulchral art and early Christian prayers: "When these highly schematized scenes are painted in the catacombs or carved on sarcophagi, their presence next to the body of the dead has the same meaning as the prayer of the burial office called the *commendatio animae*: they enumerate the precedents for divine intervention for one of the faithful, and express the desire that God may exercise this same benignity toward the person who is now dead: God, save him, as you saved Daniel, Noah, etc. The rituals that we know are not earlier than the ninth century, but the correctness of this interpretation cannot be questioned, since identical prayers for the living have come down to us, of which several go back to late antiquity. . . . Prayers of this kind, which seem to have served mostly for individual worship and even for magical invocations, probably go back to Jewish versions" (*Christian Iconography*, 10). See also Dinkler, "Abbreviated Representations," 397; and Walter Lowrie, *Art in the Early Church* (New York: Pantheon Books, 1947), 60. For citations of related prayers, in addition to the *commendatio animae*, see Morey, *Early Christian Art*, 61–62. For a thorough explication of the relationship between funerary iconography and the *commendatio animae* (and other prayers), see section 5, "Les bas-reliefs des sarcophages chrétiens et les liturgies funéraires," of the introduction of Le Blant, *d'Arles*, xxi–xxxix. On the Jewish roots of this form of prayer see Helen Rosenau, "Problems of Jewish Iconography," *Gazette des beauxarts*, Series 6, 56 (1960): 13. On problems of dating see the discussion by Murray, *Rebirth and Afterlife*, 128–29, n. 54, and the literature cited there.

43. Grabar, *Christian Iconography*, 18. Grabar bases his position on the relationship of the early Christian images to pagan versions of contemporary funerary art and especially considers a study by the Dutch archaeologist J. W. Salomonson of a pavement mosaic of the fourth century found at El DJem, Tunisia. Erwin Panofsky comments that a number of themes of the Junius Bassus sarcophagus "continued to be invested, . . . with what may be called a charismatic or 'salvational,' not to say magical, power." (*Tomb Sculpture: Four Lectures on Its Changing Aspects from Ancient Egypt to Bernini*, ed. H. W. Janson [New York: Henry N. Abrams, 1956], 42.)

44. Grabar, *Christian Iconography*, 18. Ignatius (d. 107?), Bishop of Antioch, referred to the sacrament of communion as "the medicine of immortality and the antidote against death, enabling us to live for ever in Jesus Christ" ("To the Ephesians," chap. 20; trans. Gerald G. Walsh, S.J., in *The Fathers of the Church*, Vol. 1 (Washington, D.C.: Catholic Univeristy of America Press, 1947), 95.

45. Grabar, *Christian Iconography*, 11. Weidlé understands images of deliverance and signs of the sacraments (such as Grabar isolates) as

closely intertwined, even fused, in early Christian thought and artistic expression. "The fundamental religious impulse of early Christianity," he argues, "is this belief in a deliverance from sin and death effected through the mediation of the [baptismal] mystery. . . . The Saviour, the saved, the various aspects of salvation, these, linked by the thought of the sacrament, between them exhaust the interests of Christian art in its first stages. . . . The old traditions lingered longest, it is true, in the field of funerary art" (*Baptism of Art*, 32–33).

46. What Schiller regards as the "true Passion sarcophagi" belong to the post-Constantinian group of tree and column sarcophagi. "Representations of miracles have almost disappeared from this group, and Old Testament scenes occur far less often than on the Constantinian frieze sarcophagi" (Schiller, *Iconography*, 2: 5).

47. The central motifs of these passion sarcophagi are the *crux invicta*, *Christus victor* (Christ victorious), and the *traditio legis* (the exalted Christ delivering the gospel as the New Law) (Ibid., 2: 3).

48. On some of these passion sarcophagi Old Testament motifs were certainly presented as prefigurations of the passion: most important was the sacrifice of Isaac; occurring occasionally were Job in distress and Daniel slaying the Babylonian dragon. Schiller notes: "Pictorial motifs from the Old Testament, as well as the martyrdoms of the apostles, find their place on sculptured sarcophagi among scenes from the New Testament. The only means of interpreting them is by inference from the context of the pictorial motifs" (Ibid., 2: 4).

49. Murray, *Rebirth and Afterlife*, 10–11. Cf. Stommel, who points out that early Christian artistic practice is an extension (or example) of the ancient rhetorical method known as *significatio*: it both suggests a meaning beyond the fact of the event and leaves the meaning uncertain by a conscious ambiguity (*Ikonographie*, 66, see esp. 66–68). Cf. also Maguire on polyvalence, ambivalence, and ambiguity in early Byzantine images and texts (*Earth and Ocean*, 8–13).

CHAPTER 2: Interpretations

1. Of course the present focus must also be understood, in part, as an indication of the kinds of questions and observations that intrigue me. An analogy with work in my primary field, New Testament interpretation, is obvious: I am engaged in literary critical analyses of biblical texts—whole texts, especially the Gospel of Mark—in which the compositional cues are the narrative elements and relations of the story, and the contemporary conventions are gleaned especially from the work itself and other literature of the ancient Mediterranean. This is in contrast to some other approaches to the New Testament that focus on the pre-

supposed oral tradition behind texts and the tradition history of small individual units of material (form criticism) or the editorial history of these presupposed units as they are combined in a gospel (redaction criticism).

2. My comments on the work of key art historians in relation to early Christian art, and particularly the Junius Bassus sarcophagus, might well be applied analogously to research in other fields of art history. See Herbert L. Kessler, "On the State of Medieval Art History," *Art Bulletin* 70 (1988): 166–87, and Brunilde Sismondo Ridgway, "The State of Research on Ancient Art," *Art Bulletin* 68 (1986): 7–23.

3. Snyder, *Ante Pacem*, 5; see 4–11.

4. Ibid., 5–6.

5. Ibid., 6. Cf. the critique of P. Corby Finney: "Wilpert interpreted art from the perspective of dogma and doctrine and he presumed, without ever demonstrating, that the latter had remained constant over the entire sweep of Christian history" ("Gnosticism and the Origins of Early Christian Art," in *Überlegungen zum Ursprung der Frühchristlichen Bildkunst*, ed. H. Brandenburg [Rome: IX Congresso Internazionale di Archeologia Cristiana, 1975], 111–12). Clearly the major problem with Wilpert's approach was anachronism that sometimes led to errors of fact, especially in dating and classifying monuments. A second problem was "the tendency to disciplinary isolationism." (Cf. the excursus on "Alleged Pictorial Cycles of the Fourth Century" by Alexander Coburn Soper, "The Italo-Gallic School of Early Christian Art," *Art Bulletin* 20 [1938]: 190–92.) But Wilpert's theory of origins had positive results as well, especially in encouraging scholars "to look within nascent Christianity for unparalleled factors which might have contributed to the rise of an independent Christian tradition in the visual arts" (Finney, "Origins," 112).

6. Snyder's own methodology for relating archaeological findings and textual traditions, also explicitly contrasted with that of the "Roman school," is not without problems. Snyder's apparent conception of archaeological artifacts as evidence of local or popular tradition and literary texts as evidence of the great or elite tradition is too schematic and separates two aspects of culture that are intricately interrelated. It frequently appears that Snyder himself is fitting the archaeological findings into a preexisting framework—not a literary or dogmatic but a sociological one emphasizing the tension between early Christianity and Rome and the tension between competing groups within early Christianity (cf. L. Michael White, "Review of *Ante Pacem*, by Snyder," *Journal of Biblical Literature* 106 [1987]: 560–62).

Compare my methodology with that of Maguire: "There are many ways in which the study of literary texts can aid the historian who de-

sires to understand the visual images of the past. First, and most obviously, a text can explain *why* an image has a particular form; that is, there can be a cause-and-effect relationship between literature and art, so the work of art becomes in some sense an illustration of the text. But a text can also explain *what* a given image means; it can reveal the thought processes that lie behind the work of art, even if the text itself was not known either directly or indirectly to the artist. In the latter case, the art historian is not concerned with proving that a given text has influenced an image, but he or she tries to show that both text and image reflect similar modes of thought. In this book, texts will be used with the second of these aims in view, that is, to reveal the thought patterns embodied in certain [works of art]" (*Earth and Ocean*, 1–2).

7. A similar service in relation to the end scenes of the Bassus sarcophagus is provided by Hanfmann, *Season Sarcophagus*. See chap. 5 below.

8. Alfred Neumeyer, "Review of Grabar, *Christian Iconography*," *Journal of Aesthetics and Art Criticism* 29 (1970): 139; italics mine.

9. Murray, *Rebirth and Afterlife*, 10. Cf. the comments of Maguire (although they are not made with specific reference to Grabar): "The polyvalence of the symbols used by artists makes it difficult to compile a 'dictionary' of their meanings, just as it would be a hard task to compile a dictionary of the metaphorical images employed by Byzantine writers. . . . My aim has been to use patristic texts not so much as quarries for meanings of individual motifs, but rather as constructions revealing the ways in which groups of symbols were combined to interpret a particular theme" (*Earth and Ocean*, 3).

10. Robin Cormack, "The Literature of Art: Recent Studies in Early Christian and Byzantine Art," *Burlington Magazine* 116 (1974): 411.

11. Ibid.

12. Kathleen J. Shelton, *The Esquiline Treasure* (London: British Museum Publications, 1981).

13. William Tronzo, *The Via Latina Catacomb: Imitation and Discontinuity in Fourth-Century Roman Painting* (University Park and London: Pennsylvania State University Press, 1986).

14. The mosaics of Santa Maria Maggiore date from ca. 432–440, that is, contemporary with Santa Sabina. Suzanne Spain, " 'The Promised Blessing': The Iconography of the Mosaics of S. Maria Maggiore," *Art Bulletin* 61 (1979): 518. (For a discussion of the restorations presupposed in Spain's thesis, see Per Jonas Nordhagen, "The Archaeology of Wall Mosaics: A Note on the Mosaics in Sta. Maria Maggiore in Rome," *Art Bulletin* 65 [1983]: 323–24, and Suzanne Spain, "The Restorations of the Sta. Maria Maggiore Mosaics," *Art Bulletin* 65 [1983]: 325–28.) See also the abstract of Spain's earlier paper, "The Temple of Solomon, the Incar-

nation and the Mosaics of S. Maria Maggiore," *Journal of the Society of Architectural Historians* 28 (1969): 214–15; and the summary of her dissertation, "The Program of the Fifth-Century Mosaics of Santa Maria Maggiore," *Marsyas* 14 (1968–1969): 85. It is interesting to note that the "traditional" interpretation of the infancy scenes of the arch and the Old Testament scenes of the wall mosaics of Santa Maria Maggiore as *not* directly related to each other can be supported by reference to Grabar's benchmark—the doors of Santa Sabina (see Mary L. Heuser, "Review of *Die frühchristlichen Mosaiken in S. Maria Maggiore zu Rom* by Beat Brenk," *Art Bulletin* 61 [1979]: 475).

Discussion of the iconography of the mosaics of Santa Maria Maggiore in relation to that of the Junius Bassus sarcophagus would be particularly interesting since the "classical tenor" of the architectural elements of the former (see Richard Krautheimer, "Success and Failure in Late Antique Church Planning," in Weitzmann, ed., *Age of Spirituality: A Symposium*, 129, and idem, *Rome: Profile of a City, 312–1308* [Princeton, N.J.: Princeton University Press, 1980], 46–49) might also be compared with the "fine style" of the carving and the carefully delineated architectural frame (columns, entablature, arches, gables) of the latter (see ibid., 39). Even certain details bear comparison: the biblical scenes of the nave walls, framed by twisted colonnettes and alternating segmented and triangular pediments; the (mostly) biblical scenes of the lower register of the sarcophagus, framed by (mostly) twisted columns and alternating arches and gables. Both works are to be seen against the background of "the Christianization of cultivated Roman circles from the latter fourth century on and the resulting Romanization of the Church and her assimilation of the classical heritage" (Krautheimer, "Success and Failure," 129; see in general, Krautheimer, *Rome*, 33–58).

15. Kessler, "Medieval Art History," 187.

16. Anton de Waal, *Der Sarkophag des Junius Bassus in den Grotten von St. Peter: Eine archäologische Studie* (Rome: Buchdruckerei der Gesellschaft des Göttlichen Heilandes, 1900), 78. A religious presentation on a sarcophagus can have no other reason, de Waal posits, than that pointed out by Wilpert as the main purpose of catacomb painting: the display of faith and hope as a demand for and an introduction to prayer for those lying in the graves (83).

17. Ibid., 84–85. Such a unifying thought, de Waal asserts, and not a concern for visual symmetry, influenced the selection and placement of scenes on the Bassus sarcophagus. Certain other sarcophagi were organized on the basis of visual symmetry; but had visual symmetry been the key factor in the organization of the Bassus sarcophagus, de Waal reasons, the Job and Pilate scenes would have been opposed, as would the scenes of Peter and Paul (84). De Waal does not point out, however,

that the scenes of Peter's and Paul's arrests do not follow strict visual symmetry. In addition, we may note a form of visual symmetry in the opposition of the naked figures of Adam and Eve to the original naked figure of Daniel.

18. Ibid., 84–85.

19. Ibid., 85. Additional information about de Waal's reading of the intercolumniations, spandrels, and ends is found in the following chapters.

20. Gerke, *Iunius Bassus*, 6. Gerke argues that the discrepancy in theme, composition, and style between the facade and ends has too readily been criticized (13).

21. Ibid., 10.

22. Ibid., 15.

23. Ibid., 30.

24. Ibid., 13.

25. Ibid., 16.

26. This example, not specified by Gerke, is from the crypt of San Massimino (Wilpert, *Sarcofagi*, 1: 145, 1). John W. Cook (in a paper presented to the Arts, Literature, and Religion Section of the American Academy of Religion, in Dallas, December 1980) accepted Gerke's reconstruction and argued that its upper register reflects the early Christian cult of the martyrs in its local Roman manifestation of reverence for Sts. Peter and Paul, the city's patron saints ("The Junius Bassus Sarcophagus: The Imagery").

27. Gerke, *Iunius Bassus*, 16.

28. Ibid., 27.

29. Ibid., 30.

30. Ibid., 31. Additional information about Gerke's reading of the intercolumniations, spandrels, ends, and lid is found in the following chapters.

31. Tronzo, on the contrary, finds Gerke's suggestion of an iconographical mistake (and Hanfmann's suggestion of an iconographical mistake on the lower right end scene as well) convincing and proceeds to explain it by reference to patronage. The Bassus sarcophagus (along with Santa Costanza and cubiculum O of the Via Latina catacomb) represents "the highest level of patronage" and "issued from a circle in which Christianity was not a deep-seated tradition but a relatively recent innovation, and this circumstance may explain the character of the Christian imagery found here. . . . Because of their age-old character they [the images] proclaim the patron's adherence to the Christian tradition in its most venerable manifestation. They explicitly associate the new aristocratic Christian with ancient Christianity, thus giving him a kind of pedigree he would not otherwise have had. Hence the artfulness with

which these images are displayed. They are set out proudly as visible tokens of a time-honored faith in the context of the conventions of aristocratic Roman funerary decoration. And hence, too, the apparent mistakes made in transcribing them. What mattered here above all was not the original message of deliverance and redemption but the fact that the images were venerable Christian representations. That the images had been used and revered by Christians in the past was sufficient justification for employing them. Because the original message was no longer of foremost concern, a door was opened to a variety of mistakes and misunderstandings" (*Via Latina Catacomb,* 69; see 65–70, 76–78). I am certainly not convinced that the imagery of the Bassus sarcophagus is of "this superficial sort" (69), but of course I do agree with Tronzo that artists working for Christian patrons in the mid-fourth century incorporated past images: I understand this, however, as meaningful reinterpretation rather than as mere "copying"—and reinterpretation not only of pagan imagery but also of earlier Christian imagery.

32. The upper register has, in the words of Dinkler, "an accurate iconographical parallel in a Lateran sarcophagus [Inv. 174; here fig. 10] (Bovini and Brandenburg, 1967, I, no. 677), in which the scenes are distributed over seven niches," with the Christ in majesty or the *traditio legis* scene filling the three middle niches ("Abbreviated Representations," 429). Bovini and Brandenburg date this sarcophagus to the third quarter of the fourth century (*Repertorium,* 1: 276).

33. On early Christian iconographical innovation, see Spain, " 'Promised Blessing,' " esp. 539–40.

34. Karl Schefold, "Altchristliche Bilderzyklen: Bassussarkophag und Santa Maria Maggiore," *Rivista di Archeologia Cristiana* 16 (1939): 289–316; 291–98 on the Junius Bassus sarcophagus.

35. Ibid., 291.

36. Ibid., 293, citing Von Campenhausen, *Passionssarkophage* (Marburger Jahrbuch, 1929), 33ff. II, 6 Abb. 23.

37. Ibid., 294.

38. Ibid., 295.

39. Ibid., 295–96. Daltrop presents a close-up of the Peter figure and a photograph of a statue of Demosthenes (now in the Vatican Museums) on opposite pages for easy comparison ("Anpassung," 168–69, figs. 8 and 9; see also 170, fig. 10, for the hands of the Demosthenes statue). Daltrop cites Schefold and adds this comment: "The posture and position of Peter are so reminiscent of the standing portrait of Demosthenes that was erected in the Agora in Athens in 280 B.C. that this connection can hardly be accidental, even though the figure on the Bassus sarcophagus is given mirror-reversed. Peter distinguished himself as a preacher, and thus he is here represented as the type of the great figure of the orator

from the ancient classical era. He announces the return of the Kingdom of God that was lost through Adam and Eve, who are represented below" (166–67).

40. It is not clear what Schefold means by calling Paul (rather than Stephen) "the first" Christian martyr and Job "the first" martyr of the old covenant.

41. Schefold, "Bassussarkophag," 296.

42. Ibid., 297.

43. Ibid., 298.

44. Ibid., 291.

45. Schefold regards de Waal's interpretation as "excellent" (Ibid., 291).

46. Johannes A. Gaertner, "Zur Deutung des Junius-Bassus-Sarkophages," *Jahrbuch des Deutschen Archäologischen Instituts* 83 (1968): 240–64.

47. Ibid., 241.

48. Ibid., 241–49.

49. Ibid., 249–52.

50. Ibid., 253.

51. Ibid., 253–54.

52. Ibid., 254–55. Concerning chiastic structures, Gaertner cites the acrostic of Optatianus Porphyrius; concerning complicated ordering, he cites the Lipsanothek in Brescia.

53. Ibid., 255.

54. Ibid., 255–56.

55. Ibid., 256.

56. Ibid.

57. Ibid., 257. Gaertner ventures one half step further: if we consider the spandrels as well, "we would in fact get a form of the Christ monogram that is generally employed later and is even then rare, namely,⚛. It probably goes too far to consider in our connection this cross plus X form of the monogram" (257).

58. The pairings also give Gaertner five themes: (1) the earthly and heavenly majesty of Christ—or the death and resurrection of Christ (8–3); (2) salvation from death (1–9); (3) martyrdom and salvation (2–10); (4) "the world-historical decision of mankind concerning sin and death" (5–7); (5) the "suffering righteous one" and the certainty of resurrection (4–6) (Ibid., 256–57). Gaertner regards the first three themes (and pairs) as obvious and the fourth as "a new intellectual creation, for which, to our knowledge, neither pictorial nor literary parallels exist" (258). Thus he proposes to present literary and artistic parallels only for the fifth theme (linking Job and Christ). The first theme (Christ's majesty) is indeed obvious, but the second theme (salvation from death) is exceed-

ingly general (Job could be included with Abraham/Isaac and Daniel); the third theme (martyrdom) may be obvious, but the link (Peter/Paul) is not here an emphasized connection. The fourth theme (linking Pilate and Adam and Eve) is not only unprecedented but unconvincing.

Concerning the fifth theme (Christ and Job), Gaertner does cite three passages of patristic literature to illustrate that the suffering and redemption of Job were linked with the death and resurrection of Christ, but two problems arise. First, Job is not thereby greatly distinguished from Daniel and Abraham/Isaac as Christ's forerunners and from Peter and Paul as Christ's followers: all are linked with the death and resurrection of Christ; the connection is too general to forge a specific link, especially in violation of the most obvious compositional cues. And, second, the three passages Gaertner cites as evidence of a more specific link are dated ca. 400, ca. 455/456, and sometime after 455/456—that is, forty to one hundred years after the Junius Bassus sarcophagus.

Concerning the artistic evidence for the fifth thematic link, Gaertner does not examine Job scenes and scenes of Christ's arrest on other sarcophagi but posits that the only sarcophagus "comparable" to the Junius Bassus sarcophagus is the one other extant double-register columnar sarcophagus (from the Old Church of St. Trophime in Arles, fig. 2), which he then proceeds to argue is chiastically arranged. This argument is not entirely convincing, but it is noteworthy that it is based on a *symmetrical* chiastic structure of the iconographical content, not on an off-center chiastic structure as with the Bassus sarcophagus (259–61). Gaertner finds "another interesting example of chiastic ordering, though a good 100 years after our sarcophagus," in the five-part ivory diptych in the cathedral treasure of Milan (261–63). Again Gaertner's interpretation is not without difficulties. Gaertner also mentions diagonal ordering on a medallion published by Garrucci, "innumerable" catacomb decorations, and the mosaics of Santa Costanza (264).

59. Ibid., 257.

60. Ibid., 264.

61. Tronzo labels Gaertner's interpretation "convoluted" (*Via Latina Catacomb*, 68, n. 68).

62. William Tronzo also notes "the predilection of art historians and archeologists—when they study imagery—to focus on individual iconographic units (such as the Sacrifice of Abraham or the *Traditio legis*) and to detail changes that occur in them, or on relationships between images (largely typological) that even seem at times to be read into (forced on) the work of art rather than to emerge from it (witness Gaertner, *JdI*, 83, 1968). What is neglected is the structure of the work of art as a whole" ("Christian Imagery and Conversion in Fourth-Century Rome" [abstract], in *Abstracts and Program Statements for Art History Sessions*

[New York: College Art Association of America, 1986], 30). Despite this general agreement between Tronzo and myself on an appropriate approach to imagery, we disagree on its application to the Bassus sarcophagus; see n. 31 above.

CHAPTER 3: Intercolumniations

1. Volbach, *Early Christian Art*, 23. See also Kitzinger, *Byzantine Art*, esp. 22–29 (chapter title: "Regeneration").

2. Lowrie, *Art in the Early Church*, 89.

3. See the discussion of the Fine Style in Soper, "Latin Style," 188ff.

4. Hanfmann, *Season Sarcophagus*, 1: 51–52. Cf. the description of the style of the Bassus sarcophagus given by Gerhart Egger, "Sarkophag des Junius Bassus vom Jahre 359," in "Zum Datierungsproblem in der spätantiken Kunst," *Jahrbuch der Kunsthistorischen Sammlungen in Wien* 64 (1968): 62–64. Ernst Kitzinger notes that subject matter and iconography, in contrast to style, "almost by definition are 'other-directed,' to borrow David Riesman's term." This is so "because in these matters the artist tends to be under the actual dictation (direct or indirect) of nonartists, be they clerics, scholars or lay patrons. . . . The relationship to outside forces and trends is far more problematic in the case of style" ("On the Interpretation of Stylistic Changes in Late Antique Art," *Bucknell Review* 15 [1967]: 1; reprinted in *The Art of Byzantium and the Medieval West: Selected Studies*, by Kitzinger, ed. W. Eugene Kleinbauer [Bloomington/London: Indiana University Press, 1976], 32–48).

5. Volbach, *Early Christian Art*, 23.

6. See Shelton, *Esquiline Treasure*, esp. 63–68. Shelton concludes: "The renaissance solution gives a false impression by characterising the arts of the western empire as dominated by a single style during this period. The theory implies a uniformity seldom seen or suggested for other periods of Roman art" (66). "The evidence of the Esquiline Treasure indicates that the hypothesis of multiple coexisting modes, applied to earlier periods of Roman art, would yield a less dramatic solution than a renaissance theory but one better supported by surviving evidence from the fourth century" (67).

7. As Shelton observes: "A renaissance theory may seem a necessary theoretical structure to explain the distance from the decennial monument to the sarcophagus of Junius Bassus. Monuments exist, however, which indicate that neither the early nor the mid-fourth century is accurately represented by models such as these" (*Esquiline Treasure*, 66). Nor was Junius Bassus a representative fourth-century Christian: "[I]t would seem likely that in the upper strata of society Christians were in

a very small minority. The old senatorial families certainly remained predominantly pagan down to the latter part of the fourth century. The main strength of Christianity lay in the lower and middle classes of the towns, the manual workers and clerks, the shopkeepers and merchants" (Jones, "Social Background," 21).

8. Alice Christ, a student of Kathleen Shelton (University of Chicago), is writing a dissertation on the sarcophagus of Junius Bassus. Although I have not been able to see her work, brief conversations with her have suggested that considerations of style and workshop will receive thorough treatment.

9. Grabar, *Early Christian Art*, 248.

10. See Lawrence, "Columnar Sarcophagi," 128–33, and Soper, "Latin Style," 170. Beckwith considers the Junius Bassus sarcophagus "a synthesis of 'columnar' and 'frieze' traditions" (*Early Christian*, 19). Morey writes: "[T]he double register is turned into an imitation above of a five-niche Asiatic trough with level entablature, while the lower register is one of the Latin five-arch-and-gable adaptations of the Asiatic architectural pattern" (*Early Christian Art*, 134).

11. For a careful discussion of intended (by the designer) and potential (to the viewer) symbolism, see Maguire, *Earth and Ocean*, 13–15.

12. Gaertner, "Deutung," 243.

13. For example, on the Two Brothers sarcophagus (fig. 3) the sacrifice of Isaac by Abraham may possibly be linked to the sacrifice of Christ, alluded to in the scene of Pilate's judgment, because the two scenes practically interpenetrate. There may also be a link between Abraham being stopped by the hand of God and Moses receiving the Law from the hand of God because of their parallel, but reversed, positions on either side of the shell.

14. Soper ("Italo-Gallic," 159) comments: "The double-register scheme of the sarcophagus and much of its iconography is local in origin; the rest, provided for a Roman prefect, is Roman in that fact and in nothing more"—reflecting, rather, the "Asiatic" columnar style (see Lawrence, "Columnar") and the influence of the Latin ateliers of Gaul (see Soper, "Latin Style").

15. To the discussion of de Waal and especially Schefold in chap. 2 above, we may add here reference to brief comments on the typological connections of the Bassus sarcophagus made by Rosenau, Schiller, Saxl, and Panofsky. Rosenau ("Jewish Iconography," 5) briefly refers to the sarcophagus of Junius Bassus as typological in its subject matter: "The programme is complex, meaningful, and its message clear. The Old Testament prefigures the salvation consummated in the New." Schiller posits: "Old Testament Passion typology is at its most highly developed" in the two registers of the Bassus sarcophagus (*Iconography*, 2: 4). The first

upper-register scene, the sacrifice of Isaac, receives its "antitype" (or fulfillment) in the last upper-register scene, the judgment of Pilate. (Surprisingly, Schiller, or her translator, employs the term "antitype" incorrectly: "The antitype to the scene with Pilate is the Sacrifice of Isaac in the upper register." [Ibid.].) The scene of Peter taken prisoner balances the seizure of Christ. The central scene of the upper register, Christ enthroned in heaven, above a personification of Coelus and flanked by two apostles, is an image of Christ's eternal victory over death. This image of "the proclamation of the Gospel," that is, the *traditio legis* or the exalted Christ's presentation of his eternal Law to the church, is "matched" in the lower register by Christ's triumphal entry into Jerusalem. Schiller simply mentions the remaining scenes of the facade as references to "man's Salvation through Christ's Death and Resurrection" (2: 5). Saxl, in a one-paragraph explication of the Junius Bassus intercolumnar scenes as part of a discussion of "Pagan and Jewish Elements in Early Christian Sculpture," pairs the scenes just as Schiller does—and in some cases more specifically. He labels the sacrifice of Isaac by Abraham "the Jewish prototype of the death of Christ" and Job a "protomartyr" and "the Old Testament counterpart of St. Paul"; he sees "a promise of their [Adam and Eve's] ultimate salvation" in the "corresponding picture of Daniel in the lion's den" (*Lectures*, 1: 54–55). Panofsky, after a very brief sketch of the iconographical program of the Bassus sarcophagus in the much larger context of *Tomb Sculpture*, concludes that the elements of the "highly developed program exemplify at least four different classes of imagery": (1) historical (viz., scenes from the life of Paul); (2) doctrinal (viz., the *traditio legis*); (3) typological (viz., "renderings of such events as can be interpreted, either by virtue of analogy or contrast, as 'prefigurations' of others, particularly scenes from the Old Testament foreshadowing the New"); (4) symbolical (viz., lambs as symbols of biblical characters, including Christ) (41–42). This fourfold classification, Panofsky remarks, is neither exhaustive nor exclusive. For example, the spandrels of the Bassus sarcophagus present "three 'historical' scenes from the Old Testament and three from the New, all enacted by symbols (viz., the lambs), which in addition carry a prefigurative significance" (42).

16. Kitzinger, *Byzantine Art in the Making*, 26. An "urgent personal message" may be conveyed especially by allusion to the incorporation of the deceased into the sacred history that is enacted—as later chapters will illustrate. Although he regards the theme of the Bassus sarcophagus iconography as Christian death, Gerke realizes that the scenes of the front incorporate Christian death into *Heilsgeschichte*, embracing both biblical events and the lives and deaths of the first Christian martyrs (*Iunius Bassus*, 13).

17. As Murray notes: "What is lacking in the interpretation of Grabar [esp. in *Christian Iconography*] and of other scholars is the sense of context: that is, the theological dimension involved. This is a surprising omission ... when one considers that all scholars acknowledge early Christian art to be religious. But it is to be explained by the fact that the evidence and its discussion are in the hands of scholars whose major field of interest is non-theological, while the professional theologians themselves, including the patristic scholars, confine themselves mainly to the literary remains of the early Church" (*Rebirth and Afterlife*, 10). Stommel would appear to be an exception to this general observation, at least in his discussion of the "intellectual content" of Constantinian sarcophagi (*Ikonographie*, 58–68).

18. The root of the word "typology" is the Greek word meaning "to strike," which means, "first of all, a blow, and then the mark left by a blow or the application of pressure" (J. Blenkinsopp, "Type and Antitype," *New Catholic Encyclopedia* [New York: McGraw Hill Co., 1967], 14: 351). See also K. J. Woollcombe, "The Biblical Origins and Patristic Development of Typology," in G.W.H. Lampe and K. J. Woollcombe, *Essays on Typology*, Studies in Biblical Theology (London: SCM Press, 1957), 61.

19. Blenkinsopp, "Type and Antitype," 351. For a similar definition, with a distinction between typology considered as a method of exegesis and as a method of writing, see Woollcombe, "Biblical Origins," 39–40. The classic definition of a type as "a prophecy expressed in terms of things" was framed by John Chrysostom and is quoted by J.N.D. Kelly, *Early Christian Doctrines*, 2nd ed. (New York: Harper & Row, 1960), 76.

20. Jean Daniélou, S.J., "The Fathers and the Scriptures," *Theology* 57 (1954): 87. See also Kelly, *Early Christian Doctrines*, 71, and G.W.H. Lampe, "Typological Exegesis," *Theology* 56 (1953): 202. For additional examples of typological thinking in the Old Testament, see Alan Clifford Charity, *Events and Their Afterlife: The Dialectics of Christian Typology in the Bible and Dante* (Cambridge: Cambridge University Press, 1966), 13–80; G.W.H. Lampe, "The Reasonableness of Typology," in Lampe and Woollcombe, *Essays on Typology*, 26–27; Woollcombe, "Biblical Origins," 43–46.

21. For example, types are seen in Adam (Romans 5:14), the Exodus (1 Corinthians 10:6–11), and the High Priest (Hebrews). For a discussion of Paul's understanding of and use of typology, see Woollcombe, "Biblical Origins," 61–88, and Glenn W. Olsen, "Allegory, Typology, and Symbol: The *Sensus Spiritalis*; Part II: Early Church through Origen," *Communio: International Catholic Review* 4 (1977): 359–64.

22. For example, types are seen in Jonah (Matthew 12:38–41, Luke 11:29–32) and the great Jewish feasts (John). Daniélou ("Fathers and

Scriptures," 87–88) distinguishes between Matthaean and Johannine forms of typology. For additional examples of New Testament uses of typology, see Blenkinsopp, "Type and Antitype," 351–52; Sacvan Bercovitch, "Annotated Bibliography," *Typology and Early American Literature* (Amherst: University of Massachusetts Press, 1972), 250–52; Charity, *Events*, 83–164; J. R. Darbyshire, "Typology," *Encyclopaedia of Religion and Ethics* (New York: Charles Scribner's Sons, 1955), 12: 501; Olsen, "Allegory, Typology, and Symbol; Part II," 364–69. For an older (originally 1939) overview of typology, including the use of typology in Palestinian and Hellenistic Judaism (especially Philo), as well as surveys of New Testament materials, see Leonhard Goppelt, *Typos: Die Typologische Deutung des Alten Testaments im Neuen* (Darmstadt: Wissenschaftliche Buchgesellschaft, 1969).

23. Perhaps the first such use of typology was "the apologetic use of types to prove as against Jewish or pagan objector the antiquity of the Christian faith" (Darbyshire, "Typology," 501). See also M. F. Wiles, "The Old Testament in Controversy with the Jews," *Scottish Journal of Theology* 8 (1955): 113, 115; Lampe, "Typological Exegesis," 203; and Jean Daniélou, S.J., *From Shadows to Reality: Studies in the Biblical Typology of the Fathers*, trans. Dom Wulstan Hibberd (London: Burns & Oates, 1960), 1.

24. For overviews of the exegetical methods of the early church fathers, see Darbyshire, "Typology," 501–2; Robert M. Grant, "History of the Interpretation of the Bible," *The Interpreter's Bible* (New York and Nashville: Abingdon-Cokesbury Press, 1952), 1: 109–11; Kelly, *Early Christian Doctrines*, 64–79; Woollcombe, "Biblical Origins," 50–60 and 69–75; Jean Daniélou, S.J., *The Origins of Latin Christianity* (*A History of Early Christian Doctrine before the Council of Nicaea*, Vol. 3), trans. David Smith and John Austin Baker (London: Darton, Longman & Todd, 1977; Philadelphia: Westminster Press, 1977), esp. 297–319. For a bibliography of the works of the church fathers relevant to typology, see Daniélou, *Shadows to Reality*, 1–7, and Bercovitch, *Typology*, 257–64. For an intriguing discussion of five specific types (Adam, Noah, Isaac, Moses, Joshua) as developed by the early church, see Daniélou, *Shadows to Reality*. On the Alexandrian and Antiochene schools of interpretation with an eye to their subsequent influence in the Middle Ages (the Alexandrian became overwhelmingly dominant), see Beryl Smalley, *The Study of the Bible in the Middle Ages* (Oxford: Basil Blackwell, 1952), 1–26 ("The Fathers: I. The Letter and the Spirit"). And for a consideration of the early church's biblical interpretation with an eye to biblical interpretation today, see Glenn W. Olsen, "Allegory, Typology, and Symbol: The *Sensus Spiritalis*; Part I: Definitions and Earliest History,"

Communio: International Catholic Review 4 (1977): 161–79; and "Part
II," 357–84.

25. The influence of the Alexandrian school passed to the West
through the influence of the Palestinian and Cappadocian fathers and
may be recognized in Hilary, Ambrose, Jerome, Augustine (Kelly, *Early
Christian Doctrines*, 74–75), Gregory the Great, and Thomas Aquinas
(Blenkinsopp, "Type and Antitype," 352).

26. Those who "tried to make the task of interpretation easier by a
lavish resort to allegory" (Kelly, *Early Christian Doctrines*, 66) took
their cue from Philo of Alexandria, who sought to bridge the Hebrew
Scriptures and Platonic philosophy, and thus they aimed to elicit the
moral, theological, or mystical meaning that each passage, verse, or
word was presumed to contain (Kelly, *Early Christian Doctrines*, 70). For
distinctions between allegory and typology, see also Daniélou, "Fathers
and Scriptures," 84–86; Woollcombe, "Biblical Origins," esp. 40–41 and
59–60. From another perspective, it may also be pointed out that the
"real purpose of Alexandrian allegorization was avoidance of the anthro-
pomorphisms of the Old Testament, which simple-minded Christians
took literally" (Grant, "History of Interpretation," 110).

27. The danger, of course, was and is that "[o]nce the exegete's hold
on the literal sense is loosened and the straightforward narrative or his-
torical sense is allowed to slip into the background, appeal can only be
made to something outside the text for a criterion of what it means"
(R. A. Markus, "Presuppositions of the Typological Approach to Scrip-
ture," *Church Quarterly Review* 158 [1957]: 444; reprinted in *The Com-
munication of the Gospel in New Testament Times*, by Austin Farrer et
al. [London: SPCK, 1961], 75–85). See also Darbyshire, "Typology," 500
and 502. For comments on this problem as it has continued into con-
temporary theology, see Lampe, "Reasonableness," 9–38.

28. But see Raymond E. Brown's warning against oversimplifying the
opposition of these two schools, or of typology and allegory (*The* Sensus
Plenior *of Sacred Scripture* [Baltimore: St. Mary's University, 1955], 44–
45). Terminological confusion is easy, especially since, although the
term *typos* occurs in the New Testament, "strangely enough not 'typol-
ogy' but 'allegory' was the name used by the early Fathers in referring to
this [interpretive approach]. . . . 'Typology' is a neologism in use for only
about a century, and actually seems to be of Lutheran origin" (10).

29. Olsen, "Allegory, Typology, and Symbol; Part I," 175.

30. Kelly, *Early Christian Doctrines*, 71. See also Kelly, 64–69, and
Daniélou, *Shadows to Reality*, 31–33, for a discussion of the anti-Mar-
cionite and anti-gnostic thrust of this conviction of correspondence and
the role of Justin and Irenaeus in supporting and furthering it on the
basis of belief in the oneness of God. Such interpretation paved the way

for Augustine's dictum: "In the Old Testament the New is concealed, in the New the Old is revealed" (quoted by Kelly, *Early Christian Doctrines*, 69).

31. See Markus, "Presuppositions," 449, and Walter E. Meyers, "Introduction," *A Figure Given: Typology in the Wakefield Plays* (Pittsburgh: Duquesne University Press, 1969), 11–12.

32. Daniélou ("Fathers and Scriptures," 87) has explained that "the life of Christ does not exhaust the realities of the new covenant. It is continued in the Church, which is Christ's body, and in the members of the Church, who are the stones of the temple." One of the five principal forms of typology isolated by Daniélou in this article is "churchly typology," of which the principal and "most traditional" form is "sacramental typology." In *From Shadows to Reality* Daniélou traces historical developments from eschatological typology to christological typology to ecclesiastical and sacramental typology; see pp. 287–88 for a succinct summary conclusion.

33. Lampe, "Typological Exegesis," 205. Lampe continues: "We must not forget that the same vocabulary is used by the Fathers to denote both scriptural types and figures on the one hand, and sacramental signs on the other, at least until late developments in Eucharistic 'realism' led to some reluctance to do this."

34. All of which is later exemplified in the typological reading of the mosaics of the chancel bay of San Vitale in Ravenna.

35. Cyril of Jerusalem, *The Mystagogical Lectures* II, 6, see also 7; trans. Anthony A. Stephenson, in *The Fathers of the Church*, Vol. 64 (Washington, D.C.: Catholic University of America Press, 1970), 165–66.

36. Kelly, *Early Christian Doctrines*, 71.

37. Lampe, "Typological Exegesis," 201.

38. Markus, "Presuppositions," 451.

39. Camille S. Jungman, "The Christian Context of the Late-Antique Frieze on the Arch of Constantine," unpublished Master's thesis, Florida State University, June 1971, 83. Jungman makes specific reference to the following: Justin Martyr's *Dialogue with Trypho*, Origen's *On First Principles*, Tertullian's *On Prescription of Heretics*, Lactantius's *The Divine Institutes*, the anonymous "De Sodom" and "De Jonah," Juvencus's *Books of the Evangelists*, Lactantius's "The Phoenix."

40. Grabar, *Christian Iconography*, 143; cf. Grabar, *Early Christian Art*, 38.

41. Grabar, *Early Christian Art*, 248. Contrast this statement with Grabar's reference to the image-signs of the Junius Bassus sarcophagus being "grouped systematically" (*Christian Iconography*, 12–13), cited above. For a critique of Grabar's setting forth of definitive stages of iconographical development, see chap. 2 above.

42. Stommel argues for the typological interpretation of certain Constantinian frieze sarcophagi on the same basis as is presented here: the fourth-century continuity of typological exegesis of biblical texts and artistic images (*Ikonographie*, esp. 61–64, 68).

43. Saxl, *Lectures*, 1: 55, speaking directly of the Junius Bassus sarcophagus. Cf. Brenk, *Spätantike*, 59. On the scene of Isaac and Abraham in the catacombs, where it probably was presented as a promise of salvation, see Stevenson, *Catacombs*, 67–68. The scene is "probably the most common [one] in all forms of early Christian art" (67). According to Stevenson, its suitability for funerary art is explained by Hebrews 11:17–19, "where the faith of Abraham was faith in the Resurrection" (68). "By faith Abraham, when he was tested, offered up Isaac, and he who had received the promises was ready to offer up his only son, of whom it was said, 'Through Isaac shall your descendants be named.' He considered that God was able to raise men even from the dead; hence, figuratively speaking, he did receive him back" (Hebrews 11:17–19). Thus in the catacombs the scene is "one of deliverance, and leads us to the Resurrection and its supreme importance. In one picture a dove appears, the sign of peace and deliverance" (Stevenson, *Catacombs*, 68).

44. Daniélou, *Shadows to Reality*, 115–49; cf. Jean Daniélou, S.J., "La typologie d'Isaac dans le Christianisme primitif," *Biblica* 28 (1947): 363–93. See also Kelly, *Early Christian Doctrines*, 72. According to Dinkler, the sacrifice of Isaac has been interpreted typologically as representing the crucifixion of Christ "since Melito of Sardes [sic] (about A.D. 190)" (in Weitzmann, ed., *Age of Spirituality* [Catalogue], 429). Isaac is presented as a type of Christ in fragments from the "Catena on Genesis" by Melito: "In place of Isaac the just, a ram appeared for slaughter, in order that Isaac might be liberated from *his* bonds. The slaughter of this *animal* redeemed Isaac *from death*. In like manner, the Lord, being slain, saved us; being bound, He loosed us; being sacrificed, He redeemed us. . . . But Christ suffered, and Isaac did not suffer: for he was *but* a type of Him who should suffer" (trans. B. P. Pratten, in *The Ante-Nicene Fathers*, Vol. 8 [Grand Rapids, Mich.: Wm. B. Eerdmans, n.d.], 759). For Melito of Sardis, see also *The Homily on the Passion by Melito, Bishop of Sardis, with Some Fragments of the Apocryphal Ezekiel; Studies and Documents*, Vol. 12, ed. Campbell Bonner (London: Christophers, 1940; Philadelphia: University of Pennsylvania Press, 1940). Here Melito's reference to Christ being bound like Isaac (175–76) is a minor part of his overall argument that the Passover of the Exodus was the type of Christ's passion (see esp. 16–20, 168–80).

45. Augustine, *Reply to Faustus the Manichaean*, bk. 22, 73; trans. Richard Stothert, in *A Select Library of the Nicene and Post-Nicene Fathers*, Vol. 4 (Buffalo: Christian Literature Company, 1887), 300.

46. All biblical quotations are (unless embedded in another quotation) from the *Revised Standard Version of The Bible*, copyright 1946, 1952, 1971, by the Division of Christian Education, National Council of Churches.

47. Irenaeus, *Against Heresies*, bk. 4, chap. 5, 4; trans. W. H. Rambaut, in both *Ante-Nicene Christian Library*, Vol. 5 (Edinburgh: T & T Clark, 1869), 388, and *The Ante-Nicene Fathers*, Vol. 1 (Grand Rapids, Mich.: Wm. B. Eerdmans, 1956), 467.

48. Tertullian, *An Answer to the Jews*, chap. 13; trans. S. Thelwall, in both *Ante-Nicene Christian Library*, Vol. 18 (Edinburgh: T & T Clark, 1870), 250–51, and *The Ante-Nicene Fathers*, Vol. 3 (Grand Rapids, Mich.: Wm. B. Eerdmans, 1957), 170–71.

49. John Chrysostom, *Homilarum in Genesium*, homily 47, chap. 3, in *Patrologia Graeca* 54: 432; as quoted by Daniélou, *Shadows to Reality*, 129.

50. Weidlé, *Baptism of Art*, 18. Weidlé includes the raising of Lazarus in this statement as well. On the sacrifice of Isaac, see also Snyder, *Ante Pacem*, 51–52, and the literature cited there.

51. Schiller, *Iconography*, 2: 4.

52. Ibid., 2: 64.

53. See Ibid., 2: 3, and Volbach, *Early Christian Art*, 22. On the late appearance of pictorial representations of the crucifixion of Jesus, see Massey H. Shepherd, Jr., "Christology: A Central Problem of Early Christian Theology and Art," in Weitzman, ed., *Age of Spirituality: A Symposium*, 112–13; Grabar, *Christian Iconography*, 50.

54. Bovini and Brandenburg, *Repertorium*, 1: nos. 49; 58; 189, 1; 679; cf. 667, a single-register frieze sarcophagus.

55. Panofsky, *Tomb Sculpture*, 41.

56. According to Lowrie (*Art in the Early Church*, 89), it is "the swampy region of the Tre Fontane which here is indicated by tall reeds," thus assuring us that the arrest depicted is that of Paul. According to Gerke (*Iunius Bassus*, 10, 24), the reeds indicate the marsh of the Tiber and thus Paul's martyrdom. Reeds as an iconographical sign of Paul also appear on the following sarcophagi: fragment in Valence (Wilpert, *Sarcofagi*, 1: 142, 1), fragmented sarcophagus from the Cemetery of San Sebastiano, Rome (Ibid., 1: 142, 2; Bovini and Brandenburg, *Repertorium*, 1: no. 215), Lateran 164 (here fig. 9; Wilpert, *Sarcofagi*, 1: 142, 3; Bovini and Brandenburg, *Repertorium*, 1: no. 61), sarcophagus in the crypt of San Massimino (here fig. 6; Wilpert, *Sarcofagi*, 1: 145, 1), fragment in the Lateran Museum (Ibid., 1: 233, 3).

57. According to Panofsky, who appears to be unique among art historians in making this assignation, the apostolic arrest scene opposite the arrest of Christ on the upper register is the arrest of Paul. Panofsky

understands this parallelism between Christ and Paul as "conferring upon the latter a distinction which many other sarcophagi reserve for St. Peter" [!] (*Tomb Sculpture*, 41). Panofsky identifies the lower right intercolumniation as Paul's martyrdom. On scenes of the arrest of Peter appearing on Roman monuments, see Pietri, *Roma Christiana*, 1: 341–48.

58. Schiller, *Iconography*, 2: 3.

59. Saxl, *Lectures*, 1: 55. On the similarity of the position, and especially the hands, of the Peter figure and a statue of the philosopher Demosthenes, see n. 39 to chap. 2 above. On "the first iconographic repertoire of Peter," see Pietri, *Roma Christiana*, 2: 277–82.

60. Concerning the scenes of the judgment (or arrest) of Peter and Paul on the Bassus sarcophagus and others, Grabar comments: "These first images of the passion of the apostles are summarily treated, and it is possible that the very vagueness of the action reflects the difficulty felt by the Christians in accepting the moral reversal." "Whereas the Roman state propagated these images [of judgment and execution] in order to glorify the magistrate and the military, who, by cutting off heads, established Roman order, the Christian image-makers made use of the same iconographic scheme to exalt the memory of those who were executed and to proclaim the iniquity of the representatives of the Roman state" (*Christian Iconography*, 50). But the steadfastness of the attitude of the condemned seems more to the point than any vagueness in the action of the executioners in describing these arrest scenes.

61. Cf. the post-Pauline letter, Colossians 2:12. See also the gospel passages in which Jesus alludes to his death—and that of his disciples—by the metaphors of "baptism" and/or "the cup" (a eucharistic image): Mark 10:35–40, Matthew 20:20–23, Luke 12:50.

62. See, e.g., Tertullian, *On Baptism*, chap. 16, trans. S. Thelwall, in both *Ante-Nicene Christian Library*, Vol. 11 (Edinburgh: T & T Clark, 1869), 250, and *The Ante-Nicene Fathers*, Vol. 3 (Grand Rapids, Mich.: Wm. B. Eerdmans, 1957), 677; Tertullian, *Scorpiace*, chap. 6, trans. S. Thelwall, in both *Ante-Nicene Christian Library* 11: 393, and *Ante-Nicene Fathers* 3: 639; Anonymous (early 3rd century), *The Martyrdom of Perpetua and Felicitas*, chap. 6, 1 & 4, trans. R. E. Wallis, in *Ante-Nicene Fathers* 3: 704–5; Cyprian, Letter 73, 21–22, trans. Rose Bernard Donna, C.S.J., in *The Fathers of the Church*, Vol. 51 (Washington, D.C.: Catholic University of America Press, 1964), 281–83; John Chrysostom, "Homily on Saints Bernice and Prosdoce," 6 (*Patrologia Graeca* 50: 638), in Elizabeth A. Clark, *Women in the Early Church* (Wilmington, Del.: Michael Glazier, 1983), 174–75; Gregory of Elvira, *Tract*. 15, as quoted by Daniélou, *Shadows to Reality*, 197. Cook ("Junius Bassus Sarcophagus") posits that "baptism was a form of martyrdom in that one died to the flesh and was raised in the spirit." But the argument of the early

church fathers moved in the opposite direction: martyrdom was a form of baptism. As Weidlé explains: "The baptismal mystery exerted such power over the imagination of Christians that they conceived even martyrdom, the one generally accepted substitute for it, not as something different, though having the same effect, but as its exact counterpart in a variant form" (*Baptism of Art*, 28). Martyrdom was also associated with the eucharist; for examples from the writings of Ignatius and Polycarp, see Stephen Reynolds, *The Christian Religious Tradition* (Encino, Calif.: Dickenson Publishing Co., 1977), 44–47.

63. Tertullian, *On Baptism*, chap. 16, in *Ante-Nicene Christian Library* 11: 250; also in *Ante-Nicene Fathers* 3: 677.

64. On the question of whether all the types of the Old Testament have Christ as their antitype see Brown, *The* Sensus Plenior, 19–20. Daniélou answers yes, but by Christ he means "the whole Christ," including "the earthly life of Christ, the spiritual aspects of his life, the Church or Mystical Body of Christ, Christ in the individual soul, and Christ in his second coming" (Brown, *The* Sensus Plenior, 20). For Daniélou, "This is the very hallmark of Christian typology, its basic and unique character. There is a Palestinian [Jewish] typology, eschatological in character: a moralizing Philonian allegory. Christian typology is Christological" (Daniélou, *Shadows to Reality*, 24–25). Brown himself argues that "in fact all typology is not formally christological: if something is a type of the Christian moral life, technically it is the supernatural life and not Christ that is the formal object of the typical sense" (*The* Sensus Plenior, 20).

65. See, e.g., Bovini and Brandenburg, *Repertorium*, 1: nos. 49 [here fig. 8]; 58; 189, 1 [here fig. 7]; 679; and 667 (a single-register frieze sarcophagus). Peter's position is not quite so standardized, though there may be a tendency for him to appear in the second niche. Peter appears in four of the five sarcophagi listed here: in the second position three times and in the fourth niche once. (Peter also appears in the second niche of *Repertorium*, 1: no. 61 [here fig. 9], which does not include Pilate.) In fig. 8 the carried cross that is a sign of Peter in all the other sarcophagi listed here appears to represent the cross of Christ carried by Simon of Cyrene.

66. A personification of Coelus, the heavens or the sky; see, e.g., Schiller, *Iconography*, 2: 4.

67. The two scenes are new ones, replacing the customary scenes, according to Grabar, *Early Christian Art*, 248. Kitzinger notes: "Infiltration of elements from imperial art into Christian contexts was a process which had been going on continuously throughout the fourth century. A major factor, particularly in the iconographic development of Christian art during that period, it reflects powerful and important ideological

trends connected with the Christianization of the state" (*Byzantine Art in the Making*, 39). As Grabar observes, "[T]he priority of the Imperial models is proved by the fact that the Imperial images represent real ceremonies, while the Christian figurations are imaginary, their symbolism becoming understandable only because of the ceremonies of the palace" (*Christian Iconography*, 42).

68. Grabar, *Early Christian Art*, 248. Morey notes: "The Christ enthroned above the veiled head of Caelus, and bestowing their missions on Peter and Paul, seems a Latin translation of the favorite subject of the 'city-gate' sarcophagi" (*Early Christian Art*, 135).

69. Grabar, *Christian Iconography*, 43. See also Richard Krautheimer, *Three Christian Capitals: Topography and Politics* (Berkeley/Los Angeles/London: University of California Press, 1983), 20, and Beat Brenk, "The Imperial Heritage of Early Christian Art," in Weitzmann, ed., *Age of Spirituality: A Symposium*, 39–52, esp. 45. On all aspects of Christian artistic application of imperial ceremonial motifs, see Sabine G. MacCormack, *Art and Ceremony in Late Antiquity* (Berkeley/Los Angeles/London: University of California Press, 1981); the photographs are well arranged and captioned to serve as a preview or review of her argument.

70. For sarcophagi (including fragments and reconstructions) that portray Christ enthroned with the cosmos at his feet, see Wilpert, *Sarcofagi*, 1: 28, 1; 1: 28, 2; 1: 28, 3; 1: 29, 3; 1: 121, 4; 2: 264, 1; 3: 284, 5; 3: 286, 10; and 1: p. 168, fig. 99.

71. MacCormack, *Art and Ceremony*, 129. According to Daltrop, the *maiestas domini supra caelum* is "a pictorial motif that is not to be found before 359" ("Anpassung," 164). Daltrop points to precedents for certain aspects of this scene in order to understand its "novelty," but he asserts that "these suggestions do not suffice to explain the picture of Christ on the Bassus sarcophagus" (164, n. 20). Pietri refers to the *traditio legis* scene of the Junius Bassus sarcophagus as "l'exemplaire le plus ancien" (*Roma Christiana*, 2: 1551).

72. Grabar, *Early Christian Art*, 248. According to Grabar (*Early Christian Art*, 249), these imperial borrowings undergird the central theme of the Junius Bassus sarcophagus, Christ in majesty.

73. MacCormack, *Art and Ceremony*, 41; see 39–45 on the *adventus* of Constantius II in Rome in 357 and 62–67 on the fourth-century adaptation of the *adventus* motif to Christ. Cf. Brown, *Cult of the Saints*, 98: the ceremonies of the imperial *adventus* "registered a moment of ideal concord" because "all groups in the community could unite in acclaiming the emperor's presence among them." Richard Brilliant points out more broadly that "[i]t is fundamental to the concept of the effective image that through it observer and personage are in direct relationship." "Perhaps more than any other factor, the extremely calculated manipu-

lation of art in the pursuit of non-aesthetic goals created in the Roman monuments their expressive ability to call forth a direct human response and, as well, their weakness for remaining incomplete without it. Gestures assumed great importance in this process as together with the frontal figure [such as Christ enthroned] they brought pressure on the beholder" (*Gesture and Rank in Roman Art: The Use of Gestures to Denote Status in Roman Sculpture and Coinage*, Memoirs of the Connecticut Academy of Arts and Sciences, Vol. 14 [New Haven: Connecticut Academy of Arts and Sciences, 1963], 64 and 213). On the *adventus* scene in the late empire, see Ibid., 173–77.

74. Panofsky refers to the scene in this way (*Tomb Sculpture*, 41). On the idea of the *traditio legis* as well as scenes of the *traditio legis*, see Pietri, *Roma Christiana*, 2: 1413–42. On Peter and Paul as "the two masters," symbols of the teaching of the church, see Ibid., 1: 282–86. See also Ibid., 2: 1495–1524, for a discussion of the expansion of these ideas—"From Peter to the Pope, the Two Legislators."

75. Schiller, *Iconography*, 2: 5–6.

76. Ibid., 2: 4; see 3–7.

77. Margaret E. Frazer, "The Christian Realm: Apse Themes," in Weitzmann, ed., *Age of Spirituality* (Catalogue), 556. On the few scenes of Christ in majesty in the catacombs—in the catacomb of Peter and Marcellinus, Christ appears between Peter and Paul—see Stevenson, *Catacombs*, 59–60, 108. Christ in majesty is "the latest kind of picture that belongs to the period in which the catacombs were in use" (108) and "may be based on a picture or mosaic in a church" (60).

78. Shepherd, Jr., "Christology," 111.

79. Ibid. On the imperial models and background of the *traditio legis* scene, see also Ernst Kitzinger, "Christian Imagery: Growth and Impact," in Weitzmann, ed., *Age of Spirituality: A Symposium*, 144–45. On the *adlocutio* scene in the late empire, see Brilliant, *Gesture and Rank*, 165–70.

80. MacCormack, *Art and Ceremony*, 65–66. In the caption for the Bassus sarcophagus (pl. 25) MacCormack labels the two scenes *adventus* and *parousia*.

81. Ibid., 130–31.

82. Ibid., 131, on this last point citing E. Sauser. Cf. Schiller, who observes that, in every scene of the passion on sarcophagi of this period, "all expression of suffering is absent from the figure of Christ," and concludes: "During the centuries of the christological controversies it was important to stress the divinity of the Son of God, so that Christ is portrayed not as a suffering man but as the vanquisher of death" (*Iconography*, 2: 6). It may also be pointed out that the image of Christ as victor over death on the sarcophagus of a dead Christian bears the clear appro-

priateness of a prayer of faith, whatever the contemporary christological controversies. It is true that during Junius Bassus's lifetime, under the reigns of Constantine (312–337) and Constantius II (337–361), the Arian controversy about Christ's divine nature waxed and waned with theological arguments and political maneuvers (see Henry Chadwick, *The Early Church*, The Pelican History of the Church, Vol. 1 [New York: Penguin Books, 1967], 125–45). Yet, as Chadwick points out, "many Western bishops had only the haziest idea of what the controversy was really about" (140). Thus, although the scene of the enthronement of Christ over Coelus presumably manifests an orthodox affirmation of the divinity of Christ, and the scene of the triumphal entry likely presupposes Christ's humanity, caution is appropriate in reading in any detailed references to the Arian controversy.

83. René Grousset, *Étude sur l'histoire des sarcophages chrétiens: catalogue des sarcophages chrétiens de Rome qui ne se trouvent point au Musée du Latran*, Bibliothèque des Écoles françaises d'Athènes et de Rome, 42 (Paris: Ernest Thorin, 1885), 39. But the central scene of the upper register should also be seen in relation to the "Great Commission" of Matthew 28:18-20, with two disciples representing the eleven, and the longer ending of Mark: ". . . the Lord Jesus . . . was taken up into heaven, and sat down at the right hand of God" (Mark 16:19).

84. On double-register frieze sarcophagi (there being only one other double-register columnar sarcophagus with which to compare the sarcophagus of Junius Bassus) the upper center position, and sometimes part of the lower center, is frequently given special importance by the placement there of a portrait of the deceased within a shell motif, as, for example, on the Two Brothers sarcophagus (fig. 3).

85. Grabar (*Christian Iconography*, 34) posits that youthfulness in the figures of a scene, such as the Christ here or the putti on the ends of the sarcophagus, places those represented "outside time," that is, in eternity.

86. This reading of the iconography of the upper register as it is carved might be compared with Gerke's reading of the iconography of the upper register as he "rearranges" it by replacing the sacrifice of Isaac with the arrest of Paul. The reconstructed upper register presents, according to Gerke, the death of Christ in its "original Christian triple echo": Christ-Peter-Paul (*Iunius Bassus*, 23). Peter and Paul, the principal apostles, those who first tasted martyrdom, are symbols of "the Christian death." The scenes of the arrests of Peter and Paul prefigure the death of the martyrs and thus Christian death, which is "nothing else but the way to Christ" (24). In the place of the Unconquered Cross or Symbolic Resurrection, the normal center scene of passion sarcophagi of the Christ-Peter-Paul type, the Bassus sarcophagus presents Christ enthroned. Gerke

finds "no precedents for this throne scene" (25); its newness lies in its audacity in portraying the heavenly Christ in marble (26). Gerke observes the serenity of the youthful, enthroned Christ and asserts that the style, the composition, the whole atmosphere is "ruled from the divine face" (29). According to Gerke, the placement of this enthronement between the arrests of Paul and Peter on the left and the arrest of Christ on the right is the overwhelming artistic creation of this epoch. The reconstructed upper register of the sarcophagus represents the earthly end of Christ and apostles in order to show, in the middle of death, the heavenly throne (26).

87. Schiller, *Iconography*, 2: 19.

88. Daltrop, "Anpassung," 164–65.

89. Gerke, *Iunius Bassus*, 15. Gerke sees the ("rearranged") upper and lower registers, which are "unified separately," as linked at one point— their centers (16).

90. Ibid., 27. Cf. Panofsky, who notes briefly that the facade is centered around the temporal and eternal triumph of Christ (*Tomb Sculpture*, 41).

91. Schiller, *Iconography*, 2: 4–5.

92. Daniélou, "Fathers and Scriptures," 86: "Another criterion [of typology] is that the comparison ought not to depend on isolated words or images, but on what is really common to whole passages or incidents. Very often, in the N.T. itself, the comparison with the O.T. depends on an apparently insignificant detail. . . . Every time an isolated phrase like this is cited in the N.T., the whole episode in the O.T. should be read again. . . . The comparison is thus between whole passages or incidents. As A. C. Herbert has observed, we must not stop at 'illustrative' analogies but get at the real correspondences."

93. On the significance of Job as he appears "about a dozen times in catacomb paintings," see Stevenson, *Catacombs*, 76.

94. Gaertner stresses this link, but he wrongly assumes it is specific to Job rather than shared by Isaac and Daniel as well, and thus he overestimates its significance to the composition and iconography of the Bassus sarcophagus. See chap. 2 above.

95. The sarcophagi are (1) Lateran 164 (here fig. 9; Wilpert, *Sarcofagi*, 1: 142, 3; Bovini and Brandenburg, *Repertorium*, 1: no. 61), (2) a fragmented sarcophagus from the Cemetery of San Sebastiano, Rome (Wilpert, *Sarcofagi*, 1: 142, 2; Bovini and Brandenburg, *Repertorium*, 1: no. 215), and possibly (3) fragments of a sarcophagus in Valence (Wilpert, *Sarcofagi*, 1: 142, 1; the Job scene here is completely drawn in; no fragments are shown, and the scene is not listed under Job in the Index of Christian Art). Gerke also recognizes that the Job scene cannot be explained from the frieze sarcophagi tradition but that it does appear on

passion sarcophagi of the kind with the Symbolic Resurrection in the center and martyrdoms of the apostles grouped around it (*Iunius Bassus*, 19). This arrangement—Job related to a martyrdom—is, of course, exactly what we find on the sarcophagus of Junius Bassus, but Gerke, in shifting the Abraham/Isaac and Paul scenes, seems to ignore the traditional roots of this Job-Paul arrangement. For Gerke's reading of the supposed Abraham/Isaac-Job pairing, see n. 143 below.

96. Panofsky observes a parallelism between Paul's martyrdom on the extreme right and the afflictions of Job on the extreme left, but he interprets this parallelism not in terms of a link between Paul and Job specifically and uniquely but as a repetition of the parallelism between the arrest of Christ and the arrest of Paul as illustrated in the upper register (see n. 57 above). Job is *exemplar patientiae* and, more specifically, *typus Christi patientis*. Thus Panofsky's reasoning is that both Paul and Job parallel Christ, and therefore Paul and Job are linked (*Tomb Sculpture*, 41).

97. Daniel's experience in the lions' den and Abraham's divine requirement to sacrifice Isaac may also be regarded as trials or proofs of faith, but neither was a personal or bodily affliction.

98. For a more generalized Pauline reference to his weakness and suffering, see 1 Corinthians 4:9–13.

99. On Job as an *exemplum* of patience, and of the righteous person in general, among early church writers, see Daniélou, *Latin Christianity*, 324–26. Daniélou does not mention Paul in this connection.

100. Tertullian, *Patience*, chap. 14, 2–3; trans. Emily Joseph Daly, C.S.J., in *The Fathers of the Church*, Vol. 40 (New York: Fathers of the Church, Inc., 1959), 218. In this same treatise Tertullian also refers briefly to Abraham as an example of patience (chap. 6, 1 & 2) and to Adam and Eve and the people of Israel on the occasion of Moses's striking the rock as examples of impatience (chap. 5, 9–11, 24). The reference to Job as a model of patience continues, of course, beyond the fourth century. In Augustine's treatise on *Patience* (usually dated to 417, although its authorship has been questioned) the patient Job, who does not succumb to his wife's temptation to blasphemy and death, is shown to be in contrast with Adam, whom the Devil did entice through his wife, Eve (chaps. 11–13, see esp. 12; trans. Luanne Meagher, O.S.B., in *The Fathers of the Church*, Vol. 16 (Washington, D.C.: Catholic University of America Press, 1952), 245–48, see esp. 245–46.

101. Clement, "The Letter of St. Clement to the Corinthians," chap. 5; trans. Francis X. Glimm, in *The Fathers of the Church*, Vol. 1 (Washington, D.C.: Catholic University of America Press, 1947), 13–14.

102. Athanasius, Letter 13, 1–3; trans. Henry Burgess, in *The Festal Epistles of S. Athanasius, Bishop of Alexandria; A Library of Fathers of*

the Holy Catholic Church, Anterior to the Division of the East and West, Vol. 38 (Oxford: John Henry Parker, 1854; London: F. and J. Rivington, 1854), 104–5.

103. Saxl, *Lectures*, 1: 55.

104. John Chrysostom, *In Apostolicum Dictum*, 4, in *Patrologia Graeca* 51: 248; as quoted by Daniélou, *Shadows to Reality*, 192.

105. Hippolytus, Fragments from a commentary *On Daniel*; trans. S.D.F. Salmond, in *The Ante-Nicene Fathers*, Vol. 5 (Grand Rapids, Mich.: Wm. B. Eerdmans, 1957), 177.

106. Hippolytus, Fragments from *Scholia on Daniel*, chap. 10, 16, in *Ante-Nicene Fathers* 5: 190.

107. On the deeper roots of Christian typology of paradise and Adam in Jewish prophetic and apocalyptic literature, see Daniélou, *Shadows to Reality*, 11–16.

108. Ambrose, *Expositio Evangelii Secundum Lucan*, bk. 4, 7, in *Corpus Scriptorum Ecclesiasticorum Latinorum* 32, 4: 142; as quoted by Daniélou, *Shadows to Reality*, 46. For the Latin text and a French translation, see Ambroise de Milan, *Traité sur l'Évangile de S. Luc*, 2nd ed., trans. Gabriel Tissot, O.S.B., *Sources Chrétiennes*, No. 45 (Paris: Éditions du Cerf, 1971), 153.

109. See Daniélou, *Shadows to Reality*, on Eve as the type of Mary (40–47) and as the type of the church (48–56). On Eve as the type of the church, see also Daniélou, *Latin Christianity*, 306–9.

110. Irenaeus, *Proof of the Apostolic Teaching*, 31, 33; trans. Joseph P. Smith, S.J., *Ancient Christian Writers*, No. 16 (New York: Newman Press, 1952), 68–69, italics mine. Cf. Irenaeus, *Against Heresies*, bk. 3, chap. 22, 4: "In accordance with this design, Mary the Virgin is found obedient, saying 'Behold the handmaid of the Lord; be it unto me according to thy word.' But Eve was disobedient; for she did not obey when as yet she was a virgin. And even as she, having indeed a husband, Adam, but being nevertheless as yet a virgin . . . having become disobedient, was made the cause of death, both to herself and to the entire human race; so also did Mary, having a man betrothed [to her], and being nevertheless a virgin, by yielding obedience, become the cause of salvation, both to herself and the whole human race" (in both *Ante-Nicene Christian Library* 5: 361 and *Ante-Nicene Fathers* 1: 455).

111. One might also consider a marble plaque with biblical scenes (from about A.D. 300–310) on which a naked Daniel *orant* is basically opposite a naked Adam and Eve joining right hands in the *dextrarum junctio*, the official marriage gesture (cat. no. 371, in Weitzmann, ed., *Age of Spirituality* [Catalogue], 413); although the snake appears nearby, the primal pair seems to be depicted before the Fall (contra commentator Dinkler).

112. Adam and Eve, representing to Grabar (*Christian Iconography*, 12) the "necessity of redemption," were rarely portrayed in the catacombs or on early sarcophagi. When they do begin to be portrayed, that fact signifies, according to Lowrie (*Art in the Early Church*, 78), that "the problem of sin and redemption had begun to replace the problem of natural death with which the earlier art had been exclusively concerned." Indeed, Grabar notes that the Adam and Eve scene on the Bassus sarcophagus serves "to counterbalance a whole cycle of the Redemption" (*Christian Iconography*, 13).

113. The original figure of Daniel is missing (Grabar, *Early Christian Art*, 248) and has been replaced (Volbach, *Early Christian Art*, 320); see fig. 1. Wilpert's plate (here fig. 16) shows the Daniel figure missing. Is this part of what Marion Lawrence means when she says, in a review of *I Sarcofagi Cristiani Antichi*, Vol. I (*Art Bulletin* 13 [1931]: 532), that "account has been taken of later recuttings and additions"? Grousset (*Étude*, 104) reports, from the engraving of Bottari, that the figure was originally "Daniel *orant*." This is also to be expected from a survey of extant contemporary depictions of Daniel. On Daniel figures in catacomb paintings, see Stevenson, *Catacombs*, 80. Of approximately forty-nine clearly identifiable figures of Daniel (including fragments) on sarcophagi illustrated in Wilpert, *Sarcofagi*, I have noticed only four that are draped: 1: 65, 5; 2: 164, 5; 2: 166, 3; 2: 214, 1. Nikolaus Himmelmann has reported that the present baroque Daniel figure must have replaced an original naked figure that reinterpreted the Hippolytus-type in characteristic fashion ("Der Sarkophag des Junius Bassus" [abstract], in the Chronik section (Basel) of *Antike Kunst* 15 [1972]: 146). Graphic evidence that the original figure was a naked Daniel *orant* is provided by the drawings of A. Bosio, *Roma Sotteranea* (1632) and P. L. Dionysius, *Sacrarum Vaticanae Basilicae Cryptarum Monumenta* (1773), reprinted on pl. 3 and p. 32, respectively, of Gerke, *Iunius Bassus*. These drawings are reproduced here in figs. 15 and 14.

114. Saxl, *Lectures*, 1: 55. Cf. Panofsky: the second and fourth intercolumniations of the lower register are linked because the Fall of Adam and Eve represents "the event which made salvation necessary" and Daniel in the lions' den presents "that best-loved example of salvation" (*Tomb Sculpture*, 41).

115. For citations from Tertullian and Cyprian, see Daniélou, *Latin Christianity*, 321–23.

116. The possibility of negative typology, that is, typology of contrast, is acknowledged by Panofsky, who defines typological representations as "renderings of such events as can be interpreted, either by virtue of analogy or contrast, as 'prefigurations' of others" (*Tomb Sculpture*, 41).

117. According to Gerke, the sheaf of wheat and the lamb beside Adam and Eve are symbols of the fate of humankind because Christ gave Adam wheat as a sign of his work in the fields and Eve a lamb as a sign of her domesticity. "Als Adam grub und Eva spann," quotes Gerke (*Iunius Bassus*, 17). Daltrop observes that "the Expulsion and the Assignment of Labor, originally two separate pictures of narrative character, as on the so-called Dogmatic sarcophagus [here fig. 5], here interpenetrate" ("Anpassung," 167, n. 29).

118. For additional examples, see Bovini and Brandenburg, *Repertorium*, 1: nos. 16, 23b, 26, 40, 42, 43, 44, 109, 144, 304, 364; 45 is here fig. 3.

119. For Grabar (*Christian Iconography*, 12), Adam and Eve signify the "necessity of redemption." For Schiller (*Iconography*, 2: 4–5), Daniel in the lions' den is "a symbol of redeemed mankind."

120. De Waal, *Junius Bassus*, 77.

121. Jonathan Z. Smith, "The Garments of Shame," *History of Religions* 5 (1966): 220–21. Reprinted in *Map Is Not Territory: Studies in the History of Religions* (Leiden: E. J. Brill, 1978), 1–23. See also Deborah Markow, "Some Born-Again Christians of the Fourth Century," *Art Bulletin* 63 (1981): 650–55.

122. Smith, "Garments," 221.

123. Ibid., 221–22.

124. Ibid., 223.

125. Cyril of Jerusalem, *Mystagogical Lectures* II, 2, in *Fathers of the Church* 64: 161–62.

126. Theodore of Mopsuestia, *Commentary of Theodore of Mopsuestia on the Lord's Prayer and on the Sacraments of Baptism and the Eucharist*, chap. 4; *Woodbrooke Studies*, Vol. 6, trans. A. Mingana (Cambridge: W. Heffer & Sons, 1933), 54.

127. Smith, "Garments," 227–28.

128. For a detailed study of the interpretations of baptism presented by Cyril and Theodore, along with those of John Chrysostom and Ambrose—all writing in the later part of the fourth century—see Hugh M. Riley, *Christian Initiation: A Comparative Study of the Interpretation of the Baptismal Liturgy in the Mystagogical Writings of Cyril of Jerusalem, John Chrysostom, Theodore of Mopsuestia, and Ambrose of Milan*, Studies in Christian Antiquity, No. 17 (Washington, D.C.: Catholic University of America Press/Consortium Press, 1974). On interpretations of the removal of clothing and nakedness just prior to baptism, see Ibid., 159–89.

129. Weidlé, *Baptism of Art*, 18, n. 1. Weidlé attributes to Von Sybel "the acute observation that Adam and Eve may well be represented, not

for their own sake, but simply as signposts to Eden" (18, n. 1). The Adam and Eve in the Catacombs of Domitilla are referred to by Schiller as "the types of the redeemed whom Christ has freed from the realm of death" (*Iconography*, 1: 182).

130. Daniélou, *Shadows to Reality*, 25; see also 26, especially the quotation from Hippolytus. Through baptism each Christian begins the "recapitulation of 'the first Adam' which has been so fully accomplished by Christ" (Ibid., 19; see 1 Corinthians 15:45–49). Baptism of course is the initiation, not the summation, of Christian life; paradise typology is also applied to the mystical life and to death, especially martyrdom (see Ibid., 22–29, 57–65).

131. Gregory of Nyssa, *Adversus eos qui Differunt Baptismum*; in *Patrologia Graeca* 46: 417 C; as quoted by Daniélou, *Shadows to Reality*, 26–27.

132. Gregory of Nyssa, *In Baptismum Christi*, in *Patrologia Graeca* 46: 599 A; as quoted by Daniélou, *Shadows to Reality*, 16; cf. 27. On the paradisiacal significance of Adam and Eve, see also Snyder, *Ante Pacem*, 53–54; Snyder, however, does not mention the baptismal connection.

133. Adam and Eve appear in a clear baptismal context at Dura-Europos; they are apparently depicted (the wall painting is badly damaged) at the left bottom of the niche behind the baptismal font in the third-century Christian house church, with the Good Shepherd and his flock above (see Grabar, *Christian Iconography*, 20, figs. 40 & 41). Schiller also observes a connection between baptism and Adam and Eve—on the basis of their mutual relation to Creation: "Since baptism is considered to be a regeneration, a recreation, it is paralleled by its type, the first Creation; and so the baptismal water, sanctified by Christ's Baptism, also parallels the water which was the first created element, upon the face of which the Spirit of God moved. The Holy Ghost moves upon the consecrated water of the baptismal sacrament to sanctify the person baptized (Tertullian: *De baptismo*, 2). The Baptism was, it is true, never visually represented with the Creation, but in early sepulchral art it often appears beside Adam and Eve, the first human creations and therefore representative of the Creation" (*Iconography*, 1: 128–29).

134. Daniélou, *Shadows to Reality*, 101–2, citing Lundberg, *La typologie baptismale dans l'ancienne Église*, 33.

135. Daniélou, *Latin Christianity*, 322. Daniélou continues: "Although the theme is found simultaneously both in Rome and in Carthage, the Romans gave it a sacramental interpretation, whereas the African Christians interpreted it in the moral sense."

136. See J. W. Salomonson, *Voluptatem Spectandi Non Perdat Sed Mutet: Observations sur l'Iconographie du martyre en Afrique Romaine* (Amsterdam/Oxford/New York: North-Holland Publishing Co., 1979), esp. 55–90.

137. Cyprian, Letter 61, 2, in *Fathers of the Church* 51: 197. Cyprian also cites the three youths rescued from the fiery furnace as an example of this truth.

138. Hippolytus, Fragments from a commentary *On Daniel*, in *Ante-Nicene Fathers* 5: 177.

139. Hippolytus, Fragments from *Scholia on Daniel*, chap. 10, 16, in *Ante-Nicene Fathers* 5: 190.

140. On the absoluteness and finality of baptism in early Christian faith and practice, which often led to delayed or deathbed baptism, see Weidlé, *Baptism of Art*, 26–31.

141. On the association of Daniel *orant* with the form of the cross of Christ in Christian representations of Daniel in Roman Africa, see Salomonson, *l'Iconographie du martyre*, 71, n. 108, and the literature cited there.

142. Saxl, *Lectures*, 1: 55.

143. As with the upper register, this reading of the lower register as it is carved might be compared with Gerke's reading of the lower register as he "rearranges" it by replacing the Paul scene with the Abraham/Isaac scene. The reconstructed lower register presents, according to Gerke, the pattern of a clear Old Testament sarcophagus: two pairs of "our ancestors" within Old Testament stories of promise framing the triumphal entry (*Iunius Bassus*, 16). Daniel, often seen in close connection with Adam and Eve, is symmetrically linked with them here. The earthly fate of man and woman as suggested in Adam and Eve is contrasted with the promise of salvation as suggested in Daniel. Humanity fated for death is contrasted with humanity conquering death (17). Behind the "Job idea" the early exegetes sensed the resurrection (19). As part of an outer framing pair on passion sarcophagi, Job was sometimes linked with the sacrifice of Cain and Abel, depicted not as a quarrel between brothers but as a sacrifice to the Father (see fig. 9). Thus Job paired with Cain and Abel signified resurrection and sacrifice. According to Gerke, the dignified scene of the sacrifice of Isaac by Abraham is a subsitute for the dignified scene of the sacrifice of Cain and Abel (19). It follows that Job and Abraham/Isaac signify resurrection and sacrifice. In the center of the lower register stands the scene of the triumphal entry, as portrayed here not strictly a historical scene, according to Gerke, but a scene in which history and symbol interpenetrate. The reconstructed lower register of the sarcophagus thus depicts, amid Old Testament scenes that symbol-

ize human destiny for death, Christ, smiling and triumphant, riding to death. In this way, Gerke observes, the composition is unique (20).

144. Cf. Stommel on the greater significance of center and corner pictures on Constantinian frieze sarcophagi (*Ikonographie*, 88).

145. Daniélou, *Shadows to Reality*, 30.

146. Kitzinger, *Byzantine Art in the Making*, 24. Kitzinger notes that there are possible antecedents and points out that the unusual pagan Velletri sarcophagus of the second century is "relevant in this connection" (133, n. 5).

147. The other double-register columnar sarcophagus is from the Old Church of St. Trophime in Arles (fig. 2); see Wilpert, *Sarcofagi*, 1: 215.

148. Fig. 9 is Bovini and Brandenburg, *Repertorium*, 1: no. 61, and Wilpert, *Sarcofagi*, 1: 142, 3. Cf. Bovini and Brandenburg, *Repertorium*, 1: no. 215 (= Wilpert, *Sarcofagi*, 1: 142, 2) and Wilpert, *Sarcofagi*, 1: 142, 1 (here fig. 6).

149. This sarcophagus is much simpler than that of Junius Bassus; a typological movement from the left scene of a pair to the right is not clearly manifest.

150. Fig. 7 is Bovini and Brandenburg, *Repertorium*, 1: no. 189, 1. Cf. a damaged columnar sarcophagus with a central Labarum (fig. 6; Wilpert, *Sarcofagi*, 1: 145, 1) and a single-register frieze sarcophagus with a central Labarum (*Repertorium*, 1: no. 667). Of this latter sarcophagus Saxl comments: "In the earlier period we found the simple coordination of miracles, here we perceive a clear subordination of scenes, the lateral scenes serving as an accompaniment to the triumphant Cross in the centre" (*Lectures*, 1: 54).

151. In terms of changes from possible "models," the Paul scene seems to have taken the conch (see fig. 7) with it as it "moved"; see chap. 7 below.

152. Cf. Alice Christ, "Workshop, Patron, and 'Program' in the Sarcophagus of Junius Bassus" (abstract), in *Abstracts and Program Statements for Art History Sessions* (New York: College Art Association of America, 1986), 29: "Pursuing Gerke's suggestion that the Bassus sarcophagus is somehow related to the small group of mid-fourth century sarcophagi showing scenes of the Passion and triumph of Christ and the martyrdoms of Peter and Paul, this paper will seek to redefine the workshop contribution to the iconography of the Bassus sarcophagus. The program of the Bassus sarcophagus can be understood as fundamentally conditioned by an original expansion of the column sarcophagus form to two registers. And the meaning of the Bassus sarcophagus is founded in the meaning of the rather idiosyncratic way in which it partakes in the imagery of the Passion sarcophagi." This thesis will presumably be developed in Christ's dissertation (see n. 8 above).

CHAPTER 4: Spandrels

1. Although de Waal admits that, viewed as a whole, the spandrel scenes stand without any seeming chronological order, he is not satisfied with such an initial view and speculates that the sarcophagus would be more interesting if the selection of spandrel scenes could be shown to be guided by a special idea (*Junius Bassus*, 76).

2. De Waal presents a drawing of each spandrel scene (Ibid., 68, 69, 70, 72, 73, 75). Lowrie reproduces de Waal's drawings of the first four spandrel scenes (*Art in the Early Church*, pl. 28). All of de Waal's drawings are reproduced here, in figs. 17, 19, 21, 24, 26, 28.

3. De Waal, *Junius Bassus*, 70, and Lowrie, *Art in the Early Church*, 90 and pl. 29, evidently following de Waal. Grousset, *Étude*, 104. Clement F. Rogers reads this scene as "the Christ Lamb meeting the disciple lamb in a ship at sea" (*Baptism and Christian Archaeology* [Oxford: Clarendon Press, 1903], 249). Roger's interpretations of several of the spandrel scenes are suspect; see n. 34 below.

4. De Waal notes that the portrayal of the persons of these scenes as lambs is unique on sarcophagus spandrels, that the lambs serve a decorative function as well as eliciting biblical scenes, and that the animal pictures are immediately understandable because these biblical scenes were frequently pictured in the catacombs and on sarcophagi (*Junius Bassus*, 66).

5. Panofsky, *Tomb Sculpture*, 41. On the paradoxical "repetition of the same symbol [the lamb] to represent first the Lord and then his followers" in early Byzantine art, see Maguire, *Earth and Ocean*, 11–12. The arcosolium of Celerina in the catacomb of Praetextatus presents a lamb inscribed "Susanna" between two wolves inscribed "elders" (Stevenson, *Catacombs*, 80–81, fig. 57), but the lamb seems to serve in this case as a symbol of vulnerability.

6. This is the conclusion of Henri Stern, who is influenced in part by the parallel with the Bassus sarcophagus spandrel scenes ("Les mosaïques de l'église de Sainte-Constance à Rome," *Dumbarton Oaks Papers* 12 [1958]: 207–8; figs. 20, 47, & 48).

7. Grabar, *Early Christian Art*, 249; cf. Grabar, *Christian Iconography*, 135–37.

8. Kitzinger, *Byzantine Art in the Making*, 39.

9. Snyder, *Ante Pacem*, 14.

10. Marucchi, *Christian Epigraphy*, 69.

11. Grabar refers to both types of imagery: Christ portrayed as a lamb is a "symbol of Christ as victim, sacrificed for the salvation of men"; persons as sheep represent "the flock of the Good Shepherd" (*Christian Iconography*, 136).

12. Weidlé, *Baptism of Art*, 19, n. 3, citing Oskar Wulff, *Altchristliche und Byzantinische Kunst*, 2 vols. (Potsdam: Akademische Verlagsgesellschaft Athenaion, 1936), 1: 92. Wulff's illustration (no. 74) shows two sailing ships on the sea. Some human figures are standing in each ship; others are in the water, and two appear to be in the air on their way down to the water. In the water in front of the right ship a sea monster is threatening. Both ships have nets out; one or two figures appear to be catching hold of the net from the left ship. A lamb is walking up a gangplank extending from the left ship to the water.

13. Schiller, *Iconography*, 1: 131, 132.

14. De Waal, *Junius Bassus*, 77.

15. Gerke, *Iunius Bassus*, 20.

16. Ibid., 21.

17. Schiller, *Iconography*, 1: 181; 2: 4.

18. De Waal, *Junius Bassus*, 71. The three youths in the fiery furnace also serve as *exempla* in the moral exegesis of Tertullian and Cyprian; see Daniélou, *Latin Christianity*, 322–23.

19. E. Baldwin Smith, *Early Christian Iconography and A School of Ivory Carvers in Provence* (Princeton, N.J.: Princeton University Press, 1918), 108–9. Cf. de Waal, *Junius Bassus*, 75. On this scene and its significance in catacomb paintings, see Stevenson, *Catacombs*, 92–93.

20. Theodor Klauser (*Frühchristliche Sarkophage in Bild und Wort*, ed. Friedrich Wilhelm Deichmann [Olten: Urs Graf-Verlag, 1966], 64), in commenting on the striking of the rock scene of the Two Brothers sarcophagus, refers to the person (not a lamb) represented as "Petrus, des zweiten Moses." Saxl, commenting on the striking of the rock scene on the Dogmatic sarcophagus, notes of Peter: "[H]is triumph as a second Moses [may be understood as] giving those who believe in him the water of salvation" (*Lectures*, 1: 53). Kessler, in discussing fifth-century ivories, calls Peter "Moses's Christian successor" ("Acts of the Apostles," 113). See also Stevenson, *Catacombs*, 73.

21. See, e.g., Schiller, *Iconography*, 2: 4, n. 11, commenting on a similar scene on a Constantinian frieze sarcophagus (320–330). As Morey notes, the apocryphal text behind the story "still eludes the search of scholars" (*Early Christian Art*, 67).

22. Pietri, *Roma Christiana*, 1: 341; see 316–41. Cf. Kessler: although "[t]he first reference to this event in literature is found in the sixth-century *Passio Processi et Martiani*[,] in art, the episode was popular from the third century. . . . The reason Peter's legendary miracle of the spring appeared in art before it was cited in literature is clear. The event is a pictorial invention, created as a counterpart to the popular Old Testament picture of Moses in the wilderness causing a stream to issue forth

to refresh the Israelites (Ex. 17.2 and Num. 20.2–6)" ("Acts of the Apostles," 112).

23. See Stevenson, *Catacombs*, 71–73.

24. This scene is identified as Moses receiving the Law by de Waal (*Junius Bassus*, 66), Gerke (*Iunius Bassus*, 20), Adolphe Napoleon Didron (*Christian Iconography: The History of Christian Art in the Middle Ages*, 2 vols., trans. E. J. Millington [New York: Frederick Ungar, 1851, 1965], 1: 331, with line drawings of spandrel scenes 2–6 based on the drawings of Bosio), Morey (*Early Christian Art*, 135), and Panofsky (*Tomb Sculpture*, 41).

25. This scene is identified as Moses striking the rock by de Waal (*Junius Bassus*, 66), Didron (*Christian Iconography*, 1: 331), Morey (*Early Christian Art*, 135), and Panofsky (*Tomb Sculpture*, 41).

26. De Waal (*Junius Bassus*, 92–93) discusses briefly the pairing of the miracle of the spring with a scene that portrayed, according to Ficker, the threatening of Moses as described in Exodus 17:2, and according to Rossi, Peter in fulfillment of the prophecy given in John 21:18. The question of whether this figure represents Moses or Peter may also be irresolvable, but Ficker's conclusion, as reported by de Waal (Ibid., 93), is to the point: the unity of paired scenes such as these lies directly in the close connection between the leader and lawgiver of the Old Testament and the New Testament Peter in the understanding of the early Christians. On the development of Peter-Moses typology in the Roman church, see Pietri, *Roma Christiana*, 1: 316–56 and 2: 1437–42.

27. Daniélou, *Shadows to Reality*, 286.

28. Kessler comments: "Peter was Moses's Christian successor. He received the law from Christ's hand; he was a leader of his people" ("Acts of the Apostles," 113). Peter Brown, citing Pietri, notes that "Peter as Moses" is "a symbol of concord in a rebellious community" (*Cult of the Saints*, 166, n. 64).

29. See Daniélou, *Shadows to Reality*, esp. 195–97; Lowrie, *Art in the Early Church*, 77 (with reference to Tertullian); Grabar, *Christian Iconography*, 143; and Schiller, *Iconography*, 1: 130.

30. Gregory of Elvira, *Tract*. XV, 165–66; as quoted by Daniélou, *Shadows to Reality*, 196–97. Cf. Daniélou's quotations from Tertullian and Cyprian (195).

31. Ambrose, *The Sacraments*, bk. 5, chap. 1, 3; trans. Roy J. Deferrari, in *The Fathers of the Church*, Vol. 44 (Washington, D.C.: Catholic University of America Press, 1963), 310. See also Daniélou's quotations from Chrysostom and Theodoret (*Shadows to Reality*, 193–94).

32. See Wilpert, *Sarcofagi*, 1: 24.

33. Chadwick, *The Early Church*, 266, 268.

198 NOTES TO CHAPTER 4

34. De Waal, *Junius Bassus*, 74, 73. Rogers goes a step further; he regards the fourth spandrel scene as representing the baptism *by* Christ of a disciple. However, his unique view of this scene seems influenced by his overall thesis: that early Christian archaeology illustrates the fact that the original method of administering baptism was by affusion, not submersion. Rogers reads the second spandrel scene in a similar way: "the Christ Lamb striking the rock (while a disciple lamb drinks from the water which flows down in a stream similar to that represented in the Baptism scene)" (*Baptism and Christian Archaeology*, 248–49).

35. See Dom Gregory Dix, *The Shape of the Liturgy* (London: A & C Black, 1945; New York: Seabury Press, 1982), 48–102, on the "four-action" shape of the eucharist.

36. E. Baldwin Smith, *Early Christian Iconography*, 130.

37. Ibid., 131.

38. De Waal, *Junius Bassus*, 74.

39. E. Baldwin Smith, *Early Christian Iconography*, 131. On this scene, see also Schiller, *Iconography*, 1: 164–65. On the multiplication of loaves scene in the catacombs, see Stevenson, *Catacombs*, 93–94.

40. E. Baldwin Smith, *Early Christian Iconography*, 72. According to Stevenson, the baptism of Jesus is depicted only four times in extant catacomb painting (*Catacombs*, 89).

41. E. Baldwin Smith, *Early Christian Iconography*, 72–73.

42. Daniélou, *Shadows to Reality*, 101–2. Stevenson quotes Cyprian (third century): " 'As often as water by itself is mentioned in Holy Scripture, baptism is proclaimed' " (*Catacombs*, 67).

43. On the sarcophagus of Santa Maria Antiqua, see Bovini and Brandenburg, *Repertorium*, 1: no. 747. On the characteristics of the baptism scene in the West, see E. Baldwin Smith, *Early Christian Iconography*, 71–78.

44. Saxl, *Lectures*, 1: 49.

45. Le Blant, *d'Arles*, 27; cited by E. Baldwin Smith, *Early Christian Iconography*, 75. Schiller comments on the Santa Maria Antiqua sarcophagus: "The boyishly small nude figure of the catechumen reappears in many representations and is probably meant to express the fact that Jesus has offered himself in a state of abasement" (*Iconography*, 1: 132).

46. Snyder, *Ante Pacem*, 57.

47. Daniélou, *Shadows to Reality*, 101.

48. Grabar, *Christian Iconography*, 10.

49. De Waal, *Junius Bassus*, 76.

50. Grisar's interpretation would be more understandable, de Waal suggests, if the order of the spandrel scenes were as follows: three youths in the fiery furnace, giving of the Law, baptism of Christ, multiplication of the loaves, miracle of the spring, raising of Lazarus (Ibid.).

51. Weidlé, *Baptism of Art*, 21–22.

52. Ibid., 22–26.

53. Ibid., 23–24. See also Stevenson, *Catacombs*, 89–90. On the elements of the early Christian baptismal ritual, see Pietri, *Roma Christiana*, 1: 106–11.

54. See also Mark 10:35–40 and Matthew 20:20–23.

55. See Weidlé, *Baptism of Art*, 26–31.

56. Ibid., 28–29.

57. Junius Bassus was probably baptized on his deathbed, not at Easter. There would have been many similarities between the two forms no doubt, but surely differences as well.

58. M. L. Thérel, "Légitimité et intérêt historique de la lecture 'Au second degré' des images paléochrétiennes," in *Überlegungen zum Ursprung der Früchristlichen Bildkunst*, ed. H. Brandenburg (Rome: IX Congresso Internazionale di Archeologia Cristiana, 1975), 79.

59. Daniélou, *Shadows to Reality*, 197. An earlier stage of this interpretation is represented by Melito of Sardis and elaborated by Hippolytus of Rome: the Passover of the Exodus is the type of Christ's passion (see Melito of Sardis, *Homily on the Passion*, esp. 16–20, 57–60 [on Hippolytus], 168–80). For a discussion of Old Testament and especially Exodus typology in the mystagogical interpretation of the liturgy of baptism in the later part of the fourth century, see Riley, *Christian Initiation*, 36–54.

60. See Daniélou, *Shadows to Reality*, 153–201.

61. Theodoret, *Questions on Exodus*, chap. 27, in *Patrologia Graeca* 80: 257; as quoted by Daniélou, *Shadows to Reality*, 194.

62. Hilary, *Tractatus Mysteriorum*, bk. I, 29; as quoted by Daniélou, *Shadows to Reality*, 220. For the Latin text and a French translation, see Hilaire de Poitiers, *Traité des Mystères*, trans. Jean-Paul Brisson, *Sources Chrétiennes*, No. 19 (Paris: Éditions du Cerf, 1947), 122–25.

63. The intercolumnar scene of the triumphal entry is also from the frieze repertoire.

64. See Bovini and Brandenburg, *Repertorium*, 1: no. 43.

65. On this type of scene as the commissioning of Peter (John 21:15–17), see the reference to Stommel, *Ikonographie*, 88–109, in n. 39 to chap. 1 above.

CHAPTER 5: Ends

1. Goodenough notes: "The little baby-boy figures are commonly called cupids or 'amorini' when they have wings, 'putti' when without wings, and 'genii' when they are larger in proportion to their setting. But

these distinctions break down altogether when we try to use them systematically" (*Jewish Symbols*, 8: 3).

2. Hanfmann, *Season Sarcophagus*, 2: 184–85. Peter Kranz presents a thorough catalogue, classification, and discussion of season sarcophagi and lids of the time of the Roman empire, but the distinctive scenes on the ends of the Bassus sarcophagus are beyond the scope of his work. He notes briefly: "In the second quarter of the fourth century, then, the development of Roman season sarcophagi will have come to an end. By this time the season scenes on the ends of the Junius Bassus sarcophagus from the year 359 A.D. obviously no longer stood in direct connection with the iconography and stylistic development of Constantinian season sarcophagi" (*Jahreszeiten-Sarkophage: Entwicklung und Ikonographie des Motivs der Vier Jahreszeiten auf Kaiserzeitlichen Sarkophagen und Sarkophagdeckeln* [Berlin: Gebr. Mann Verlag, 1984], 68; see also 32, n. 126; 54, n. 298; 145, n. 934).

3. Hanfmann, *Season Sarcophagus*, 1: 19.

4. Ibid., 1: 64.

5. Ibid., 1: 223.

6. Ibid. The nude putti and classically attired Psyches of these "panoramic" scenes, Hanfmann specifies, contrast strongly with the realistic seasons in contemporary costumes that began to prevail in most other late antique monuments.

7. The season motif was apparently also acceptable to Jews, as is suggested most notably by a fragment of a sarcophagus facade now in storage in the Terme Museum in Rome: in what would have been the center of the facade is a seven-branched lampstand on a medallion held by two draped cupids (Victories); below the medallion three nude wingless cupids tread grapes in a vat; to the right of the center is a nude cupid holding a basket of fruit and two geese (autumn) and a fragment of a second cupid holding a boar (winter). Surely two additional nude cupids with appropriate seasonal objects once completed the left side. One might easily imagine that this season sarcophagus was a stock item and that the Jewish purchaser had the identifying menorah carved where a pagan or Christian buyer would have had carved a portrait bust of the deceased. On this suggestion, cf. J. B. Frey as cited by Arthur Darby Nock, "Sarcophagi and Symbolism," in *Essays on Religion and the Ancient World*, by Nock, 2 vols., ed. Zeph Stewart (Oxford: Clarendon Press, 1972), 2: 615, n. 31. On the Jewish sarcophagus, from the Catacomb Vigna Randanini, see Franz Cumont, "Un fragment de sarcophage judéo-païen," in *Recherches sur le symbolisme funéraire des Romains*, by Cumont (Paris: Librairie Orientaliste Paul Geuthner, 1942), 484–98, first published in *Revue archéologique*, Ser. 5, 4 (1916): 1–16, and Goodenough,

Jewish Symbols, 2: 26–27; 3: fig. 789; 8: 3–4. According to Cumont, the seasons symbolize here—as for pagans—future life, and the Victories and Bacchic putti have a similar meaning. Goodenough suggests that "[t]he menorah, itself a sign of the seven planets, flanked by Seasons, meant much in terms of Jewish thought: it meant hope of immortality, astral immortality granted by that beneficence which, while it came from the relentlessly regular heaven, made all the earth fertile and promised renewed life also to man. But the menorah added that all this came from the Jewish God who governed the universe. When Christians took over the same value and put Christ enthroned between the Seasons upon a sarcophagus in place of the candlestick, it may be assumed that in Christian terms the design indicated the same hope" (8: 218). Additional evidence of the acceptability of the seasons in Jewish contexts is given in this and other Jewish catacombs in Rome (see Ibid., e.g., 2: 19 [on the stunning Painted Room II of the Catacomb Randanini] and 29; 8: 172–73).

8. Hanfmann, *Season Sarcophagus*, 1: 56. For Lateran 110 and 184, see Bovini and Brandenburg, *Repertorium*, 1: nos. 48 and 39. Marion Lawrence argues that Lateran 110 is a forgery or falsification of early Christian sculpture; she discusses its stylistic peculiarities and points out that it "entered the Lateran in 1854; there is no record of its provenance or previous history" ("Season Sarcophagi of Architectural Type," *American Journal of Archaeology* 62 [1958]: 295, n. 116, see 294–95). Murray points out that the "marriage of pagan and Christian" imagery generally is consistently illustrated on "[l]uxury craftsmanship whether in the service of individuals or of the Church" ("Art and the Early Church," 340, n. 1; cf. Murray, *Rebirth and Afterlife*, 144–45, n. 115). As examples she cites the Projecta casket, the Traprain treasure, the Mildenhall treasure, and the Water Newton silver hoard.

9. Hanfmann, *Season Sarcophagus*, 1: 244. See also Stevenson, *Catacombs*, 58.

10. Hanfmann, *Season Sarcophagus*, 1:244.

11. Ibid., 1: 190.

12. Minucius Felix, *Octavius*, chap. 34, 11–12; trans. Rudolph Arbesmann, O.S.A., in *The Fathers of the Church*, Vol. 10 (Washington, D.C.: Catholic University of America Press, 1950), 393–94.

13. Tertullian, *Apology*, chap. 48, 8; trans. Emily Joseph Daly, C.S.J., in *The Fathers of the Church*, Vol. 10 (Washington, D.C.: Catholic University of America Press, 1950), 119.

14. Tertullian, *On the Resurrection of the Flesh*, chap. 12; trans. Peter Holmes, in both *Ante-Nicene Christian Library*, Vol. 15 (Edinburgh:

T & T Clark, 1870), 235, and *The Ante-Nicene Fathers*, Vol. 3 (Grand Rapids, Mich.: Wm. B. Eerdmans, 1957), 553.

15. This was a widespread notion. Lawrence presents selections in which Ovid, Horace, and Seneca speak of the eternal cycle ("Season Sarcophagi," 277).

16. Hanfmann, *Season Sarcophagus*, 1: 191.

17. Hanfmann explains that Tertullian "attempted to meet the difficulty by dividing time into two great periods, of which only the first is characterized by cyclic continuity" (Ibid.).

18. Hanfmann cites, by way of example, Dracontius (ca. 480–500), who, in celebrating the power of time to produce constant changes (seasons, ages, etc.), suggested that "even Christ awaited the time appointed for his Passion," that is, that even Christ obeyed the laws of eternal time (*Satisfactio* 216ff., ed. Sister M. Margaret, Philadelphia, 1936, 41, 43, 92ff.; as quoted by Hanfmann, *Season Sarcophagus*, 1: 191).

19. Augustine, *Sermones*, sermon 361, chap. 10, in *Patrologia Latina* 39: 1604; as quoted and interpreted by Hanfmann, *Season Sarcophagus*, 1: 191.

20. Ibid., 1: 203: "For the late antique thinkers, the existence of a regular order of time had been one of the few certain and positive manifestations of the divine. When God was removed to eternity, when Christian ritual and scriptural symbolism had crystallized, the argument lost much of its conviction; it seems not to be a matter of chance that the representations of Seasons dwindle in number after the time of Augustine."

21. Hanfmann, *Season Sarcophagus*, 1: 244–45.

22. Ibid., 1: 192.

23. Ibid., 1: 245.

24. Ibid., 1: 205.

25. Ibid.

26. Origen, *In Epist. S. Pauli ad Rom. V, 6*, in *Patrologia Graeca* 14; as referred to by Hanfmann, *Season Sarcophagus*, 1: 205–6. Romans 5:6 reads: "While we were still weak, at the right time Christ died for the ungodly."

27. Hanfmann, *Season Sarcophagus*, 2: 184. The "iconographic mistakes" are these: (1) the fourth amorino in the summer grain-gathering scene is climbing a ladder up an olive tree and thus seems to belong with the winter olive-harvesting scene of the opposite end; (2) the second amorino of the varied spring scene, who is pulling a lizard out of a vat with one hand and holding a bunch of grapes with the other, "really belongs to autumn."

28. Ibid.

29. Hanfmann's assignations, however, are not universally shared.

Wilpert labels the representations as follows: the first putto, close to a goose, is winter; the second, with "the handle of a broken sickle," is summer; the fourth, with a lizard attached to a rope being pulled out of a vat (invoking a "cure" explained in Dioscurides's *De materia medica*) in the right hand and a bunch of grapes in the left, is autumn. The remaining three putti (holding, respectively, flowers, a bird, and a glass) are not specifically assigned to spring by Wilpert, but that appears to be his understanding (*Sarcophagi*, 3: p. 16). If so, Wilpert's system provides this pattern: winter, summer, spring, autumn, spring, spring—which is no more compelling than that suggested by Hanfmann. De Waal and Gerke propose assignations in agreement with each other but differing in some respects from both Wilpert and Hanfmann: first putto, with an olive twig and olive basket and approaching "the winter goose"—winter; second putto, with a hare—autumn; third and fourth putti, with a flower wreath and a lizard—summer; fifth and sixth putti, with a bird and a bird's nest or a dish of water—spring (de Waal, *Junius Bassus*, 88–89; Gerke, *Iunius Bassus*, 14). Gerke's description of these six putti as arranged "in the pattern of the year" fits only if they are observed from right to left. In a study of "Season Sarcophagi of Architectural Type," Lawrence concludes: "The Seasons are usually represented from the left to the right, beginning with Spring and following the cycle of the year" (293). In a quite different context Maguire notes, tangentially, that an apse mosaic in a basilica constructed by Bishop Severus, who was in office from 363 until 409/10, and known only from a "curious description" in the ninth-century *Liber Pontificalis* of Naples, apparently presented four figures personifying the seasons in the sequence winter, autumn, summer, spring below the portrayal of Christ seated with the twelve apostles (*Earth and Ocean*, 13). Henri Stern labels the six putti of the Bassus sarcophagus right end as follows: (1) with olives, clothed—winter; (2) with hare and dog—second autumn; (3) with garland of flowers—second spring; (4) with lizard and grapes—first autumn (August 11—autumnal equinox); (5) with swallow—first spring (February 8—spring equinox); (6) with glass—summer (summer solstice—August 10) (*Le calendrier de 354: étude sur son texte et ses illustrations* [Paris: Imprimerie Nationale/Librairie Orientaliste Paul Geuthner, 1953], 292–93). Stern presents evidence that the ancients divided each season into two periods (292, n. 8), but he does not comment on why the Bassus sarcophagus sculptor chose to represent this twofold division only for spring and autumn or—more importantly—why the sculptor chose this very peculiar order for representing the seasons.

30. Hanfmann, *Season Sarcophagus*, 2: 185. Lawrence argues that the Three Good Shepherds sarcophagus and the Bassus sarcophagus seem to derive from the same model ("Columnar Sarcophagi," 133).

31. E.g., sources of this borrowing are observed in autumn with a lizard from September in the Calendar of 354, spring holding a bird from March in the mosaic of Ostia, and spring or summer drinking out of a bowl from August in the Calendar of 354 (Hanfmann, *Season Sarcophagus*, 2: 39, n. 87). On the Calendar of 354, an almanac in codex form now known only from fifteenth- and sixteenth-century copies of a Carolingian copy, see Stern, *Le calendrier*.

32. Hanfmann, *Season Sarcophagus*, 2: 184–85. (By a confusing error 2: 185 reads "on the left end" instead of "on the right end.") Although Hanfmann does not directly draw out this parallel, he has earlier pointed out that "the sculptor of Lateran 181 took at least a part of the picture of Autumn to decorate the front of his sarcophagus" (1: 64); that is, the Lateran 181 sculptor also considered the vintage to be a subject distinct from the representations of the seasons, as well as a part of those representations.

33. On the use of putti in "certain scenes of symbolic grape-gathering (in allusion to the 'vine of the Lord' and to communion)," see Grabar, *Christian Iconography*, 34; and on wheat harvest scenes as pointers to the sacrifice of the body of Christ, the bread of the eucharist, and the *agape* meal of paradise, see Ibid., 9. In discussing the vault mosaics of Santa Costanza (ca. 354), Walter Oakeshott concludes that "the vine is surely the True Vine, Christ (this, as a Christian motif, having already appeared in the earliest Christian catacombs of the first to second centuries). . . . Leonardi shows that to the early Fathers the vine harvest signified martyrdom [see, however, the reference to martyrdom and the eucharist in n. 62 to chap. 3 above]; but he thinks that in the graphic arts the vine was simply adopted, for Christian use, as a symbol of joyful immortality. But it is hard to believe that it had failed, by this date, to acquire 'overtones' from St John's Gospel ["I am the true vine"]. The detailed activities of the *putti* do not matter. But the idea of the harvest, the end of one life and the beginning of another, is central." Oakeshott also refers to "the vine harvest (which is death, or perhaps more precisely the Last Day; the symbol comes probably from Revelation XIV. 17–20]" (*The Mosaics of Rome: From the Third to the Fourteenth Centuries* [London: Thames and Hudson, 1967], 62). The vineyard as a metaphor for the people of God or the kingdom of God is familiar in the Jewish (e.g., Isaiah 5:1–7) and the Christian traditions (e.g., Mark 12:1–11, Matthew 21:33–44, Luke 20:9–18). See also n. 39 below concerning pagan and Jewish use of vine imagery. Clearly vine/vintage symbols are polyvalent.

34. De Waal also notes that the grape-gathering putti amid vines of the inner columns and the end of the Bassus sarcophagus are related to one another and are borrowed from secular art of the time (*Junius Bassus*,

86). Gerke argues that the repetition of the vine motif of the end on the columns of the middle front—columns that frame the most important scenes, the heart of the composition—gives further evidence of thematic unity (*Iunius Bassus*, 15).

35. De Waal, *Junius Bassus*, 87.

36. See Soper, "Latin Style," 170, and Gerke, *Iunius Bassus*, 13. Gerke (14) also sees a parallel to the Junius Bassus vintage scene—especially its wagon and wine press—in the mosaics of Santa Costanza. Marion Lawrence sees a parallel to the Junius Bassus vintage scene in "a frieze of cupids gathering grapes for the vintage" on the cover of a sarcophagus. This cover now rests on the Dionysus and Ariadne sarcophagus in the Walters Art Gallery in Baltimore, but it "was made for another Dionysiac one" ("Three Pagan Themes in Christian Art," in *Essays in Honor of Erwin Panofsky*, 2 vols., ed. Millard Meiss [De Artibus Opscula XL; New York: New York University Press, 1961], 1: 327 and 2: 102, fig. 9). Cupids are portrayed picking the grapes, trampling them in a large vat, and carting them off in a two-wheeled oxcart. They appear on both sides of a bust of the deceased.

37. Fig. 34 is Bovini and Brandenburg, *Repertorium*, 1: no. 771; Wilpert, *Sarcofagi*, 1: 127, 2. See also Bovini and Brandenburg, *Repertorium*, 1: nos. 833 (lid), 883 (lid), and 947, 2 and 3 (ends).

38. Fig. 36 is Bovini and Brandenburg, *Repertorium*, 1: no. 188.

39. Scenes of grape picking and grain harvesting are not, of course, uniquely Christian. The images are pagan ones adopted and adapted for Christian use—and acceptable, it would seem, for Jewish use as well: (1) a fragmented sarcophagus facade discovered in the Jewish Catacomb Vigna Randanini bears a scene of putti treading grapes below a central medallion with a menorah (the Victories holding the medallion are flanked by seasonal putti, as discussed in n. 7 above); see Goodenough, *Jewish Symbols*, 2: 26–27, 3: fig. 789, 8: 3–4; (2) a small fragment of the cover of a sarcophagus found in the largest Jewish catacomb of Rome, known as Catacomb Torlonia or Catacomb Nomentana, shows a putto picking grapes to the left of an empty name plate (Ibid., 2: 41 and 3: fig. 820). Goodenough regards the wine symbols (the cup, the vine, the grape, etc.) as part of "the lingua franca of the religious symbolism of the time." "The symbol is really a common denominator. . . . For in both religions [paganism and Christianity] the cup and vine symbolize mystic union with the saving god, and eternal life" (Ibid., 4: 37). The sarcophagus cover mentioned by Lawrence ("Three Pagan Themes," 1: 327 and 2: 102, fig. 9; see n. 36 above)—with the vintage scene surrounding the portrait bust—might be presumed to be pagan. For additional scenes of grape treading beneath the portrait rondel, see Kranz, *Jahreszeiten-Sarkophage*, pls. 26, no. 1; 31, 5; 32, 3; 33, 4; 35, 2; 42, 5; 44, 3; 44, 4; 45,

1 is the Jewish sarcophagus from Catacomb Vigna Randanini, now in the Terme Museum, with a menorah replacing the portrait; all of these are season sarcophagi. For additional scenes of grape picking and/or treading and grain harvesting on sarcophagi lids, see Kranz, *Jahreszeiten-Sarkophage*, pl. 95, nos. 3 and 4 (no. 2 is Bovini and Brandenburg, *Repertorium*, 1: no. 883; no. 6 is the lid of the sarcophagus shown here in fig. 34). The image of wheat and grapes appears in catacomb painting as well; Tronzo notes that "there may also have been an implicit Christian message in the grapes and sheaves of wheat held by the enthroned figures on the ceiling" of cubiculum O of the Via Latina catacomb (*Via Latina Catacomb*, 67 and fig. 97).

40. Goodenough, *Jewish Symbols*, 12: 117–18; for full details on bread and wine symbolism, see vols. 5 and 6.

41. Ibid., 12: 121: "The survival of the vine and wine, water and bread and milk, in Christian iconography to indicate Christian hopes needs no exposition for those who know early Christian art, and is utterly too complicated to recount here for those who do not. Scholars have always assumed that the Christian representations of the vine, wine, and bread referred to the Eucharist, and the Catholic tradition of interpretation has been that Christians took over a series of dead forms, purely decorative, and in making them symbolize the Eucharist turned them into symbols for the first time. The material here summarized [concerning wine symbols in the East, ancient Egypt, Greece, and the Roman world] makes that assumption dangerous, to say the least."

42. Ibid., 5: 81–82.

43. Ibid., 5: 90.

44. Daniélou, *Latin Christianity*, 315, citing Cyprian, Letter 69, 14.

45. Cyprian, Letter 63, 11, in *Fathers of the Church* 51: 210.

46. Daniélou, *Latin Christianity*, 317, citing Lebeau.

47. Hanfmann, *Season Sarcophagus*, 2: 184.

48. Stern asserts that the copying was in the opposite direction: "It is clear, finally, that the sculptor of the sarcophagus of the Lateran [no. 181; here fig. 32] has copied the reliefs of the sarcophagus of Junius Bassus. He attributes to spring the swallow and the flowers and limits himself to following a new fashion without troubling himself otherwise about the why of these alterations" (*Le calendrier*, 293). Stern offers no further argumentation for this view.

49. Hanfmann, *Season Sarcophagus*, 1: 205.

50. Origen, *In Epist. S. Pauli ad Rom. V, 6*, in *Patrologia Graeca* 14; as referred to in Hanfmann, *Season Sarcophagus*, 1: 205–6.

51. Gregory of Nyssa, *Commentary on the Song of Songs*, homily 5; trans. Casimir McCambley, O.C.S.O. (Brookline, Mass.: Hellenic College Press, 1987), 116, italics mine.

52. Putti often appear nude, of course, but that does not deprive their nudity of all symbolic significance—especially when contrasted with a clothed putto. On the link between nudity and the new life promised in the resurrection, see the discussion of Adam and Eve and Daniel in chap. 3 above. Lawrence concludes that on season sarcophagi of architectural type winter "is usually clothed in chiton or mantle" ("Season Sarcophagi," 293).

53. This sarcophagus, in the Musée National Parc Trémaux in Tipasa (Wilpert, *Sarcofagi*, 3: 290, 2; Kranz, *Jahreszeiten-Sarkophage*, pl. 126, no. 2), as a whole suggests an interesting iconographical and thematic comparison with the Junius Bassus sarcophagus. The niche farthest right presents the miracle of the spring, a reference to the sacrament of baptism. (The figure is Moses according to Lawrence ["Season Sarcophagi," 290] and others; the scene is the baptism of the centurion Cornelius [Acts 10] according to Hanfmann [*Season Sarcophagus*, 1: 56] and others.) If Wilpert's reconstruction is accurate, the niche farthest left presents Christ's miracle of turning water into wine, a type of the sacrament of communion. The central niche portrays Christ enthroned, a sign of his eternal kingship. The second and fourth niches present putti representing the cycle of the seasons, a symbol of resurrection. Thus a reading of the facade suggests: through the sacraments comes resurrection to eternal life.

54. See n. 29 above.

55. Both de Waal and Gerke label the seasons represented in the lower right end scene as winter, autumn, summer (two putti), spring (two putti). Neither scholar comments on this strange order, but it is at least interesting to speculate that the seasons are depicted from winter backwards to spring so as better to reflect Christian death, which, surprisingly, leads back to life, new life, resurrection. Such an interpretation is not out of line with de Waal's reference to the "eternal spring in heaven" (*Junius Bassus*, 89) or with Gerke's observation that the serenity of the youthful, enthroned Christ is observed again in the faces of the grape-gathering putti of the end (*Iunius Bassus*, 29).

56. De Waal and Gerke also notice that the right lower compartment depicts a topic separate from the other three compartments of the ends. Both classify the former as a seasonal cycle showing all four seasons and the latter as a depiction of the harvest. De Waal notes that both the season putti and the harvest putti serve first as decoration, but he asserts that one can easily see a deeper meaning within these scenes. The changing seasons, de Waal explains, point to the "eternal spring in heaven" (*Junius Bassus*, 89; see 88–89). The harvests point to that "great blissful day of harvest" in heaven (Ibid., 89). According to Gerke, the season putti of the ends show the passage of time and suggest the inclu-

sion of human beings in the cosmos; symbolic of ripeness and decay, the harvest and seasons mythology of the ends is a "gentle, universal echo" of the main motif of the front, Christian death (*Iunius Bassus*, 11, 15; see also 13–14). Stern reaches the same general conclusion: on the lower right six putti represent the four seasons; the upper right and both panels of the left depict harvests ("Mosaïques," 213).

57. Cf., in general, the work of Maguire on images of the terrestrial world in early Byzantine art: "Throughout this book I have stressed the ability of individual motifs to carry different meanings in different contexts, and sometimes several meanings in one context. By exploiting the polyvalences inherent in their artistic vocabulary, designers of the sixth century were able to saturate their compositions with meaning and to produce works of considerable intellectual complexity and sophistication" (*Earth and Ocean*, 83).

58. See, e.g., Stevenson, *Catacombs*, 58 and 99.

59. Hanfmann, *Season Sarcophagus*, 1: 205.

60. Ignatius, "To the Ephesians," 20, in *Fathers of the Church* 1: 95.

61. Although the season and harvest putti of the ends must be seen as "in strange contradiction" to the front in terms of style and subject matter, if their "deeper meaning" concerns eternal life, it is difficult to understand why de Waal finds it so "hard to see a connection between the front and the ends" (*Junius Bassus*, 87).

62. Daniélou, *Shadows to Reality*, 153, citing Cullmann.

CHAPTER 6: Lid

1. For a review of the arguments on whether the lid and the box belong together and a conclusion that one can assume the original unity (and artistic unity) of both components, see Nikolaus Himmelmann, *Typologische Untersuchungen an römischen Sarkophagreliefs des 3. und 4. Jahrhunderts n. Chr.* (Mainz am Rhein: Philipp von Zabern, 1973), 15–16.

2. Or in 1595. The 1597 date derives from the diary entry (October 1, 1597) of Pompeo Ugonio (died 1614), reporting the finding of the sarcophagus at St. Peter's beneath the *confessio* opposite the altar of St. Peter himself, only a hand or perhaps less below the pavement, when it was dug out for the ornamentation of Clement VIII. See Daltrop, "Anpassung," 159–60 (from which one phrase of Ugonio's statement appears to be missing; Daltrop reproduces Ugonio's sketch as ill. 3 on p. 160); and Bovini and Brandenburg, *Repertorium*, 1: 279. The (April) 1595 discovery date derives from Ugonio's student Antonio Bosio, in his work *Roma Sotteranea*, which did not appear until three years after his death

in 1632 (Daltrop, 160; cf. *Repertorium*, 1: 279). See also Himmelmann, *Typologische*, 15, n. 2, and de Waal, "Chronologie," 120.

3. Daltrop, "Anpassung," 161. Cf. Himmelmann, *Typologische*, 15, nn. 4 & 5.

4. Daltrop, "Anpassung," 157, 161.

5. Giuseppe Bovini, *I Sarcofagi Paleocristiani: Determinazione della Loro Cronologia Mediante l'Analisi dei Ritratti* (Vatican City: Società Amici Catacombe/Pontificio Istituto di Archeologia Cristiana, 1949), 23. The carving of the lower portion of the lid was shown, sketchily, in the drawing by Philippus Laurentius Dionysius originally published in 1773 (Daltrop, "Anpassung," 161; Dionysius, *Cryptarum Monumenta*, 201–8, pl. 31); here fig. 14.

6. De Waal, *Junius Bassus*, 81.

7. In 1903 according to Bovini, *Sarcofagi*, 23; see de Waal, "Chronologie," 121.

8. See Wilpert, *Sarcofagi*, 2: 14*.

9. De Waal, "Chronologie," 117–34, esp. 124; see Himmelmann, *Typologische*, 15, 17.

10. Wilpert reported that he asked another scholar, Carlo Robert, if he knew of any pagan models for this scene. Robert knew of none in which Dionysus was seated on a folding stool rather than on a rock. Robert originally advised Wilpert to look in Holy Scriptures or Christian legends for a solution; in a second letter to Wilpert, however, Robert was convinced of the pagan character of this scene (Wilpert, *Sarcofagi*, 2: 14*).

11. De Waal's uncovering and Wilpert's observations were reported briefly by Marion Lawrence, "Review of Wilpert, *I Sarcofagi Cristiani Antichi*, Vol. II," *Art Bulletin* 16 (1934): 313; and also by Lowrie, *Art in the Early Church*, 90, who saw them as evidence that the sarcophagus was not made expressly for Junius Bassus but was purchased in the shop after his death.

12. Gerke, *Iunius Bassus*, 13.

13. Bovini, *Sarcophagi*, 23. Cf. Bovini and Brandenburg, *Repertorium*, 1: 282: "The representations on both sides of the lid front probably refer to the life and profession of the owner of the grave (another view is represented by Wilpert: on the right Dionysus is seated with a panther; this is mistaken)."

14. Himmelmann considered the lid of the Junius Bassus sarcophagus in chap. 2 of his study, which is concerned especially with the mutilated lids of sarcophagi and their possible allegorical interpretations (*Typologische*, 15–28). See the review by Robert Turcan in *Revue archéologique* N.S. 2 (1975): 369–71.

15. Himmelmann, *Typologische*, 21, 50, pl. 31.

16. Ibid., 17. There are, of course, a number of pagan or, perhaps more appropriately, secular scenes that appear on Christian sarcophagi. Of these, Himmelmann found hunting scenes, wagon journeys, pictures of shepherds and fishermen, the vintage, and groups of putti and personifications of seasons to have no typological connections with either Bassus sarcophagus lid relief. "With the teaching scenes, the *sigma* meals, and the *dextrarum junctio* one could think of individual details that might be points of connection, but they do not lead to a conclusive interpretation of the whole."

17. Daltrop, "Anpassung," 157.

18. I. A. Richmond, *Archaeology, and the After-Life in Pagan and Christian Imagery* (London/New York/Toronto: Oxford University Press, 1950), 18. Richmond's general thesis—that in the early centuries of the Christian era there is a convergence of pagan and Christian ideas of the afterlife—is certainly of relevance to the lid of the Junius Bassus sarcophagus.

19. Himmelmann, *Typologische*, 17.

20. Ibid., 10. Daltrop, "Anpassung," 157–58, ill. 2, adds to Himmelmann's examples the Ara of Q. Socconius Felix, Rome.

21. Himmelmann, *Typologische*, 18.

22. Ibid., 19.

23. Ibid., 20.

24. Ibid.

25. Himmelmann commented: "Most revealing is the comparison with the [right] lid relief Porto Torres [here fig. 41], on which the figures that close on the right and on the left—the servant who is hastening to the right and the long-garmented female servant—are identical typologically with the corresponding figures of the Bassus sarcophagus" (Ibid., 20–21).

26. Himmelmann (Ibid., 21) wondered whether the figure seated on the folding stool on the Bassus sarcophagus lid was to be identified with the motif of the playing children in front of the *klinē*. In favor of this interpretation is the fact that the dog springs up to this figure. Against it is the general thought that the motif "appears a little too playful for a military person," and the more specific observation that the size of the figure, the nature of the clothing, and the form of the seat fail to correspond exactly with other examples. But Himmelmann also noted that "the shoe work that has been strung above the instep is repeated with the child Isaac on the facade of the Bassus sarcophagus." And Himmelmann argued that the larger size may not represent an insuperable difficulty because a similarly large child appears on a sarcophagus fragment in the Vatican Grottoes! This we now know as a fragment of the Bassus sarcophagus itself; it is the same child and, indeed, somewhat distinc-

tive among other examples. Daltrop ("Anpassung," 158) refers to this figure as holding an unidentifiable (musical) instrument in its hands. See also Daltrop's n. 4 for a reference to the relief of the meal of the dead of C. Rubrius Urbanus in the Barberini Palace, in which the son is sitting before the *klinē.*

27. According to Marucchi, "the fish indicates that these [funeral] banquets were fairly costly" (*Christian Epigraphy,* 123).

28. Himmelmann, *Typologische,* 20.

29. Ibid., 21. On the relation of such funeral banqueting scenes to Dionysiac imagery, see Goodenough, *Jewish Symbols,* 12: 117.

30. Himmelmann, *Typologische,* 21.

31. Ibid., 28: "It is unlikely that in the transmission from these late examples to the Bassus sarcophagus the meal of the dead would have become a familiar memorial picture."

32. Ibid., 23–24.

33. Ibid., 24–26. Perhaps Peter Brown is thinking of the contrast between the *sigma* meals of early Christian art and the *klinē* meal of the Bassus sarcophagus when he notes: "In early Christian art, the meal of the dead is almost invariably presented as an eye-to-eye affair. No one is shown presiding, except in one case—and that is the aristocrat Junius Bassus, urban prefect of Rome. Nothing is more impressive than the spate of eloquence, from all over the empire, with which a new generation of bishops now presented the festivals of the martyrs, no longer as family *laetitiae* [feastings], but as full-dress public banquets given by the invisible *patroni* [i.e., the martyred saints] to their earthly clients" (*Cult of the Saints,* 38). See also Paul-Albert Février, who discusses catacomb depictions of Christian funerary meals (as *sigma* meals) as settings of peace and love ("A propos du repas funéraire: culte et sociabilité," *Cahiers archéologiques* 26 [1977]: 29–45). But the Bassus sarcophagus meal scene draws on the older and aristocratic tradition of the continuity of the family—from the honored dead to the remembering living.

34. Himmelmann, *Typologische,* 26–28. Of special interest is the lid from Porto Torres (fig. 41), whose scene of the meal of the dead (to the right of the inscription) is, as Himmelmann pointed out (see n. 25 above), comparable in several details to that to the right of the Bassus lid inscription. To the left of the Porto Torres lid inscription appears a scene of putti harvesting grapes that recalls, in a general way, the grape-harvesting scenes of the left end of the Bassus sarcophagus.

35. Ibid., 28.

36. Ibid., 23.

37. Ibid., 26.

38. Ibid., 28.

39. Daltrop, "Anpassung," 158.

40. As Franz Cumont notes: "No religious ceremony was more universally performed in the most diverse regions of the Empire than this cult of the grave" (*After Life in Roman Paganism* [New Haven: Yale University Press, 1922; New York: Dover Publications, 1959], 55; see 50–56, 199–206). On the distinction between the eucharist and the *agape* meal in early Christianity, within the social context of meals for the dead, see Snyder, *Ante Pacem*, 64–65, 167, and the literature cited there; and on the cult of the dead in early Christianity, see Ibid., 143–45, 167. For a brief sketch of the relationship of early Christianity to the burial guilds and of Christian love-feasts held in memory of the dead to "pagan" funeral banquets, see Marucchi, *Christian Epigraphy*, 30–31; see also Robert L. Wilken, "Christianity as a Burial Society," chap. 2 of *The Christians as the Romans Saw Them* (New Haven/London: Yale University Press, 1984), 31–47. For a discussion of Christian funerary banquets and Christian funerary banqueting halls/covered cemeteries, see Richard Krautheimer, "Mensa—Coemeterium—Martyrium," in *Studies in Early Christian, Medieval, and Renaissance Art*, by Krautheimer (New York: New York University Press, 1969; London: University of London Press, 1969), 35–58, figs. 6a–11; first published in *Cahiers archéologiques* 11 (1960): 15–40. On the cult of the dead (including memorial meals) in the ancient Near East, in Israel, and in the early church, see Charles A. Kennedy, "Dead, Cult of the," in *Anchor Bible Dictionary* (Garden City, N.Y.: Doubleday, forthcoming).

41. Février notes: "Le repas sur la tombe est d'abord l'occasion d'assurer la stabilité et l'unité de la famille" ("Repas funéraire," 38).

42. Himmelmann, *Typologische*, 21.

43. Ibid.

44. Ibid., 22.

45. Ibid., 21–22, with specific examples. See also the earlier sarcophagus of Santa Maria Antiqua (figs. 11–13).

46. Himmelmann cited a fragment in the Terme Museum and the lid with the circus procession in San Lorenzo (Ibid., 22, pls. 56a & b).

47. Himmelmann surmised that this figure must be taking a wide step (Ibid., 21, n. 46). This is not apparent to me.

48. Ibid., 22.

49. Snyder argues that the Roman significance of the *orant* (or Orante) as *pietas* (especially filial piety) was not transformed in early Christian art (prior to 313) but simply taken over: "Before Constantine there is no reason, either in the art itself or in the social context, to suppose the Orante refers to the soul of the dead person as the 'Roman school' so often maintained. Quite the contrary, the familial understanding of the Orante fits quite well with the popular Roman understanding of death and the notion of the dead as extended family. The Christian symbol

differs primarily in that the faith community family was a religious association, not an extended blood relationship" (*Ante Pacem*, 20).

50. Himmelmann, *Typologische*, 22. Note the *orant* and philosopher at the center of the sarcophagus of Santa Maria Antiqua (fig. 11). On Christian sarcophagi the *orant*, when present, frequently occupies the center.

51. Ibid., 22, n. 51.

52. The marriage pair, joining right hands, and frequently with a small Eros figure between them, is "a familiar group on Roman tombs" (Lawrence, "Season Sarcophagi," 287). For examples occurring on season sarcophagi, see n. 55 below. For examples on columnar sarcophagi, see Lawrence, "Columnar Sarcophagi," nos. 1, 2, 3, 12, 13, 34, 37, 47, 49. "It is also a popular theme for the center of strigil sarcophagi" (Lawrence, "Season Sarcophagi," 287, n. 84); for an example, see fig. 38, to be discussed below.

53. Himmelmann, *Typologische*, 21.

54. Ibid., 21–22. Pietri notes that a parapetasma evokes the promises of the future life (*Roma Christiana*, 1: 283).

55. Lawrence, "Season Sarcophagi," 286–90. The two sarcophagi showing a parapetasma behind the *dextrarum junctio* are the season sarcophagus from Teboursouk (Musée Alaoui, Tunis; Ibid., figs. 18 & 19) and the season sarcophagus in the Campo Santo (Pisa; Ibid., fig. 21). The sarcophagus known from a sixteenth-century drawing by Bosio (?; *sic* Dosio; Ibid., fig. 23) and from a fragment (Ibid., fig. 24) is from Santa Cecilia in Trastevere (Rome); the fragment shows a parapetasma behind the personification of winter in the niche farthest right. Lawrence's description of the Teboursouk sarcophagus is of interest here: "The central position is occupied by the marriage couple who must have been in the *dextrarum junctio* although those hands are broken. . . . A large parapetasma hangs behind them. . . . The woman turns towards her husband so that she is almost in three-quarters view. She wears an extremely long belted chiton over which a voluminous mantle is draped and which covers her head as well, hiding almost all her hair. The man is enveloped in an equally long tunic and toga, but is bareheaded with short curly hair. He was beardless and seems to have held a rotulus. Between them stood a small Eros as we know from the torso and wings which remain. . . . This is a familiar group on Roman tombs" (287). In connection with these four season sarcophagi with the *dextrarum junctio* we should remember that the ends of the Bassus sarcophagus present "panoramic" seasonal scenes.

56. According to Himmelmann, "[T]he border of the parapetasma is clearly visible between the woman and the togatus, whereas it is missing on the left of it" (*Typologische*, 22, n. 47). This is not apparent to

me. Bovini and Brandenburg refer to the "Parapetasma (?)" (*Repertorium*, 1: 282).

57. Daltrop, "Anpassung," 162 and 162, n. 13. Contra Himmelmann, *Typologische*, 21, n. 46: "The beginning line that is recognizable between the feet cannot belong to a garment since the pallium is worn considerably shorter."

58. Himmelmann, *Typologische*, 21, n. 46: "The finding that I was able to test briefly on the original through the kind aid of G. Daltrop remains puzzling in individual details. For the two togati standing on the right there are approximately 25 cm. of lower length at their disposal; the corresponding room on the left is approximately 22 cm. If one calculates the footprint of a right foot for the same figure as the left foot with the sandal, then a figure that is taking a wide step must be represented."

59. Bovini and Brandenburg, *Repertorium*, 1: 282.

60. Daltrop, "Anpassung," 162–63.

61. Weitzmann, ed., *Age of Spirituality* (Catalogue), 400, fig. 55.

62. Bovini and Brandenburg, *Repertorium*, 1: 282.

63. For a brief description of Christian metrical inscriptions, which "increase in number" after the Peace of the church, see Marucchi, *Christian Epigraphy*, 71–74, quotation from 73.

64. The emendated Latin text given here is taken from Bovini and Brandenburg, *Repertorium*, 1: 279 (relying on B. M. Apolloni Ghetti, A. Ferrua, E. Josi, and E. Kirschbaum, *Esplorazioni sotto la confessione di San Pietro in Vaticano* [Vatican City, 1951], 220). The translation of lines 4a–8b is my own—made with indispensable assistance from Glenn Bugh and Andrew Becker. I have also been able to compare the unpublished translation of White, "Social Setting," 15.

65. The reconstructed phrase of line 8b is difficult: the noun *culmen* (height) is neuter, but the adjective *celsus* (lofty) is masculine, and the only other available noun, *mors* (death), is feminine. The neuter form of the adjective, *celsum*, would appear to be called for, unless *celsus* could serve as a noun.

66. Himmelmann (*Typologische*, 21, n. 45) cites de Waal, "Chronologie," 124, and T. Brennecke, "Kopf und Maske" (Diss., Berlin, 1970), 148–49. Daltrop ("Anpassung," 162, n. 14) cites Brennecke and Himmelmann. Neither Himmelmann nor Daltrop discusses the significance of corner masks or of Sol and Luna. The briefly stated view of Egger is not convincing: "Iconographically important is the noteworthy combination of scenes from the Old and New Testaments, which also exists on other sarcophagi, which here too—above all in relation to the remains of a tragic mask on its lid—suggests the probability that the scenes are related to mystery plays" ("Sarkophag des Junius Bassus," 62).

67. Nock, "Sarcophagi and Symbolism," 2: 627.

68. Goodenough, *Jewish Symbols*, 7: 206.

69. Ibid., 7: 204. A Jewish example, the lid of the sarcophagus of Faustina from Rome (probably originally from the Catacomb Randanini), shows a (possibly tragic) mask at the center and a (possibly comic) mask at each end, with a Greek inscription accompanied by Jewish symbols and the word "peace" in Hebrew between the central and right masks (see Ibid., 2: 25; 3: fig. 787; 7: 201; 12: 35).

70. Ibid., 7: 206, following Bieber.

71. Ibid., 7: 218. "The masks on sarcophagi may have conveyed any of these divergent notions, or all of them at once. In friezes and in what would generally be called 'purely decorative' usage they may well have recalled that the presence of the mask was in one way or another a presence of deity, whether as an apotropaic protection, a catharsis, or as a suggestion of the deification to which so many of the people of the ancient world were aspiring. Certainly I cannot believe that the masks on sarcophagi in an environment which was using them with so much significance, ever lost all value" (Ibid., 7: 210).

72. Schiller, *Iconography*, 2: 5.

73. Daltrop, "Anpassung," 162.

74. Cf. Peter Brown, commenting on the fact that by the middle of the third century the portrait of the deceased has moved to a central position on sarcophagi: "The restless pageantry of classical mythology will come to rest around his grave figure and will be used to express his destiny and to clarify the nature of his links with heaven" (*The Making of Late Antiquity* [Cambridge, Mass./London: Harvard University Press, 1978], 26).

75. Daltrop, "Anpassung," 168.

76. Daltrop (Ibid., 161, n. 12) reports Wilpert's assertion (in *Erlebnisse und Ergebnisse*, Freiburg, 1930, 173 f.) that because the reliefs were pagan they were half broken off, and the rest of the lid was covered with a hard stucco whereby the scenes became completely invisible. Daltrop questions "whether in 1597 the relief images could be separated so clearly into pagan and Christian, especially since the reliefs on the sarcophagus box had not yet been conclusively interpreted." Neither Wilpert's argument nor Daltrop's is thoroughly convincing. I doubt that the absence of clear distinctions or conclusive interpretations would bother anyone who felt strongly that the lid reliefs were offensive or inappropriate in some way. And yet it would appear that a significant (and perhaps the only) breaking of the lid occurred accidentally in 1597 when the floor of the Cappella Clementina was being lowered. (See n. 2 above. Ugonio's sketch dated 1597 shows only the box, no lid or lid fragment.) But it may be that the stucco that was applied to the lower lid fragment

sometime after 1773 (Dionysius's drawing) and before 1903 or 1907 (de Waal's removal of the stucco) was intended to cover the fragmented pagan relief (certainly not recognizable as a biblical scene) that was thought to detract or at least distract from the preserved Christian ones below.

77. Daltrop, "Anpassung," 170.

CHAPTER 7: Elements

1. Gerke, *Iunius Bassus*, 7.

2. Ibid., 15.

3. Ibid., 7. A five-niche, single-register columnar sarcophagus from the crypt of San Massimino (Wilpert, *Sarcofagi*, 1: 145, 1) serves as an example of such a sarcophagus. Although badly damaged, it shows evidence of two central columns decorated by putti gathering grapes (other columns being strigilated) flanking an apparent center scene of the Symbolic Resurrection (fig. 6). As noted in chap. 3 above, the five scenes of this sarcophagus provide an interesting comparison with the scenes of the Junius Bassus sarcophagus: from left to right, the arrest of Paul, the arrest of Peter, the Symbolic Resurrection, the arrest of Christ, the judgment of Pilate; and still visible over the central scene and suggested by fragments over each scene is a conch.

4. Gerke, *Iunius Bassus*, 15.

5. Ibid., 7.

6. Hippolytus, *On the Benedictions of Isaac*, 25; *Patrologia Orientalis* 27: 99; as quoted by Jean Daniélou, S.J., "The Vine and the Tree of Life," in *Primitive Christian Symbols*, by Daniélou, trans. Donald Attwater (Baltimore: Helicon Press, 1964), 37.

7. Zeno of Verona, *Treatises* [*Tractatus*], bk. 2, tract. 28, in *Patrologia Latina* 11: 471–72; as quoted by Daniélou, "Vine," 38.

8. Asterius the Sophist, *Homilies on the Psalms*, bk. 14, 1–2; as quoted by Daniélou, "Vine," 38.

9. From the Greek *neophytos* (see Marucchi, *Christian Epigraphy*, 220). For additional inscriptions containing *neofitus* or *neofita*, see Ibid., 106, 220–21. See Daniélou, "Vine," 35 (on *neofitus*) and 25–35 (on "planting" and "tree").

10. De Waal, *Junius Bassus*, 87, and Gerke, *Iunius Bassus*, 7.

11. As was the case with many, if not most, biblical characters, Job had a traditional form of presentation on early Christian sarcophagi: seated, in profile, frequently with his wife offering food while holding drapery over her nose. In addition, the representation of Job—like the Symbolic Resurrection, Pilate, and certain other scenes—also had a traditional place of presentation: one of the ends of a register, that is, either

as the farthest left or farthest right scene of the facade. This also seems to be true of the Pilate scene, and it may be that in both cases this placement was for compositional reasons: seated figures facing inward form a satisfying visual frame for a row of, or several niches of, standing figures. For example, on Lateran sarcophagus 164 (fig. 9; Wilpert, *Sarcofagi*, 1: 142, 3; Bovini and Brandenburg, *Repertorium*, 1: no. 61), a five-niche tree sarcophagus centered on the Symbolic Resurrection, Job is opposite the sacrifices of Cain and Abel to God (Genesis 4:3–4), and the visual symmetry is clear: God is seated on the left, facing two standing figures to the right, Abel in the foreground offering a lamb, Cain in the background holding a sheaf of wheat; Job is seated to the right, facing two standing figures to the left, Job's wife in the foreground offering food, a man in the background. Wilpert pictures two additional sarcophagi that repeat this arrangement exactly (*Sarcofagi*, 1: 142, 1; 1: 142, 2 = Bovini and Brandenburg, *Repertorium*, 1: no. 215).

12. Saxl is speaking of Christian frieze sarcophagi of the early to mid-fourth century when he writes: "If anywhere in sculpture, the eye is here the mirror of the living soul" (*Lectures*, 1: 52). Saxl has in mind particularly the expressive eyes of *orant* figures, but the observation may be applied more generally.

13. With the *iit ad deum* we may compare the *receptus ad deum* of a presumably Christian inscription dated to 217 in Rome. The inscription, on the upper edge of the right end of a sarcophagus at the Villa Borghese, reads in part:

> Prosenes receptus ad deum
> V non(as) [Iul]ias S[ame in Cephalle]
> nia Praesente et Extricato II

> Prosenes was received by God
> July 25 at Same in Cephallenia
> during the consuls of Praesens and Extricatus II

(Text and translation from Snyder, *Ante Pacem*, 121–22.) On the basis of the two inscriptions on this sarcophagus, Snyder concludes: "[O]ne is inclined to suppose this was the sarcophagus of a high-level Christian freedman from the household of Caesar" (122).

14. So de Waal, "Chronologie," 123, who notes that the words NEO-FITVS IIT AD DEVM are strung together without interruption, whereas the consular indication is spread out in consideration of the remaining space.

15. Daltrop, "Anpassung," 164.

16. Lawrence, "Columnar Sarcophagi," 131.

17. Ibid., 132.

18. Like the Christ enthroned and the triumphal entry, the Symbolic

218 NOTES TO CHAPTER 7

Resurrection scene manifests motifs borrowed from imperial iconography; see Brenk, "Imperial Heritage," 42–43.

19. Lawrence, "Columnar Sarcophagi," 132. Cf. Nock, commenting on pagan sarcophagi: "Individual types [i.e., model figures or scenes] can always be explained as purely ornamental and no doubt they often were (though by the way it would be a bold assumption that any such work of art corresponded to single or simple motives in the artist or in those who had evolved the model which he followed or in the patron who had given him the commission)" ("Sarcophagi and Symbolism," 2: 639).

20. Gerke, *Iunius Bassus*, 8, 25. Gerke points out that the eagle with a laurel wreath as a Roman symbol of victory (8) is usual over the Unconquered Cross or Symbolic Resurrection (25). He discusses the absence of the Symbolic Resurrection from the Bassus sarcophagus upper register (which he "rearranges"), although he assumes its replacement on the lower register as well.

21. See n. 95 to chap. 3 above.

22. As Goodenough summarizes: "The shell is a widespread symbol for association with the dead. The Jewish [and Christian] usage seems to be an adaptation from the Greek tradition, where it originally represented the vulva of the sea from which Aphrodite was born, and then the vulva of sea goddesses—especially Aphrodite and the nymphs—which they offer to men for rebirth into immortality. It was used conspicuously on sarcophagi in the marine thiasos, where the birth of Aphrodite from the shell of the sea was interchangeable with the portrait of the deceased in the shell, or with the shell empty. Varieties of presentation of the symbol in Greek and Christian tradition (where it came finally to represent divine quality like a halo) are so manifold that the Jewish use clearly belongs in this tradition" (*Jewish Symbols*, 12: 147; see also 8: 95–105).

23. Ibid., 8: 142. Goodenough makes this generalization about the meaning (or "value") of the eagle *in funerary art*—pagan, Jewish, or Christian. He traces pagan and Jewish usage of the eagle (8: 121–42), pointing out that "no eagles at all appear in western Jewish remains, so that we may suppose that it is the eastern eagle, not the Roman imperial eagle, that was being adopted" (12: 149). Goodenough regards the eagle as a "live symbol" in its migration. "The persistence of these [live symbols] in Jewish and Christian art cannot be presumed to be the persistence of the merely ornamental, of dead emblems." What "remains constant in the migration of a symbol" is its "value," its "meaning in the connotational or associational realm" (4: 36). Cf. Pierre du Bourguet, "Le sujet figuratif et la valeur qu'il revêt dans les monuments préconstantiniens," in *Überlegungen zum Ursprung der Frühchristlichen Bildkunst*, ed. H. Brandenburg (Rome: IX Congresso Internazionale di Archeologia

Cristiana, 1975), 51–53. On the variety of meanings of the eagle in early
Christian literature, see Maguire, *Earth and Ocean*, 65. Two meanings
are of special interest here: the eagle could symbolize "Christ who takes
the Christian captive to the heavens, as the eagle carries off its prey [cit-
ing Maximus of Turin, *Homilia* 60]. The eagle could also be a reminder
of the Resurrection and of immortality, because it gives itself a new
lease on life by reshaping its beak against a stone, just as the Christian
renews himself upon the rock of Christ [citing Augustine, *Enarratio in
Psalmum* 102]" (*Earth and Ocean*, 65).

 24. Schiller, *Iconography*, 2: 5; Maguire, *Earth and Ocean*, 65–66.
 25. Gerke, *Iunius Bassus*, 8; Maguire, *Earth and Ocean*, 66.
 26. See also Colossians 2:12, Mark 10:35–40, Matthew 20:20–23, and
Luke 12:50.

CHAPTER 8: Integration

 1. By almost passing allusions, Daltrop suggests vertical connections
between the scenes of the two registers, with no reference to horizontal
connections: "In the middle Christ appears on the throne of heaven. . . .
Christi adventus in the picture below it shows the triumphal entry into
Jerusalem" ("Anpassung," 164). "On the left side, Abraham and Job are
represented as precursors of Christ with respect to sacrifice and suffer-
ing; both figures stand for an unshakable faith in the prophecy granted
to them by God. On the right side the Romans Pilate and Paul are repro-
duced; the one pronounces the judgment that became the *felix culpa* for
Christians of the fourth century, the other suffers as the first *civis ro-
manus* the death of a martyr" (165). "Jesus [before Pilate], calls himself
Basileus [Lord], but in another sense than the accusation indicates (John
18, 36f.). His power is revealed in the figure of Daniel below" (166). "[Pe-
ter] announces the return of the Kingdom of God that was lost through
Adam and Eve, who are represented below" (166–67).
 2. Grabar, *Christian Iconography*, 18.
 3. Olsen, "Allegory, Typology, and Symbol; Part I," 172.
 4. Brown, *Making of Late Antiquity*, 74.
 5. According to Gerke (*Iunius Bassus*, 15), the scenes from the life of
Junius Bassus on the lid—an official scene and a family scene—comprise
a secular presentation that is a minor part of the front, the representa-
tion of the events of *Heilsgeschichte*, "holy history" or "salvation his-
tory."
 6. Ibid., 13. As pointed out by Hanfmann, "Although Bassus was bap-
tized only on his deathbed, it is at least probable that the sarcophagus
was prepared during his lifetime" (*Season Sarcophagus*, 2: 27, n. 3). An-
thony Cutler proposes that "[t]he more elaborate the creation, the more

it is likely to represent the interest of others beyond the craftsman: first of course, his client; then this patron's associates, his 'circle' " ("Authentic Iconography: Ptolemy and Hermes in Malibu, Ca." [abstract], in *Abstracts and Program Statements for Art History Sessions* [New York: College Art Association of America, 1986], 28).

7. Thus I am in agreement, in one general sense, with Tronzo's observations that "an important change in the meaning of imagery occurred in Christian funerary art in Rome in the fourth century; that this change is perceptible not so much in the individual images used in a given work (though it is also apparent in them) as in the way these images are put together; and that this change must be seen as the direct expression of a new constituency of converts arising with the emperor's adoption of Christianity, who wanted to define themselves in terms of the past" ("Christian Imagery," 30). But I sense a more active reinterpretation of past imagery, whereas Tronzo perceives a more passive copying, with its attendant "mistakes" (*Via Latina Catacomb*, esp. 65–78; see n. 31 to chap. 2 above). "For to copy on such a scale," Tronzo asserts of the fourth-century practice in Christian art, "must have exerted an essentially disruptive influence on the development of Christian imagery and a retarding effect on the growth of programmatic decoration" (78). Just the opposite would seem to be the case: with certain basic vocabulary established, Christian imagery was free to develop more fully its syntax.

For an interesting development of this idea of reinterpretation of the past, of inclusion within a larger history, see Herbert L. Kessler, "Pictorial Narrative and Church Mission in Sixth-Century Gaul," in *Pictorial Narrative in Antiquity and the Middle Ages*, ed. Herbert L. Kessler and Marianna Shreve Simpson, Studies in the History of Art, Vol. 16 (Washington, D.C.: National Gallery of Art, 1985), 75–91. Kessler writes of the narrative cycle of Martin's miracles at Tours: "The pictured text was a typology, disclosing that one narrative completed an earlier sequence of events and thus that a regional chronicle was part of universal history. The cycle at Tours tied the distant past to the story of foundation, the Christianization of Gaul. At the same time, it also carried the proximate past into the present" (84).

8. Kelly, *Early Christian Doctrines*, 71.

9. Compare the maxim Weidlé coins, by reversing the usual phrase, in relation to early Christian art (mostly third-century catacomb paintings and sarcophagi): "No salvation without sacrament, but also: No sacrament without the idea of salvation" (*Baptism of Art*, 18; see 14–21).

10. Lawrence, "Review of Wilpert, Vol. II," 311.

11. Grabar, *Early Christian Art*, 248. Although Grabar does seem to contradict himself on this point elsewhere; see n. 41 to chap. 3 above.

12. E.g., Gerke, Hanfmann, Lawrence; see chaps. 2, 5, and 7 above.

13. Goodenough, *Jewish Symbols*, 8: 220. "There is no way to prove this (or anything else connected with this study), and I do not assert it as a fact. . . . I would only point out that categorical denial is just as unproved as categorical assertion" (7: 219–20). "Direct 'proof' . . . cannot be offered, and at no time did I suggest that I was 'proving' this to be true. Modern empiricism and Plato alike have taught us to offer what explanations we can to 'save the phenomena,' and it seemed to me that any other explanation . . . could be made only by ignoring very essential parts of the data" (8: 230).

14. Cf., on the one hand, Murray: "The material remains, ignored by church historians, have been left to the analysis of art historians, Roman and Byzantine social historians, or sub-departments of classical archaeology. Yet the purpose of all this art was religious and therefore it is the theological dimension which in the end is paramount; discussions of types [i.e., models], origins of motifs, etc. are only ancillary, though essential, studies. Perhaps therefore it may be pleaded that the monuments of the Church should be put back into the context of church history alongside the literary remains in order to arrive at a more rounded estimate of matters of fact in the early Church" ("Art and the Early Church," 344–45). And, on the other hand—emphasizing archaeology's contribution to church history rather than theology's contribution to art, see Snyder, *Ante Pacem*.

15. Daniélou, "Fathers and Scriptures," 89.

16. Brown, *World of Late Antiquity*, esp. chap. 4, "The New Mood: Directions of Religious Thought, c. 170–300," 49–57.

17. Ibid., 53.

18. Ibid., 56. Arthur Darby Nock's older work, *Conversion: The Old and the New in Religion from Alexander the Great to Augustine of Hippo* (Oxford: Clarendon Press, 1933), manifests an overly intellectualized understanding of conversion, as well as a prejudice in favor of Christianity. This is not the case in two related books by Ramsay MacMullen, *Paganism in the Roman Empire* (New Haven and London: Yale University Press, 1981) and *Christianizing the Roman Empire (A.D. 100–400)* (New Haven and London: Yale University Press, 1984). MacMullen, who is here dealing with the fourth century as well as—or perhaps more than—the second and third, calls attention to the emphasis on this-worldly salvation, especially restoration of health, among both "pagans" and Christians.

19. Saxl, *Lectures*, 1: 49.

20. Weidlé, *Baptism of Art*, 18. Murray, in her study of early Christian Orpheus imagery, the imagery of Tomb M of the necropolis below St. Peter's (Fisherman, Good Shepherd, Jonah, Christ-Helios), and Noah imagery, concludes that (1) pre-Constantinian Christian funerary art "rep-

resents in some way a reinterpretation of certain pagan funerary beliefs" and (2) "in some way, express[es] something of a connection between the doctrine of baptismal rebirth and the idea of the afterlife" (*Rebirth and Afterlife*, 112).

21. Brown, *World of Late Antiquity*, chap. 3, "A World Restored: Roman Society in the Fourth Century," 34–45.

22. Ibid., 34.

23. Maguire, *Earth and Ocean*, 64.

24. Brown, *World of Late Antiquity*, 34.

25. Ibid., 82. Cf. Richard Krautheimer on "The Christianization of Rome and the Romanization of Christianity," chap. 2 of *Rome*, 33–58.

26. Marta Sordi comments: "With the Greek world, the Christians used an intellectual approach. With the Roman world, characterised as it was by traditions of universally applied policies and jurisprudence, with practice taking precedence over theory, the Christian's approach was political, legal and moral. Roman traditions had to be separated from their roots in polytheistic paganism and transplanted into the new soil of the Christian faith. This operation was the first and most important act undertaken by the Christians in the Roman world" (*The Christians and the Roman Empire*, trans. Annabel Bedini [Norman/London: University of Oklahoma Press, 1986], 168; see chap. 10, "Christianity and the Culture of the Roman Empire," first published in *Vetera Christianorum* 18 [1981]: 129–42).

27. Saxl, *Lectures*, 1: 54.

28. The phrases are employed by Krautheimer; see n. 25 above.

29. Jones, "Social Background," 21.

30. De Waal, "Chronologie," 117–20. De Waal argues that the counter-pope, Felix, would have been responsible for this placement, since Pope Liberius was in exile at the time of Bassus's death.

31. Stevenson notes that "there grew up, from the second half of the third century, at the site where the basilica of St Sebastian now stands on the Via Appia Antica, a centre of veneration of the Apostles Peter and Paul. Now the bodies of the two Apostles had long been in their tombs, the one on the Vatican Hill, the other on the road to Ostia. The existence of this cult centre on the Via Appia, to which numerous (640 in all) *graffiti* at the site testify, is most perplexing. The *graffiti* also, if we may judge from the names of those who wrote them and the expressions that they used, are the scratchings of visitors, not of Romans. 'These *graffiti* constitute one of the best documents to demonstrate how much the devotion towards the founders of the Roman Church had penetrated even to the humblest social classes of the Christian world in the second half of the third century' [quoting E. Josi]" (*Catacombs*, 31–32; for examples of the *graffiti*, see 163). On this martyrium on the Via Appia, see also

Pietri, *Roma Christiana*, 1: 40–46 (establishment) and 1: 522–24 (later developments).

In the second half of the *fourth* century Damasus, Bishop of Rome from 366 to 384, wrote verses for the site on the Via Appia Antica. Stevenson presents the sense of them as: "Whoever you are who seeks the names of Peter and Paul, you ought to know that here formerly the saints [i.e., Peter and Paul] dwelt (. . .). The East sent the disciples—that we willingly admit—and by the shedding of their blood they followed Christ through the stars and have sought their home on high. Rome rather [i.e., than any other city] deserved to claim them as her citizens. May Damasus declare these words to praise you that now are stars!" (*Catacombs*, 32). See also Pietri, *Roma Christiana*, 1: 522–24.

In studying a group of ivories produced in Rome around the turn of the *fifth* century, Kessler notes that "[t]he special interest in the activities of Peter and Paul . . . also reflected entirely local concerns. For Christian commentators of the period, Peter and Paul were not merely the co-founders of the Roman church, of the *ecclesia ex circumcisione* and the *ecclesia ex gentibus*; they were civic heroes, the successors of Romulus and Remus who, by establishing a Christian Rome, had restored the glory of the empire and had ushered in a new golden age of peace and unity. In their battle against the pagan aristocracy, the new Christian elite enlisted Peter and Paul. They set July 29, the anniversary of Rome's founding, as the day for the joint festival of Peter and Paul and they designated the apostles as the protectors of the city. That a sequence of pictures portraying the lives of Peter and Paul was chosen for the nave wall of San Paolo f.l.m. is no mere coincidence; nor is it chance that all the early ivories with scenes from *Acts* originated in Rome around the year 400" ("Acts of the Apostles," 116). Kessler suggests "a striking parallel" between the Carrand ivory and Prudentius's use of the text of Acts in his *Contra Symmachum* (ca. 402). "Both the treatise and the carving emphasize Paul's ability to 'subdue the wild hearts of the Gentiles with his holy pen and his peaceable teaching' as well as with supernatural deeds; and both adopt an overtly classical style to meet the challenge of the pagans on their own terms." Both works "reflect the special significance attached to [the conversion of the gentiles begun by Paul and the other apostles as narrated in] the *Acts of the Apostles* just before the final victory of Christianity in Rome" (117).

A major source—and source of sources—for investigating the development of the importance of Paul and especially Peter as *Roman* apostles is the immense two-volume work of Pietri, *Roma Christiana*, which covers the period 311–440. See especially the following sections: the tomb and early basilica of St. Paul (1: 33–37); the site associated with Peter and Paul on the Via Appia (1: 40–46, establishment; 1: 522–24,

later developments); the tomb of St. Peter on the Vatican Hill (1: 51–64, establishment; 1: 519–22, later developments); "A Certain Idea of Peter" (1: 272–95); the typology of Peter-Moses (1: 313–56); the developing hagiography and cult of Peter and Paul in Rome (1: 357–401); chap. 17, which opens with a discussion of the *traditio legis* to Peter and Paul and closes with a discussion entitled "From Peter to the Pope, the Two Legislators" (2: 1413–1524); "Peter and Rome" (2: 1537–71); "The Association of the Apostle Martyrs with Rome" (2: 1571–96); "The Theology of the Succession" (2: 1596–1626). Obviously the topic is too vast for a full discussion here.

32. See Grabar, *Christian Iconography*, 31–54, "The Assimilation of Contemporary Imagery." See also Kessler, "Medieval Art History," 167–68, and the literature cited there. Michele Basso demonstrates that the integration of various influences (Egyptian, Etruscan, Jewish) into *Roman* funerary art was a well-established pattern in the non-Christian and Christian monuments around the tomb of St. Peter; Basso's book, however, is limited by his concern to show the completion and perfection of all earlier eschatological ideas in the Christian revelation (*Eschatological Symbolism in the Vatican Necropolis* [Vatican City: Tipografia Poliglotta Vaticana, 1982]).

33. Chadwick, *The Early Church*, 278.

34. See Oakeshott, *Mosaics of Rome*, 61. A Dionysiac sarcophagus, however, would likely portray satyrs rather than putti. This motif (the vintage with putti) is repeated in the paired vault mosaics on the axis that crosses the entrance/sarcophagus axis of Santa Costanza. Without other cues a Christian interpretation of it is not obvious; in fact, Santa Costanza's "understatement of any specifically Christian 'message' " is such "that in medieval times it was called a 'Temple of Bacchus' " (59). Saxl even argues that the very existence of early Christian *sculpture* is a direct "pagan" influence: "Early Christian sculpture was the expression of a short-lived paganizing revolt which began about 250 A.D. and lasted only two hundred years. For the next six or seven hundred years the anti-sculptural feeling prevailed in most of Europe, as it had done in Judaism and during the first two centuries of the Christian era" (*Lectures*, 1: 57).

35. Oakeshott, *Mosaics of Rome*, 65. For a detailed description and interpretation of the mosaics of Santa Costanza (vault, cupola, and tower), see Stern, "Mosaïques," 157–218. Stern identifies the lower-register scenes of the cupola as follows, beginning above the entrance and moving around to the right: (1) sacrifice of Elijah on Mount Carmel, (2) an unidentified arrest scene, (3) Noah building the ark, (4)–(6) lost, (7) unidentified: group of seated men receiving something written from two soldiers, (8) Tobias with the fish, (9) Lot and the angels (?) [the vision of Abraham at Mambre, according to Tronzo, *Via Latina Catacomb*, 68],

(10) Susanna and the elders, (11) sacrifices of Cain and Abel, and (12) Moses striking the rock (the only scene also represented on the Bassus sarcophagus). Stern identifies the one known upper-register scene as (2) the centurion of Capernaum approaching Christ. Stern states that it is correct to suppose that the lower register is reserved for the Old Testament and the upper for the gospels (181). But the two unidentified scenes of the lower register bear a relationship—admittedly a problematic one—to early Christian scenes of Peter: with (2) compare Peter's arrest and with (7) compare the Peter scene below the portrait shell of the Two Brothers sarcophagus (here fig. 3). The linking of "pagan" and Christian motifs throughout the mosaics of Santa Costanza is of particular interest to Stern. The two apse mosaics also exhibit Christian themes (sometimes labeled the *traditio clavium* [keys] and the *traditio legis*), but their dating, as well as their subject and degree of restoration, is unsettled. Tronzo finds the Bassus sarcophagus, the mosaics of Santa Costanza, and the paintings of cubiculum O of the Via Latina catacomb comparable at several points: "[t]he ornate framework employed to enhance the image and the pagan themes and motifs, together with the use of older Christian imagery and the apparent mistakes and misunderstandings" (*Via Latina Catacomb*, 67). While disagreeing with Tronzo concerning the mistakes on the Bassus sarcophagus at least, I agree that "[i]f cubiculum O, the sarcophagus of Junius Bassus, and the mosaics of Sta. Costanza tell at least part of the story accurately, it was the Christian usurpation of the pagan past that was one of the true pagan's most justified fears" (70). But, from the other side, one might also say that the three monuments Tronzo points out are manifestations of what Peter Brown observes: "that the change in the official religion of Rome took the form, not of a brutal rejection of the past by an authoritarian régime, but of a transformation in which much of the Roman secular tradition was preserved" ("Aspects of the Christianization of the Roman Aristocracy," in *Religion and Society in the Age of Saint Augustine*, by Brown [New York: Harper & Row, 1972], 164; first published in *Journal of Roman Studies* 51 [1961]: 1–11). See also R. A. Markus, *Christianity in the Roman World* (London: Thames and Hudson, 1974), 123–40, chap. 7, "The Christian Times and the Roman Past."

36. Weitzmann, ed., *Age of Spirituality* (Catalogue), 330–32, no. 310 (by Kathleen J. Shelton). See also Shelton, *Esquiline Treasure*, esp. 63–67, in which she makes this comment: "Recent historical studies have discussed this period as one of gradual diffusion and transition. A parallel for the visual arts would be appropriate. Questions of pagan and Christian imagery are best treated with caution: the lesson of the Esquiline Venus with its Christian inscription should finally be committed to memory" (65).

37. Chadwick, *The Early Church*, 154.

38. For a brief description of the Calendar of 354, see Weitzmann, ed., *Age of Spirituality* (Catalogue), 78–79, no. 67. For a full description and discussion, see Stern, *Le calendrier*.

39. Chadwick, *The Early Church*, 154, italics mine.

40. Stephen R. Zwirn, "Drawings of the Calendar of 354," in Weitzmann, ed., *Age of Spirituality* (Catalogue), 79, italics mine. On the transition or blending of "pagan" and Christian elements of religious experience and expression other than the artistic, see Robin Lane Fox, *Pagans and Christians* (New York: Alfred A. Knopf, 1987), esp. 663–81, "From Pagan to Christian."

41. Kessler, "Acts of the Apostles," 113.

42. For the pre-Constantinian period, including the sarcophagus of Santa Maria Antiqua, Snyder argues that the *orant* (or Orante) suggests not the soul but *pietas*—simply applied to the Christian family rather than to the blood family as in Roman art (*Ante Pacem*, 20; see n. 49 to chap. 6 above).

43. Janet Huskinson, "Some Pagan Mythological Figures and Their Significance in Early Christian Art," *Papers of the British School at Rome* 29 (1974): 82. On Christ as Orpheus in early Christian literature and catacomb painting, see Stevenson, *Catacombs*, 101. On the Christian significance of Orpheus and Sol (Helios), see also Murray, *Rebirth and Afterlife*, 37–63, 77–87, 94–97. The focus of Murray's discussion of the iconography of the figures of Tomb M, the tomb of the Julii, in the necropolis beneath St. Peter's (Fisherman, Good Shepherd, Jonah, Christ-Helios), is the transmutation of pagan imagery in early Christian funerary art (37–97).

44. Huskinson, "Mythological Figures," 84–85.

45. Ibid., 84.

46. Lawrence, "Three Pagan Themes," 1: 323–34; 2: 100–6 (figs.). On the appropriation of the chariot of Helios as the chariot of Elijah or Christ in early Christian art, see Stevenson, *Catacombs*, 74–75.

47. Lawrence, "Three Pagan Themes," 1: 323.

48. Johannes Quasten, *Patrology*, 3 vols. (Utrecht-Antwerp: Spectrum Publishers, 1964; Westminster, Md.: Newman Press, 1964), 2: 155; see 155–63. See Minucius Felix, *Octavius*.

49. Quasten, *Patrology*, 2: 396; see 392–410. See Lactantius, *The Divine Institutes*, trans. William Fletcher, in *The Ante-Nicene Fathers*, Vol. 7 (Grand Rapids, Mich.: Wm. B. Eerdmans, [1886]), 9–223.

50. Quasten, *Patrology*, 2: 398.

51. See Lactantius, *The Phoenix*, trans. William Fletcher, in *Ante-Nicene Fathers* 7: 324–26. On the phoenix as a symbol of renewal in Roman and early Christian literature and art, see Maguire, *Earth and Ocean*,

63–64; on its appearance in the catacombs, see Stevenson, *Catacombs*, 130.

52. Quasten, *Patrology*, 2: 247; see 246–340. See Tertullian, *Apology*, and *The Soul's Testimony*, trans. S. Thelwall, in both *Ante-Nicene Christian Library*, Vol. 11 (Edinburgh: T & T Clark, 1869), 36–45, and *The Ante-Nicene Fathers*, Vol. 3 (Grand Rapids, Mich.: Wm. B. Eerdmans, 1957), 175–79.

53. The work was begun ca. 396 (i.e., about the time Augustine became Bishop of Hippo) and completed through paragraph 35 of book 3. Book 3 was completed and book 4 written in 427, in the course of Augustine's writing the *Retractions* (D. W. Robertson, Jr., "Translator's Introduction," ix, in Saint Augustine, *On Christian Doctrine*, Library of Liberal Arts, No. 80 [New York: Liberal Arts Press, 1958]).

54. Augustine, *On Christian Doctrine*, bk. 2, chap. 40, 60–61; trans. D. W. Robertson, Jr., 75–76. Robertson asserts that no better introduction to the rationale underlying the symbolic techniques of medieval art may be found than Augustine's *On Christian Doctrine* (xiii).

55. Shelton, *Esquiline Treasure*, 64.

56. Goodenough, *Jewish Symbols*, passim but see esp. 13: 64–77. Goodenough states that "the major premise" of his "entire study" is "that borrowed symbols may be given new interpretations but will keep their old values" (12: 123).

57. Murray, *Rebirth and Afterlife*, 5. Murray elaborates: "[I]t is the conviction of this book that 'Christian art' is not a style but a content or meaning given to an image, and that it is from the point of view of innovation in interpretation of content that Christian artists, despite lack of originality, may be thought to be creative—although as history shows, eventually the content did affect the style itself" (7). With specific reference to funerary art, the fluidity of "pagan" and early Christian images and meanings is made possible by the convergence of "pagan" and Christian understandings of afterlife. Richmond argues that "perhaps the clearest impression conveyed in the various spheres is the increasing movement towards an interpretation of after-life in terms of human experience"; archeological material "furnishes evidence of a very remarkable degree of interplay and dependence between the Christian and pre-Christian spheres of eschatological ideas. . . . the movement is towards integration rather than conflict" (*Archaeology, and the After-Life*, 41, 57).

58. Goodenough, *Jewish Symbols*, 8: 221.

59. This estimated date, like the two given below, is from Bovini and Brandenburg, *Repertorium*, 1. It may be that the Three Good Shepherds sarcophagus is to be dated earlier. As argued in chap. 5 above, the Bassus

sarcophagus end sculptor very likely "copied" from the Three Good Shepherds sarcophagus end scenes in 359.

60. See Stevenson, *Catacombs*, 99.

61. In addition to being outdated in its identification of the right relief scene of the lid, W.H.C. Frend's brief analytic description of the Junius Bassus sarcophagus oversimplifies its interrelation of pagan and Christian motifs: the work "illustrates the way in which biblical subjects such as Adam and Eve were simply substituted for pagan motifs, while the traditional arrangement of the funeral procession accompanying the soul of the deceased to blessedness remained the same" (*The Rise of Christianity* [Philadelphia: Fortress Press, 1984], 555).

62. J. D. Breckenridge, "The Reception of Art into the Early Church," in *Überlegungen zum Ursprung der Frühchristlichen Bildkunst*, ed. H. Brandenburg (Rome: IX Congresso Internazionale di Archeologia Cristiana, 1975), 33, 32.

63. Panofsky, *Tomb Sculpture*, 41.

64. See Spain, " 'Promised Blessing.' "

65. See Grabar, *Christian Iconography*, 142–44; Grabar, *Early Christian Art*, 231.

66. Lampe, "Typological Exegesis," 201.

67. Jungman, "Christian Context," 83.

68. In setting forth the history of the eucharistic liturgy, Dix depicts the fourth century as the beginning of a major shift: from a private (family-like) celebration to a public one, from a corporate to an individual sense, from an eschatological to an *historical* orientation (*Shape of the Liturgy*).

69. Cf. Riley, *Christian Initiation*, 1: "[T]his symbolic rite of passage into a new world does not remove them [catechumens] from the world in which they live. The words and gestures which form the symbolism of the initiation rites themselves depend on and are drawn from the world of the catechumen. Rather than rupturing his relationship to the world, this liturgy initiates the catechumen into a deeper understanding of his own world, and a way of viewing it at a level heretofore inaccessible to him. . . . the candidate will be initiated through the medium of symbolic word and action into the depth and scope of the hitherto invisible mystery of God's salvific plan for the world and his position in this plan, his response to this revelation. . . . Engaged by the medium of visible symbol which comprises the liturgical initiation the candidate, in what he says and does and in what is said and done to him, is enlightened to discover the meaning of salvation history."

70. Lactantius, *Of the Manner in which the Persecutors Died*, chap. 48, trans. William Fletcher, in *The Ante-Nicene Fathers*, Vol. 7 (Grand Rapids, Mich.: Wm. B. Eerdmans, [1886]), 320.

71. Jungman, "Christian Context," 94–99; see also 74–108. On the typological connection between the overthrow of Maxentius at the River Tiber and that of Pharaoh at the Red Sea, see Pietri, *Roma Christiana*, 1: 319, citing Eusebius, *Ecclesiastical History*, 9, 9, 5.

72. Although Gerke makes no specific reference to the Arch of Constantine, the following general conclusion of his concerning the Bassus sarcophagus is relevant in this connection: "[I]ts classicism lies precisely in the unity of the historical- and devotional-image. Therein the old idea of the Roman triumphal arch relief is fulfilled, the artistic formation of which finally rested upon the tension of symbol and history, for the first time now in Christian form. In this sense the Bassus sarcophagus is the completion and end of Roman sculpture" (*Iunius Bassus*, 30).

73. Daniélou, *Shadows to Reality*, 30.

74. Ibid., 252.

75. Ibid., 165.

Bibliography

Ambrose. *The Sacraments*. Trans. Roy J. Deferrari. In *The Fathers of the Church*, Vol. 44. Washington, D.C.: Catholic University of America Press, 1963. 269–328.

———. *Traité sur l'Évangile de S. Luc*. 2nd ed. Trans. Gabriel Tissot, O.S.B. *Sources Chrétiennes*, No. 45. Paris: Éditions du Cerf, 1971.

Ammianus Marcellinus. 3 vols. Trans. John C. Rolfe. Loeb Classical Library. Cambridge: Harvard University Press, 1935, 1963.

Athanasius. *The Festal Epistles of S. Athanasius, Bishop of Alexandria*. Trans. Henry Burgess. *A Library of Fathers of the Holy Catholic Church, Anterior to the Division of the East and West*, Vol. 38. Oxford: John Henry Parker, 1854; London: F. and J. Rivington, 1854.

Augustine, *On Christian Doctrine*. Trans. D. W. Robertson, Jr. Library of Liberal Arts, No. 80. New York: Liberal Arts Press, 1958.

———. *Patience*. Trans. Luanne Meagher, O.S.B. In *The Fathers of the Church*, Vol. 16. Washington, D.C.: Catholic University of America Press, 1952. 237–64.

———. *Reply to Faustus the Manichaean*. Trans. Richard Stothert. In *A Select Library of the Nicene and Post-Nicene Fathers*, Vol. 4. Buffalo: Christian Literature Company, 1887. 155–345.

Balil, A. "Iunius Bassus Problema Prosopografico." *Sobretiro de Zephyrus* 11 (1960). Seminario de Arqueologia de Salamanca, Varia 249.

Basso, Michele. *Eschatological Symbolism in the Vatican Necropolis*. Vatican City: Tipografia Poliglotta Vaticana, 1982.

Beckwith, John. *Early Christian and Byzantine Art*. Baltimore: Penguin Books, 1970.

Bercovitch, Sacvan. *Typology and Early American Literature*. Amherst: University of Massachusetts Press, 1972.

Blenkinsopp, J. "Type and Antitype." *New Catholic Encyclopedia*. New York: McGraw Hill Co., 1967. 14: 351–52.

Bourguet, Pierre du. *Early Christian Art*. Trans. Thomas Burton. New York: Reynal & Co./William Morrow & Co., 1971.

———. "Le sujet figuratif et la valeur qu'il revêt dans les monuments préconstantiniens." In *Überlegungen zum Ursprung der Frühchristlichen Bildkunst*. Ed. H. Brandenburg. Rome: IX Congresso Internazionale di Archeologia Cristiana, 1975. 51–53.

Bovini, Giuseppe. *I Sarcofagi Paleocristiani: Determinazione della Loro Cronologia Mediante l'Analisi dei Ritratti*. Vatican City: Società Amici Catacombe/Pontificio Istituto di Archeologia Cristiana, 1949.

Bovini, Giuseppe and Hugo Brandenburg. *Repertorium der Christlich-Antiken Sarkophage, I: Rom und Ostia.* Ed. Friedrich Wilhelm Deichmann. Wiesbaden: Franz Steiner Verlag, 1967.

Breckenridge, J. D. "The Reception of Art into the Early Church." In *Überlegungen zum Ursprung der Frühchristlichen Bildkunst.* Ed. H. Brandenburg. Rome: IX Congresso Internazionale di Archeologia Cristiana, 1975. 29–38.

Brenk, Beat. "The Imperial Heritage of Early Christian Art." In *Age of Spirituality: A Symposium.* Ed. Kurt Weitzmann. 39–52.

———. *Spätantike und Frühes Christentum.* Frankfurt am Main/Berlin/Vienna: Propyläen Verlag, 1977.

Brilliant, Richard. *Gesture and Rank in Roman Art: The Use of Gestures to Denote Status in Roman Sculpture and Coinage.* Memoirs of the Connecticut Academy of Arts and Sciences, Vol. 14. New Haven: Connecticut Academy of Arts and Sciences, 1963.

Brown, Peter R. L. "Art and Society in Late Antiquity." In *Age of Spirituality: A Symposium.* Ed. Kurt Weitzmann. 17–27.

———. "Aspects of the Christianization of the Roman Aristocracy." In *Religion and Society in the Age of Saint Augustine,* by Brown. New York: Harper & Row, 1972. 161–82. First published in *Journal of Roman Studies* 51 (1961): 1–11.

———. *The Cult of the Saints: Its Rise and Function in Latin Christianity.* Chicago: University of Chicago Press, 1981.

———. *The Making of Late Antiquity.* Cambridge, Mass./London: Harvard University Press, 1978.

———. *The World of Late Antiquity: From Marcus Aurelius to Muhammad.* London: Thames and Hudson, 1971.

Brown, Raymond Edward. *The Sensus Plenior of Sacred Scripture.* Baltimore: St. Mary's University, 1955.

Chadwick, Henry. *The Early Church.* The Pelican History of the Church, Vol. 1. New York: Penguin Books, 1967.

Charity, Alan Clifford. *Events and Their Afterlife: The Dialectics of Christian Typology in the Bible and Dante.* Cambridge: Cambridge University Press, 1966.

Christ, Alice. "Workshop, Patron, and 'Program' in the Sarcophagus of Junius Bassus" (abstract). In *Abstracts and Program Statements for Art History Sessions.* New York: College Art Association of America, 1986. 29.

Clark, Elizabeth A. *Women in the Early Church.* Wilmington, Del.: Michael Glazier, 1983.

Clement. "The Letter of St. Clement to the Corinthians." Trans. Francis X. Glimm. In *The Fathers of the Church,* Vol. 1. Washington, D.C.: Catholic University of America Press, 1947. 9–58.

Cook, John W. "The Junius Bassus Sarcophagus: The Imagery." Paper presented to the American Academy of Religion, Dallas, December 1980.

Cormack, Robin. "The Literature of Art: Recent Studies in Early Christian and Byzantine Art." *Burlington Magazine* 116 (1974): 411–12.

Cumont, Franz. *After Life in Roman Paganism.* New Haven: Yale University Press, 1922; New York: Dover Publications, 1959.

―――. "Un fragment de sarcophage judéo-païen." In *Recherches sur le symbolisme funéraire des Romains,* by Cumont. Paris: Librairie Orientaliste Paul Geuthner, 1942. 484–98. First published in *Revue archéologique,* Ser. 5, 4 (1916): 1–16.

Cutler, Anthony. "Authentic Iconography: Ptolemy and Hermes in Malibu, Ca." (abstract). In *Abstracts and Program Statements for Art History Sessions.* New York: College Art Association of America, 1986. 28.

Cyprian. *Letters (1–81).* Trans. Rose Bernard Donna, C.S.J. *The Fathers of the Church,* Vol. 51. Washington, D.C.: Catholic University of America Press, 1964.

Cyril of Jerusalem. *The Mystagogical Lectures.* Trans. Anthony A. Stephenson. In *The Fathers of the Church,* Vol. 64. Washington, D.C.: Catholic University of America Press, 1970. 153–203.

Daltrop, Georg. "Anpassung eines Relieffragmentes an den Deckel des Iunius Bassus Sarkophages." *Rendiconti della Pontificia Accademia Romana di Archeologia* 51–52 (1978–1980): 157–70.

Daniélou, Jean, S.J. "The Fathers and the Scriptures." *Theology* 57 (1954): 83–89.

―――. *From Shadows to Reality: Studies in the Biblical Typology of the Fathers.* Trans. Dom Wulstan Hibberd. London: Burns & Oates, 1960.

―――. *The Origins of Latin Christianity. A History of Early Christian Doctrine before the Council of Nicaea,* Vol. 3. Trans. David Smith and John Austin Baker. London: Darton, Longman & Todd, 1977; Philadelphia: Westminster Press, 1977.

―――. "La typologie d'Isaac dans le Christianisme primitif." *Biblica* 28 (1947): 363–93.

―――. "The Vine and the Tree of Life." In *Primitive Christian Symbols,* by Daniélou. Trans. Donald Attwater. Baltimore: Helicon Press, 1964. 25–41.

Darbyshire, J. R. "Typology." *Encyclopaedia of Religion and Ethics.* New York: Charles Scribner's Sons, 1955. 12: 500–4.

Didron, Adolphe Napoleon. *Christian Iconography: The History of Christian Art in the Middle Ages.* 2 vols. Trans. E. J. Millington. New York: Frederick Ungar, 1851, 1965.

Dinkler, Erich. "The Christian Realm: Abbreviated Representations." In *Age of Spirituality* (Catalogue). Ed. Kurt Weitzmann. 396–448.

Dionysius, Philippus Laurentius. *Sacrarum Vaticanae Basilicae Cryptarum Monumenta.* Rev. ed. Rome: Superiorum Facultate, 1828.

Dix, Gregory. *The Shape of the Liturgy.* London: A & C Black, 1945; New York: Seabury Press, 1982.

Egger, Gerhart. "Sarkophag des Junius Bassus vom Jahre 359." In "Zum Datierungsproblem in der spätantiken Kunst." *Jahrbuch der Kunsthistorischen Sammlungen in Wien* 64 (1968): 62–64.

Enking, Ragna. *S. Andrea Cata Barbara e S. Antonio Abbate Sull' Esquilino.* Le Chiese de Roma Illustrate, 83. Rome: Marietti, 1964.

Février, Paul-Albert. "A propos du repas funéraire: culte et sociabilité." *Cahiers archéologiques* 26 (1977): 29–45.

Finney, P. Corby. "Gnosticism and the Origins of Early Christian Art." In *Überlegungen zum Ursprung der Frühchristlichen Bildkunst.* Ed. H. Brandenburg. Rome: IX Congresso Internazionale di Archeologia Cristiana, 1975. 109–43.

Fox, Robin Lane. *Pagans and Christians.* New York: Alfred A. Knopf, 1987.

Frazer, Margaret E. "The Christian Realm: Apse Themes." In *Age of Spirituality* (Catalogue). Ed. Kurt Weitzmann. 556–63.

Frend, W.H.C. *The Rise of Christianity.* Philadelphia: Fortress Press, 1984.

Gaertner, Johannes A. "Zur Deutung des Junius-Bassus-Sarkophages." *Jahrbuch des Deutschen Archäologischen Instituts* 83 (1968): 240–64.

Geertz, Clifford. "Art as a Cultural System." *Modern Language Notes* 91 (1976): 1473–99.

Gerke, Friedrich. *Der Sarkophag des Iunius Bassus.* Berlin: Verlag Gebr. Mann, 1936.

Goodenough, Erwin R. *Jewish Symbols in the Greco-Roman Period.* 13 vols. New York: Pantheon Books and Princeton University Press (vol. 13), 1953–1968.

Goppelt, Leonhard. *Typos: Die Typologische Deutung des Alten Testaments im Neuen.* Darmstadt: Wissenschaftliche Buchgesellschaft, 1969.

Gordon, Arthur E. *Illustrated Introduction to Latin Epigraphy.* Berkeley/Los Angeles/London: University of California Press, 1983.

Grabar, André. *Christian Iconography: A Study of Its Origins.* Trans. Terry Grabar. Princeton, N.J.: Princeton University Press, 1968.

———. *Early Christian Art: From the Rise of Christianity to the Death of Theodosius.* Trans. Stuart Gilbert and James Emmons. New York:

Odyssey Press, 1968. Published in England as *The Beginnings of Christian Art: 200–395*. London: Thames and Hudson, 1967.

Grant, Robert M. "History of the Interpretation of the Bible." *The Interpreter's Bible*. New York and Nashville: Abingdon-Cokesbury Press, 1952. 1: 106–14.

Gregory of Nyssa. *Commentary on the Song of Songs*. Trans. Casimir McCambley, O.C.S.O. Brookline, Mass.: Hellenic College Press, 1987.

Grousset, René. *Étude sur l'histoire des sarcophages chrétiens: catalogue des sarcophages chrétiens de Rome qui ne se trouvent point au Musée du Latran*. Bibliothèque des Écoles françaises d'Athènes et de Rome, 42. Paris: Ernest Thorin, 1885.

Hanfmann, George M. A. *The Season Sarcophagus in Dumbarton Oaks*. 2 vols. Cambridge, Mass.: Harvard University Press, 1951.

Heuser, Mary L. "Review of *Die früchristlichen Mosaiken in S. Maria Maggiore zu Rom* by Beat Brenk." *Art Bulletin* 61 (1979): 473–77.

Hilaire de Poitiers. *Traité des Mystères*. Trans. Jean-Paul Brisson. Sources Chrétiennes, No. 19. Paris: Éditions du Cerf, 1947.

Himmelmann, Nikolaus. "Der Sarkophag des Junius Bassus" (abstract). In the Chronik section (Basel) of *Antike Kunst* 15 (1972): 146–47.

———. *Typologische Untersuchungen an römischen Sarkophagreliefs des 3. und 4. Jahrhunderts n. Chr.* Mainz am Rhein: Philipp von Zabern, 1973.

Hippolytus. *Fragments from Commentaries*. Trans. S.D.F. Salmond. In *The Ante-Nicene Fathers*, Vol. 5. Grand Rapids, Mich.: Wm. B. Eerdmans, 1957. 163–203.

Huskinson, Janet. "Some Pagan Mythological Figures and Their Significance in Early Christian Art." *Papers of the British School at Rome* 29 (1974). 68–97, pls. III–VI.

Ignatius. "To the Ephesians." Trans. Gerald G. Walsh, S.J. In *The Fathers of the Church*, Vol. 1. Washington, D.C.: Catholic University of America Press, 1947. 87–95.

Irenaeus. *Against Heresies*. Trans. Alexander Roberts and W. H. Rambaut. Ante-Nicene Christian Library, Vols. 5 & 6. Edinburgh: T & T Clark, 1869. Also in *The Ante-Nicene Fathers*, Vol. 1. Grand Rapids, Mich.: Wm. B. Eerdmans, 1956. 315–567.

———. *Proof of the Apostolic Teaching*. Trans. Joseph P. Smith, S.J. Ancient Christian Writers, No. 16. New York: Newman Press, 1952.

Janson, H. W. *History of Art*. Englewood Cliffs, N.J.: Prentice-Hall, 1962; New York: Harry N. Abrams, 1962.

Jones, A.H.M. *The Later Roman Empire, 284–602: A Social, Economic, and Administrative Survey*. 2 vols. Norman: University of Oklahoma Press, 1964.

Jones, A.H.M. "The Social Background of the Struggle between Paganism and Christianity." In *The Conflict between Paganism and Christianity in the Fourth Century*. Ed. Arnaldo Momigliano. Oxford: Clarendon Press, 1963. 17–37.

Jones, A.H.M., J. R. Martindale, and J. Morris. *The Prosopography of the Later Roman Empire, Vol. I: A.D. 260–395*. Cambridge: Cambridge University Press, 1971.

Jungman, Camille S. "The Christian Context of the Late-Antique Frieze on the Arch of Constantine." Unpublished Master's thesis, Florida State University, June 1971.

Kelly, J.N.D. *Early Christian Doctrines*. 2nd ed. New York: Harper & Row, 1960.

Kennedy, Charles A. "Dead, Cult of the." In *Anchor Bible Dictionary*. Garden City, N.Y.: Doubleday, forthcoming.

Kessler, Herbert L. "On the State of Medieval Art History." *Art Bulletin* 70 (1988): 166–87.

———. "Pictorial Narrative and Church Mission in Sixth-Century Gaul." In *Pictorial Narrative in Antiquity and the Middle Ages*. Eds. Herbert L. Kessler and Marianna Shreve Simpson. Studies in the History of Art, Vol. 16. Washington, D.C.: National Gallery of Art, 1985. 75–91.

———. "Scenes from the Acts of the Apostles on Some Early Christian Ivories." *Gesta* 18 (1979): 109–19.

Kitzinger, Ernst. *Byzantine Art in the Making: Main Lines of Stylistic Development in Mediterranean Art, 3rd–7th Century*. Cambridge: Harvard University Press, 1977.

———. "Christian Imagery: Growth and Impact." In *Age of Spirituality: A Symposium*. Ed. Kurt Weitzmann. 141–63.

———. "On the Interpretation of Stylistic Changes in Late Antique Art." *Bucknell Review* 15 (1967): 1–10. Reprinted in *The Art of Byzantium and the Medieval West: Selected Studies*, by Kitzinger. Ed. W. Eugene Kleinbauer. Bloomington/London: Indiana University Press, 1976. 32–48.

Klauser, Theodor. *Frühchristliche Sarkophage in Bild und Wort*. Ed. Friedrich Wilhelm Deichmann. Olten: Urs Graf-Verlag, 1966.

Kranz, Peter. *Jahreszeiten-Sarkophage: Entwicklung und Ikonographie des Motivs der Vier Jahreszeiten auf Kaiserzeitlichen Sarkophagen und Sarkophagdeckeln*. Berlin: Gebr. Mann Verlag, 1984.

Krautheimer, Richard. "Mensa—Coemeterium—Martyrium." In *Studies in Early Christian, Medieval, and Renaissance Art*, by Krautheimer. New York: New York University Press, 1969; London: University of

London Press, 1969. 35–58, figs. 6a–11. First published in *Cahiers archéologiques* 11 (1960): 15–40.

———. *Rome: Profile of a City, 312–1308.* Princeton, N.J.: Princeton University Press, 1980.

———. "Success and Failure in Late Antique Church Planning." In *Age of Spirituality: A Symposium.* Ed. Kurt Weitzmann. 121–39.

———. *Three Christian Capitals: Topography and Politics.* Berkeley/Los Angeles/London: University of California Press, 1983.

Lactantius. *The Divine Institutes.* Trans. William Fletcher. In *The Ante-Nicene Fathers,* Vol. 7. Grand Rapids, Mich.: Wm. B. Eerdmans, [1886]. 9–223.

———. *Of the Manner in which the Persecutors Died.* Trans. William Fletcher. In *The Ante-Nicene Fathers,* Vol. 7. Grand Rapids, Mich.: Wm. B. Eerdmans, [1886]. 301–22.

———(attributed). *The Phoenix.* Trans. William Fletcher. In *The Ante-Nicene Fathers,* Vol. 7. Grand Rapids, Mich.: Wm. B. Eerdmans, [1886]. 324–26.

Lampe, G.W.H. "The Resonableness of Typology." In *Essays on Typology,* by Lampe and Woollcombe. Studies in Biblical Theology. London: SCM Press, 1957. 9–38.

———. "Typological Exegesis." *Theology* 56 (1953): 201–8.

Lawrence, Marion. "Columnar Sarcophagi in the Latin West: Ateliers, Chronology, Style." *Art Bulletin* 14 (1932): 103–85.

———. "Review of Wilpert, *I Sarcofagi Cristiani Antichi,* Vol. I." *Art Bulletin* 13 (1931): 532–36.

———. "Review of Wilpert, *I Sarcofagi Cristiani Antichi,* Vol. II." *Art Bulletin* 16 (1934): 309–13.

———. "Season Sarcophagi of Architectural Type." *American Journal of Archaeology* 62 (1958): 273–95, pls. 72–79.

———. "Three Pagan Themes in Christian Art." In *Essays in Honor of Erwin Panofsky.* 2 vols. Ed. Millard Meiss. De Artibus Opscula XL. New York: New York University Press, 1961. 1: 323–34; 2: 100–6 (figs.).

Le Blant, M. Edmond. *Étude sur les sarcophages chrétiens antiques de la ville d'Arles.* Paris: Imprimerie Nationale, 1878.

Lowrie, Walter. *Art in the Early Church.* New York: Pantheon Books, 1947.

MacCormack, Sabine G. *Art and Ceremony in Late Antiquity.* Berkeley/Los Angeles/London: University of California Press, 1981.

MacMullen, Ramsay. *Christianizing the Roman Empire (A.D. 100–400).* New Haven and London: Yale University Press, 1984.

MacMullen, Ramsay. *Paganism in the Roman Empire.* New Haven and London: Yale University Press, 1981.

Maguire, Henry. *Earth and Ocean: The Terrestrial World in Early Byzantine Art.* University Park and London: Pennsylvania State University Press for the College Art Association, 1987.

Markow, Deborah. "Some Born-Again Christians of the Fourth Century." *Art Bulletin* 63 (1981): 650–55.

Markus, R. A. *Christianity in the Roman World.* London: Thames and Hudson, 1974.

———. "Presuppositions of the Typological Approach to Scripture." *Church Quarterly Review* 158 (1957): 442–51. Reprinted in *The Communication of the Gospel in New Testament Times,* by Austin Farrer et al. London: SPCK, 1961. 75–85.

The Martyrdom of Perpetua and Felicitas. Trans. R. E. Wallis. In *The Ante-Nicene Fathers,* Vol. 3. Grand Rapids, Mich.: Wm. B. Eerdmans, 1957. 699–706.

Marucchi, Orazio. *Christian Epigraphy: An Elementary Treatise with a Collection of Ancient Christian Inscriptions Mainly of Roman Origin.* Trans. J. Armine Willis. Cambridge: Cambridge University Press, 1912.

Melito of Sardis. *Fragments.* Trans. B. P. Pratten. In *The Ante-Nicene Fathers,* Vol. 8. Grand Rapids, Mich.: Wm. B. Eerdmans, n.d. 751–62.

———. *The Homily on the Passion by Melito, Bishop of Sardis, with Some Fragments of the Apocryphal Ezekiel. Studies and Documents,* Vol. 12. Ed. Campbell Bonner. London: Christophers, 1940; Philadelphia: University of Pennsylvania Press, 1940. 85–180.

Meyers, Walter E. *A Figure Given: Typology in the Wakefield Plays.* Pittsburgh: Duquesne University Press, 1969.

Minucius Felix. *Octavius.* Trans. Rudolph Arbesmann, O.S.A. In *The Fathers of the Church,* Vol. 10. Washington, D.C.: Catholic University of America Press, 1950. 321–402.

Morey, Charles Rufus. *Early Christian Art.* Princeton, N.J.: Princeton University Press, 1942.

Murray, (Sister) Charles. "Art and the Early Church." *Journal of Theological Studies,* N.S. 28 (1977): 303–45. Later incorporated as chap. 1 of *Rebirth and Afterlife.*

———. "Early Christian Art and Archaeology." *Religion* 12 (1982): 167–73. Cf. the Introduction to *Rebirth and Afterlife.*

———. *Rebirth and Afterlife: A Study of the Transmutation of Some Pagan Imagery in Early Christian Funerary Art.* Oxford: B.A.R., 1981.

Neumeyer, Alfred. "Review of Grabar, *Christian Iconography.*" *Journal of Aesthetics and Art Criticism* 29 (1970): 139.

Nock, Arthur Darby. *Conversion: The Old and the New in Religion from Alexander the Great to Augustine of Hippo.* Oxford: Clarendon Press, 1933.

————. "Sarcophagi and Symbolism." In *Essays on Religion and the Ancient World*, by Nock. 2 vols. Ed. Zeph Stewart. Oxford: Clarendon Press, 1972. 2: 606–41.

Nordhagen, Per Jonas. "The Archaeology of Wall Mosaics: A Note on the Mosaics in Sta. Maria Maggiore in Rome." *Art Bulletin* 65 (1983): 323–24.

Oakeshott, Walter. *The Mosaics of Rome: From the Third to the Fourteenth Centuries.* London: Thames and Hudson, 1967.

Olsen, Glenn W. "Allegory, Typology, and Symbol: The *Sensus Spiritalis;* Part I: Definitions and Earliest History." *Communio: International Catholic Review* 4 (1977): 161–79.

————. "Allegory, Typology, and Symbol: The *Sensus Spiritalis;* Part II: Early Church through Origen." *Communio: International Catholic Review* 4 (1977): 357–84.

Panofsky, Erwin. *Tomb Sculpture: Four Lectures on Its Changing Aspects from Ancient Egypt to Bernini.* Ed. H. W. Janson. New York: Henry N. Abrams, 1956.

Pietri, Charles. *Roma Christiana: Recherches sur l'Église de Rome, son organisation, sa politique, son idéologie de Miltiade à Sixte III (311–440).* 2 vols. Palais Farnèse: École Française de Rome, 1976.

Prudentius. 2 vols. Trans. H. J. Thomson. Loeb Classical Library. Cambridge: Harvard University Press, 1949.

Quasten, Johannes. *Patrology.* 3 vols. Utrecht-Antwerp: Spectrum Publishers, 1964; Westminster, Md.: Newman Press, 1964.

Reynolds, Stephen. *The Christian Religious Tradition.* Encino, Calif.: Dickenson Publishing Co., 1977.

Richmond, I. A. *Archaeology, and the After-Life in Pagan and Christian Imagery.* London/New York/Toronto: Oxford University Press, 1950.

Ridgway, Brunilde Sismondo. "The State of Research on Ancient Art." *Art Bulletin* 68 (1986): 7–23.

Riley, Hugh M. *Christian Initiation: A Comparative Study of the Interpretation of the Baptismal Liturgy in the Mystagogical Writings of Cyril of Jerusalem, John Chrysostom, Theodore of Mopsuestia, and Ambrose of Milan.* Studies in Christian Antiquity, No. 17. Washington, D.C.: Catholic University of America Press/Consortium Press, 1974.

Rogers, Clement F. *Baptism and Christian Archaeology.* Oxford: Clarendon Press, 1903.

Rosenau, Helen. "Problems of Jewish Iconography." *Gazette des beaux-arts,* Series 6, 56 (1960): 5–18.

Salomonson, J. W. *Voluptatem Spectandi Non Perdat Sed Mutet: Obser-vations sur l'Iconographie du martyre en Afrique Romaine*. Amster-dam/Oxford/New York: North-Holland Publishing Co., 1979.

Saxl, Fritz. "Pagan and Jewish Elements in Early Christian Sculpture." In *Lectures*, by Saxl. 2 vols. London: Warburg Institute, 1957. 1: 45–57; 2: pls. 26–33.

Schefold, Karl. "Altchristliche Bilderzyklen: Bassussarkophag und Santa Maria Maggiore." *Rivista di Archeologia Cristiana* 16 (1939): 289–316.

Schiller, Gertrud. *Iconography of Christian Art*. 2 vols. Trans. Janet Se-ligman. Greenwich, Conn.: New York Graphic Society, Vol. 1: 1971; Vol. 2: 1972.

Shelton, Kathleen J. *The Esquiline Treasure*. London: British Museum Publications, 1981.

Shepherd, Massey H., Jr. "Christology: A Central Problem of Early Christian Theology and Art." In *Age of Spirituality: A Symposium*. Ed. Kurt Weitzmann. 101–20.

Smalley, Beryl. *The Study of the Bible in the Middle Ages*. Oxford: Basil Blackwell, 1952.

Smith, E. Baldwin. *Early Christian Iconography and A School of Ivory Carvers in Provence*. Princeton, N.J.: Princeton University Press, 1918.

Smith, Jonathan Z. "The Garments of Shame." *History of Religions* 5 (1966): 217–38. Reprinted in *Map Is Not Territory: Studies in the His-tory of Religions*. Leiden: E. J. Brill, 1978. 1–23.

Snyder, Graydon F. *Ante Pacem: Archaeological Evidence of Church Life Before Constantine*. Macon, Ga.: Mercer University Press, 1985.

Soper, Alexander Coburn. "The Italo-Gallic School of Early Christian Art." *Art Bulletin* 20 (1938): 145–92.

———. "The Latin Style on Christian Sarcophagi of the Fourth Cen-tury." *Art Bulletin* 19 (1937): 148–202.

Sordi, Marta. "Christianity and the Culture of the Roman Empire." In *The Christians and the Roman Empire*, by Sordi. Trans. Annabel Be-dini. Norman/London: University of Oklahoma Press, 1986. 156–70. First published in *Vetera Christianorum* 18 (1981): 129–42.

Spain, Suzanne. "The Program of the Fifth-Century Mosaics of Santa Maria Maggiore" (dissertation summary). *Marsyas* 14 (1968–1969): 85.

———. " 'The Promised Blessing': The Iconography of the Mosaics of S. Maria Maggiore." *Art Bulletin* 61 (1979): 518–40.

———. "The Restorations of the Sta. Maria Maggiore Mosaics." *Art Bul-letin* 65 (1983): 325–28.

————. "The Temple of Solomon, the Incarnation and the Mosaics of S. Maria Maggiore" (abstract). *Journal of the Society of Architectural Historians* 28 (1969): 214–15.

Stern, Henri. *Le calendrier de 354: étude sur son texte et ses illustrations.* Paris: Imprimerie Nationale/Librairie Orientaliste Paul Geuthner, 1953.

————. "Les mosaïques de l'église de Sainte-Constance à Rome." *Dumbarton Oaks Papers* 12 (1958): 157–218.

Stevenson, J. *The Catacombs: Rediscovered Monuments of Early Christianity.* London: Thames and Hudson, 1978.

Stommel, Eduard. *Beiträge zur Ikonographie der konstantinischen Sarkophagplastik.* Bonn: Peter Hanstein Verlag, 1954.

Tertullian. *An Answer to the Jews.* Trans. S. Thelwall. In *Ante-Nicene Christian Library,* Vol. 18. Edinburgh: T & T Clark, 1870. 201–58. Also in *The Ante-Nicene Fathers,* Vol. 3. Grand Rapids, Mich.: Wm. B. Eerdmans, 1957. 151–73.

————. *Apology.* Trans. Emily Joseph Daly, C.S.J. In *The Fathers of the Church,* Vol. 10. Washington, D.C.: Catholic University of America Press, 1950. 7–126.

————. *On Baptism.* Trans. S. Thelwall. In *Ante-Nicene Christian Library,* Vol. 11. Edinburgh: T & T Clark, 1869. 231–56. Also in *The Ante-Nicene Fathers,* Vol. 3. Grand Rapids, Mich.: Wm. B. Eerdmans, 1957. 669–79.

————. *On the Resurrection of the Flesh.* Trans. Peter Holmes. In *Ante-Nicene Christian Library,* Vol. 15. Edinburgh: T & T Clark, 1870. 215–332. Also in *The Ante-Nicene Fathers,* Vol. 3. Grand Rapids, Mich.: Wm. B. Eerdmans, 1957. 545–94.

————. *Patience.* Trans. Emily Joseph Daly, C.S.J. In *The Fathers of the Church,* Vol. 40. New York: Fathers of the Church, Inc., 1959. 193–222.

————. *Scorpiace.* Trans. S. Thelwall. In *Ante-Nicene Christian Library,* Vol. 11. Edinburgh: T & T Clark, 1869. 379–415. Also in *The Ante-Nicene Fathers,* Vol. 3. Grand Rapids, Mich.: Wm. B. Eerdmans, 1957. 633–48.

————. *The Soul's Testimony.* Trans. S. Thelwall. In *Ante-Nicene Christian Library,* Vol. 11. Edinburgh: T & T Clark, 1869. 36–45. Also in *The Ante-Nicene Fathers,* Vol. 3. Grand Rapids, Mich.: Wm. B. Eerdmans, 1957. 175–79.

Theodore of Mopsuestia. *Commentary of Theodore of Mopsuestia on the Lord's Prayer and on the Sacraments of Baptism and the Eucharist.* Woodbrooke Studies, Vol. 6. Trans. A. Mingana. Cambridge: W. Heffer & Sons, 1933.

Thérel, M. L. "Légitimité et intérêt historique de la lecture 'Au second degré' des images paléochrétiennes." In *Überlegungen zum Ursprung der Frühchristlichen Bildkunst.* Ed. H. Brandenburg. Rome: IX Congresso Internazionale di Archeologia Cristiana, 1975. 79.

Tronzo, William. "Christian Imagery and Conversion in Fourth-Century Rome" (abstract). In *Abstracts and Program Statements for Art History Sessions.* New York: College Art Association of America, 1986. 30.

—————. *The Via Latina Catacomb: Imitation and Discontinuity in Fourth-Century Roman Painting.* University Park and London: Pennsylvania State University Press, 1986.

Turcan, Robert. "Review of N. Himmelmann, *Typologische Untersuchungen an römischen Sarkophagreliefs des 3. und 4. Jahrhunderts n. Chr.*" *Revue archéologique* N.S. 2 (1975): 369–71.

Volbach, W. F. *Early Christian Art.* London: Thames and Hudson, 1961.

Waal, Anton de. *Der Sarkophag des Junius Bassus in den Grotten von St. Peter: Eine archäologische Studie.* Rome: Buchdruckerei der Gesellschaft des Göttlichen Heilandes, 1900.

—————. "Zur Chronologie des Bassus-Sarkophags in den Grotten von Sankt Peter." *Römische Quartalschrift* 21 (1907): 117–34.

Ward-Perkins, John B. "The Role of the Craftsmanship [sic] in the Formation of Early Christian Art." *Studi di Antichità Cristiana* 32 (1978) = *Atti del IX Congresso Internazionale de Archeologia Cristiana* (Roma, 21–27 Settembre 1975): 637–52.

—————. "Workshops and Clients: The Dionysiac Sarcophagi in Baltimore." *Rendiconti della Pontificia Accademia Romana di Archeologia* 48 (1975–1976): 191–238.

Weidlé, Wladimir. *The Baptism of Art: Notes on the Religion of the Catacomb Paintings.* Westminster [London]: Dacre Press, n.d.

Weitzmann, Kurt, ed. *Age of Spirituality: A Symposium.* New York: Metropolitan Museum of Art/Princeton University Press, 1980.

—————. *Age of Spirituality: Late Antique and Early Christian Art, Third to Seventh Century* (Catalogue). New York: Metropolitan Museum of Art/Princeton University Press, 1979.

White, L. Michael. "Review of *Ante Pacem*, by Snyder." *Journal of Biblical Literature* 106 (1987): 560–62.

—————. "The Social Setting of the Junius Bassus Sarcophagus: Analysis and Implications." Paper presented to the American Academy of Religion, Dallas, December 1980.

Wiles, M. F. "The Old Testament in Controversy with the Jews." *Scottish Journal of Theology* 8 (1955): 113–26.

Wilken, Robert L. *The Christians as the Romans Saw Them.* New Haven/London: Yale University Press, 1984.

Wilpert, Giuseppe. *I Sarcofagi Cristiani Antichi.* 3 vols. Rome: Pontificio Istituto di Archeologia Cristiana, 1929–1936.

Woollcombe, K. J. "The Biblical Origins and Patristic Development of Typology." In *Essays on Typology,* by Lampe and Woollcombe. Studies in Biblical Theology. London: SCM Press, 1957. 39–75.

Wulff, Oskar. *Altchristliche und Byzantinische Kunst.* 2 vols. Potsdam: Akademische Verlagsgesellschaft Athenaion, 1936.

Zwirn, Stephen R. "Drawings of the Calendar of 354." In *Age of Spirituality* (Catalogue). Ed. Kurt Weitzmann. 78–79.

Index of Biblical Citations

Index of Ancient Authors

Index of Modern Authors

250 INDEX

Index of Subjects

frieze sarcophagi, 8, 15–18, 34, 67, 71, 89, 136–37

Gaertner, 34–37
Gerke, 30–32
Grabar, 24–26

harvests, 205–6 n.39, 206 n.40, 207–8 n.56; harvests and eucharist, 95–99, 204 n.33, 206 n.41

"iconographic mistake," 30–32, 70–71, 99, 135, 169–70 n.31, 202 n.27, 206 n.48, 220 n.7, 225 n.35
imperial art, 50–52, 183–84 n.67, 184 n.69, n.72, 185 n.79, 218 n.18
Isaac, sacrifice of, 43–47, 165 n.48, 174 n.13, 175 n.15, 180 nn.43–44, 181 n.50, 193 n.143

Job, 165 n.48, 175 n.15, 187 nn.93–95, 188 nn.99–100, 193 n.143, 216–17 n.11; and Paul, 54–59, 132, 188 nn.95–96
Junius Bassus, life, 3–4
Junius Bassus sarcophagus: compositional elements, 7–10, 121–23, 128–29; date, 155 n.2; drawing by P. L. Dionysius (fig. 14), 62, 190 n.113, 209 n.5; engraving by A. Basio (fig. 15), 62, 190 n.113; inscription, 3, 123–24, 134; inscription, verse, 114–16; original position, 140, 156 n.3; photograph in Wilpert (here fig. 16), 190 n.113; "popularity index" of biblical scenes, 12–16; size, 7; style, 39, 174 n.8. See also chapter headings and sub-headings

kliné meal. See meal of the dead

Labarum. See Symbolic Resurrection
lambs, 73–76, 195 nn.3–5, n.11, 196 n.12
Lateran sarcophagus 110, 92, 201 n.8
Lateran sarcophagus 164 (fig. 9), 19, 32, 51, 55, 63, 70–71, 125, 181 n.56, 183 n.65, 187 n.95, 193 n.143, 194 nn.148–49, 217 n.11
Lateran sarcophagus 171. See Domitilla (Cemetery of), sarcophagus from (fig. 8)

Lateran sarcophagus 174. See St. Peter's, sarcophagus (inv. 174) from (fig. 10)
Lateran sarcophagus 181. See Three Good Shepherds sarcophagus (figs. 33, 30, 32)
Lateran sarcophagus 184, 92, 201 n.8
Law, receiving the, 78–82, 174 n.13, 197 n.24
Lazarus, raising of, 72, 76–78

martyrdom, 48–49, 66–67, 182–83 n.62, 188 n.95, 192 n.130; of apostles, 19, 165 n.48
masks on sarcophagi, 116–18, 214 n.66, 215 n.69, n.71
meal of the dead (kliné meal), 106–11, 136, 211 n.26, n.31, nn.33–34, 212 n.40
"mistake." See "iconographical mistake"
Missorium of Theodosius I, 51
Moses. See Law, receiving the; Peter, and Moses; striking the rock
multiplication of the loaves, 82–83, 198 n.39
Museo Gregoriano Profano, sarcophagus (inv. 9539) in (fig. 42), 107–8
mystagogical catechesis, 43, 121

nakedness, 64–67, 89–90, 191 n.128, 207 n.52

orant, 16–17, 92, 111, 113, 138–39, 142, 212–13 n.49, 213 n.50, 217 n.12, 226 n.42

"pagan" and Christian images/motifs, in art, 118–19, 140–42, 201 n.8, 210 n.16, 225 nn.35–36, 226 n.43, n.46, 227 n.57, 228 n.61; in texts, 143–47, 210 n.18, 226 n.40
parapetasma, 112, 213 nn.54–55, 213–14 n.56
passion sarcophagi, 16–19, 30, 34, 46, 50–51, 67, 70–71, 89, 121, 137, 139, 165 nn.46–48, 188 n.95, 194 n.152
Paul, arrest of, 47–48, 181 n.56, 181–82 n.57, 182 n.60. See also Job, and Paul; Peter, and Paul
Peter, 183 n.65, 225 n.35; arrest of, 47–48, 182 n.57, n.60; commission-

Plates

1. Junius Bassus Sarcophagus (Treasury Museum, St. Peter's, Rome): Front. Double-register columnar sarcophagus with carved lid. Fragmented lid (center to right): verse inscription, *klinē* (Greek: couch) meal or meal-of-the-dead scene, mask of Luna (the moon). Biographical inscription on upper edge of facade. Five upper-register scenes, left to right: Sacrifice of Isaac, Arrest of Peter, Christ Enthroned over Coelus (personification of the universe) and Giving the Law (*traditio legis*) to Two Apostles, Arrest of Christ, Judgment of Pilate. Six spandrel scenes, left to right: Three Youths in the Fiery Furnace, Striking the Rock, Multiplication of the Loaves, Baptism of Christ, Receiving the Law, Raising of Lazarus. Five lower-register scenes, left to right: Distress of Job, Adam and Eve in the Garden, Triumphal Entry, Daniel in the Lions' Den, Arrest of Paul. Central columns (upper and lower) carved with grapevines; others strigilated. Level entablature above upper-register niches; alternating arches and gables below. Eagle-headed conchs in arches of lower register.

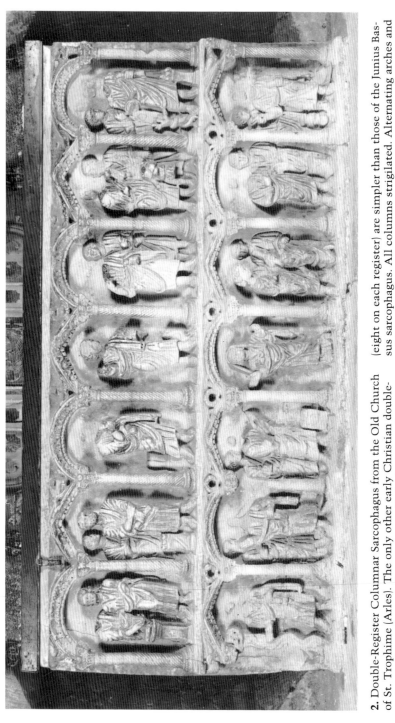

2. Double-Register Columnar Sarcophagus from the Old Church of St. Trophime (Arles). The only other early Christian double-register columnar sarcophagus extant. Both the intercolumnar scenes (seven on each register) and the spandrel decorations (eight on each register) are simpler than those of the Junius Bassus sarcophagus. All columns strigilated. Alternating arches and gables.

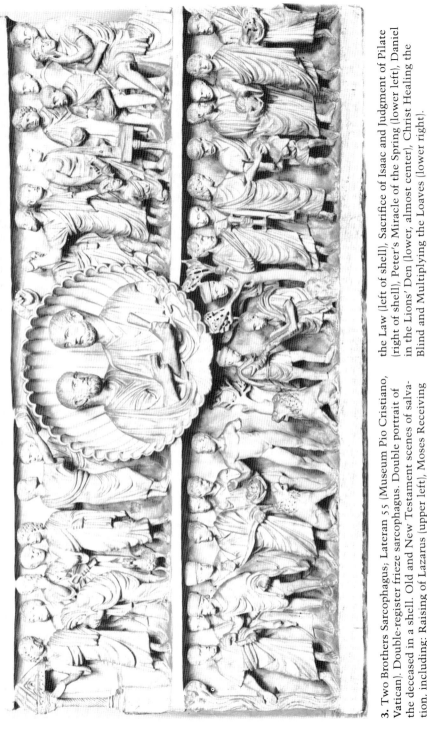

3. Two Brothers Sarcophagus; Lateran 55 (Museum Pio Cristiano, Vatican). Double-register frieze sarcophagus. Double portrait of the deceased in a shell. Old and New Testament scenes of salvation, including: Raising of Lazarus (upper left), Moses Receiving the Law (left of shell), Sacrifice of Isaac and Judgment of Pilate (right of shell), Peter's Miracle of the Spring (lower left), Daniel in the Lions' Den (lower, almost center), Christ Healing the Blind and Multiplying the Loaves (lower right).

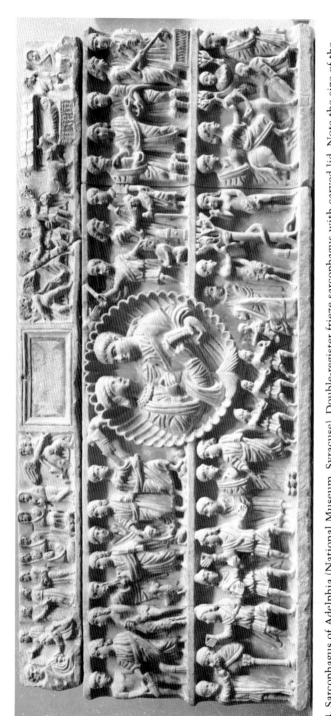

4. Sarcophagus of Adelphia (National Museum, Syracuse). Double-register frieze sarcophagus with carved lid. Note the size of the carved lid; the carved lid of the Junius Bassus sarcophagus was higher. Double portrait of the deceased in a shell. Old and New Testament scenes of salvation on the facade, including: Creation of Adam and Eve (upper left), Moses Receiving the Law (left of shell), Sacrifice of Isaac, Christ Healing the Blind, Multiplication of the Loaves, (an unusual) Raising of Lazarus (upper right), Changing Water into Wine and Adoration of the Magi (lower center), Adam and Eve in the Garden and Triumphal Entry (lower right).

5. Dogmatic Sarcophagus; Lateran 104 (Museo Pio Cristiano, Vatican). (opposite page) Double-register frieze sarcophagus with a strigilated lid. Old and New Testament scenes of salvation. Upper-register scenes, from left to right: Creation of Adam and Eve, Assignment of Tasks to Adam and Eve in the Garden, double portrait in a rondel, Christ Changing Water into Wine, Multiplying the Loaves, Raising Lazarus. Lower-register scenes, left to right: Adoration of the Magi, Christ Healing the Blind, Daniel in the Lions' Den, Peter's Commissioning (or Denial), Peter's Arrest, Peter's Miracle of the Spring. Six scenes with parallels in the Junius Bassus sarcophagus intercolumnar and spandrel scenes. Note the grouping of Christ scenes at the upper right and lower left, and of Adam and Eve scenes at the upper left and Peter scenes at the lower right.

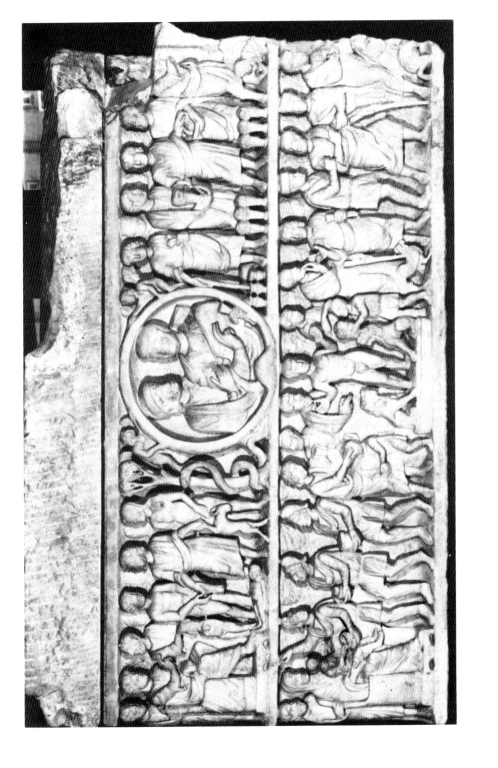

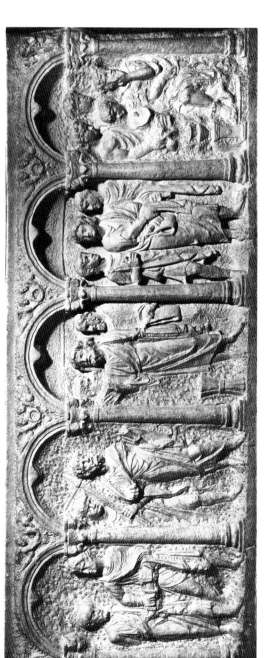

6. Sarcophagus from the Crypt of San Massimino (Rome). Badly damaged five-niche single-register columnar passion sarcophagus. Scenes, from left to right: Arrest of Paul (note reeds), Arrest of Peter, Symbolic Resurrection (compare figs. 8 and 9), Arrest of Christ, Judgment of Pilate. Central columns carved with grapevines; others strigilated. Shell over central niche.

7. Unfinished Sarcophagus from San Sebastiano (Rome). Unfinished five-niche single-register columnar passion sarcophagus. Scenes, from left to right: Arrest of Paul, Arrest of Peter, Christ Teaching, Arrest of Christ, Judgment of Pilate. Shell over each niche. Putti with wreaths in spandrels.

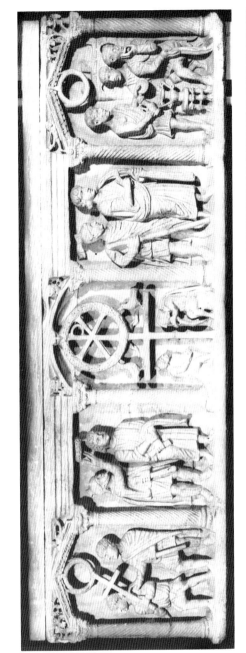

8. Sarcophagus from the Cemetery of Domitilla, Lateran 171 (Museo Pio Cristiano, Vatican). Five-niche single-register columnar passion sarcophagus. Scenes, from left to right: Simon of Cyrene Carrying Christ's Cross, Christ Crowned with Thorns, Symbolic Resurrection, Arrest of Christ, Judgment of Pilate. All columns strigilated. Gables over first and fifth niches; level entablatures over second and fourth niches; arch with eagle's head over central niche.

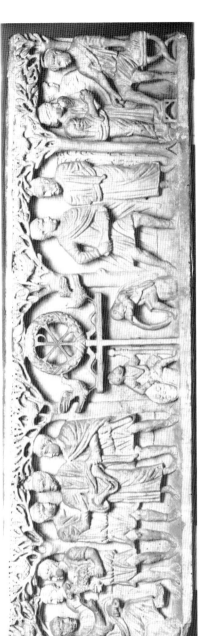

9. Lateran Sarcophagus 164 (Museo Pio Cristiano, Vatican). Five-niche single-register tree passion sarcophagus. Scenes, from left to right: Sacrifice of Cain and Abel to God, Arrest of Peter, Symbolic Resurrection, Arrest of Paul (note reeds), Distress of Job. Old Testament scenes in first and fifth niches; scenes of apostolic martyrdoms in second and fourth niches. Christological scene at the center. Note that end figures (God and Job) are seated and facing inward.

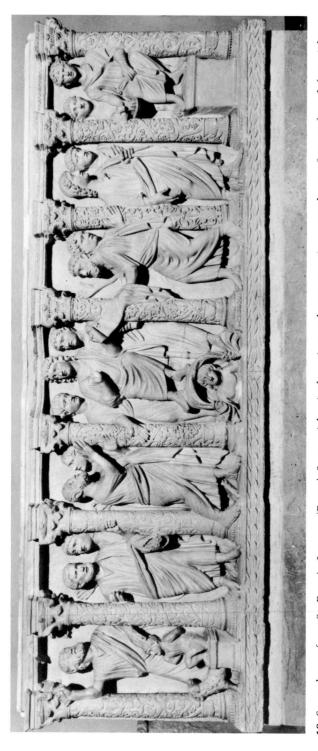

10. Sarcophagus from St. Peter's; Inv. 174 (Rome). Seven-niche single-register columnar passion sarcophagus. Scenes, from left to right: Sacrifice of Isaac, Apostle, three central scenes—Christ Enthroned over Coelus (personification of the universe) and Giving the Law (*traditio legis*) to Two Apostles, two right scenes—Christ before Pilate. All columns carved with grapevines. Level entablature.

11. Sarcophagus of Santa Maria Antiqua (Rome): Front. Single-register trough sarcophagus. Old and New Testament scenes of salvation, plus symbolic figures. Scenes, from left to right: Jonah Cast Up and Resting under Gourd Vine, *Orant* (female figure representing *pietas*, prayer, the soul, and/or the deceased), Philosopher Reading (male figure representing intellectual life, reception of revealed Scripture, and/or the deceased), Good Shepherd, Baptism of Christ.

12. Sarcophagus of Santa Maria Antiqua (Rome): Left End. Scene: Neptune (representing the seal), Jonah on the Ship.

13. Sarcophagus of Santa Maria Antiqua (Rome): Right End. Scene: Two Fishermen (Disciples) with a Net.

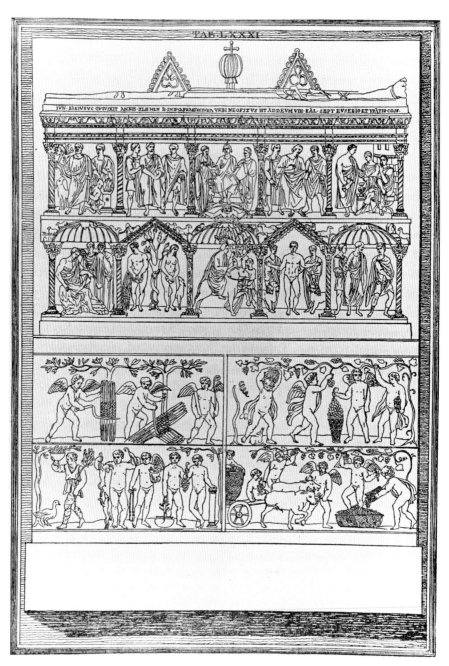

14. Drawing of Junius Bassus Sarcophagus by P. L. Dionysius, *Sacrarum Vaticanae Basilicae Cryptarum Monumenta*, 1773. Decorations above the broken lid are on the wall of the Vatican Grotto. Note the naked Daniel *orant* in the fourth niche of the lower register. Drawings of the left end scenes (upper and lower) presented to the right; drawings of the right end scenes (upper and lower) presented to the left.

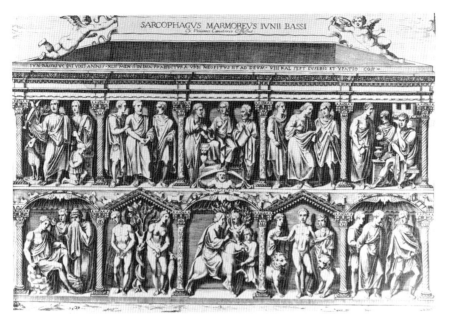

15. Engraving of Junius Bassus Sarcophagus by A. Bosio, *Roma Sotterranea*, 1632. Note the naked Daniel *orant* in the fourth niche of the lower register.

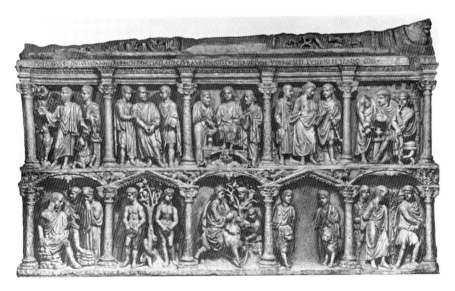

16. Junius Bassus Sarcophagus: Front—from Wilpert, *I Sarcofagi Cristiani Antichi*. Note that the Daniel figure (fourth niche of lower register) is "missing."

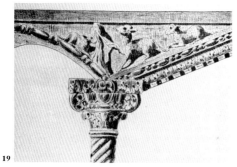

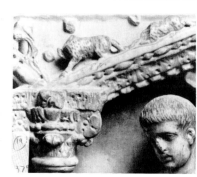

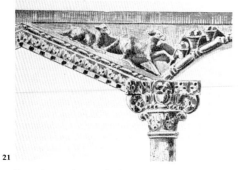

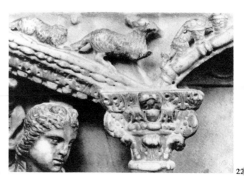

Drawings of Spandrels of Junius Bassus Sarcophagus by A. de Waal and Photographs.
17, 18. First Spandrel: Three Youths in the Fiery Furnace.
19, 20. Second Spandrel: Striking the Rock.
21, 22. Third Spandrel: Multiplication of the Loaves.

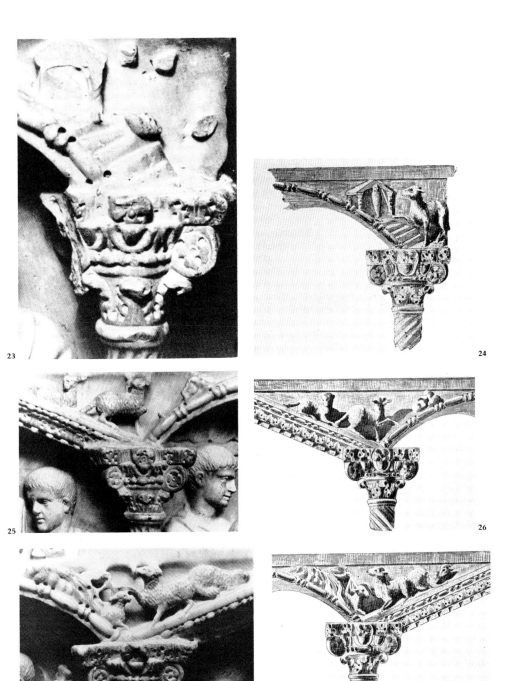

Photographs of Spandrels of Junius Bassus Sarcophagus and Drawings by A. de Waal.
23, 24. Sixth Spandrel: Raising of Lazarus.
25, 26. Fifth Spandrel: Receiving the Law.
27, 28. Fourth Spandrel: Baptism of Christ.

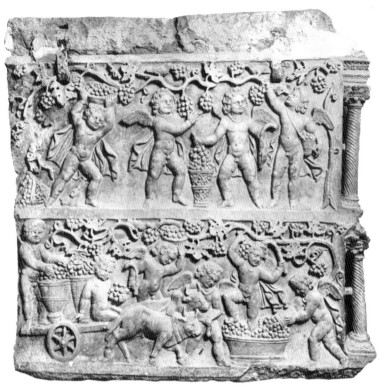

29. Junius Bassus Sarcophagus: Left End. Grape harvest by winged putti.

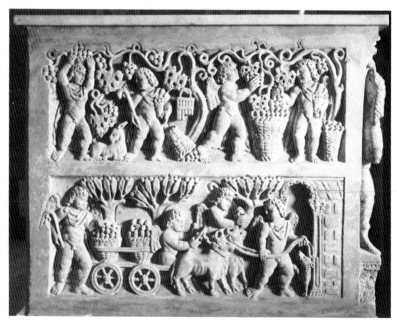

30. Three Good Shepherds Sarcophagus; Lateran 181 (Museo Pio Cristiano, Vatican): Left End. Grape harvest by winged putti.

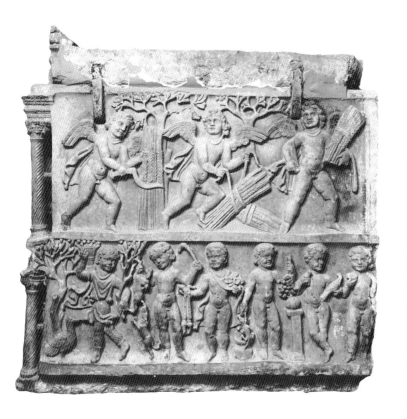

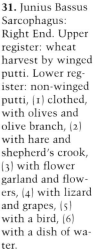

31. Junius Bassus Sarcophagus: Right End. Upper register: wheat harvest by winged putti. Lower register: non-winged putti, (1) clothed, with olives and olive branch, (2) with hare and shepherd's crook, (3) with flower garland and flowers, (4) with lizard and grapes, (5) with a bird, (6) with a dish of water.

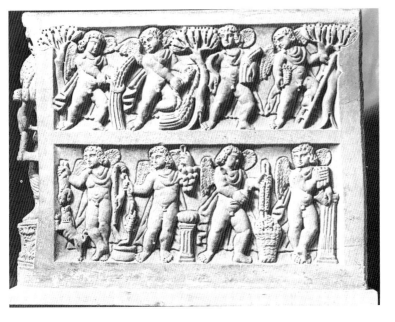

32. Three Good Shepherds Sarcophagus; Lateran 181: Right End. Upper register: wheat harvest by winged putti, under olive trees, with olive-picking putto at the right end. Lower register: winged putti with (1) hare and shepherd's crook, (2) lizard and grapes, (3) bird and flower garland, (4) shepherd's pipes.

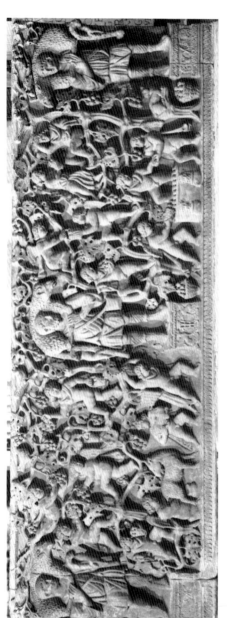

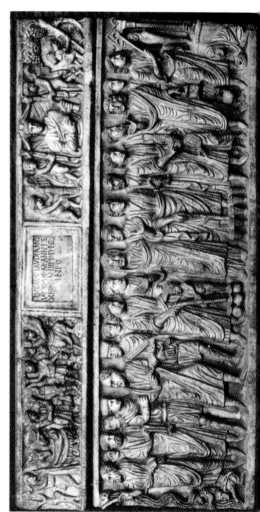

33. Three Good Shepherds Sarcophagus; Lateran 181: Front. Grape harvest by winged putti; three Good Shepherds.

34. Claudiano Sarcophagus in the Terme Museum (Rome). Single-register frieze sarcophagus with carved lid. Old and New Testament scenes of salvation and references to the sacraments. On the lid, to the left of the inscription, note Sacrifice of Isaac, Moses Receiving the Law. On the lid, to the right of the inscription, note portrait of the deceased in front of a parapetasma (curtain—indicating death, or life in another world), held by putti and framed by putti harvesting grain and grapes. On the facade, at the center, note an *orant* (symbolic of *pietas*, prayer, the soul, and/or the deceased) framed by Christ Changing Water to Wine and Multiplying the Loaves.

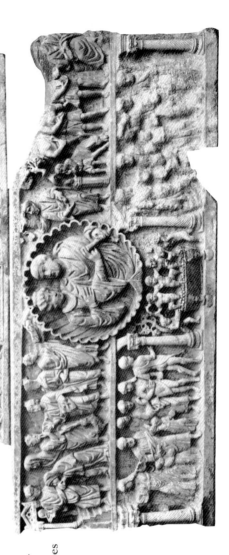

35. Season Sarcophagus from Tipasa (Parc Trémaux). Five-niche single-register columnar season sarcophagus. Scenes, from left to right: missing (Wilbert draws in Christ Changing Water to Wine), Putti representing Spring (with flowers) and Summer (with sickle and wheat), Seated Christ, Putti representing Fall (with grapes and lizard) and Winter (clothed, with goose), Striking the Rock or Miracle of the Spring.

36. Sarcophagus in the Cemetery of San Sebastiano (Rome). Unfinished and damaged double-register frieze sarcophagus with carved lid. Note putti treading grapes beneath shell with a double portrait.

37. Junius Bassus Sarcophagus: Detail of Lid—Left Side and Inscription Table.

38. Engraving of Strigilated Sarcophagus by A. Bosio, *Roma Sotterranea*, 1632. Scene: *dextrarum juntio*—joining right hands, the Roman marriage gesture, over a bundle of scrolls.

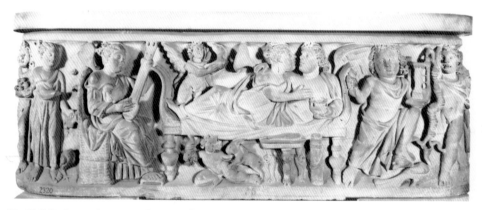

39. Child's Sarcophagus in the British Museum (London). Scene: *klinē* (Greek: couch) meal or meal of the dead with Amors and Psyches. Several elements in common with the right relief of the Junius Bassus sarcophagus lid: woven chair with female stringed-instrument player, couch, three-legged table with fish, basket bottle (compare fig. 40).

40. Junius Bassus Sarcophagus: Detail of Lid—Inscription Table and Right Side. Fragments of a *klinē* meal or meal of the dead (compare figs. 39, 41, 42). Note fragments of female instrument player, couch, child and dog below couch, three-legged table with fish, double basket bottle. Mask of Luna (the moon) at right end.

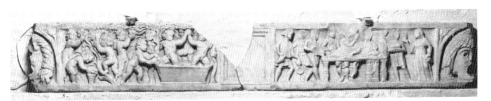

41. Sarcophagus Lid (Porto Torres, Sardinia). At ends: masks. Left relief: putti harvesting grapes. Center: inscription table. Right relief: *klinē* meal or meal of the dead. Note couch, three-legged table with fish, double basket bottle.

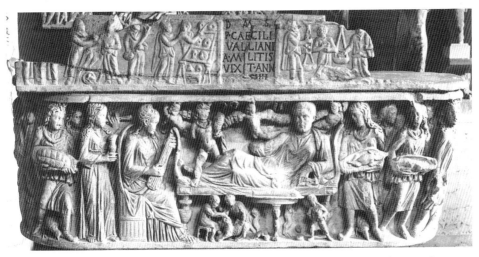

42. Sarcophagus in the Museo Gregoriano Profano; Inv. 9539 (Rome). Trough sarcophagus with carved lid. Scene: *klinē* meal or meal of the dead. Note woven chair with female stringed-instrument player, couch, child and dog below couch, three-legged table with fish.

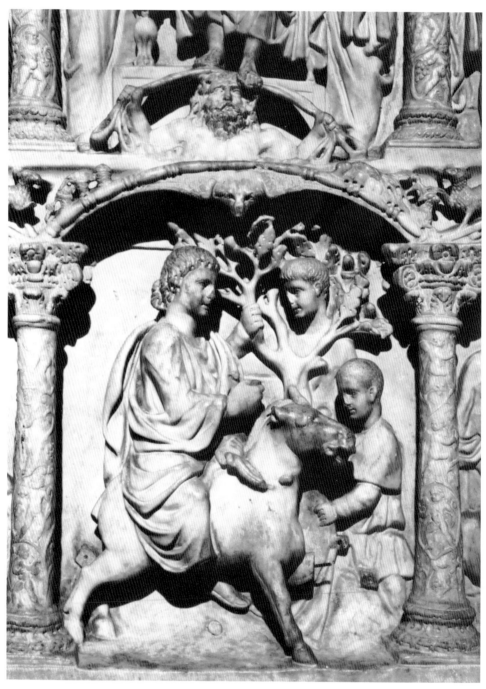

43. Junius Bassus Sarcophagus: Detail of Front—Triumphal Entry of Christ into Jerusalem. Note vine columns, eagle-headed conch in arch, repetition of curve of arch in cape over the head of Coelus (personification of the universe).

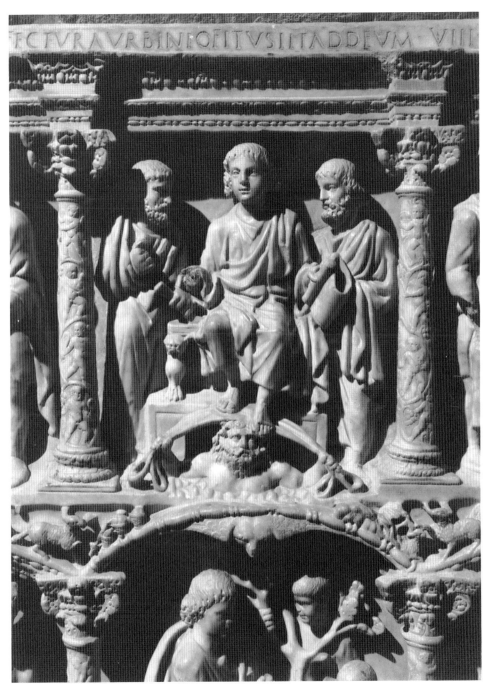

44. Junius Bassus Sarcophagus: Detail of Front—Christ Enthroned. Note centralized references to the sacraments: NEOFITVS IIT AD DEVM of inscription, vine columns, spandrels: Multiplication of the Loaves and Baptism of Christ, eagle-headed conch.

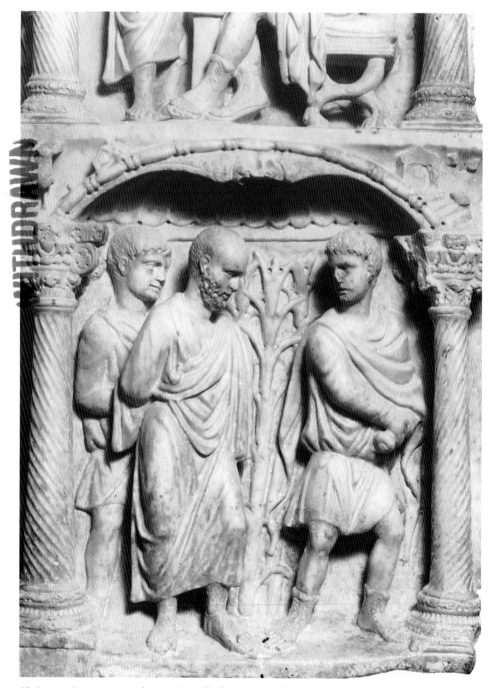

45. Junius Bassus Sarcophagus: Detail of Front—Paul's Arrest. Note eagle-headed conch above, reeds in background.

OEMCO